Contents

This book is dedicated to
NORMA BARTMAN
for her years of support of fin-de-siècle
art and literature at the Zimmerli

Théophile-Alexandre Steinlen, detail of "Au clair de la lune," pen and ink, 62 x 49.5, reproduced in *Le Chat noir*, 7 June 1884. Bartman Fund.

Introduction and Acknowledgments

On the evening of 9 December 1896 at the Théâtre de l'Oeuvre in Montmartre, Alfred Jarry's *Ubu Roi* was performed for the first time on stage by actors, not puppets. Presented within the prestigious showcase of serious avant-garde theater, the nonsensical production scandalized the audience with its irrational, schoolboy humor, its strange concatenations of elevated and vulgar language, the crude, erratic actions of its grotesque protagonist, and its lack of either a moral or a political premise. In one sense, Jarry's play was consistent with the aims of its highbrow, elitist Théâtre de l'Oeuvre context. It not only departed from but subverted many of the time-honored conventions of French theater; the text being wrought through with parodical allusions to both classical and romantic drama, and the staging breaking completely with traditional scene and costume design. However, *Ubu Roi* also pushed the limits of avant-garde theater much further than had ever been tried before, principally because of the blunt ironical treatment of its own "cutting edge," the avant-garde aesthetic itself. This was achieved through its autoparodical caricatures of both Naturalism and Symbolism–antithetical movements that had dominated avant-garde theater since the establishment of the Théâtre Libre in 1887 and the Théâtre d'Art in 1890 respectively, and which the Théâtre de l'Oeuvre had set out specifically to refine. Mocking every passing trend as well as all venerable traditions, *Ubu Roi*'s anarchic character challenged, along with the main tenets of French academic and previous avant-garde literature and theater, the rules and conventions of society as a whole. Thus it is not surprising that the play is often considered to mark not only the birth of modern drama but the emergence of twentieth-century avant-garde aesthetics. Among the first to merge art and life successfully in all of his work and with his daily actions, Jarry was an essential precursor to Futurism, Dada, Surrealism, and, more generally, to performance art. Over the years, Jarry has gained

recognition. And his work, as is normal in the process of canonization, has been increasingly studied as a unique and isolated phenomenon, as the exceptional creation of genius. What has not been sufficiently noted, however, is that Jarry's life and work represent only one manifestation (albeit a major one) of an important and influential current of avant-garde artistic activity prevalent at the turn of the last century in Paris, a current that slowly evolved after and in response to the humiliating defeat of France in the Franco-Prussian War of 1870.

The Hydropathes, founded in 1878 by the poet Emile Goudeau, and the Incohérents, founded by the writer and publisher Jules Lévy in 1882, were two of the overlapping groups of Left Bank artists, writers, and performers who first formalized the radical, fumistic characteristics of this fin-de-siècle activity, which, we endeavor to show, was also distinctly tied to and indeed emanated principally from the *cabarets artistiques* of Montmartre.

Basic aspects of this activity were its reliance on humor–its antiserious approach to art–and the fact that much of it was collaborative or even anonymous, thus denying the very concepts of canon and hierarchy, fundamental criteria for the ordering and valorization of literature, music, and art. Perhaps this is why the academic painter Jean-Léon Gérôme equated the actions of the Incohérents with "anarchism." More destabilizing still, the artworks produced by the most radical late-nineteenth-century avant-garde generally were presented in nontraditional media. Often ephemeral, multidisciplinary, and conceptual in nature–characteristics that would profoundly mark twentieth-century art–these works are difficult to classify and have therefore been easily passed over by critics of the period in the various aesthetic disciplines. Fin-de-siècle avant-garde activity is thus little known. And, although it forms an essential part of the cultural context surrounding the more historically comprehensible masterpieces of writers such as Stéphane Mallarmé, Emile Zola, and Joris-Karl Huysmans, of composers such as Claude Debussy and Erik Satie, and of artworks made in the traditional media of painting and sculpture by the Impressionists and Post-Impressionists, it has been overshadowed to the point of eclipse by the mass of critical attention devoted to figures and movements such as these. This is unfortunate, not only for our near loss of the many interesting, if "minor," works and artists involved in this earliest, authentically original avant-garde group phenomenon, but also in that several of the most radical, experimental works of canonical figures such as Mallarmé have also been neglected, or misunderstood, owing to a general unawareness of their contemporary avant-garde context.

With the Chat Noir cabaret (1881–97) and the Quat'z'Arts cabaret (1893–1910) as its main focus, this collection of essays documents and explores the development of the Montmartre cabaret from 1875 to 1905 as the primary promoter, catalyst, and, often, site for the collaboration of artists, writers, composers, and performers in the production of illustrated journals, books, dramatic pieces, music, puppet shows, and the protocinema invention of the shadow theater. The book's primary aims are to reveal the essence of Montmartre's artistic, intellectual environment, to analyze its

inextricable relations with an important, multidisciplinary body of fin-de-siècle art, literature, and music, and to indicate that oeuvre's connections with other important works, which both precede and follow it: the writings of Rabelais, which by all accounts heavily influenced the spirit of Montmartre, as well as many twentieth-century avant-garde works, which appear to have been deeply influenced by the Montmartre spirit in turn.

We are very thankful to our fellow essayists–Olga Anna Dull, Daniel Grojnowski, and Steven Moore Whiting–for their contributions to this publication, without which we could not have attempted a reevaluation of the fin-de-siècle avant-garde. In addition, Madhuri Mukherjee, a doctoral candidate in the Rutgers Department of French and currently cataloguer of the Zimmerli's extensive collection of fin-de-siècle illustrated books and journals, has been of invaluable assistance in this project. She is also the author of the appendix of biographies.

Finally, we owe a great deal to two previous works that have been seminal for our study: Daniel Grojnowski and Bernard Sarrazin's anthology, *L'Esprit fumiste ou les rires fin de siècle* (Paris: José Corti, 1990), and François Caradec's recent biography, *Alphonse Allais* (Paris: Belfond, 1994).

Search uh sources for Caradec's bio of Allais

* * *

In the spring of 1995 the Zimmerli Art Museum officially inaugurated its David A. and Mildred H. Morse Research Center for Graphic Arts. Within this new facility is the Herbert D. and Ruth Schimmel Rare Books Library, which houses the Zimmerli's collection of over three thousand illustrated French books and journals, from the approximate period of 1870 to 1914. The creation over the last decade of this concentrated collection of original fin-de-siècle research material has been made possible with the generous donation of books and funds by Norma Bartman and by Herbert D. and Ruth Schimmel. *The Spirit of Montmartre* is, in large part, the direct result of research performed at the Zimmerli, and all works reproduced in the publication are from the Zimmerli collection unless otherwise indicated.

<div align="center">
Phillip Dennis Cate

and Mary Shaw
</div>

Captions to illustrations: All measurements are given in centimeters, with height preceding width. Unless otherwise indicated all works belong to the collection of the Jane Voorhees Zimmerli Art Museum. The following abbreviations are used for credit lines of Zimmerli acquisitions.

Schimmel Fund: The Herbert D. and Ruth Schimmel Museum Library Fund
Bartman Fund: Norma B. Bartman Purchase Fund
Morse Fund: David A. and Mildred H. Morse Art Acquisition Fund

LE RAT MORT (THE DEAD RAT [CAFÉ])

This rat is painted by Léon Goupil on the ceiling of an artists' café on the place Pigalle in Montmartre. At five o'clock in the evening, the café begins to fill up with a special crowd of artists and women enticed in from the street. The women, dressed to the nines and even better, are nobody in particular. The artists are Messrs. Degas, Pissarro, Manet, Pierre [*sic*] Carrier-Belleuse, Cabaner, Tivoli, Goeneutte, Detouche, Cézanne, Paul Alexis, Métra, and Vallès–in general, the modernists. They talk and drink....

It is eight o'clock. Every evening in the café a hubbub ascends, a din of ideas and words about modernism, while a scattering of well-dressed women, rigid in their corset, under their vests buttoned to the waist, bosom now a single curve as if it were another rear end, or leaned back against the garnet velvet of the sofas, look around nonchalantly, with the eyes of cows in a meadow where there is nothing left to crop....

But Messrs. Degas, Pissarro, and Manet are carried away in a satire of painting, historical painting. People who have heard the names of Messrs. Degas and Pissarro think, wrongly, that they are young men. Mr. Degas, painter of dancers, who captures with wonderful accuracy their balanced high kicks on the toes of their silk slippers, has salt-and-pepper hair; and Mr. Pissarro, a skilled landscapist who sees nature in blue, with his bald forehead and his spiritual eyes under their dark brows, resembles a comic-opera Abraham with his long white beard. Mr. Degas is a militant who gets carried away and often talks well of himself, so that something will be left. Manet, a perfect gentleman at home and in the brasserie as well as in a salon, states his opinion with sly indifference:

"For me, to paint an historical picture based on the Chronicles of Froissart or Joinville is to paint a portrait of people according to the description in their passports."

Félicien Champsaur, *La Presse parisienne*, 2 April 1882.

Then came the Incohérents!

Fig. 1.
Henri Boutet, photo-relief invitation for the 1882 *Exposition des Arts incohérents.* Bartman Fund.

PHILLIP DENNIS CATE

The Spirit of Montmartre

On Sunday afternoon, 1 October 1882, the artists Edouard Manet, Pierre-Auguste Renoir, Camille Pissarro, and Louise Abbéma, the composer Richard Wagner, and the king of Bavaria were among two thousand curious invitees reported to have crowded into the small, Left Bank apartment of the young writer Jules Lévy, over a period of four hours, to view the exhibition bizarrely entitled *Arts incohérents* [Fig. 1]. The young journalist and writer Félicien Champsaur chronicled this unusual event:

> If you didn't see it, you haven't seen anything. It was extraordinary. Ferdinandus enjoyed enormous success with a painting in relief, *Le Facteur rural* [The Rural Postman]. It really was painting in relief, because the mailman's shoe, a real shoe that had very visibly been worn, vigorously thrust back, protruded from the canvas. . . . Miss Chabot, a dancer at the Opéra, told me that she had exhibited a landscape on the sole of her ballet slipper. It's so small that I didn't see it.[1]

Lévy's first idea was to "faire une exposition de dessins exécutés par des gens qui ne savent pas dessiner" (have an exhibition of drawings made by people who don't know how to draw) and to have it "dans ma chambre à coucher, chambre qui me sert de salon, de salle à manger, de cuisine et de salle de bain"[2] (in my bedroom, a room that also serves as my living room, dining room, kitchen, and bathroom). In fact he had organized such a show, but not at his home, on 2 August of that same year as a charity benefit for victims of a gas-main explosion. By October this proto-"happening" included work by nonartists and artists alike and had acquired the name *incohérent*.

Manet had returned to Paris from his summer retreat in Rueil just in time for Lévy's event. He was suffering, however, from a nervous disorder which was aggravated by his prescribed medicine; within seven months he would be dead. It must have been physically uncomfortable for Manet to travel from his home just below place de Clichy on the rue St. Petersburg to attend Lévy's exhibition on the Left

1

Bank. Yet, curiosity may not have been his only motivation, for he also may have been attracted to the show because of the inclusion of a number of his colleagues. The artists Henry Somm and Luigi Loir were of his generation and milieu, as were the poets Charles Monselet and Charles Cros, and the journalist Jules de Marthold; the latter two were Manet's close friends. Eight years earlier Manet had created etchings to illustrate Cros's poem "Le Fleuve." Numerous artists of the younger generation such as Henri Detouche, who had sat with Manet at the Rat Mort cabaret the previous April, and Henri Gray, who two years later would be responsible for the cover of the first illustrated *Incohérent* catalogue, lived, worked, and relaxed in and around Manet's neighborhood.

The fact that Manet and other illustrious leaders of progressive art such as Renoir and Pissarro traveled down from the heights of Montmartre to attend such an eccentric art event at a young man's studio apartment suggests that Lévy's one-day salon was considered by the avant-garde as more than just a prank; indeed, many artistically sophisticated Parisians were prepared, at least philosophically, for Lévy's unconventional, humorous approach to art. As we will see, much organized group activity within the liberal ranks of the Parisian world of arts and letters during the previous seven years paved the way for Lévy's formalized challenge to established notions of art with the creation of the Incohérents. Lévy later stated his purpose in patriotic terms: "That glory of the nation known as the French wit must be rehabilitated. This is why the Incohérents are here. And without ever being dirty, they do everything possible to be merry."[3]

While the defeat of the French army at the Sedan by Germany in September 1870 ended the imperial reign of Napoleon III, it ushered in conservative leaders of the newly formed Third Republic who were responsible for the brutal destruction of the French Commune the following spring. The humiliation of France by Germany and of what many considered genocide by the new government combined to create a deep-seated malaise among intellectuals, who questioned traditional notions of patriotism and national identity. It would take several years and a painting by Manet before the healing process would set in, and for a new, positive vision of the French spirit to emerge from the tattered national ego.

The big success of the official Salon of 1873 was Manet's painting *Le Bon Bock* (*The Good Pint* ; Philadelphia Museum of Art) [Fig. 2]. Stylistically and thematically, it was inspired by the seventeenth-century art of Frans Hals, which Manet had seen in July 1872 during his visit to the new Hals museum in Haarlem.[4] The painting was received equally well by the Salon's conservative jury and the press. *Le Bon Bock*, unlike *Olympia* eight years earlier, offered little in the way of controversy; on the contrary, coming only two years after France's defeat, it was appreciated by some for its joie de vivre, its serenity, and its supposedly apolitical subject. However, Jules Claretie noted in his review of the Salon in the newspaper *Le Soir* that "ce doit être un bon philosophe et bon patriote d'Alsace qui déguste sans bruit son tabac et son houblon"[5] (It must be a good philosopher and a good Alsatian patriot quietly

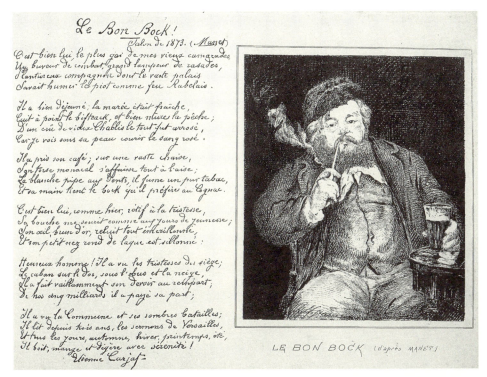

Le Bon Bock!
Salon de 1873. (Manet)

C'est bien lui le plus gai de mes vieux camarades,
Un buveur de combat, grand lampeur de rasades,
L'aventureux compagnon dont le vaste palais
Savait humer le piot comme feu Rabelais.

Il a bien déjeuné; la marée était fraîche,
Cuit à point le biftéack, et bien mûres la pêche;
D'un cru de vieux Chablis le tout fut arrosé,
Car je vois sous sa peau courir le sang rosé.

Il a pris son café; sur une vaste chaise,
Son torse monacal s'affaisse tout à l'aise,
La blanche pipe aux dents, il fume un pur tabac,
Et sa main tient le bock qu'il a préféré au Cognac.

C'est bien lui, comme hier, rétif à la tristesse,
Sa bouche me sourit comme aux jours de jeunesse;
Son œil brun d'or, reluit tout émerveillé,
Et son petit nez rond de laque est sillonné:

Heureux homme! Il a vu les tristesses du siège;
Le caban sur le dos, sous l'obus et la neige,
Il a fait vaillamment son devoir au rempart;
De nos cinq milliards il a payé sa part;

Il a vu la Commune et ses sombres batailles;
Il lit depuis trois ans, les sermons de Versailles,
Et tous les jours, automne, hiver, printemps, été,
Il boit, mange et digère avec sérénité!
Etienne Carjat

LE BON BOCK (d'après MANET)

Fig 2. Page from *Album du Bon Bock*, photolithograph (Paris: Ludovic Baschet, 1878). Schimmel Fund.

The Bon Bock!

Salon of 1873–Manet

It's him indeed, the merriest of my old comrades,
A combat drinker, swigger of brimming glasses,
Big bodied companion whose huge palate
Was able to hold booze like the late Rabelais.

He has had a good lunch; the fish was fresh,
The steak done just right, the peach quite ripe,
All of it washed down with an old Chablis,
For I see the flush on his cheek.

He's had his coffee; into a huge armchair
His monkish torso sinks back, comfortably;
His white pipe between his teeth, he smokes a
pure tobacco,
And his hand holds the bock beer that he likes
better than brandy.

It's him indeed, as if it were yesterday, resistant
to sadness,
His mouth smiles at me as in the days of our
youth;
His eyes, golden brown, shine brightly,
And his little round nose is furrowed with lacquer:

Lucky man! He saw the sorrows of the siege;
His overcoat on his back, under shells and snow,
He did his duty valiantly on the ramparts;
He paid his share of our five billion;

He saw the Commune and its somber battles;
For the past three years he has been reading the
sermons of Versailles,
And everyday, fall, winter, spring, summer,
He drinks, eats, and digests serenely!

Etienne Carjat

enjoying his tobacco and hops). In fact, the recognition of the corpulent beer drinker as a French Alsatian patriot rather than a typical Hals Dutchman permitted *Le Bon Bock* to be perceived as a reference to the loss of the Alsace-Lorraine region by France to the Germans in the recent war. Yet, the painting was not to become an immediate rallying cry for revenge. Rather, as Etienne Carjat's poetic homage to Manet's painting five years later implies, *Le Bon Bock* became a symbol of national introspection.

Emile Bellot, a printmaker, had posed for *Le Bon Bock* at the Café Guerbois. He was one of the artists who, along with Manet, regularly frequented the café in the early 1870s. In February 1875 Bellot organized a luncheon for his colleagues in honor of Manet's painting at the Krauteimer, an Alsatian restaurant in Montmartre, at 108, boulevard Rochechouart. Before the Franco-Prussian War, the restaurant was frequented by actors from the Théâtre Montmartre and local painters, especially those of Alsatian and German origin. After the war, however, the Germans left Paris, and the restaurant became the reserve of the Alsatians. Murals depicting the Rhine and the river's nearby villages decorated the Krauteimer. The Alsatian artist and illustrator Eugène Cottin organized the luncheon with Bellot; there Carjat recited his "Toast to Alsace-Lorraine," stirring the emotions of all those in attendance.[6] Incredibly, this event was to initiate a series of monthly Bon Bock dinners, which was to last uninterrupted, except during the First World War, for more than fifty years and was to include hundreds upon hundreds of participants. Félix Galipaux, the popular café-concert humorist and monologist, was a frequent and early participant

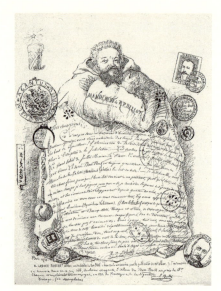

Fig. 3.
Emile Bellot, preface, *Album du Bon Bock*, photolithograph (Paris: Ludovic Baschet, 1878). Schimmel Fund.

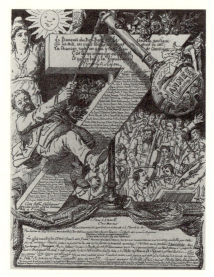

Fig. 4.
H. Castelli, lithographic invitation for the seventy-third dinner of the Société du Bon Bock, 8 March 1881. Bartman Fund.

in Bon Bock dinners; he describes the dinner's beginnings in his memoirs:

> In February 1875 the engraver Emile Bellot, very well known in the artistic milieu of his day, a regular guy, a Rabelaisian, a jolly wine sniffer, organized a lunch on boulevard Rochechouart for a few friends and fans of the painter Manet, whose *Le Bon Bock*, a portrait of Bellot smoking his pipe before a stein of light Strasbourg ale, had enjoyed enormous success at the Salon of 1873. At this lunch poems were recited, songs were sung, the pianist Ben-Zayoux made a worn-out piano groan. The event was so merry that Bellot was asked to organize monthly dinners that would include artists, men of letters, and musicians. With Bellot as president, the monthly "Bon Bock" dinner, as it continued to be known, was held initially in the old Vendanges de Bourgogne cabaret on rue de Jessaint. It was not easy to become a guest: you had to belong, that is, you had to be involved in literature and the arts. The guests included Daudet, Monselet, André Gill, Carjat, the poet-photographer (who was it that said to him, "You're a *faux* (false) poet, a *faux* caricaturist, and a *faux tographe*[r]), Charles and Antoine Cros, Monprofit, Grenet-Dancourt, Boudouresque from the Opéra, Georges Lorin, singers, and composers.[7]

Bon Bock dinners were held the second Tuesday of each month and were convivial events at which representatives of literature, art, music, and poetry were comrades, united under the republican ideals of democracy and fraternity. As president and chief organizer of the Bon Bock dinners, Bellot set the Rabelaisian tone of the evening. To document the monthly events he provided a Bon Bock *livre d'or*, for which participants were coaxed to contribute original drawings, poems, music, and puns that were placed indiscriminately on the page. In 1875 and 1878 Bellot and a fellow Bon Bocker, the editor Ludovic Baschet, published the *Album du Bon Bock*; the 1878 album contains photolithographic reproductions of a selection of fifty pages of the contributions made by Bon Bockers since the group's inception. Included are drawings and writings by such future Incohérents as Henry Somm and Henri Pille, Charles Monselet and Coquelin Cadet. The preface [Fig. 3] of the album presents Bellot's Republican-Rabelaisian mandate for Bon Bockers:

> Literature and the Fine Arts, Music and Poetry, hand in hand, forming a magnificent crown at our meetings. No arguments, no jealousies, no animosities. All equal, all united, we assemble around that Republican banner that bears as its device: FRATERNITY! So I can say without arrogance that if Gaiety and Intelligence and Congeniality were banished from the rest of the earth, they would be found at the Bon Bock. Wherefore, beloved brothers, I pray our immortal grand master, Rabelais, to maintain you in good bodily health and joyous frame of mind.[8]

It was thus under the leadership of Bellot that Bon Bockers searched the depth of their cultural heritage to find a new means to define the French national spirit. They articulated a vision of the true *esprit gaulois* (Gallic spirit) as one specifically equated with the gutsy humor of the sixteenth-century satirist François Rabelais.

4

Standing aloof from the conservative political realities of the day, the Bon Bock promoted a concept of ideal French national identity, one composed of a liberal republican form of government and a Rabelaisian spirit. Essentially, for Bon Bockers liberty and humor were indivisible. This sentiment supported a climate of literary-artistic freedom and experimentation, which engendered tongue-in-cheek, antiacademic, and anti-institutional satire and parody. Eventually, as in the case of the Incohérents, it allowed for breaking all the rules. By early 1880 *fumisme* had become the term to refer to this kind of skeptical, politically incorrect frame of mind.[9]

Bellot states in his preface to the 1878 album that "le sacré Bon Bock va toujours grandissant. Que Notre Dame du Moulin de la Galette (Moulinus Galettae) lui soit en aide!" (the sacred Bon Bock keeps growing bigger. May Our Lady of the Moulin de la Galette protect it!). In fact, just as the Moulin de la Galette was a famous Montmartre landmark, so too was the Bon Bock dinner a Montmartre event: although its location changed a few times during its long existence, the restaurants that served as its home were always located in or around Montmartre [Fig. 4]. Apparently in response to the success of the Bon Bock dinners, the Brasserie du Bon Bock was founded in 1879 by Charles Moreux at 2, rue Dancourt in the heart of Montmartre.[10] Nonetheless, although the Brasserie du Bon Bock included Bon Bockers among its regular clients, it never hosted the group's dinners.

The Brasserie du Bon Bock, La Grande Pinte (1878), and L'Auberge du Clou (1883) were three of Montmartre's earliest *brasseries artistiques*. They could be described as such not solely because of their artistic clientele, which was also a characteristic of older Montmartre-area establishments such as the Café Guerbois, the Nouvelle Athènes, and the Rat Mort cabaret, but because they were decorated with framed artwork or murals by local artist-clients. The Brasserie du Bon Bock featured numerous paintings and drawings by the ex-clown Joseph Faverot and André Gill's painting of a statuesque nude, *La Femme au bock* [Fig. 5]; it also became the home of Jules de Marthold's entry for Lévy's October 1883 Incohérent exhibition [Pl. IIIa].

Somm created an accurate account of the interior of the Bon Bock in his etching entitled *Brasserie Lott* [Figs. 6, 7]. One may identify Gill's painting faintly depicted to the left of a clown by Faverot on the wall behind the bar. Somm's print also shows a fantasy of little men, including an artist with palette in hand, scurrying about or being served pints of beer by the barmaid. In fact, the Bon Bock was a *brasserie à femmes* in which, as in Manet's *Bar at the Folies-Bergère* (1881–82, London, Courtauld Institute Galleries), women replaced male waiters in order to attract greater numbers of male customers–with the promise of services beyond those encompassed by the term *waitress*. Somm's title, *Brasserie Lott*, at first glance is confusing. Why, one may ask, would this name be given to what in reality was the Brasserie du Bon Bock? The answer is found in the 1878 *Album du Bon Bock*, where Jules Dementhe created a rebus, or a visual pun, on the name "Bellot". By designing a decorative, that is, beautiful zero, Dementhe created a play on words with *belle* and *O* and the two syllables of the name "Bellot" [Fig. 8]. To complete his rebus for *Bellot du Bon Bock* he

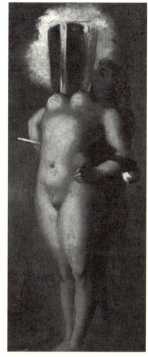

Fig. 5.
After André Gill, *La Femme au bock*, 1883, oil on panel, 55.5 x 24. Morse Fund.

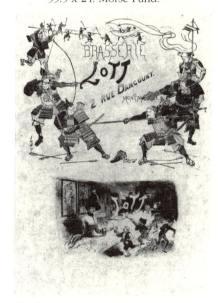

Fig. 6.
Henry Somm, *Brasserie Lott*, c. 1884, etching over Japanese color-woodblock print, 32.5 x 24. Gift of Christopher Drake.

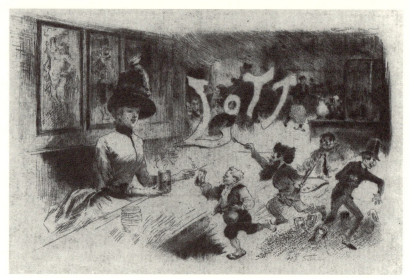

Fig. 7.
Detail of fig. 6.

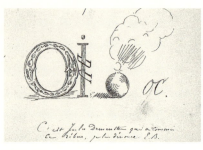

Fig. 8.
Jules Dementhe, Bon Bock rebus, photo-lithograph in *Album du Bon Bock* (Paris: Ludovic Baschet, 1878). Schimmel Fund.

drew a bomb and wrote the syllable *oc*. Somm twice pays similar homage to Bellot in the Zimmerli Museum's proof of his etching, which has been printed onto a Japanese color-woodblock print; he also indirectly suggests the proper name of the brasserie. In the upper portion of the paper, Somm takes advantage of the letter-B configuration of the Japanese warrior's bow and arrow to indicate the phonetic sound of *Be* as in "Bellot"; within the interior view of the brasserie, the barmaid becomes the *Belle* for Bellot and the printed *Lott* completes the rebus for both sections of the print. Since Bellot was Manet's *Bon Bock*, the *Brasserie Bellot* is, thus, the Brasserie du Bon Bock. The rebus already existed in the Middle Ages, and by the nineteenth century it had become a word game found in popular journals. Somm's print is an example of the adoption of the rebus by artists for the purpose of creating sophisticated visual puns. As we will see, a variety of approaches to word-image, conceptual art was developed at the end of the nineteenth century, forms that had great ramifications for the twentieth century.

It is not possible to date Somm's print precisely, yet the dress and the hat of the barmaid are similar to styles fashionable in 1884. There is evidence to suggest that the print refers directly to Manet, who had died on 30 April the previous year, and to Manet's last major composition, *Bar at the Folies-Bergère*, which had been shown at the Salon of 1882. One may conjecture that the little men in the foreground represent Bon Bockers and that the bearded artist is, in fact, Manet himself putting the last touches of paint on the word *Lott*, that is, the portrait of Bellot. The barmaid refers to the similar subject in Manet's *Bar at the Folies-Bergère* and also represents the allegorical female muse of art who, by serving "good pints of beer," inspires artists to paint and writers to write. Note that Manet's *Lott* emerges like a genie out of the glass of beer held in the barmaid's hand. That same year, in the illustrated catalogue for the 1884 Incohérent exhibition, Henri Boutet also pays tribute to Manet [Fig. 10].

6

Fig.9.
Edouard Manet,
Polichinelle, 1874, color
lithograph,
57 x 32.7. Lillian Lilien
Memorial Fund.

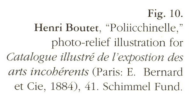

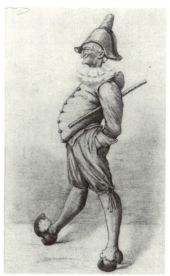

Fig. 10.
Henri Boutet, "Poliicchinelle,"
photo-relief illustration for
*Catalogue illustré de l'expostion des
arts incohérents* (Paris: E. Bernard
et Cie, 1884), 41. Schimmel Fund.

This time, however, the allusion is made not to *Le Bon Bock* but rather to Manet's 1874 controversial color lithograph, *Polichinelle* [Fig. 9], which was censored by the conservative Third Republic government because of the image's similarity to President Mac Mahon. Thus, two years after Manet had visited Lévy's exhibition, the two Incohérents, Somm and Boutet, paid homage to Manet, who, by then, was a deceased hero of the avant-garde.

The formalized Bon Bock dinners were the precedent for the group gatherings of the Hydropathes (see below) and the Incohérents. The two Bon Bock albums and the monthly, illustrated Bon Bock invitations also provided the precedent for the Incohérents and the Chat Noir cabaret for ephemeral, photomechanically printed products and documentation of group activities. A number of early participants in the Bon Bock dinners, such as Somm, Pille, Ferdinandus, Cros, Cabriol, Gill, Monselet, and Coquelin Cadet, not surprisingly, also became members of the Hydropathes and/or the Incohérents or were involved with the Chat Noir cabaret, because of the similar antiestablishment focus of each group. Participation in Bon Bock dinners through the early years of the twentieth century was to be a common auxiliary activity of most individuals associated with the above groups in the late 1870s and early 1880s, and with the Quat'z'Arts cabaret in the 1890s. While the Bon Bock dinners and invitations [Fig. 4] served for more than forty years as constant reminders of the country's forfeiture of its eastern citizens to the Germans, they also reinforced in the minds of two generations of artists, writers, and performers a commitment to a Rabelaisian type of parody and satire. Thus, there was during the last quarter of the nineteenth century an implicit unity of radical thought and innovation within the literary-artistic community of Paris. This unity had as its origin Manet's painting *Le Bon Bock* and may be referred to as the "spirit of Montmartre."

7

Plate I, II (opposite page).
Alphonse Allais, cover and seven monochromatic images for *Album primo-avrilesque* (April fool-ish album) (Paris: Paul Ollendorff, 1879). Schimmel Fund.

Plate I.

a. Cover

b. *Negroes Fighting in a Cellar at Night*; based on Paul Bilhaud's entry in the 1882 *Exposition des arts incohérents.* (See fig. 25)

Pl. Ia.

Pl. Ib.

Plate II (opposite page).

a. *Some Pimps, Still in the Prime of Life, Lying on Their Stomachs in the Grass, Drinking Absinthe.*

b. *Round of Drunks in the Fog.*

c. *Manipulation of Ocher by Jaundiced Cuckolds.*

d. *Astonishment of Young Recruits Seeing for the First Time Your Azure Expanse, O Mediterranean!*

e. *Tomato Harvest by Apoplectic Cardinals on the Shore of the Red Sea (Aurora Borealis Effect).*

f. *First Communion of Chlorotic Young Girls in Snowy Weather.*

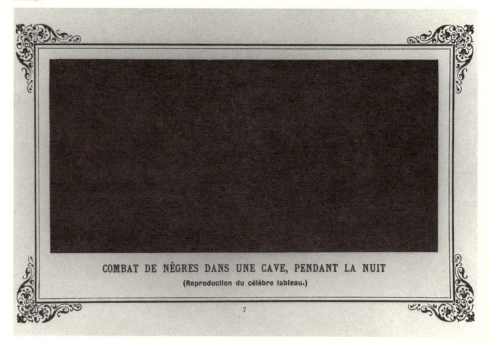

COMBAT DE NÈGRES DANS UNE CAVE, PENDANT LA NUIT
(Reproduction du célèbre tableau.)

7

8

DES SOUTENEURS, ENCORE DANS LA FORCE DE L'AGE ET LE VENTRE DANS L'HERBE,
BOIVENT DE L'ABSINTHE

Pl. IIa.

RONDE DE POCHARDS DANS LE BROUILLARD

Pl. IIb.

MANIPULATION DE L'OCRE PAR DES COCUS ICTÉRIQUES

Pl. IIc.

STUPEUR DE JEUNES RECRUES APERCEVANT POUR LA PREMIÈRE FOIS TON AZUR,
O MÉDITERRANÉE !

Pl. IId.

RÉCOLTE DE LA TOMATE PAR DES CARDINAUX APOPLECTIQUES
AU BORD DE LA MER ROUGE
(Effet d'aurore boréale.)

Pl. IIe.

PREMIÈRE COMMUNION DE JEUNES FILLES CHLOROTIQUES
PAR UN TEMPS DE NEIGE

Pl. IIf.

Pl. IIIa.
After Jules de Marthold, *Le Poème du cochon*, 1882, included in the 1883 *Exposition des Arts incohérents*, reproduced in John Grand-Carteret, *Raphaël et Gambrinus* (Paris: Louis Westhausser, 1886), 162. Schimmel Fund.

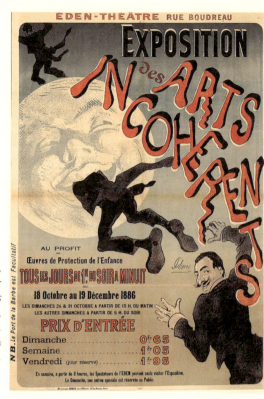

Pl. IIIb.
Jules Chéret, poster for *L'Exposition des Arts incohérents*, 1886, lithograph, 123.6 x 86. Herbert Littman Purchase Fund.

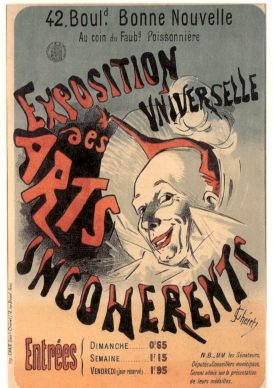

Pl. IIIc.
Jules Chéret, poster for *L'Exposition universelle des Arts incohérents,* 1889, lithograph, 58.7 x 40.2. Morse Fund.

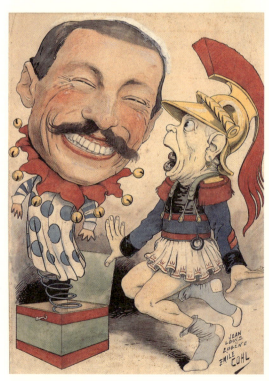

Pl. IIId.
Emile Cohl, study for the poster for *L'Exposition des Arts incohérents*, 1893, watercolor and gouache, 76 x 54.7. Schimmel Fund. (See Fig. 112)

10

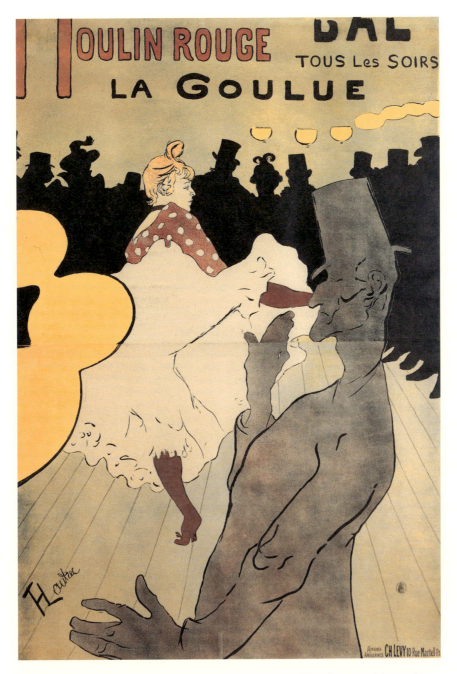

Pl. VI. Henri de Toulouse-Lautrec, poster for *Moulin Rouge: La Goulue*, 1891, lithograph, 195 x 122. Collection of Michel Romand, Paris.

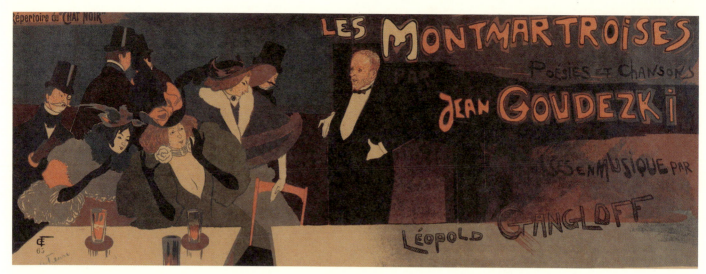

Pl. VIIa. Georges de Feure, poster for *Les Montmartroises*, 1894, lithograph, 80 x 30. Collection of Michel Romand, Paris.

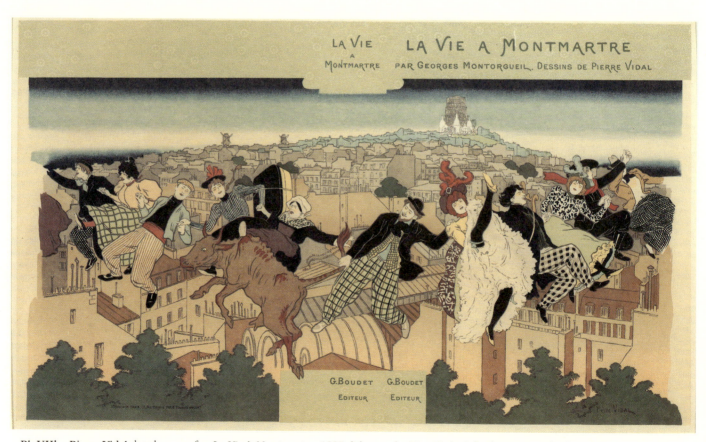

Pl. VIIb. Pierre Vidal, book cover for *La Vie à Montmartre*, 1897, lithograph, 30 x 51.4. Gift of Marion and Allan Maitlin.

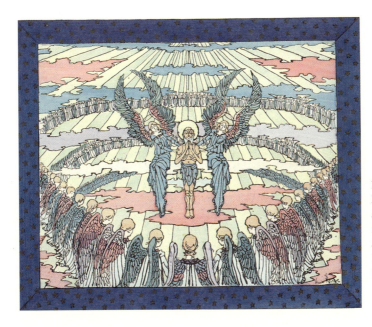

Pl. VIIIa.
Henri Rivière, "Apothéose,"
stencil-colored photo-relief
illustration for *La Tentation de
Saint Antoine* (Paris: E. Plon,
Nourrit et Cie, 1888), 87.
Bartman Fund.

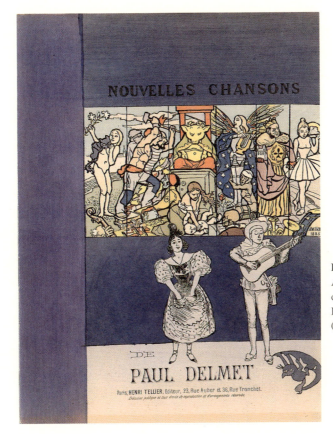

Pl. VIIIb.
Adolphe Willette, stencil-
colored photo-relief cover for
Paul Delmet, *Nouvelles Chansons*
(Paris: Henri Tellier, 1895).

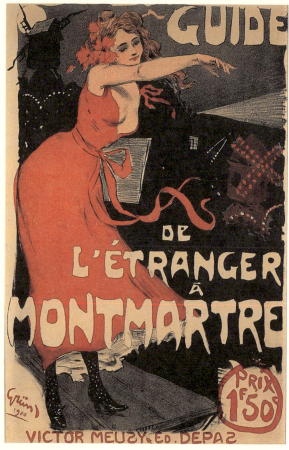

Pl. IXa.
Jules Grün, poster for *Guide de l'étranger à Montmartre*,
1900, lithograph, 60 x 40.5. The Phillip Dennis Cate
25th Anniversary Art Acquisition Fund.

Pl. IXb.
Maxime de Thomas,
poster for *Montmartre*,
1897, lithograph, 58 x 79
(mat opening). Gift of
Herbert D. and Ruth
Schimmel.

Pl. IXc.
Unidentified,
Montmartre, c. 1900,
lithographic
postcard, 13.8 x 9.
Schimmel Fund.

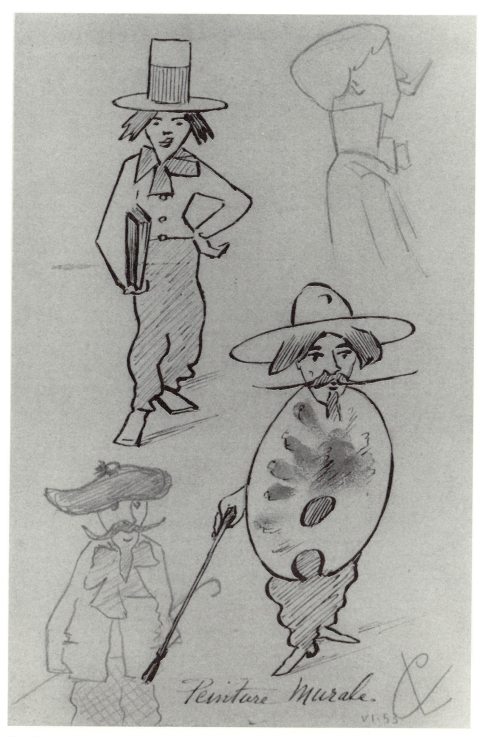

Fig. 11.
Unidentified, "Peinture murale," from *Le Mur,* c. 1900, ink, crayon, and oil pigment, 24 x 16. Schimmel Fund.

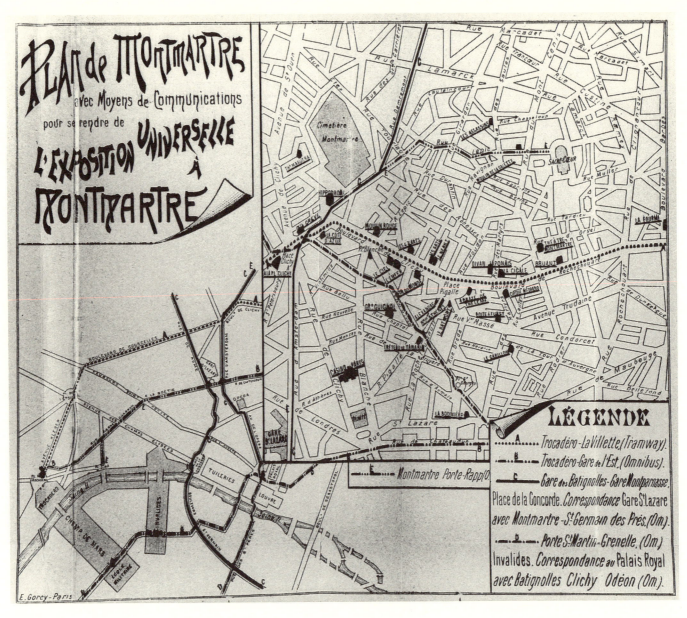

Fig. 12. "Plan de Montmartre," illustration in Victor Meusy and Edmond Depas, *Guide de l'étranger à Montmartre* (Paris: J. Strauss, 1900). Gift of Herbert D. and Ruth Schimmel.

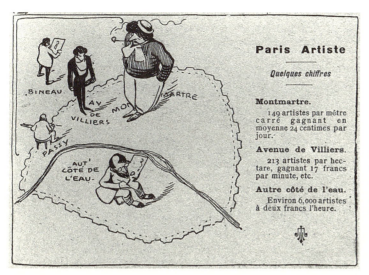

THE HYDROPATHES

> Paris has two Montmartres: the official Montmartre, classified for admin-
> istrative purposes as the eighteenth arrondissement; . . . the other is an
> arbitrary Montmartre whose limits may change depending on the vogue
> for certain establishments, but whose center always remains the Butte.[11]

Montmartre [Fig. 12], once a commune on the northern outskirts of Paris, was
annexed by the city in 1860 as its eighteenth arrondissement. It is officially defined
by the boulevards de Clichy, de Rochechouart, and de la Chapelle to the south; by
the boulevard de Ney to the north; by the avenues de St. Ouen and de Clichy to the
west, and by the rue d'Aubervilliers to the east. However, as Meusy explains in his
1900 guide to Montmartre, it did not completely stay within the official boundaries:

> Take the map of Paris, draw a line from Notre-Dame-de-Lorette along the
> street of the same name, rue Fontaine-Saint-Georges, and rue de Douai to
> place Clichy with its statue of Marshal Moncey, continue along avenue de
> Clichy to the fork formed by avenue de St.-Ouen; to the right, draw a
> perpendicular that will cut the Butte of Montmartre in half, ending at
> boulevard Ornano. From there, creating an acute angle, return to that
> same church of Notre-Dame-de-Lorette via rue de Rochechouart, rue de
> Maubeuge, and rue de Châteaudun.[12]

In fact, the spirit of Montmartre was not, and could not be, confined by geogra-
phy. It was an avant-garde state of mind, which may best be explained by the new
institutions of entertainment, by the community of artists, writers, and performers,
and by the vehicles for promotion that emerged and thrived there during the last
two decades of the nineteenth century [Fig. 13].

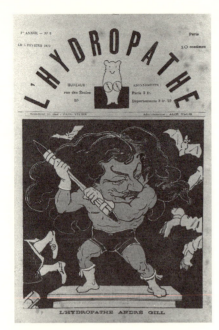

Fig. 14.
Georges Lorin (Cabriol), "L'Hydropathe André Gill," hand-colored photo-relief cover for *L'Hydropathe*, 5 February 1879. Schimmel Fund.

Fig. 15.
Unidentified, *André Gill*, n.d., photograph, 18.8 x 13.5. Schimmel Fund.

As Raymond de Casteras describes, there was a pre–fin-de-siècle tradition, based primarily in the Latin Quarter, of cafés serving as regular gathering places for small groups of artists, writers, and poets with similar aesthetics to discuss and spontaneously perform their work.[13] Yet, as de Casteras also argues, it was the modern imagination and organizational skills of the young poet Emile Goudeau who, with the founding on the Left Bank of the Hydropathes, transformed this kind of casual get-together into a grander scale of group entertainment, collaboration, and self-promotion. The Hydropathes were an eclectic society of writers, poets, artists, and performers whose principal goal was to serve as a nonjuried arena for diverse artistic voices. Goudeau describes the Hydropathes as follows:

> There were of course students of law, medicine, and pharmacology, but also students from the School of Fine Arts and the Conservatory, ministry and city hall employees, engineers and sons of building superintendents, and even a certain number of ordinary drunks who had come to raise Cain. It was a Chamber of Deputies on a small scale.... Fortunately, youth and laughter got the upper hand. A group of *fumistes*, art lovers but also pranksters, formed and at first saved the institution, then later ruined it, by force of circumstances.[14]

Established in the fall of 1878 and officially existing until the fall of 1881 when Goudeau and his associates changed the group's name to the Hirsutes, the Hydropathes were precursors, by six years, of the equivalent, democratic forum for the visual arts–the Salon des Artistes Indépendants. Yet, unlike the latter, which exhibited annually, the Hydropathes met each Wednesday and Saturday at a Latin Quarter café and, for nearly a year and a half, published their self-promoting bimonthly journal, *L'Hydropathe*. The Hydropathes formalized and intensified the role of the café as the noninstitutional showplace for emerging and recognized figures of an increasingly close-knit segment of the Parisian literary-artistic community. The Hydropathes included among their ranks not only old-guard Bon Bockers but also a strong contingent of young people such as Emile Cohl, Jules Lévy, Sapeck (Eugène Bataille), and Alphonse Allais, whose creative talents and influence were just emerging. These four, in particular, along with Goudeau, were to lead the younger, postwar generation of artists and writers into the new fields of *fumiste* battle and collaboration that mark the Chat Noir and the Incohérents.

While the Hydropathes were predominantly poets and writers, the artists Cohl, Eugène Mesplès, Sapeck, and André Gill [Figs. 14, 15] also attended and, at times, participated in the soirées. Gill was also a recognized writer whose poems appeared in his journal *La Petite Lune* (1878–79) and were compiled along with those of Louis de Gramont in the book *La Muse à Bibi* (1879). The artist-poet Georges Lorin, alias Cabriol, was the sole illustrator of the thirty-two covers of *L'Hydropathe*. His portraits of leading Hydropathes–one on the cover of each issue–were inspired by the satirical caricatures of Gill. Goudeau, as founder, was on the cover and praised within the text of the first issue of *L'Hydropathe*, and Gill was the subject of the second issue.

Gill was the mentor of many young humorist-illustrators, including Sapeck, Willette, Uzès (J. Lemot), and Cohl. At the end of the 1870s not only did they attend Gill's popular soirées at his atelier on the avenue Denfert Rochereau at the top of the boulevard St. Michel, but they also apprenticed under him as caricaturists.

Beginning in 1865 with the journal *La Lune*, Gill had led an unrelenting, one-artist battle against the status quo with his famous *portraits-charges*, comic depictions of individuals in which the head and facial features are overemphasized. Gill's career of attacking the establishment–first that of the Second Empire and, after 1870, that of the Third Republic–with caustic satirical illustrations in *La Lune* and *L'Eclipse* [Fig. 16] gained for him the respect of liberal Republicans and placed him, in the minds of the avant-garde, as the successor to Honoré Daumier. Like the latter, Gill's journalistic assaults were also censored by the government to the point of ridiculousness. Gill's fellow Hydropathes and young admirers could not have failed to know about the artist's brush with the law with his infamous illustration for *L'Eclipse* of 9 August 1868 entitled "Monsieur X . . . ?" [Fig. 17]. They must have fully appreciated the artist's symbolic victory over the government of Napoléon III with his portrait of a melon. Gill later related the story in his memoirs published in 1883; one day in August 1868, Gill bought a melon to share with some friends for lunch at his home. To judge its freshness, he cut a piece from the melon; as the meal proceeded it was decided by those at the table that since the censors of journals prohibited almost everything, one might as well submit a drawing of a melon to avoid any conflict:

> The drawing was submitted the next day to the ministry; the censor was magnanimous, the authorization to publish was granted.
>
> But on the following day we were served at the office of the publication with an order to appear before a criminal-court examining magistrate whose name I have forgotten–what a pity! The news of this prosecution shocked the public.... We were accused . . . of obscenity! . . .
>
> Since the sketch did not depict anyone, it was easy to apply its intention to everyone, and each in turn turned it into his pet aversion.

Finally, the judge interrogated Gill:

> "Do you admit that you are the author of a drawing showing a melon minus one slice that is fleeing from a pencil, and entitled, Mr. X., two dots?"
>
> Do you understand, readers? X followed by two dots, i.e., X . . , a three-letter word, so to speak.
>
> Two dots, three dots. I didn't think anything of it, and for some reason, seized by a sudden and providential desire for absolute precision, I answered, "No, Sir: X plus three dots."
>
> "Nonsense!" the judge said. He picked up the newspaper and looked at it. "It's true," he said. "You're dismissed."
>
> The investigation was abandoned; Themis, disarmed![15]

The incident offered important lessons to the Incohérents in subverting, that is, embarrassing the system through humor. The fact that the image was perceived by the

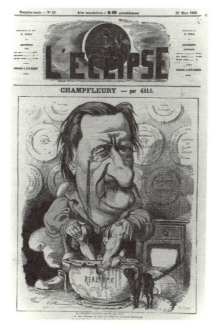

Fig. 16.
André Gill, "Champfleury," hand-colored wood-engraved cover for *L'Eclipse*, no. 10 (29 March 1868). Schimmel Fund.

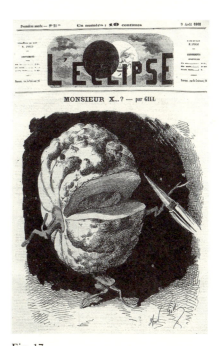

Fig. 17.
André Gill, "Monsieur X . . . ?," hand-colored wood-engraved cover for *L'Eclipse*, no. 29 bis (9 August 1868). Schimmel Fund.

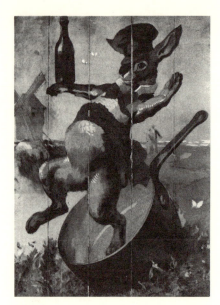

Fig. 18.
André Gill, *Lapin à Gill* (Gill's Rabbit), c. 1880, oil on panel, as reproduced in Charles Fontane, *Un Maître de la caricature, André Gill* (Paris: Aux Editions de l'Ibis, 1927), 2:215. Schimmel Fund.

authorities to be sexually obscene, whether it was meant to be or not, was confirmation of the potential of sexual innuendo and double entendre. The association of the image with the incongruous title – "Monsieur X . . . ?"– proved the power of suggestion and the effectiveness of word-image puns.

In September 1878 Gill and the young Hydropathe Champsaur collaborated on the newly founded journal *L'Homme d'aujourd'hui*, a weekly publication of biographical sketches of prominent personalities. Gill produced the *portraits-charges* for the covers of the first 141 issues. Champsaur was responsible for the biographical texts. The same year Gill joined Renoir and several other artists in creating drawings for the first illustrated edition of Zola's novel *L'Assommoir* (1877) from the author's Rougon-Macquart series. The novel deals with the misery of a life of poverty and alcoholism in Montmartre. In fact, Montmartre was Gill's regular haunt at this time, as it was Renoir's. In 1880 Gill was commissioned to paint a sign for the façade of the Cabaret aux Assassins located at the corner of the rues des Saules and St. Vincent at the top of the Butte. The Cabaret aux Assassins was frequented by a contingent of artists and writers that included Gill and Monselet, who initiated the cabaret's Thursday, Saturday, and Sunday soirées.[16] Gill's sign [Fig. 18] depicts a rabbit (a specialty of the cabaret's cuisine) dressed like a fin-de-siècle dandy hoodlum, jumping out of a saucepan while balancing a bottle of wine on his paw. The painting gained great renown within the Montmartre cabaret circle, to the extent that the cabaret was soon identified with it and was referred to as the "Lapin à Gill." By 1883 the cabaret's name had evolved fumistically even further, so that when Picasso and his group moved into Montmartre at the beginning of the twentieth century, the cabaret had already been known for some years as the Lapin Agile, the Agile Rabbit.

By the end of 1881 Gill's mental, physical, and financial health began to deteriorate; on 25 October he entered the Hôpital St. Maurice at Charenton on the eastern outskirts of Paris. For the next three and a half years, he was in and out of the hospital, depending on his fluctuating mental condition. His Hydropathe colleagues–in particular, the young Emile Cohl–cared for him and sought to secure peace and financial security for Gill during his remaining years. Cohl organized a benefit of Gill's art that was open from December 1883 to January 1884. It was held at the Galerie Vivienne, just south of Montmartre, as, not so coincidentally, were the 1883 and 1884 Incohérent exhibitions. Sixty paintings and more than 150 drawings and caricatures were on display, including Gill's two cabaret paintings, *La Femme au bock* and *Au Lapin Agile*, which had been replaced with copies at their respective cabarets earlier in 1883.[17] In February 1885 Gill died at the mental asylum at Charenton; although never officially a member of Lévy's group, Gill's life ended morosely and appropriately as a true Incohérent. A decade later his old colleagues and a new generation of Montmartre artists recognized Gill's artistic contributions and honored his memory by commissioning a portrait bust of him by the sculptor Marcel-Alexandre Rouillière. This monument, installed on the place St. Georges, several blocks below the Chat Noir, was formally dedicated on 28 April 1895.[18]

LE CHAT NOIR CABARET

In 1880 Georges Fragerolle–composer, Bon Bocker, Hydropathe, and future participant in the Incohérent and Chat Noir activities–defined *fumisme*. It

> is to humor what the operetta is to comic opera, satire to caricature, prunes to Hunyadi-Janos water. . . . In order to be considered a wit, sometimes you need only be an ass in a lion's skin; to be a good *fumiste*, it is often absolutely necessary to be a lion in the skin of an ass. In the former case the effect is direct, in the latter it is once, twice, often ten times removed.[19]

In theory, *fumisme* was not a quick laugh, nor was it always obvious. A *fumiste* did not rely for self-satisfaction on an audience's response to his actions; rather, *fumisme* was a way of life, an art form that rested on skepticism and humor, of which the latter was often a black variety verging on the morbid and the macabre. As Fragerolle stated, *fumisme* "made art for art's sake" (fait de l'art pour l'art). *Fumisme* had no social or humanitarian agenda; in fact, *fumisme* was, if anything, politically incorrect, to use a modern term. Its only goal was to "coupe[r] le ciel de prud'homie sous lequel nous vivons" (cut open the smug sky under which we live). In other words, the function of *fumistes* was to counteract the pomposity and hypocrisy they perceived as characterizing so much of society.

Significantly, Fragerolle named Sapeck and Allais as the Hydropathes who were the two leaders of *fumisme*'s "scientific-philosophical" formula: "La philosophie c'est Sapeck, la science c'est Alphonse Allais. L'un plus dandy, l'autre plus chimiste" (Philosophy is Sapeck, science is Alphonse Allais. One is more the dandy, the other more the chemist). Therefore, seven years before the publication of Sapeck's visual parody on the Mona Lisa [Fig. 174] and three years before Allais's first official participation with the Incohérents, their positions as the leaders of *fumisme* were secure.

Goudeau stated in *Dix Ans de Bohème* that *fumisme* was the philosophy behind the creation of the Hydropathes in the fall of 1878.[20] Three years later, he reorganized the Hydropathes and was behind the renaming of the group as the Hirsutes. Early in 1882 Jules Lévy attempted to create a group called the Décadents; it foundered, and, as we have seen, the Incohérents were born a few months later. Charles Cros's Zutistes, George Auriol's Nous Autres, and Les Jeunes, all of 1883, and Les Jemenfoutistes of 1884 were other short-lived literary-artistic societies organized along the lines of the original Hydropathes to meet and perform within a Left Bank café environment.[21] It was, however, the Chat Noir cabaret in Montmartre [Fig. 19], founded by Rodolphe Salis in November 1881, and Lévy's Incohérents that carried on the *fumiste* agenda of Goudeau's Hydropathes and that simultaneously shared many of the same participants.

According to Goudeau, he first encountered Salis at the Cabaret de la Grande Pinte:

> One evening I climbed gloomily up the hilly rue des Martyrs on my way to the Grand'Pinte cabaret, where I was hoping to recover my peace of

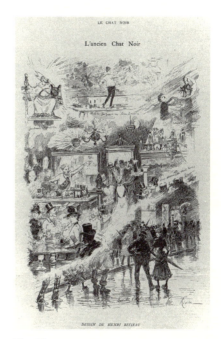

Fig. 19.
Henri Rivière, "L'Ancien Chat noir," photo-relief illustration for *Le Chat noir*, 13 June 1885. Schimmel Fund.

Fig. 20.
Uzès, "Rodolphe Salis," photo-relief illustration for *Le Chat noir*, 24 November 1883. Schimmel Fund.

mind somewhat by chatting with Manet, Desboutins, and others. Several minutes after I had sat down, a cheerful bunch entered. They were Montmartre Hydropathes: the painter René Gilbert, the giant Parizel, this person, that person. They sat down near me. Suddenly, pointing out a sturdy, tawny blond young fellow who was with them, Gilbert said to me, "Do you know Rodolphe Salis?"

"No," I answered. "You never came to Hydropathe meetings."

"Never," the blond man answered. "I was painting in Cernay, far from the noise of the city."

And then he added, "I'm founding an artists' cabaret at 84, boulevard Rochechouart. Would you like to come to the opening dinner?"

"I'd be glad to," I said.

That's how I got to know Rodolphe Salis.[22]

The alliance of Salis [Fig. 20] and Goudeau at the Chat Noir initiated the full-fledged migration of the Hydropathes from the Left Bank to Montmartre; the literary soirées of the Latin Quarter were soon replaced by the *matinées littéraires* of the Chat Noir. Salis's cabaret soon became "absolument comme aux hydropathes, un mélange–sans doctrine–de gaîté et de sérieux"[23] (absolutely as in the days of the Hydropathes, a mixture of fun and seriousness without doctrine). Within a month of the cabaret's inauguration, Salis founded *Le Chat noir* journal, with Goudeau as its editor in chief. While the purpose of *L'Hydropathe* was to promote itself and its individual members, the strategy adopted by *Le Chat noir* for a similar purpose was far more aggressive and expansive. Immediately, in its first issue of 14 January 1882, a full-page illustration by Salis [Fig. 21] demonstrates the kind of *fumiste* bravado propaganda that would be his standard means of selling the Chat Noir and Montmartre for the subsequent fifteen years: "Ne bougeons plus! Tout le monde y passera" (Freeze! Everyone will have to go through it [Montmartre]). With the Moulin de la Galette in the background representing Montmartre, a black cat, symbolizing both the cabaret and its journal, takes photographs as all the strange creatures of the world pass by. The implication is obvious; according to Salis, the Chat Noir is the center of the universe. This *fumisterie* is echoed in the same issue's front-page article:

It is high time to correct an error that has weighed on more than sixty whole generations We read in Genesis that Noah's Ark dropped anchor on Mount Ararat.

Mount Ararat, what can that mean?

Read: Montmartre! . . . So Montmartre is the cradle of humanity.

I'll say more. Montmartre is a breast. Let me explain.

Two large streams rise in the flanks of this sacred mountain and proceed to form a large river called the Seine So Montmartre is the center of the world.[24]

Salis's illustration refers directly to Gill's painting *Au Lapin Agile*: Salis's cat has the same pose as Gill's rabbit, and the Moulin de la Galette has the same location and

function in both images. Significantly, the camera replaces Gill's saucepan. For Salis, photography or, rather, the new technology of photomechanical printing is the means by which the Chat Noir communicates with its audience and is able to proclaim its audacious program. Salis's incorporation of readily recognizable visual references to Gill within the inaugural issue of *Le Chat noir* not only pays homage to the much-admired satirist but also helps to set the parodical tone of the new journal. The implication is also that Gill, the rabbit, has been replaced by Salis, the black cat, and that the cabaret Lapin Agile has been replaced by the Chat Noir cabaret.[25]

Billed as the "cabaret Louis XIII, Fondé par un fumiste" (a Louis XIII–style cabaret, founded by a *fumiste*), the first Chat Noir opened in November 1881 and was located at 84, boulevard Rochechouart, in an old post office. In renovating the building, Salis participated in the growing popular practice in Paris of referring back to medieval or Renaissance France for architectural inspiration, typified, for instance, in the cabaret Grande Pinte's Rabelais-period interior. At the Chat Noir, "des chaises rustiques, des bancs et des tables en bois massif, un vitrail enluminé, une haute cheminée, quelques armures anciennes, de luisantes pièces de dinaderie, constituaient l'établissement Louis XIII"[26] (rustic chairs, benches, and tables in solid wood, an illuminated stained-glass window, a large fireplace, some ancient armor, and glowing brass and copperware made up the Louis XIII establishment). For the interior, Eugène Grasset designed iron chandeliers; Willette was responsible for the design of the cabaret's distinctive exterior sign: a black cat on a crescent moon [Fig. 39]. The cabaret was quite small. Its two narrow rooms, one behind the other, together barely

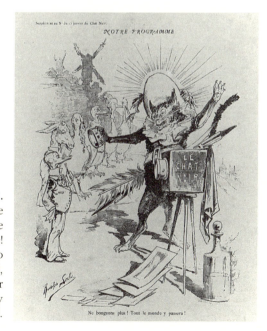

Fig. 21.
Rodolphe Salis, "Ne bougeons plus! Tout le monde y passera" (Freeze! Everyone will have to go through it [Montmartre]), photo-relief illustration for *Le Chat noir*, 14 January 1882. Schimmel Fund.

25

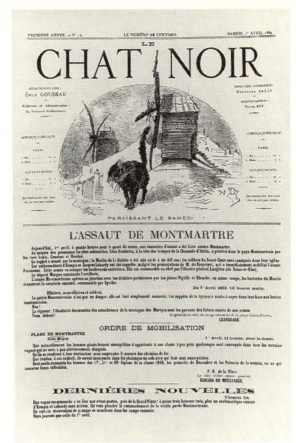

Fig. 22.
Le Chat noir, 1 April 1882.
Schimmel Fund.

held thirty people. At the beginning, the dimly lit, uninspiring rear room attracted few customers. Salis solved this problem in a *fumiste* manner while simultaneously creating a parody on the French Academy's home on the Left Bank by naming the dingy back space the Institut, which from then on was reserved solely for the privileged artistic, literary, and musical habitués of the Chat Noir. *Le Chat noir* of 8 April 1882 bragged:

> The Chat Noir is the most extraordinary cabaret in the world. You rub shoulders with the most famous men of Paris, meeting there with foreigners from every corner of the globe. Victor Hugo, Emile Zola, Barbey d'Aurevilly, the inseparable Mr. Brisson, and the austere Gambetta talk buddy-to-buddy with Messrs. Gaston Vassy and Gustave Rothschild. People hurry in, people crowd in. It's the greatest success of the age! Come on in!! Come on in!!

The front room served the cabaret's less-illustrious clientele.

This system of segregation and snobbism heightened the public appeal of the cabaret. Then, by overcoming an old government statute, Salis was allowed to have a piano in the Chat Noir–a very important victory within the history of cabaret

26

entertainment: music and song were now added to the spoken repertoire of poetry and verse within the Institut. Salis's impresario skills, combined with the vigorous, exaggerated promotion of the cabaret in *Le Chat noir* – "Since its founding by Julius Caesar for the vigorous artists of our time, the Chat Noir cabaret has not ceased to be the obligatory meeting place for everyone who is seriously a lover of art"[27] – created a self-fulfilling situation:

> The elite of artistic and literary Paris came to listen to these poems and these songs. Emile Zola, Francisque Sarcey, Jules Vallès, Félicien Rops, Henri Pille, Desboutins, Jules Claretie, Alphonse Daudet, Clovis Hugues, Paul Ginisty, Paul Alexis, and Rochegrosse could be seen at the Chat Noir. . . . The Chat Noir vogue quickly spread to high society, and the cabaret soon became a fashionable place. Friday was the "night" devoted more particularly to literary meetings at which guests from the noble suburb arrived in fancy coupés and were welcomed by Salis with an extravagant eloquence drawn from a wide variety of sources. Montmartre, previously merely an outlying district like Belleville and Ménilmontant, suddenly became a famous center of artistic activity.[28]

Led by Salis and Goudeau, the cabaret's journal promoted with political spoofs the fantasy of a Montmartre centrism. The *fumiste* headline of the 1 April 1882 issue [Fig. 22] announced the fictitious "assaut de Montmartre" (siege of Montmartre) by Léon Gambetta, the Republican hero of the siege of Paris and the Paris Commune of 1870–71. Six months later, the 28 October issue is an "appel aux armes" (call to arms) by Salis against the "coup d'état du 2 Novembre 1882" by President Jules Grévy, which *Le Chat noir* inexplicably reports in full detail five days in advance. The article must have easily brought to mind President Louis-Napoléon's coup d'état of 1852, which resulted in his almost twenty-year reign as Emperor Napoléon III. The threat of a one-man dictatorship in France was certainly not out of the question in the early 1880s, yet Salis's cry of "vive l'anarchie" (long live anarchy!) within this farcical script of Parisian, bourgeois, political upheaval was probably just as disconcerting to the average Republican whose bitter memories of the Paris Commune were still fresh. The antibourgeois premise and the theatricality of this political spoof predicts Jarry's more universal approach to the theme in *Ubu Roi*. Indeed, the editors of *Le Chat noir* used qualities of the absurd and parody to put the establishment–political, social, or artistic–on edge; part of this *fumiste* process was also the promotion of itself and the Montmartre artistic community as the one true, regenerative force in French culture:

> The blood that reddens the gutters of boulevard Rochechouart cries out for vengeance. *Le Chat noir*, still being printed clandestinely, in an untraceable hideout, calls upon all true Republicans, all true Frenchmen.
> Our supremacy in the arts, humanities, and science is at stake!
> Our honor is at stake!
> MONTMARTRE , VENGEANCE![29]

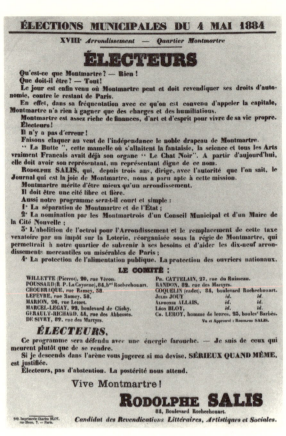

Fig. 23.

Rodolphe Salis's notice for the Montmartre municipal election, 1884, 61.7 x 42.6. Morse Fund.

Salis's political-artistic philosophy became fully codified and publicly announced by the spring of 1884 in which he ran (and lost) as a candidate from the eighteenth arrondissement (Montmartre) in that year's municipal elections [Fig. 23]. As "the candidate of literary, artistic, and social demands," Salis's platform was essentially the official separation and independence of Montmartre from the city of Paris. While there may have been a degree of serious expectation on Salis's part in regard to his candidacy, it is exactly on this kind of ambiguity between *fumiste* joke and seriousness that he and his associates played.

For readers not clued in to the antics and personalities of the Chat Noir group, it was, and is, difficult to decipher the distinctions within the articles of *Le Chat noir* between truth and farce, between reports of actual or fabricated events. The childlike tendencies of exaggerating, deceiving, and outright lying were aesthetic tools of the *fumistes*. Goudeau abruptly introduces these elements to the journal in the 22 April 1882 issue with the dramatic and elaborate announcement of Salis's premature death, which was for some readers so real that they appeared at the cabaret at the hour appointed to pay homage to him. *Le Chat noir* attributed Salis's death to his extreme state of depression caused by his belief that Zola had stolen his literary ideas and had published them as the realist novel *Pot-Bouille*.[30] Like Orson Welles's radio broad-

28

cast a half-century later describing Martians landing in New Jersey, this kind of literary joke verged on dangerous deception, as its ultimate success relied on the reactions of a gullible public.

Initially, *Le Chat noir* and its cabaret were closely associated with the members and activities of the Incohérents. The catalogue of Lévy's October Incohérent exhibition is actually a one-page, two-sided, large-format supplement to the 1 October 1882 issue of *Le Chat noir*, listing 159 of the exhibition's entries [Fig. 24]. This is the most complete record of Lévy's revolutionary first salon. Salis and Goudeau are listed among the exhibitors along with a description of their works, as are numerous other habitués of the Chat Noir such as Cabriol, François Coppée, Achille-Albert Mélandri, Monselet, Pille, the young Henri Rivière, Charles de Sivry, Somm, the illustrator Henri de Sta, and others. A week later, an article in the cabaret's journal, signed with the pseudonym "Constant Chanouard"–an obvious pun on "Chat Noir"– summed up the significance of this first formalized Incohérent exhibition and falsely credited the administration of the *Chat noir* with organizing the exhibition by naming Lévy as its agent:

> In this highly progressive century in which all outmoded ideas have succumbed under the merciless hammer of powerful innovators, while political revolutions lit up the world with their lightning bolts, parallel literary revolutions were leading to brilliant triumphs, and Art took possession of itself.
>
> What the Impressionists had attempted earlier, namely, the exact vision and rendering in the impossible tenuousness of values and color strokes, the Incohérents were to furnish to a crowd eager to study this essentially innovative form.
>
> On Sunday, 1 October 1882–remember this memorable date–the *Chat noir*, in the person of Mr. Jules Lévy, authorized organizer, opened the door of a modest studio located at 4, rue Antoine-Dubois; and thanks to the magic wand of a powerful idea, thanks to the radiance that emanates from works of genius, for a few hours transformed this dwelling into a temple of Art, a solemn cathedral of the Future.
>
> When incoherence finally triumphs over envy, people will say, That's where they were born.[31]

In addition to the art historically precocious relief painting by Ferdinandus, *Le Facteur rural* (The Rural Postman), one finds clearly described in the catalogue, or may decipher from it, other equally strident anomalies of art for that time. With tongue-in-cheek humor, the Incohérents explored various kinds of off-beat surfaces on which to paint: #5, Porcelain paste (Peinture à la barbotine), for *Assiettes anglaises* [English Plates], by René d'Alisy; #78, a skimmer (peinture sur écumoire), for *Portrait de M. Louis Veuillot*, by Edmé Langlois; #91, "Peinture exécutée sur la monture ordinaire d'une Sorcière de Walpurgis" (painting executed on the common mount of a Walpurgis witch), for *Trois Paysages et deux dames du corps de balai* (Three Landscapes and Two Ladies from the Corps de Ballet/Broom), by Paul l'Heureux; #101,

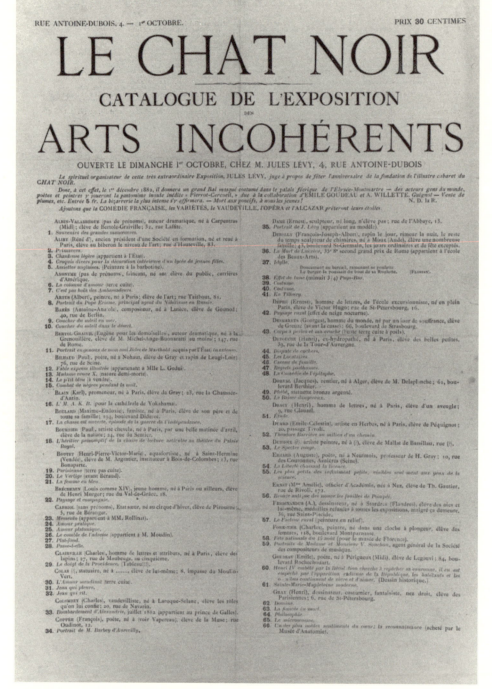

Fig. 24.
Catalogue de l'exposition des arts incohérents, special supplement to *Le Chat noir*, 1 October 1882.
Schimmel Fund.

"Peinture sur pain de 4 livres" (painting on 4-pound bread), for *Duo de Sépyramides*, by G. Livet; and #152, on "cervelas à l'ail" (garlic sausage). Unusual mixed media include #104, "cire molle, drap, poil, bouton, émail, cuir, bois, carton" (soft wax, cloth, hair, button, enamel, leather, wood, cardboard); #98, "Terre non cuite mais peinte" (clay not baked but painted); and #71, "sculpture sur fromage" (sculpture on cheese).

There is even a group painting (#114, "Peinture collectiviste") à la Surrealism by six Incohérents. The entry has the following annotation: "Le public s'expliquera l'incohérence de cette oeuvre quand il saura que les artistes qui l'ont peinte, n'ont pu, malgré leur union parfaite, arriver à tomber d'accord sur la composition de leur sujet" (The public will comprehend the incoherence of this work when it discovers that the artists who painted it could not, despite their perfect harmony, arrive at an agreement on the composition of their subject). The description of #159, *Le Poulet amoureux* (The Love Chicken/Letter), by Jules Thin, suggests that it may have been an abstract, gestural drawing because it was made by his foot in two seconds (dessin fait avec le pied en 2 secondes). Salis's entry, *Le Jugement de Paris*, #140, which, based on tradition, one would assume depicted three nudes, is described lasciviously as a "licked painting" (peinture léchée). The title of #126 by Stany [*sic*] Oppenheim creates, apparently for the first time, the official Incohérent pun: *Lézards incohérents* ("Oeuvre d'art"); one assumes the work was a depiction of a lizard.

Finally, however, the most provocative entry, at least in art-historical hindsight, is #15 by the poet Paul Bilhaud, entitled *Combat de nègres dans une cave pendant la nuit* (Negroes Fighting in a Cellar at Night) [Fig. 25]. This is the first documented monochromatic painting. Before Kazimir Malevich, Ad Reinhardt, or the numerous other twentieth-century practitioners of black-on-black painting and its color variants, Bilhaud is the father of a reductive art, although his purpose was hardly related to that of his successors. Alphonse Allais is often credited for this seminal work because of his subsequent monochromatic white and red paintings, exhibited in the 1883 and 1884 Incohérent exhibitions, respectively, and because he ambiguously refers to the black painting in his 1897 publication *Primo-avrilesque* (Pls. I, II) without giving credit to Bilhaud.[32]

In the 18 November 1882 issue of *Panurge*, Henri Detouche, a Hydropathe and an exhibitor in the October 1882 Incohérent exhibition, offers the basic rationale for his generation's radical challenge to traditional art: "Il me semble qu'en face du chef-d'oeuvre de Michel Ange, *Moyse*, le véritable artiste aujourd'hui doit dire: Je voudrais faire tout autre chose" (It seems to me that in front of Michelangelo's masterpiece, *Moses*, the true artist of today should say: I would like to do something else). In general, the artists and writers involved in the Incohérents and at the Chat Noir had thorough academic training. Yet, as the preface to the 1884 Incohérent exhibition catalogue declares: "L'ennui, voi[l]là l'ennemi de l'incohérence" (Boredom, 'tis the enemy of incoherence), and as Henri Gray's cover illustration [Fig. 26] for the catalogue suggests, these artists and writers had no interest in repeating the aesthetic achievements of the past; rather, they wished to sweep the classical tradition

Fig. 25.
After Paul Bilhaud, *Negroes Fighting in a Cellar at Night,* in *Album primo-avrilesque.* (See plates I, II).

Fig. 26.
Henri Gray, photo-relief cover for
*Catalogue illustré de l'exposition des arts
incohérents* (Paris: E. Bernard et Cie, 1884).
Schimmel Fund.

off its proverbial pedestal. Thus, it seems fair to say that beginning in 1882, the artistic antics of the Incohérents and the Chat Noir circle were the means by which artists and writers counteracted the pomposity and boredom of bourgeois society and of the art-related status quo. As we will see, these kinds of acts multiplied in quantity and complexity throughout the 1880s and 1890s and mark the genesis of essential aspects of twentieth-century avant-garde aesthetics.

During the approximately three and a half years (December 1881–May 1885) that the Chat Noir cabaret existed in its small structure on the boulevard Rochechouart, Salis and Goudeau attracted an entourage of writers, musicians, and artists who would give the cabaret and its journal much of its individual, although eclectic, character [Fig. 27]. Although women were not regular participants at the Chat Noir, the poet and composer Marie Krysinska was included in the Saturday and Wednesday literary-artistic sessions at which "le Paris artiste, le Paris littéraire, le Paris jeune, le Paris moderne d'aujourd'hui se retrouve causant du livre ou du tableau de la semaine"[33] (artistic Paris, literary Paris, young Paris, today's modern Paris meet to discuss the book or painting of the week). Some ten years later Krysinska, along with the actress Louise France, would be active at the Quat'z'Arts cabaret, and most notably with the cabaret's ephemeral journal *Le Mur*. The young painter Paul Signac published his first article, "Une Trouvaille" in the 11 February 1882 issue of *Le Chat*

noir; also in that year he introduced his childhood friend Henri Rivière to Salis. Before he had reached the age of nineteen, Rivière was exhibiting with the Incohérents and creating illustrations for *Le Chat noir*.[34] George Auriol had just turned twenty when in 1883 he became "secrétaire de la direction" of Salis's journal.[35] Rivière, the future inventor of the Chat Noir's shadow theater, and Auriol, the artist and writer, would be two of the most creative and prolific contributors to the Chat Noir's activities, as well as the most loyal to Salis himself. Goudeau was chief editor of *Le Chat noir* until March 1884; Allais began writing *fumiste* articles for the journal under pseudonyms in 1882 and under his own name the next year. As Caradec points out:

> Yet the title "editorial secretary" appears in the masthead of the journal starting on 12 January 1884, . . . but it is a whimsical title attributed to a person who had recently drawn attention to himself by his presence at the cabaret, or for some completely different reason that often escapes us. The first names to appear are those of Jules Jouy, Coquelin Cadet, Jules Grévy, president of the Republic, Sarah Bernhardt, the duke d'Aumale, the Prince of Wales.[36]

During the early 1880s the evolving Chat Noir group was involved in activities beyond the cabaret itself, expanding its adherents and instituting a greater camaraderie. On 13 May 1882 the journal announced the "Grande Exposition du Club Montmartrais des Hareng-Saurs, 6 rue de Steinkerque" (Great Exhibition of the Montmartre Red Herrings Club), which for almost three weeks exhibited paintings "Montmartraises" of Salis, Willette, and others. In October many of the Chat Noir group participated in Jules Lévy's Incohérent exhibition; the next year, on 15 February, L'Association Syndicale des Journalistes Républicains organized a Fête de nuit, grand bal paré et travesti (Night Festival, grand, formal costume ball) at Lemardelay's on rue Richelieu. For this event Jules Lévy organized a Salon Incohérent during which quick sketches were created by Caran d'Ache, Gandara, H. Gray, Henri Rivière, de Sta, Steinlen, Willette, and others.[37] This was followed in September with the announcement of the first monthly dinner of La Soupe et le Boeuf, which took place at the Cabaret des Assassins on 5 September; Jules Jouy was president of this new society, and guests first gathered at the Chat Noir before moving on to the Cabaret des Assassins (Au Lapin Agile) for dinner.[38] Some of those in attendance were Jouy, Lévy, Paul Alexis, Willette, Rivière, Achille Mélandri, Salis, Paul Vivien, and Gérault-Richard.[39] The second dinner of La Soupe et le Boeuf took place on 3 October 1883 at the Brasserie des Bosquets with eighty guests, including Allais, Cohl, Detouche, Pille, Rivière, Salis, Léo Trézénik, Vivien, Willette, and Choubrac (Hope).[40] Less than two weeks later that year's *Exposition des arts incohérents* opened at the Galerie Vivienne. Simultaneous with all these events were the regular gatherings of the Chat Noir poets, artists, and musicians at the cabaret itself and, of course, the monthly Bon Bock dinners in which many of the Chat Noir group participated. The artistic community of Montmartre quickly evolved with the Chat Noir cabaret as its center.

Fig. 27.
Antonio de la Gandara, members of the Chat Noir (clockwise from top left: H. Rivière, E. Goudeau, R. Salis, A. Willette), c. 1882, pen and ink, 27 x 20.5.

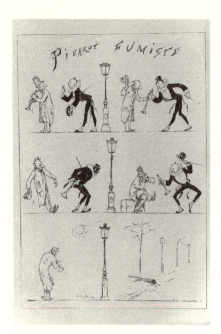

Fig. 28.
Adolphe Willette, "Pierrot fumiste,"
photo-relief illustration for *Le Chat noir,*
18 March 1882. Schimmel Fund.

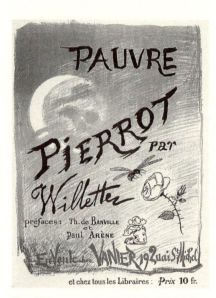

Fig. 30.
Adolphe Willette, poster for *Pauvre*
Pierrot, 1884, lithograph, 73 x 56. Gift of
Ralph and Barbara Voorhees.

Fig. 29. Notice in *Le Chat noir,* 9 September 1882. Schimmel Fund.

LE CHAT NOIR

Although Salis and other Incohérents with already established careers such as Henri Pille (designer of the journal's distinctive masthead) [Fig. 22], Henri de Sta, André Gill, and Uzès illustrated *Le Chat noir* in its early days, their work was soon augmented and the pages eventually dominated by the drawings of a contingent of younger Incohérents composed principally of Adolphe Willette, Caran d'Ache, Théophile- Alexandre Steinlen, and, to a lesser degree, Rivière and Auriol, all of whose later fame derived from their work for *Le Chat noir* or at the cabaret. Vice versa, it is the work of Willette, Caran d'Ache, and Steinlen that in fact make the pages of the journal distinctive.

Willette's first drawing for *Le Chat noir,* "Pierrot fumiste" [Fig. 28] is also the journal's first "story without words" (histoire sans paroles). Willette attributes his knowledge of this kind of pictorial narrative to his encounter with illustrations in the journal *Die fliegende Blätter* while he studied at the academy of Kassel in 1871.[41] Steinlen and Caran d'Ache will also use this system to illustrate, often in a childlike scribble, single pages and double-page spreads of *Le Chat noir* [Figs. 31–33]. The three artists combined this format with infantile but sometimes macabre stories, which hardly seem the diet of a sophisticated journal, but again, they refer back to a non-academic stage of existence, one that gives credibility to childhood nightmares and fantasies. In fact, many of Steinlen's large story-without-words illustrations are dedicated to Salis's young daughter Sara; eventually, in 1898, they were published by Flammarion as a picture book entitled *Des chats, dessins sans paroles* and served an audience of either children or adults [Fig. 34]. In 1884 Willette was commissioned to produce the album

Fig. 31.
Théophile-Alexandre Steinlen, "Idylle," photo-relief illustration for *Le Chat noir,* 28 February 1885. Schimmel Fund.

Fig. 32.
Théophile-Alexandre Steinlen, "Au clair de la lune," pen and ink, 62 x 49.5, reproduced in *Le Chat noir,* 7 June 1884. Bartman Fund.

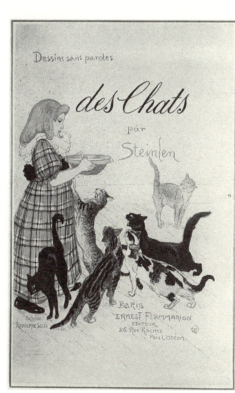

Fig. 33.
Théophile-Alexandre Steinlen, "Histoire d'un chat, d'un chien, et d'une pie" (Story of a Cat, a Dog, and a Magpie), photo-relief illustration for *Le Chat noir,* 17 May 1884, and *Des chats, dessins sans paroles* (Paris: Flammarion, 1898). Schimmel Fund.

Fig. 34.
Théophile-Alexandre Steinlen, cover for *Des chats, dessins sans paroles* (Paris: Flammarion, 1898), color lithograph, 44.5 x 30.5. Gift of Norma B. Bartman.

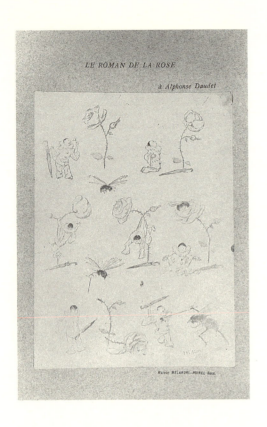

Figs. 35 and 36.
Adolphe Willette, "Le Roman de la rose," 14 x 10.5, "Le Passage de Vénus," 14 x 10, woodburytypes for *Pauvre Pierrot* (Paris: E. Vanier, 1884). An album of twenty photo-reproductions after illustrations in *Le Chat noir*. Schimmel Fund.

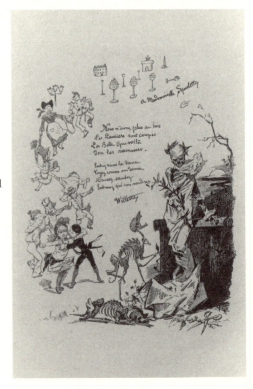

Figs. 37 and 38.
Adolphe Willette, "Pierrot s'amuse" (Pierrot Having Fun), 17 x 10, and "Mademoiselle Squelette," 15 x 12, photoengravings for the expanded version of *Pauvre Pierrot*, with 42 images (Paris: E. Vanier, c. 1887).

36

Pauvre Pierrot [Figs. 30, 35, 36], based on his own story-without-words illustrations. In 1887 this was expanded in format and included explanatory text [Figs. 37, 38].

Often, both the image of the black cat and the term *chat noir* had a double meaning. As Willette confirms, they could be simultaneously innocent and sexually provocative: "But since the print run of the journal was only eleven hundred copies, *Le Chat noir* was not available at all newsstands, and asking, 'Madame, do you have *Le Chat Noir* [a black pussy]?' often earned you a slap when the dealer was a brunette."[42] Sexual innuendo is a prevailing characteristic of the adolescent-like humor of the Incohérents; thus it is not surprising to find the term *chat noir* incorporated into Incohérent wordplay. Georges Bézodis's illustrated entry for the 1884 Incohérent exhibition catalogue [Fig. 39] rephrases the main stanza of Aristide Bruant's *Chat noir ballade* [Fig. 40] to create an obvious, lewd pun on the term:

> Je cherche fortune, autour du Chat Noir, au clair de la lune, à Montmartre,
> le soir. (Bruant)
> (I'm seeking fortune, around the Black Cat [Le Chat Noir], in the moon-
> light, in Montmartre!)
> Je cherche ma fortune avec mon Chat Noir, au clair de la lune, à
> Montmartre, le soir. (Bézodis)
> (I'm seeking my fortune with my black pussy [*mon chat noir*], in the moon-
> light, in Montmartre!)[43]

With "Pierrot fumiste" Willette introduces his career-long alter ego, as the sympathetic metaphor for the artists' plight in society. For Willette, Pierrot–dressed in either white or black–"est devenu poète, artiste, mais précisément à cause de ces deux qualités qui ne furent jamais des professions sérieuses, l'infortuné Pierrot reste et restera un tire-au-flanc, un benêt blanc, un blanc benêt!" (has become a poet, an artist, but precisely because of these two qualities which never made serious professions, the unfortunate Pierrot remains and will remain a malingerer, a simple Simon, a Simon pure and simple [pun on *blanc bonnet,* white cap]).[44] For three years (March 1882–May 1885), throughout the pages of *Le Chat noir*, the artist-poet Pierrot is often accompanied by a troublemaking black cat or by his wife, Pierrette, as he struggles humorously or melancholically with daily life or fumistically takes his revenge. Willette depicts his alter ego as "Poor Pierrot" (Pauvre Pierrot), the vulnerable artist-poet whose genius and sensitivity are never fully appreciated by society. So too does he fall prey to the ridicule of a femme fatale, a symbol of worldliness and greed, with whom he fails at love and, thus, with a broken heart, he commits suicide. As in the morose songs of his friends the composers-musicians Maurice Rollinat, Jouy, and Maurice Mac-Nab who performed regularly at the Chat Noir, Willette presents in his images of Pierrot a fin-de-siècle sense of doom. Although Willette's fragile Pierrot is a fool and has many weaknesses–like Jarry's amoral, abhorrent Ubu–Pierrot, however, reveals redeeming human qualities of idealism and love; however, as with Jarry, Willette's ultimate enemy is the bourgeoisie. For Goudeau, Willette, and others of the Chat Noir group, the emerging artist colony in Montmartre was potentially

Fig. 39.
Georges Bézodis, "Crépuscule," photo-relief illustration for *Catalogue illustré de l'exposition des arts incohérents* (Paris: E. Bernard et Cie, 1884), 45. Schimmel Fund.

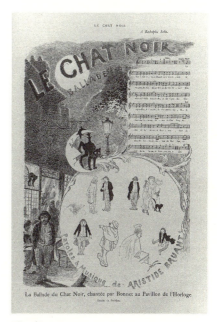

Fig. 40.
Théophile-Alexandre Steinlen, "La Ballade du Chat noir," photo-relief cover illustration for *Le Chat noir*, 9 August 1884. Schimmel Fund.

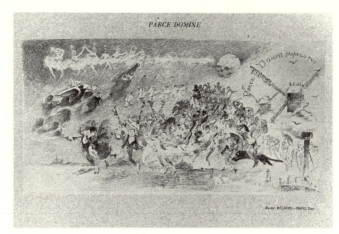

Fig. 41.
Adolphe Willette, "Le Parce Domine," woodburytype, 9 x 18.3, from *Pauvre Pierrot* (Paris: E. Vanier, 1884).

an ideal society, an escape, physically and psychologically, from establishment Paris and one in which Pierrot could exist. In fact, Willette's 1884 large mural painting for the Chat Noir entitled *Le Parce Domine* [Fig. 41] dramatically expresses this life-or-death attitude toward an ideal Montmartre versus the real Paris.

Le Chat noir was staunchly nationalistic. Revenge against Germany was one of its regular themes. Within France, the enemy of the rebellious artists was, of course, the bourgeoisie, the capitalists, and for Willette, as it was for the hate-mongering writer Edmond Drumont, it was the Jew who personified the enemy from both within and without.[45] In 1885 Salis commissioned Willette to design a large, six-panel stained-glass window to be installed in the Chat Noir's new home. Entitled *Veau d'or* (Golden Calf), this pictorial, anti-Semitic statement equates the loss of innocence of the cabaret itself, and of society in general, to a succumbing to avarice, that is, to paying homage to the "Golden Calf [Fig. 42, Pl. VIIIb]."[46] To the far left (panel 1), a nude female, symbolizing Virtue, and her black cat are symbols of past innocence. Next (panel 2) are workers exploited by capitalism (panel 3), represented by the Golden Calf and the stock market (the Bourse); also included is a Jew with a box of coins and a mother sacrificing her child for money. Poetry (panel 4) in the guise of Joan of Arc is held back from temptation by an impoverished cripple. Finally, the king of wealth and, thus, power (panels 5, 6) is represented by the stereotypical fin-de-siècle image of a Jew who holds the hand of a no-longer-virtuous dancer. She, like Salomé, holds a decapitated head on a platter; however, it is that of Pierrot, the artist-poet, and not that of St. John the Baptist. Orchestrating this moral narrative is Death in the guise of a skeleton-conductor. The meaning is clear: as the Chat Noir cabaret gained popular and financial success, Salis had sold out to greed, and the seemingly original idealistic premise that the cabaret was a haven for artists and poets no longer held true. Goudeau's final break with Salis in 1885 was in part due to the Chat Noir's move in June 1885 to a much larger and extravagantly furnished hôtel on the rue Laval, only blocks away from its old home.[47]

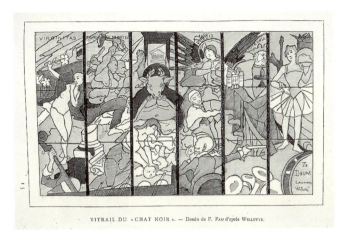

VITRAIL DU « CHAT NOIR ». — Dessin de F. FAU d'après WILLETTE.

Fig. 42.
Fernand Fau after Adolphe Willette, *Veau d'or* (Golden Calf), 1885, as illustrated in John-Grand Carteret, *Raphaël et Gambrinus* (Paris: Louis Westhausser, 1886), 89. Schimmel Fund.

Salis made the actual transfer from the boulevard Rochechouart to the rue Laval a flamboyant performance:

> The march was headed by two Swiss guards in full dress uniform, magnificently adorned with plumes, preceded by an amateur brass band. Salis followed, dressed as a prefect, then two pages carrying the Chat Noir banner, on which shone the famous escutcheon "*d'or au Chat de sable passant, armé et lemplacé de gueules*," bearing this device: "*Montjoye-Montmartre.*" Four Academicians (in exact costume) piously carried Willette's *Parce Domine!* and modestly piled other objects in a handcart. Escorted by an enormous crowd and illuminated by a large number of torches, the procession made a tour of the outer boulevards to the sound of the brass band playing minuets and gavottes. Then the company rushed into the new, beautifully decorated dwelling, the appearance of which had been singularly modified. . . .
> Salis had founded Montmartre![48]

Fifteen years later Goudeau's preface to *Guide de l'étranger à Montmartre* confirms that the Chat Noir's bow to commercialism was the wave of the future of Montmartre's artist-cabaret community:

> Then, far from wanting to detach itself from the rest of the universe, Montmartre made conciliatory advances to Paris; having sufficiently disdained wealth, it turned to the Golden Calf and offered it ironic, licentious, and waggish excuses; but the Golden Calf, who is very cunning, pretended to accept these jests as candid speech, and it came to Montmartre to cover the Artists, the Poets, the Musicians, with jingling écus, with daily bread, even with tuxedos and polished shoes.
> The cabarets saw at their formerly modest doors the throng of emblazoned carriages and the wealthiest bankers contributing their subsidy to this former Golgotha transformed into Gotha of the silly songs.[49]

Fig. 43.
Maurice Neumont, *Bal des Incohérents,*
1896, color lithograph, 23 x 16.5.

Fig. 44.
E. Langlois, photo-relief invitation for
the 1886 *Exposition des Arts incohérents.*
Bartman Fund.

Fig. 45.
Henri Gray, photo-relief press invitation for
the 1886 *Exposition des Arts incohérents,*
Schimmel Gift.

THE INCOHÉRENTS

From August 1882 to the spring of 1893, Lévy organized a total of seven Incohérent exhibitions in Paris plus several in the provinces, such as the large one that took place in February and March 1887 at Nantes.[50] Although the very first exhibition had no catalogue, each subsequent one had a publication of some sort. As we have seen, a list of participants and works for the October 1882 show was printed in *Le Chat noir*; a nonillustrated brochure, listing 284 entries, was published for the 1883 exhibition, and illustrated catalogues were printed for the 1884, 1886, 1889, and 1893 Paris showings, as well as for the various provincial shows. In addition, Lévy organized Incohérent balls in 1885, 1886, 1887, 1889, two in 1891, 1892, 1893, and 1896. None of the exhibitions or balls [Figs. 43–54] took place in Montmartre; beginning with the exhibition of 1883, large indoor spaces located usually in the ninth arrondissement, directly south of Montmartre, were utilized. After 1882, between 200 and 250 works were shown; with little publicity, twenty thousand people attended the 1883 show. The years 1884, 1885, and 1886 were the peak of Incohérent popularity. All in all, one is able to discern over one hundred actual, versus make-believe, participants in the exhibitions. If we use Charpin's dictionary of the better-known Incohérent artists as a guide,[51] more than 80 percent were one-time Hydropathes and/or were involved with the activities of the Chat Noir. Essentially, with the creation of the Incohérents, Lévy had formalized the *fumiste* mentality into a loosely knit group and program of activities.

According to Lévy: "The Incohérents have no pretensions, they are neither more cunning nor wittier than all the people who concern themselves with art in any way, whether as painters, poets, sculptors, or cabinetmakers, but they have the conviction that they are not complete imbeciles."[52] And according to Goudeau, the Incohérent "belongs to all the crafts that draw near to art: a typographer can be Incohérent, a zinc worker, never! So the Incohérent is a painter or a bookseller, a poet or a bureaucrat, or a sculptor, but what distinguishes him is the fact that the moment he surrenders to his incoherence he prefers to pass for what he is not: the bookseller becomes a tenor, the painter writes verses, the architect discusses free trade, all with exuberance."[53] In fact, the idealized Incohérent was the epitome of a free spirit, the individual manifestation of Salis's Montmartre. And, as the spirit of Montmartre was being fabricated by Salis, Goudeau, and others, so too was the personality of the Incohérent artist; however, the fictionalized character of the Incohérent artist took on many of the same unconventional and whimsical qualities of Willette's Pierrot without the morose overtones.

> The Incohérent walks through Paris like everyone else, he bows to his superiors, and shakes the hands of his equals; but if perchance he meets a fellow Incohérent somewhere, his body suddenly dislocates and he disintegrates: His forehead, his nose, his eyes, and his mouth make cabalistic grimaces, his arms twist strangely, and his legs thrash about, following an

absurd rhythm. This lasts only a moment or two. But these are Masonic signs by means of which F***s in Incohérence recognize one another.[54]

The Incohérent is a worthy young man, an artist by temperament but still naive. He is a time-waster who uses his qualities and his talent to discover something funny that will make the public laugh. There may be among the Incohérents some budding Raphaels, some infant Guido Renis who although able to spend three months creating a "Holy Family" or a "Beatrice" prefer to compose a brasserie sketch or a caricature for a ten-penny newspaper.

 The Incohérent is nevertheless a good fellow; he is generous and merry. What he does is done not for himself but to serve others, engage in charity, and cheer up his neighbor. He is a spendthrift who sows his pearls without begrudging them and with no hope of return. He has courage and wit, but he exercises both of them badly. I love the Incohérent because he has no pretensions and because, unlike the Wagnerian and the Impressionist, he does not claim to be regenerating art. He enjoys himself and wants to amuse others, but he makes the mistake of according too much importance to his amusements, which are as childish as they are useless, and nothing of which will survive.[55]

Fig. 46.
Henri-Patrice Dillon, color lithograph invitation for the 1893 *Exposition des Arts incohérents.*

Fig. 47.
Henri-Patrice Dillon, color lithograph invitation for the 6 December 1894 Bal des Incohérents.

Fig. 48.
E. Lévy Dorville, color photo-relief invitation for the 14 October 1883 opening of *L'Exposition des Arts incohérents.* Bartman Fund.

Fig. 49.
A. Ferdinandus, collotype invitation for the 19 October 1884 opening of *L'Exposition des Arts incohérents.* Bartman Fund.

Fig. 50.
Henri-Patrice Dillon, photo-relief exhibitor's card for the 1884 *Exposition des Arts incohérents.* Bartman Fund.

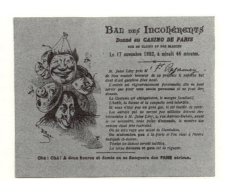

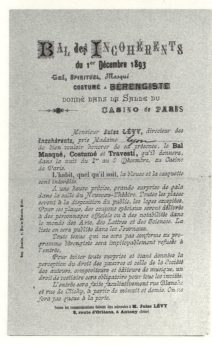

Fig. 55.
Adolphe Willette, poster for *Le Courrier français,* 1885, color lithograph, 80.6 x 55.7. Gift of Ralph and Barbara Voorhees.

Fig. 56.
Uzès, "Henri Gray," 1885, photo-relief, as published in the album *Les Dessinateurs du Courrier français* (Paris: Jules Roques, n.d.).

In November 1884 *Le Courrier français* [Fig. 55] was founded with Jules Roques as editor. Although its office was not located in Montmartre, its primary emphasis was on Montmartre artists, writers, and other personalities, and it served as a chronicle of Montmartre entertainment. The illustrators of *Le Courrier français* were many of the same artists also working for Salis's *Chat noir*: Uzès, Pille, de Sta, Ferdinandus, Choubrac, Willette (beginning in March 1885), and eventually Rivière, Cohl, Steinlen, and Caran d'Ache. The journal existed until 1913, employing numerous other important artists, including Henri de Toulouse-Lautrec, Charles Maurin, Louis Legrand, Jean-Louis Forain, Félix Vallotton, Hermann-Paul, and Jacques Villon, among many others. Although it was strong competition for Salis's journal, it reinforced with straightforward journalism his efforts to promote Montmartre as the center of Parisian artistic life.

The Incohérent Henry Gray [Fig. 56] was *Le Courrier français*'s initial resident illustrator, responsible for the covers and many of the interior illustrations during its first year. Throughout the 1880s and the 1890s, Gray created distinctive Incohérent-related costume designs, as well as fantasized and contorted female imagery that looks forward to the imagination of the Surrealists. It was through Gray that Roques was introduced to the Incohérents; the latter reproduced in the journal a number of works from the 1884 Incohérent catalogue and soon made the group a principal concern of *Le Courrier français* [Fig. 57]. In fact, while other journals regularly covered Incohérent exhibitions and balls, *Le Courrier français* went beyond that by dedicating two expanded, special issues to the group, the first on 12 March 1885 and the second on 4 April 1886. The former reported on that year's *bal des Incohérents,* depicting costumes and participants, while the latter gave extensive coverage to the history of the group, its purpose, and its art.

Today, much of our knowledge of the actual works of art created for the Incohérent exhibitions and of Incohérent costumes is obtained from the pages of *Le Courrier français* and, to a lesser degree, from other journals such as *La Vie parisienne*. The primary resources for visually understanding the productions of the Incohérents, however, are Lévy's exhibition catalogues [Figs. 58–65, 67], which are illustrated with photographic reproductions of drawings by the artists themselves, based on their work in the show. In fact, with *fumiste* mimicry the 1884 *Catalogue de l'exposition des arts incohérents* was produced by the same printer, E. Bernard & Cie, in the same manner, with the same typography and format as for the illustrated catalogues of the annual Salon of La Société des Artistes Français. In the preface to the 1884 Incohérent catalogue, the anonymous authors defend the artistic abilities of Incohérent artists: "It has been said that they were incapable of anything besides bad jokes; as if there were among the Incohérents no real artists who no longer have to prove themselves, and who shine among the best."[56]

Indeed, it is just as important for us, today, as it was for the Incohérents' audience, then, to recognize that the Incohérents were competent academic artists. Willette was proud of the fact that in both 1881 and 1883 a painting of his was accepted into

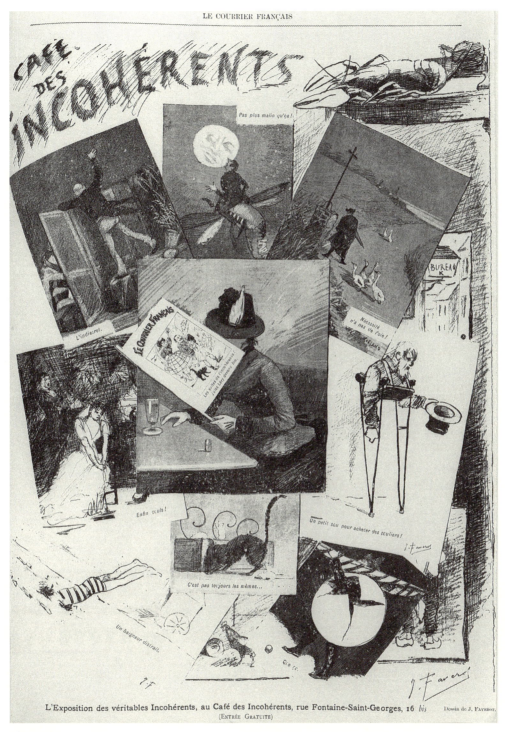

L'Exposition des véritables Incohérents, au Café des Incohérents, rue Fontaine-Saint-Georges, 16 bis
(ENTRÉE GRATUITE)

Dessin de J. FAVEROT.

Fig. 57.
Joseph Faverot, "Café des Incohérents," photo-relief from *Le Courrier français*, 14 November 1886.
Schimmel Fund.

Selections of images from the Incohérents Catalogues of 1884 and 1886.

Fig. 58.
Emile Cohl, "Portrait garanti ressemblant, 1883" (Portrait Guaranteed Life-like, 1883) (1884), xiv.

Fig. 59.
Amédée Marandet, "Portrait sans pieds d'un sociétaire de la Comédie-Française" (Bust of a Comédie-Française Member) (1884), 77.

Fig. 60.
Henry Gray, "La Marchande de pommes" (The Apple Seller) (1884), 40.

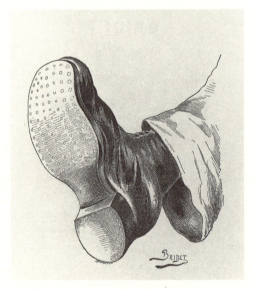

Fig. 61.
Bridet, "Essai de peinture mouvementiste" (Attempt at Movementist Painting) (1884), 51.

Cruelle énigme!!! Charmant!!!

Fig. 62.
Marc Sonal, "Cruelle énigme!!
Charmant!!!" (1886), 57.

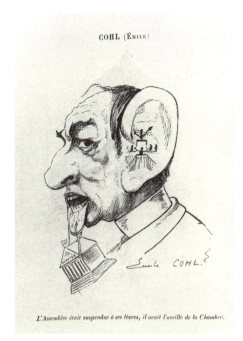

L'Assemblée était suspendue à ses lèvres, il avait l'oreille de la Chambre.

Fig. 63.
Emile Cohl, "L'Assemblée était suspendue
à ses lèvres, il avait l'oreille de la Chambre"
(The Assembly Was Hanging on His Lips,
He Had the Chamber's Ear) (1886), 82.

Fig. 64.
Henri Lanos, "La Femme honnête et l'autre" (The Honest
Woman and the Other Woman) (1886), 133.

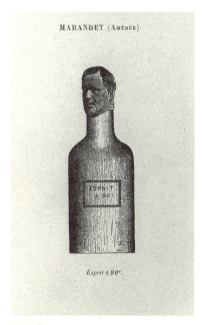

Esprit à 90°.

Fig. 65.
Amédée Marandet, "Esprit à 90°" (1886), 99.

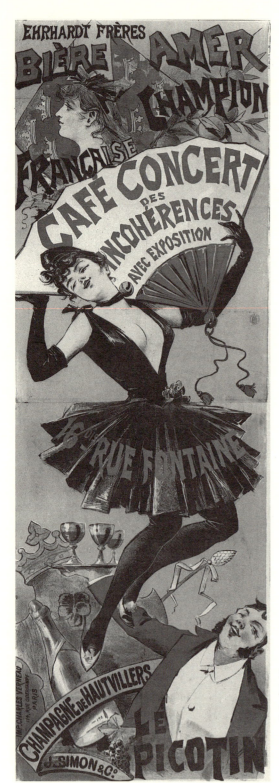

—24—

GRAY (En rit) dessinateur, etc. (voir le catalogue précédent). Membre du jury (oh! là là). Sous-écuyer de cavalerie (16me Dragon). Réserviste classe 1879. Prépare un rapport illustré sur les avantages de la suppression de la croupière appliquée aux hommes de troupe des deux sexes, signe particulier : n'est pas de Montmartre.

99. — *Fleur d'Oranger* ou « *Tu n'auras pas ma rose !* »
Je veux t'ouvrir un monde où nul ne t'a menée
Si beau qu'on n'en revient qu'en pleurant de regrets
Le sire de Chambley.
Légende des sexes. (Adultère.)

100. — *La Beauté en 1886.*
D'après les documents puisés dans les œuvres de François Coppée, Louise Michel, Maygrier, Zola, Naquet, le docteur Ricord, etc.

101. — *Le Gnon fait la bosse* (proverbe).

GRIMAR (François), élève de je ne sais qui, vit je ne sais où en l'an de grâce, demeure rue des Petits-Carreaux, 55, a envoyé une légende plus longue, mais pas drôle.

102. — *Travail des pauvres employés. Pour le singe.*
103. — *Un repas de gala-pint.*
104. — *Seigneurs à la cour de la reine.* (Et ta sœur !) NOTE DU JURY.

GRIVAZ (Eugène), né à Paris, la preuve c'est qu'il n'est jamais monté sur la colonne Vendôme, fait du canotage dans des bateaux Louis XV (très rares), 178, faubourg Saint-Denis.

105. — *Les Voyages déforment les jeunesses.*

GRUEZ, peintre à ses heures, en temps ordinaire remonte les pendules pneumatiques ; né à Succi en Brie ; en 1293 la Bourgogne était heureuse.

106. — *Le Caporal et la Payse s'aimaient.*
Le caporal avait une noble tête de vieillard. La payse avait beau lui répéter : Marguery ces fers me font mal. Le caporal n'en vidait pas moins des pots chez le tavernier du diable et sous l'influence de l'ivresse demandait à tous, nobles, truands et ribauds. Ces messieurs sont satisfaits ?

Fig. 67.
Catalogue de l'exposition des Arts incohérents (Paris, 1886), 24. Schimmel Fund.

Fig. 66.
José Roy, poster for *Café-concert des Incohérents*, 1888, color lithograph, 217 x 75. Class of 1937 Art Purchase Fund.

the annual Salon, and his *Mauvais Larron* of 1883 was reproduced in the 19 March 1883 issue of *Le Chat noir* [Fig. 68]. Yet Willette could also make fun of his training as he did in his autobiography printed in the 17 May 1885 issue of *Le Courrier français*, where he states, "Mon maître était M. Cabanel à l'école des lézards (laids arts)" (My teacher was M. Cabanel at the school of lizards/[ugly arts]). Here, the pun on *lézards* is made with the word for "ugly" (laids) or "ugly art" [Fig. 69], and is certainly not respectful of his mentor, Cabanel. Creating parodies of famous works by academic artists was a particularly popular activity of rebellious young artists in the 1880s. And one of the most famous artists to be "honored" in this way was the painter of vast pastoral and serious allegorical scenes, Pierre Puvis de Chavannes. Rivière created a parody of Puvis de Chavannes's *Enfant prodigue* for Lévy's October 1882 exhibition, while *Le Pauvre Pêcheur* was subjected to parodies by Cohl in the 1884 and 1889 Incohérent exhibitions. In the spring of 1884, Toulouse-Lautrec and his fellow students at the Montmartre studio of the academic artist Fernand Cormon created a parody of Puvis de Chavannes's large canvas *Le Bois sacré, cher aux arts et aux muses* [Figs. 73, 70], after they had seen it at the 1884 Salon of the Société des Artistes Français.[57] For the 1884 Incohérent exhibition and catalogue, the bogus artist "N. Nair" created a parody on J.-J. Henner's *Nymphe qui pleure* [Fig. 71], also shown in that year's Salon [Fig. 72]. However, none of their ridicule of the Salon or the academy kept the Incohérents from fraternizing with the enemy. This becomes conspicuously evident and rather ironic when one compares entries from the catalogue of the 1884 Incohérent exhibition with those of the catalogue of the 1885 *Exposition internationale de blanc et noir*, which was held at the Louvre from 15 March to 30 April. This very serious, juried exhibition dedicated to black-and-white drawing and printmaking was organized by the journal *Le Dessin*, "revue des Beaux-Arts et de l'Enseignement artistique," to demonstrate the centrality of drawing to art and to support Ingres's claim that "le Dessin c'est la probité de l'art"[58] (Draftsmanship is the probity of art). A total of 658 drawings, charcoals, and black-and-white prints were exhibited by such renowned academic artists as Adolphe Appian, Paul Flandrin, Eugène Froment, and even the truly anti-Incohérent Jean-Léon Gérôme! Yet, amid them all were the works of eight Incohérents who had participated in Lévy's 1884 show: Detouche, Félix Dupuis, Albert Habert, Japhet, Mesplès, Gaston Paqueau, Pille, and Uzès. In addition, Willette was represented by two of his *Pauvre Pierrot* drawings: *Le Roman de la rose* [Fig. 35] and *Deux Pages d'amour*, both of which had been originally created for *Le Chat noir*.

In the 1884 Incohérent catalogue, Mesplès is represented by perhaps the most radical work in the show, *L'Honnête Femme et l'autre* [Fig. 74]; in retrospect, it is a tour de force of conceptual art worthy of Lawrence Wiener. On the other hand, Mesplès's homage to Victor Hugo [Fig. 75] for the *Blanc et noir* exhibition is as academically tedious and pompous as any work of the nineteenth century. It is highly incongruous to place the two images side by side, and it is difficult to reconcile Mesplès the Incohérent with these comments in the *Blanc et noir* catalogue:

Fig. 68.
Adolphe Willette, "Le Mauvais ou le bon larron" (The Bad or the Good Thief), 1883, woodburytype, from the album *Pauvre Pierrot* (Paris: E. Vanier, 1884).

Fig. 69.
Théophile-Alexandre Steinlen, "Lézards-cohérents" (Coherent arts / lizards), photo-relief illustration in Félicien Champsaur, *Entrée des clowns* (Paris: Jules Lévy, 1886), 144. Bartman Fund.

Fig. 70.
Henri de Toulouse-Lautrec, *Le Bois sacré, parodie du panneau de Puvis de Chavannes du Salon de 1884*, 1884, oil on canvas, 172.8 x 381. The Henry and Rose Pearlman Foundation, Inc.

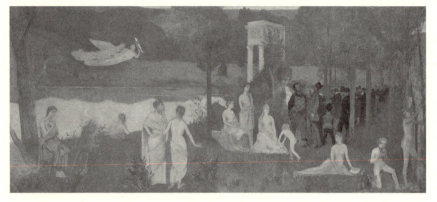

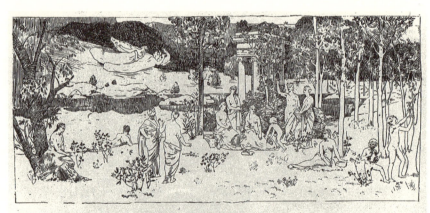

Fig. 71.
N. Nair, "Une Nymphe," photo-relief illustration for the *Catalogue illustré de l'exposition des Arts incohérents* (Paris: E. Bernard, 1884), 115. Schimmel Fund.

Figs. 72 and 73.
Photo-relief illustrations for the *Catalogue illustré du Salon* (Paris: L. Baschet, 1884), 214, 221. Schimmel Fund.

HENNER (J. J.). H. C. *Nymphe qui pleure. — A weeping nymph.*

PUVIS DE CHAVANNES (P.). H. C. *Le Bois sacré, cher aux Arts et aux Muses. — The sacred wood dear to the Arts and the Muses.*

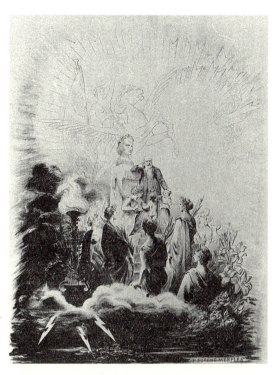

Fig. 74.
Eugène Mesplès, "L'Honnête Femme et l'autre," photo-relief illustration for the *Catalogue illustré de l'exposition des Arts incohérents* (1884), 154. Schimmel Fund.

Fig. 75.
Eugène Mesplès, "Apothéose de Victor Hugo," collotype illustration for the *Catalogue illustré de l'exposition Internationale de blanc et noir* (Paris: E. Bernard et Cie, 1885), 77.

"Mesplès est élève de M. Gérôme, mais, peu nous importe à quelle Ecole il appartient: il nous suffit qu'il soit un parfait dessinateur pour être des nôtres"[59] (Mesplès is the student of M. Gérôme, but we are little concerned with which school he belongs to: to be counted among us, it suffices that he is a perfect draftsman). However, this schizophrenic approach to art is symptomatic of the Montmartre avant-garde. With humor and *esprit gaulois* as the rationale for every iconoclastic step taken, artists such as Mesplès and Willette could, also seemingly comfortably, take one step backward for every two steps forward. This system of accommodation made their divergence from artistic orthodoxy that much more credible. The Incohérents raised questions about the nature of art by challenging existing techniques, forms, and content of art. The fact that their art was not always consistent with their vanguard visions or that their radical work was not "serious" does not reduce the value of their production to the genesis of twentieth-century aesthetics.

The collapse of the imperial government of Napoléon III in 1870 was the beginning of the end of the traditional symbiotic relationship between the ruling power and artists. In 1880 official government control of the annual Salon was relinquished to the equally conservative, newly established Société des Artistes Français. During the 1880s and 1890s, the centralized system of patronage and control was further weakened by the development of a greater number of commercial alternatives for artists, such as galleries, photomechanically illustrated journals, and of course

51

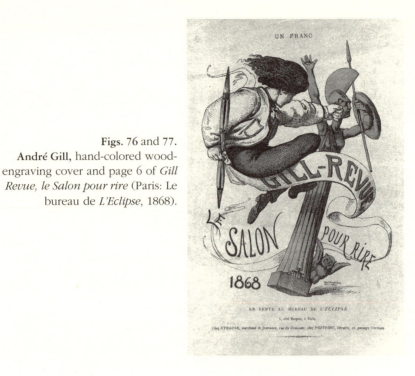

Figs. 76 and 77.
André Gill, hand-colored wood-engraving cover and page 6 of *Gill Revue, le Salon pour rire* (Paris: Le bureau de *L'Eclipse*, 1868).

Fig. 78.
Alphonse Allais, "*Album primo-avrilesque,*" 1897. (See Pls. I, II)

the *cabarets artistiques*, all of which promoted and financially supported emerging artists. By 1882 the Salon and the academy that ran it were ripe for the kind of collective attack offered by the Incohérents, who had been well prepared for the task by one of their own–André Gill.

Gill's *Salon pour rire* of 1868 [Figs. 76, 77] offered the Incohérents a relatively recent precedent in the French press of poking fun at the official annual Salon. Gill depicts himself on the cover, with crayon in hand, knocking over a classical statue of Athena. Sixteen years later, Gray will use a similar iconographic device for his cover design of the 1884 Incohérent catalogue to suggest knocking academic art off its pedestal [Fig. 26]. Within his eight-page revue, Gill parodies eighteen paintings and sculptures from the 1868 Salon; included among them is *Le Jeu* by Puvis de Chavannes. But most amazing is Gill's conceptual preemption of Bilhaud's and Allais's mono-chromatic paintings of 1882 and 1883 [Fig. 78] with the former's parody on Ludovic Piette's Salon painting *Effet de neige* [Fig. 77]. The differences between Gill's comic, journalistic attack on the Salon and that of the Incohérents, however, are significant. Gill's parodies never left the pages of his journal, and they were never more than a single individual's critique. Under the leadership of Lévy, the Incohérents, as an organized group of artists, poets, and others, moved from theory to reality by pro-ducing actual works of "art" for public display.

52

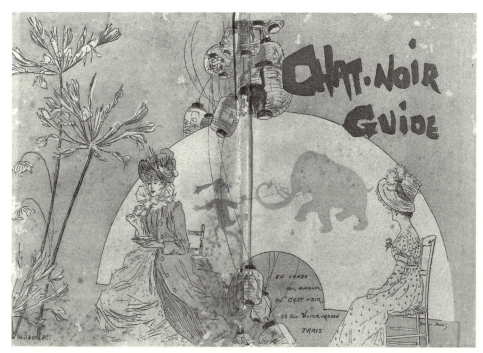

Fig. 79.
George Auriol, stencil-colored photo-relief cover of *Chat noir— guide* (Paris, 1887). Gift of Sara and Armond Fields.

Fig. 80.
Henry Somm, photo-relief cover of *La Berline de l'émigré* (Paris: Léon Vanier, 1892). Schimmel Fund.

PUPPET AND SHADOW THEATERS

The Incohérent exhibitions were a direct challenge, albeit tongue in cheek, to the art establishment. In 1888 Caran d'Ache visualized this challenge as characterized by defecation. His caricature of Lévy as the "Incohérent" in Albert Millaud's *Physiologies parisiennes* presents Lévy as an artist standing at his easel gleefully painting his canvas with the contents of a chamber pot [Fig. 215]. By coincidence, in 1890 the young Alfred Jarry and his high school friends Charles and Henri Morin constructed the Théâtre des Phynances, for marionettes, in their homes in Rennes for *Les Polonais*, the first version–complete with the introductory expletive *merdre*–of what was to become Jarry's great challenge to art, *Ubu Roi*.[60] "Epater la bourgeoisie" (shock the bourgeoisie) was, of course, the purpose of the Incohérents; adolescent-like humor, with sexual innuendo or scatological references, was as effective for them as it was for the young and, eventually, the mature Jarry. Rather than being atypical for his time, when Jarry finally arrived in Paris in 1891, he fit in perfectly with the aesthetics of the Montmartre avant-garde as it had evolved over the previous ten years. In fact, the first theatrical production at the new Chat Noir was Henry Somm's scatological comedy *La Berline de l'émigré* [Fig. 80], which was first perfomed as a puppet play on Christmas Day, 1885.[61]

The following year Goudeau describes the Chat Noir's new home in his book *Les Billets bleus*:

Fig. 81.
Henry Somm, watercolor and hand-colored photo-relief, title page of *La Berline de l'émigré*, 1892. (See fig. 80)

The new *Chat Noir* has three stories; it is no longer a cabaret, it is a veritable country inn. On the façade, a *gigantic cat* on a gold sun basks between two colossal wrought-iron *lanterns*, all designed by Grasset, next to an inscription indicating the date of establishment followed by this admonition: You who pass by, be modern! In the waiting room, a tall guard is stationed in front of Houdon's Diana. The stained-glass window was designed by Willette, who is also responsible for several panels in the first room. Then cats, a myriad of cats by Steinlen: cats of every kind and every size, including a cat that has only three paws. A fireplace and chandeliers copied from Grasset. Farther along, Willette's *Parce Domine*, which I have already mentioned, and which perhaps will be better understood by the habitués of the old *Chat Noir* than by newcomers.

For the ground floor belongs to the fashionable; the poets, musicians, and painters prefer the third floor, where the piano moans, the violins sing, sonnets burst forth in resonant fireworks. Here I must call attention to Rivière's painting *Boulevard Rochechouart*, now less macabre, statuettes, and bronzes, but above all, suspended from the ceiling, a strange-looking animal that the guide calls *nir didja*, or Chinese gudgeon. Buffon, help me!

On a platform, Guignol's booth . . . but shhh! political, literary, social, and artistic satire! . . . excellent pupazzi! I'll keep your secret, O Caran d'Ache!

The second floor, between earth and heaven, between the bourgeois customers on the ground floor and the empyrean artists on the third, is where the journal *Le Chat noir* is edited, in rooms cluttered with trinkets. Its editors must heretofore give up thoughts of the Academy, since the cabaret is served by waiters in Institut costume. The Institut of the boulevard Rochechouart has bewildered these honorable functionaries of the Boum-Terrace; smile at this, pale poets, who so majestically descended the three steps toward your listeners?[62]

In the nineteenth century, guignols, or puppet-theater performances, were popular, domestic forms of family entertainment; one could also regularly encounter groups of small children watching Punch and Judy puppet shows in the public gardens of the Luxembourg and Tuileries. In the fall of 1885 George Auriol and Henry Somm constructed a small puppet theater in the Chat Noir's third-floor Salle des Fêtes. As Goudeau implies above, the performances were not for a children's audience. The setting of Somm's one-act *Berline de l'émigré* is a family-run public toilet [Fig. 81]. It opens with dialogue among the male customers, who have various degrees of intestinal distress, the proprietress Mme Gardetout (Madame Hold-All), and her daughter Léocadie. The latter is in love with Jules Cantoisel, a Jules Lévy look-alike, who spends more time than is necessary at the establishment so he can see Léocadie. The mother, ironically a longtime sufferer of constipation, senses that Jules, too, is constipated. She refuses to let him marry Léocadie because Mme Gardetout wants her daughter to enjoy the pleasures of a marriage in which both husband and wife have regular constitutions. The young couple is saved, however, when the "émigré," the Marquis Agénor Waldemar de la Saladière, arrives direct from Germany in his

berline, or overland carriage (thus, "The Carriage of the Emigrant"), with his black African manservant, Bakouk, whose main retort is "li qui fait caca." As it turns out, Jules's father, a close friend of the marquis, was guillotined under the name of Saladière (salad basket) twenty years before. The marquis, understanding his parental responsibilities toward Jules, locates a drug to alleviate Mme Gardetout's constipation, and all is well. This silly play, with its childish overindulgence in toilet habits and its sequence of *fumiste* puns, in-jokes, and racial slurs, is echoed sixteen years later in Jarry's second *Almanach du Père Ubu.*

Fig. 82.
Paul Eudel, *Les Ombres chinoises de mon père* (My father's shadow theater) (Paris: Editions Rouveyre, 1885). Schimmel Fund.

The guignol existed a relatively short time at the Chat Noir before it was converted to a shadow theater, another traditional form of family entertainment. After one of the early performances of *La Berline de l'émigré,* Rivière put a white napkin over the opening of Somm's puppet theater; then, after making small cardboard cutouts of policemen (*sergents de ville*), he placed them behind the white screen, creating silhouettes that he moved across the screen as Jules Jouy sang his popular "Chanson des Sergots."[63] This was the birth of the Chat Noir's famous shadow theater.

It was not by chance that Rivière discovered the shadow theater. The climate was certainly right for investigations into the artistic effects of silhouettes. Thanks to the newly developed photomechanical relief-printing processes, which easily and inexpensively reproduced high-contrast black-and-white drawings–such as those by Georges Lorin for the covers of *L'Hydropathe*–artists and writers of the Chat Noir group were collaborating on publications related to Rivière's aesthetic interests. Less than two months earlier, Paul Eudel, who by coincidence lived directly across the street from the Chat Noir, published his important study on shadow plays entitled *Les Ombres chinoises de mon père* [Fig. 82].[64] Cohl and Ferdinandus, Chat Noir regulars and Incohérents, created many of the silhouette illustrations for the book. Rivière was obviously aware of Eudel's publication just as he was surely aware of Henri de Sta's humorous books, such as *La Chanson du colonel* [Fig. 83], which were illustrated by de Sta entirely with silhouette images.[65] In addition, Georges Lorin's *Paris rose* of 1884 innovatively incorporates silhouette images within the text to suggest movement from one page to the next [Figs. 84a–b].[66] Lorin's dynamic placement of silhouettes, in fact, predicts the effect, ten years later, of celluloid frames of a moving picture, as well as the bold black-and-white book illustrations of Vallotton.[67] Finally, Rivière was strongly attracted to Japanese art and, in particular, to ukiyo-e, color-woodblock prints, in which silhouettes have a variety of compositional and decorative functions. When Lévy published Bilhaud's poem "*Les Petits japonais*" [Fig. 85],[68] it was printed on Japanese color-woodblock prints in which silhouettes dominate the imagery and which inspired the subject matter of the poem. These publications by his Chat Noir colleagues introduced Rivière to the artistic potential of silhouettes and motivated his investigations into the shadow theater as a modern medium. Most important, the shadow theater was able to merge the two-dimensional aesthetics of the visual arts with characteristics intrinsic to theater: movement and the interaction of music and voice.

Uzès's illustration of "Le Guignol du Chat Noir" [Fig. 86] in the 27 February

Fig. 83.
Henri de Sta, photo-relief illustration in *La Chanson du colonel, opérette par Albert Millaud et Hennequin,* (Paris: Léon Vanier, 1882), 9. Schimmel Fund.

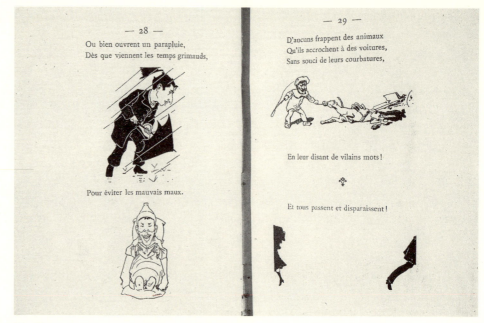

Figs. 84a–b.
Georges Lorin (text and photo-relief illustrations), *Paris rose* (Paris: Paul Ollendorff, 1884), 28–31. Schimmel Fund

— 28 —

Ou bien ouvrent un parapluie,
Dès que viennent les temps grimauds,

Pour éviter les mauvais maux.

— 29 —

D'aucuns frappent des animaux
Qu'ils accrochent à des voitures,
Sans souci de leurs courbatures,

En leur disant de vilains mots !

Et tous passent et disparaissent !

Fig. 84a.

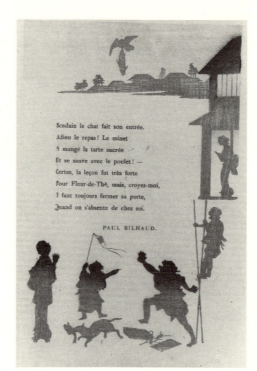

Soudain le chat fait son entrée.
Adieu le repas ! Le minet
A mangé la tarte sucrée
Et se sauve avec le poulet ! —
Certes, la leçon fut très forte
Pour Fleur-de-Thé, mais, croyez-moi,
Il faut toujours fermer sa porte,
Quand on s'absente de chez soi.

PAUL BILHAUD.

Fig. 85.
Paul Bilhaud, *Les Petits japonais*, letterpress on Japanese color-woodblock prints (Paris: Jules Lévy, c. 1884). Schimmel Fund.

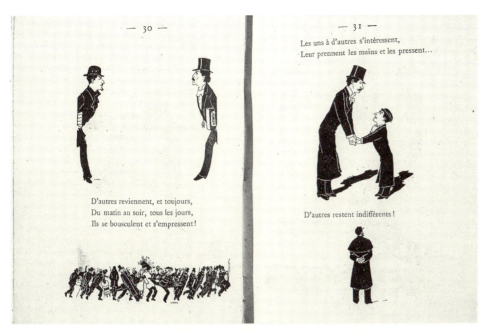

Fig. 84b.

1886 issue of the cabaret's journal reveals the hybrid of puppet and shadow performances that played daily at the Chat Noir early that year. Uzès's illustration also clearly shows that Somm's soon-to-be-famous, thirty-second shadow sketch *L'Eléphant* was based on the character Bakouk and was created almost immediately after the first performance of *La Berline de l'émigré*. Salis used this short, comic, scatological skit daily until his death in 1897 to introduce the cabaret's shadow-theater performances [Fig. 79]:

> No set: a lighted screen.
> A Negro, his hands behind his back, is tugging on a rope. He advances, disappears–the rope stretches horizontally. Then, a knot in the rope. The rope continues to stretch, eternally. . . . Then, at one end, there appears an Elephant who drops "an odoriferous pearl"–in the words of the Gentleman Cabaret Owner–from which a Flower springs up–then: Curtain![69]

By 9 December 1896, when Jarry premiered *Ubu Roi* at Montmartre's Nouveau Théâtre, Somm's *Eléphant* had been performed at least four thousand times.[70] Defecation, obviously, had its literary and theatrical precedent at the Chat Noir, and such scatological references were by that time commonplace for the sophisticated audience that attended the rehearsal for Jarry's premiere. In fact, sometime in late November or early December 1895, more than a year before Jarry's preview performance of *Ubu Roi*, François Trombert, owner of Les Quat'z'Arts cabaret, agreed to

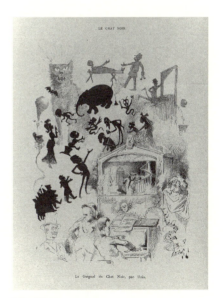

Fig. 86.
Uzès, "Le Guignol du Chat noir," photo-relief illustration for *Le Chat noir*, 27 February 1886. Schimmel Fund.

Fig. 87.
Lucien-Victor Guirand de Scévola,
"Jehan Rictus," from *Le Mur*, 1895–96,
ink and crayon, 21 x 13.5. Schimmel Fund.

Fig. 88.
Unidentified, "Le Mur" (Jehan Rictus),
from *Le Mur*, 1895–96, crayon, 33 x 23.
Le Mur. Schimmel Fund.

have Gabriel Randon, poet and sometime art critic, perform for the first time in public a selection from his compilation of poems entitled *Les Soliloques du pauvre*. In the fall of 1895 Randon was inspired by François Villon's verse "Je ris en pleurs" (I laugh in tears) to change his name to Jehan Rictus. Unlike the usual humorous, parodical fare, Rictus's poems were serious outcries against poverty and social injustice in modern Paris. To press his points he spoke in argot, the language of the poor and of the street. His first soliloquy, "L'Hiver," begins: "Merd'! V'là l'Hiver et ses dur'tés" (Shit! Here's Winter and its hardships), which probably generated as raucous an audience response as that to Ubu's *merdre* one year later.[71] After years of living in poverty himself, and receiving little recognition for his poetry, Rictus became an overnight success at Les Quat'z'Arts. This was not overlooked by the "editors" of *Le Mur*, the cabaret's ephemeral journal, and Rictus's scatology immediately became the subject of *Le Mur's* literary and visual parodies and ridicules that hung on the cabaret's wall [Figs. 87–89].

As Frantisek Deak has recently demonstrated, the response to Jarry's use of *merdre* was mixed:[72] some were outraged, others, nonplussed. Reactions to *merdre* were neither more nor less than the audience's vocal response to other aspects of Jarry's production of the play–its stage set, costumes, movements, and the voices of the performers. But it was with this one dramatic verbal gesture, à la Rictus, that Jarry succeeded in merging cabaret and theater. Jarry's use of the pseudo-expletive became the symbol of his challenge to legitimate theater.

Although the 26 June 1886 issue of *Le Chat noir* discusses "Les Ombres japonaises" at the cabaret, announces the 195th performance of *L'Eléphant*, and mentions the forthcoming production of Rivière's *Tentation de Saint Antoine*, it was not until 1887 that Rivière [Fig. 90] replaced Somm and Auriol's puppet theater with a real shadow theater. To do this it was necessary to break through the main wall of the Salle des Fêtes and construct a screen and rear staging area. At first the screen measured almost one meter square. Eventually, it was enlarged to 1.12 meters high by 1.40 meters wide with a huge backstage attached to the outside of the building [Fig. 91].[73] Essentially, Rivière created a system in which he placed silhouettes of figures, animals, elements of landscapes, and so forth, within a wooden framework at three

Fig. 89.
Unidentified, "Tu me dégoutes
avec ton front à la Victor
Hugots" [*sic*] (You disgust me
with your Victor Hugots–like
face), from *Le Mur*, 1895–96,
graphite. Schimmel Fund.

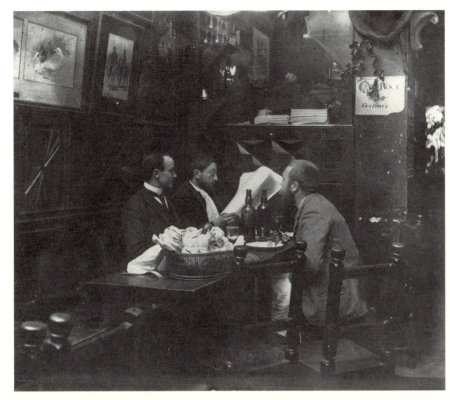

Fig. 90.
Unidentified, interior of the Chat Noir with (from left to right) Narcisse Lebeau, Henri Rivière, George Auriol, photograph, c. 1885–86. Morse Fund.

distances from the screen: the closest created an absolutely black silhouette, and the next two created gradations of black to gray, thus suggesting recession into space. Silhouettes could be moved across the screen on runners within the frame. For instance, perspective was created by a succession of large to small silhouettes placed against the screen. The silhouettes were at first made from cardboard and then, in 1888 with the first full-scale production of Caran d'Ache's *Epopée*, from zinc. Behind the three tiers of silhouettes were sliding structures supporting glass panels, which could be painted in a variety of transparent colors; and finally, at the rear of the work area was the oxyhydrogen flame, which served as the light source. With the help of backstage assistants who could number as many as twenty, the perfectionist Rivière was able to develop complicated and sophisticated effects of color [Pl. VIIIa], sound, and movement for the series of over forty eclectic plays that he and his colleagues produced during the eleven years that the shadow theater existed at the Chat Noir [Fig. 105].

The Chat Noir closed in February 1897, a month before Salis's death. It left no greater legacy than Rivière's shadow theater, which was the cabaret's biggest public attraction [Figs. 93–98]. From the very beginning, Salis was the improvisational narrator, or *bonimenteur* of each shadow performance [Fig. 92]. His eccentric, egocentric personality gave the performances added verve and excitement. In 1887–88,

Fig. 91.
After Georges Redon, backstage of the Chat Noir shadow-theater with Henri Rivière in center middle ground, 1893, illustration for unidentified journal.

59

Fig. 92.
Charles Léandre, "Le 'Chat Noir' se ballade" (The Chat Noir Goes on Tour), photo-relief illustration for *Le Rire*, 17 August 1895.

the year after the shadow theater became fully established at the Chat Noir, Auriol published *Le Chat noir–Guide* [Fig. 79], which, with Incohérent annotations, lists the art on display in this cabaret-museum. With the following contemporary artists represented on the Chat Noir walls, one may assume that Rivière's shadow theater played a crucial role in establishing the credibility of the cabaret with that other tier of the avant-garde, the Impressionists/Post-Impressionists: Edgar Degas, Camille Pissarro, Claude Monet, Mary Cassatt, and others.[74]

The three most popular shadow theater productions were *L'Epopée* (1888) by Caran d'Ache, and *La Tentation de Saint Antoine* (1887) and *La Marche à l'étoile* (1890), both by Rivière. It was Rivière who facilitated the technical requirements of all the plays produced at the Chat Noir. In some cases the demands were extraordinary, especially when productions such as *L'Epopée*, *La Tentation*, and *La Conquête de l'Algérie* (1888) by Louis Bombled called for forty to fifty different sets, or if they required subtle effects of color and movement such as *Phryné* (1891) by Maurice Donnay. Georges Fragerolle, Albert Tinchant, or Charles de Sivry were most often responsible for the musical scores. The plays were varied in content; Caran d'Ache created a seriocomic monochromatic vision of Napoléon I's military campaigns in *L'Epopée* [Figs. 103, 104], which included dramatic perspective views of the Grand Army. Rivière's Symbolist-religious play *La Marche à l'étoile* [Pl. Vc] evoked with minimalist tints of blue the mystical procession of believers to Bethlehem to worship the new-born Christ, and Donnay's *Ailleurs* was a "poème satirique, classique, gaulois, mystique, socialiste et incohérent"[75] (a satirical, classical, Gallic, mystical, socialistic, and incoherent poem). The *fumiste* character of the Chat Noir was maintained by such plays as *Le Fils de l'eunuque* (1888) by Somm, *L'Age d'or* (1888) by Willette, *Le Secret du manifestant* (1893) [Fig. 99] by Jacques Ferny, and *Pierrot pornographe* (1894) by Louis Morin. The forty scenes of Rivière's *Tentation de Saint Antoine* [Figs. 106, 107] visualize the odyssey of the hermit saint as the Devil presented him with myriad contemporary and ancient, worldly and other-worldly temptations, including present-day Paris represented by Les Halles (the meat market) [Fig. 245] and La Bourse (the stock market) [Fig. 217], science, and new technology, the awesome universe, a variety of ancient deities [Fig. 218], and the seductress queen of Sheba. Quotations from Flaubert's novel of the same name were recited and accompanied by selections of music by Richard Wagner, Fragerolle, and Albert Tinchant. The play reaches its crescendo with the apotheosis of the saint after he successfully rejects all temptations [Pl VIIIa]. *La Tentation de Saint Antoine* was the Chat Noir's first major shadow theater production. Its premiere performance on 28 December 1887 took place eighteen months after it was first announced in *Le Chat noir*. It must have taken Rivière that long to develop the ability to obtain the great variety and nuance of color as well as the spatial effects that distinguish his adaptation of the traditional shadow theater concept from all those which went before his. However, it was also Rivière's sophisticated technology that made the Chat Noir's protocinematic productions ephemeral. While zinc silhouettes and preparatory studies remain today

Figs. 93–98.
Stencil-colored photo-relief posters for
the Chat Noir shadow-theater,
58 x 42 each. Schimmel Fund.

Fig. 93. c. 1887.

Fig. 94. c. 1893.

Fig. 95. c. 1895.

Fig. 96. c. 1895.

Fig. 97. c. 1895.

Fig. 98. c. 1896.

61

Fig. 99.
Fernand Fau, stencil-colored photo-relief cover for *Le Secret du manifestant,* shadow play by Jacques Ferny (Paris: E. Fromont, 1894).

Fig. 100.
Henri de Toulouse-Lautrec, "Le Dernier Salut," stencil-colored photo-relief cover for *Le Mirliton,* March 1887. Schimmel Fund.

[Pl. Va], it is only by means of the printed, color facsimile albums of plays such as *La Tentation de Saint Antoine, La Marche à l'étoile* [Fig. 108], *L'Enfant prodigue* (1894), and several others published at the time, and by means of the decorative programs designed by Auriol and Rivière that we can come close to understanding the content and visual impact of the Chat Noir's shadow plays [Fig. 109].

Toulouse-Lautrec was one of the first artists to be influenced by the shadow theater; his illustration for Bruant's March 1887 issue of *Le Mirliton* [Fig. 100], in which a worker is placed directly in the front plane, separated by a field of white from a distant, silhouetted funeral procession, is derived from the visual effects of the shadow theater. By 1891 this dynamic kind of composition was used by Toulouse-Lautrec to create his first poster, *Moulin Rouge: La Goulue* [Pl. VI].[76] The next year Maurice Donnay and Adolphe Gérardot teamed up to create *L'Album de l'oncle,* an unpublished album of watercolors that pokes fun at the Chat Noir group's favorite satirical target, the theater critic Francisque Sarcey [Fig. 101]; among the series of humorous images of the Chat Noir's "Uncle" Sarcey depicted at various theatrical and entertainment establishments is that of the venerable critic dancing at the Moulin de la Galette designed, à la Toulouse-Lautrec's Moulin Rouge poster, with silhouettes and all [Pl. Vb].[77]

As Patricia Eckert Boyer has effectively documented, shadow theater aesthetics were also shared by the young Nabis–Pierre Bonnard [Fig. 102], Edouard Vuillard, Henri Ibels, Maurice Denis, Félix Vallotton–whose works were characterized by overlapping broad, flat areas of color, the white field functioning as an active, compositional device, and the emphasis on the two dimensional and on silhouettes.[78] In

1891 Nabi artists painted stage sets for the Symbolist plays of Paul Fort's innovative Théâtre d'Art, as they would five years later for the first stage production of Jarry's *Ubu Roi.* Rivière's minimal designs for *La Marche à l'étoile* [Fig. 108] must have reinforced the Nabis' goal of creating simple, abstract equivalents to Symbolist literary works for the Théâtre d'Art such as Pierre Quillard's *Fille aux mains coupées.*[79] Two years later, on 17 May 1893, as a prelude to their founding of the Théâtre de l'Oeuvre, Lugné-Poe and Camille Mauclair opened Maurice Maeterlinck's *Pelléas et Mélisande* for one performance at the Bouffes Parisiens; Lugné-Poe conceived the stage set, which received the following review from Sarcey:

> One had an impression of watching a succession of images projected by a magic lantern, in faded colors, subdued tones like that of old Flemish tapestries.
> The beings that we see acting on stage look like shadows. They live, speak, and move in the atmosphere of artifice; they are creatures of a dream.[80]

Over the years, thousands upon thousands of individuals viewed the Chat Noir's shadow theater productions: bohemians, aristocrats, politicians, generals, and members of the bourgeoisie sat side by side in the Salle des Fêtes with artists, writers, actors and actresses, scientists, and adventurers. Beginning in 1888 with the Théâtre d'Application on the rue St. Lazare, shadow theaters eventually spread to other locations in Paris as well as to other Montmartre cabarets, Le Conservatoire de Montmartre and Les Quat'z'Arts, in particular. In addition, as Fernand Fau's illustration for *Le Chat noir* indicates, beginning in 1892–à la Lévy and his Incohérent exhibitions–Salis took his shadow theater company on the road to the provinces [Fig. 110]. In 1893 Somm, Steinlen, and Michel Utrillo traveled to the World's Columbian Exposition in Chicago to present their shadow plays. Thanks to Utrillo, by 1897 Barcelona's avant-garde, which soon included the young Pablo Picasso, had its own shadow theater at Ils Quatre Gats, the *modernista* cabaret that took its name from both Le Chat Noir and Les Quat'z'Arts; in fact, the artistic connections between Barcelona and Paris were greatly strengthened in the 1880s and 1890s by the emergence of the Montmartre community of Spanish artists who moved back and forth between the two cities and included Michel Utrillo, Ramon Casas, Santiago Rosignol, Joachim Sunyer, and, eventually, in 1900, Picasso.[81] That year, attracted by the world's fair, the latter made his first trip to Paris, where he briefly lived in Montmartre and was introduced to French artists and cabarets; simultaneously, the journal *Le Rire* brought Montmartre shadow theater and humor to visitors from around the world by installing on the fairgrounds along the Seine the Maison du Rire [Fig. 111], which performed a repertoire of Chat Noir shadow plays and cabaret revues.

Although Incohérent exhibitions and balls continued until 1895, seven years earlier Lévy had supposedly given the group its death knell. By 1887 the exhibitions were criticized as being repetitive, and Lévy himself was condemned for profiting financially from the Incohérent activities, which had initially been organized in support of charities. As with Salis's ostentatious performance with the move of the

Fig. 101.
Adolphe Gérardot, watercolor title page for *L'Album de l'oncle,* 1892. Morse Fund.

Fig. 102.
Pierre Bonnard, lithographic illustration for Claude Terrasse, *Petit Solfège illustré* (Paris: Quantin, 1893), 20.

63

Fig. 103.
Caran d'Ache, study for *L'Epopée*,
1888, india ink, 27.2 x 57.5.
Gift of Carleton A. Holstrom.

Fig. 104.
Caran d'Ache, study for
L'Epopée, 1888, india ink. Gift of
Carleton A. Holstrom.

64

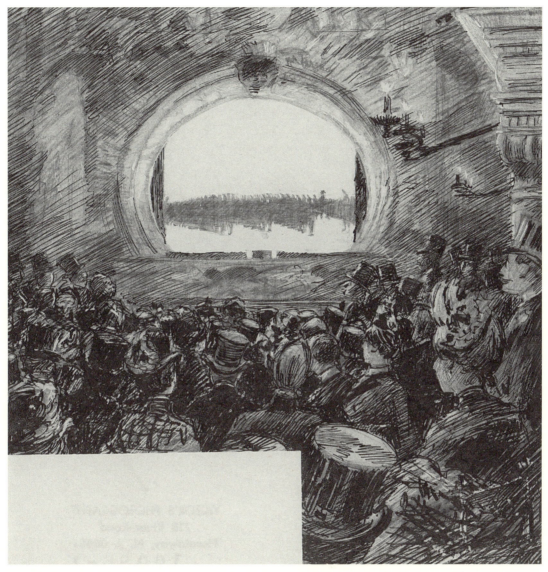

Fig. 105.
Henri Rivière, *The Théâtre d'Ombres at the Chat noir*, c. 1888, pen, ink, and gouache, 20.5 x 20. Mindy and Ramon Tublitz Purchase Fund.

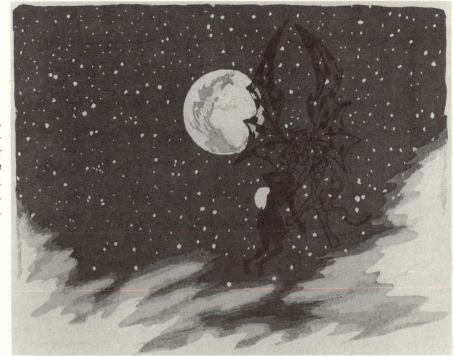

Fig. 106.
Henri Rivière, "Le Ciel," stencil-colored photo-relief illustration for the shadow-theater album *La Tentation de Saint Antoine* (Paris: E. Plon, Nourrit et Cie, 1888). Bartman Fund.

Fig. 107.
Henri Rivière, *"The Devil and St. Anthony,"* 1887–90, zinc cutout for the shadow-theater play *La Tentation de Saint Antoine,* 32 x 55. Gift of the University College New Brunswick Alumni Association.

Fig. 108.
Henri Rivière, "La Crèche," lithographic illustration for *La Marche à l'étoile* (Paris: Flammarion, 1902), 33.

Fig. 109.
Louis Morin, *Le Carnaval de Venise*, c. 1892, etching based on the artist's 1891 Chat Noir shadow play, 34.5 x 65. Gift of Herbert D. and Ruth Schimmel.

Fig. 110.
Fernand Fau, "Solemn cortege of the Chat Noir Going to Explore the Regions of the South," pen and ink, 49 x 37, reproduced in *Le Chat noir*, 30 July 1892. Morse Fund.

Identifiable individuals in the procession starting at bottom center with Rodolphe Salis on horseback: Jules Jouy (with accordion), Paul Verlaine (angel with harp), Armand Masson (left of Verlaine), Charles Léandre (with drum), Victor Meusy (in tuxedo with violin), George Auriol (in plaid), Fernand Fau (behind Auriol), Caran d'Ache (with palette), Alphonse Allais (with stovepipe) next to Raoul Ponchon (on donkey), Henri Rivière (with dog and whips), Jules Ferry (with top hat and cutout of President Carnot), Trimouillat (right of Ferry behind wheel of cart), Vincent Hyspa to right of Trimouillat, Maurice Donnay (with hand-held music organ), Francisque Sarcey (with hands held up in the air, next to Father Time), Le Sar Péladan (behind and to the right of Sarcey), Pierre Loti (with a sailor's hat and below the Moulin de la Galette), President Carnot (with top hat), Marianne or La République (holding Carnot's arm).

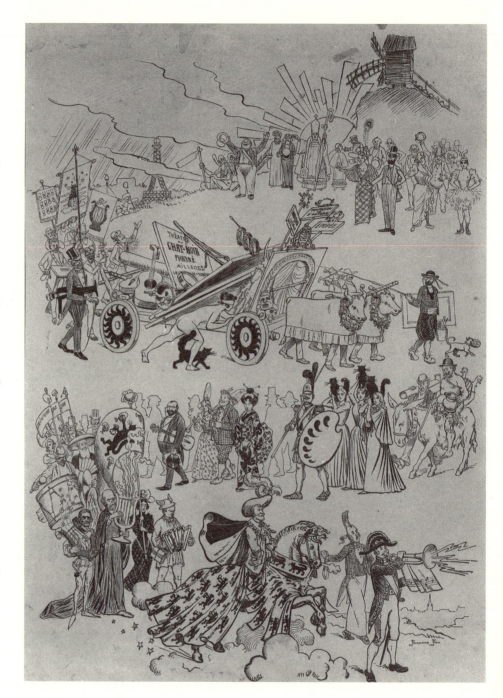

68

Chat Noir in June 1885, Lévy organized on the evening of 17 April 1887 an elaborate funeral, a street procession of costumed Incohérents, which ended with a "wake" at the Folies-Bergère.[82] As the posters [Pls. IIIb–c], catalogues, and other Incohérent ephemera attest, the death pronouncement of the group was, obviously, premature. In 1893 four senior Incohérents, Cohl, Henri Dillon, Gray, and Pille, created a *collectiviste* poster for that year's exhibition [Fig. 112]. Cohl's section of the poster [Pl. IIId] reiterates the role, even at this late date, of the group as personified by their leader Lévy: the latter is depicted as a jack-in-the-box startling a Roman centurion, a symbol of antiquity and academic officialdom. It is a restatement of the avant-garde commitment to the battle of the *modernes* (*vivants*) against the *anciens*, which had been enunciated by Goudeau in *Dix Ans de Bohème*.[83]

LES QUAT'Z'ARTS CABARET

François Trombert tried his entrepreneurial skills as a cabaret impresario first in 1892 at the Lyon d'Or on the rue Helder without much success, but in December 1893, as Olga Anna Dull discusses in her essay in this volume, Trombert opened Les Quat'z'Arts cabaret at 62, boulevard de Clichy. It was Trombert and Les Quat'z'Arts that would continue into the twentieth century and expand on the dynamic role of the *cabaret artistique* initiated by Salis with the Chat Noir twelve years earlier. If Salis and Lévy, respectively, were the visible leaders of the Chat Noir group and the Incohérents, Goudeau [Fig. 130] was the catalytic, omnipresent intellect behind the scenes; his was the literary talent that gave rise to the early success of *Le Chat noir*; he was the coeditor of Willette's journal *Le Pierrot* (1888–89), and nine years later, the coeditor, with François Trombert, of *Les Quat'z'Arts* journal [Fig. 254]. While fellow Incohérent Abel Truchet was artist-in-residence at Trombert's Quat'z'Arts cabaret–responsible for, among other designs, its stained-glass window and poster [Pl. IVb]–Goudeau was its poet-in-residence, as well as, along with the artists Willette and Auguste Roedel, the force behind the Quat'z'Arts's organization of Montmartre's two Vache Enragée artists' processions in 1896 and 1897 [Figs. 113, 116, 117].[84]

These processions were named after Goudeau's 1885 book, *La Vache enragée*; the title refers to the period of financial struggle within an artist's career. The parades and the two related issues of *La Vache enragée* journal attempted to promote Montmartre by competing with the annual Parisian Boeuf Gras procession. The spectacle of thematic artists' floats winding through the streets and the climactic crowning of the Muse de Montmartre were geared to attract tourism to the Butte and to maintain the idealized artist-colony image of Montmartre. However, the combination of bad weather, the lack of audience and money, and harassment by hooligans finished off the event after only its second incursion into the streets.

By 1900, in addition to work by Truchet, the Quat'z'Arts cabaret was decorated with large panel paintings by Faverot (clowns à la Bon Bock) and Jules Grün, a poster artist

Fig. 111.
Lucien Métivet, "La Maison du rire," color photo-relief illustration in *Les Plaisirs de Paris* (Paris: *Le Rire*, 1900), back cover.

Fig. 112.
Henry Gray, Henri-Patrice Dillon, Emile Cohl, and Henry Pille, poster for *L'exposition des Arts incohérents*, 1893, color lithograph, 157.5 x 117. Bartman Fund.

Fig. 113.
Henri de Toulouse-Lautrec, poster for
La Vache enragée, 1896, color lithograph,
82.5 x 60. Ex-Schimmel Collection.

and one of the editors of *Le Mur*. Most dominant, however, were the many caricatures by Charles Léandre [Fig. 114] and Lucien-Victor Guirand de Scévola [Fig. 260], the two principal illustrators of *Les Quat'z'Arts* journal.

> Léandre and Guirand de Scévola are profusely present here with admirable caricatures, portraits, or sketches of artists and actors. They hang alongside Willette, Roedel, Redon, Pelez, E. Vincent, Toulouse-Lautrec, Markous, Brunner, Cohl, etc. . . . Among them a portrait by Guirand of Louise France in the role of Frochard in *Deux Orphelines* and another of the same by Chahine [Fig. 115] are two notably strange masterpieces.[85]

If Auguste Roedel and Guirand de Scévola represented a new generation of artists who were actively involved with the Quat'z'Arts, its journal, and *Le Mur*, Willette, Léandre, and Truchet represented members of the previous generation. One figure, at the Quat'z'Arts in particular, who spanned three decades of café-cabaret life was the painter and etcher Marcellin Desboutin [Fig. 118]. In the early seventies Desboutin mixed with the Impressionists at the Café Guerbois and moved with them at the end of the decade to La Grande Pinte, La Nouvelle Athènes, and Le Rat Mort; in the 1880s he was a regular at Le Chat Noir, where his prints decorated the walls; he also was the model for Manet's painting *The Artist* (1875) and posed with the actress Ellen Andrée for Degas's *Absinthe Drinkers* (1876). Like Verlaine, Desboutin was the quintessential bohemian artist and a permanent fixture at the cafés and cabarets of Montmartre.

After his December 1895 performance, Rictus remained at Les Quat'z'Arts

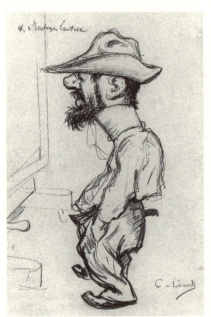

Fig. 114.
Charles Léandre, caricature of Henri de Toulouse-Lautrec, c. 1896–97, crayon, 47.3 x 31.4. Schimmel Fund.

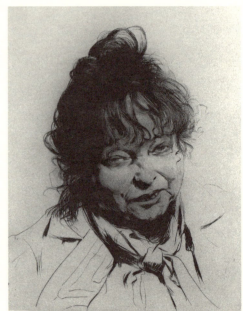

Fig. 115.
Edgar Chahine, *Louise France,*
1902, drypoint, 40.5 x 30.
Morse Fund.

Fig. 116.
PAL (Jean de Paleologu), poster for *La Vache enragée* procession, 1896, color lithograph, 148.5 x 109. Morse Fund.

Fig. 117.
Fernand Pélez, poster for *La Vache enragée* procession, 1897, color lithograph, 148.8 x 103. Gift of Mr. and Mrs. Herbert Littman.

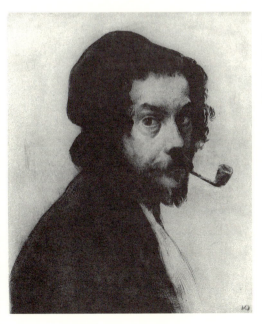

Fig. 118.
Marcellin Desboutin, *L'Homme à la pipe* (Self-Portrait), 1879, drypoint, 61.6 x 48.5. Friends Purchase Fund.

Fig. 119.
Abel Truchet, *Les Grecs*, c. 1895, charcoal, 33.5 x 26.8. Morse Fund.

71

Fig. 120.
Théophile-Alexandre Steinlen,
lithographic cover for Jehan Rictus,
Les Soliloques du pauvre (Paris, 1895).

Fig. 121.
Théophile-Alexandre Steinlen, photo-
relief cover for Jehan Rictus, *Les Soliloques
du pauvre* (Paris, 1897). Schimmel Gift.

cabaret for only a short time; Trombert refused to increase the poet's nightly pay even though his performance was attracting large audiences. Rictus, thus, went to Salis and negotiated better compensation at the Chat Noir.

Rictus had a soulmate in Steinlen, *Le Chat noir* artist who also illustrated, since the mid-1880s, Aristide Bruant's monologues and songs. Bruant's career began at the Chat Noir, but when Salis moved in 1895 to the expanded facilities on the rue Victor Massé, Bruant took over the old premises at 84, boulevard Rochechouart and established the cabaret Le Mirliton which, in the manner of the Chat Noir and Quat'z'Arts cabarets, had its own journal, *Le Mirliton*. Steinlen was a socialist-anarchist and, like Rictus, was sympathetic to the plight of the impoverished and oppressed and even to the outbreak of anarchist violence in France in the early 1890s, which resulted in the 1894 assassination of President Sadi Carnot. Unlike the majority of artists, poets, and performers at Les Quat'z'Arts, Rictus and Steinlen had serious social agendas for their poetry and art. Thus, it was natural for Rictus to ask Steinlen to illustrate the cover for the brochure that the former published within days after his performance at Les Quat'z'Arts [Fig. 120].[86] In 1897 Joachim Sunyer, the young Spanish expatriate living in Montmartre and admirer of both Rictus and Steinlen, created an album of eight color lithographs dedicated to Rictus and entitled *Les Soliloques du pauvre* [Figs. 122, 123]. However, Steinlen's 110 black-and-white drawings [Fig. 190] for the 1903 expanded edition of *Les Soliloques du pauvre* [Fig. 124] are the definitive visual rendition of Rictus's poems.[87]

In 1883 Albert Robida, the humorous illustrator of Rabelaisian tales and of fashion journals, published *Le Vingtième Siècle* [Fig. 125], a science-fiction look at the

Figs. 122, 123.
Joachim Sunyer y Miro, color lithographs for Jehan Rictus, *Les Soliloques du pauvre*, 1897. Morse Fund.

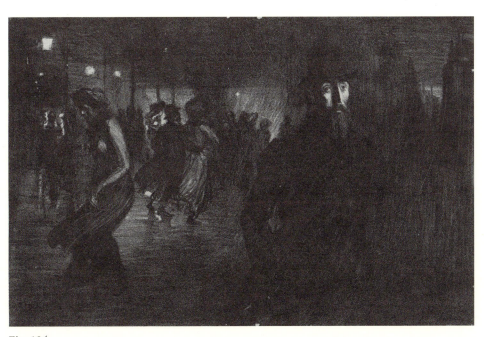

Fig. 124.
Théophile-Alexandre Steinlen, color lithographic cover for Jehan Rictus, *Les Soliloques du Pauvre*
(Paris: P. Sévin et E. Rey, 1903).

year 1952.[88] Yet, try as he did to visualize the developments in fashion and technology seventy years in the future, he was not able to break out of the confines of the fin-de-siècle vocabularies of forms, materials, and styles that define his art. In fact, his comic images of mid-twentieth-century flying machines, communication systems, urban structures, and modes of dress are way off the mark. On the other hand, a number of Robida's peers, without any conscious effort to predict art of the future, nevertheless created works of art or anti-art in the name of *incohérence* that trenchantly foresaw tendencies and forms of twentieth-century aesthetics. Hydropathes, Incohérents, and others, using the tools of parody and rebus and by stretching their unfettered imaginations, developed new forms, media, and styles, which pushed or dissolved traditional boundaries of art [Figs. 126–130]. Most important, one finds at the end of the nineteenth century the emergence of an art driven by literary-artistic collaboration for which the new, inexpensive, photo-printing processes served as a primary catalyst, while individuals such as Goudeau, Lévy, Cohl, and Salis acted as the agents or publishers-editors who initially promoted or funded the collaborations among the Montmartre avant-garde. The end result was, among other things, the development of nascent forms of twentieth-century conceptual art in which words and images are equally significant, and even, at times, codependent.

The monochromatic paintings by Bilhaud and Allais in the early Incohérent exhibitions and Gray's *Fête du 14 juillet. Effet de nuit*, which was included in Lévy's

Fig. 125.
Albert Robida, *Le Vingtième Siècle* (Paris: Georges Decaux, 1883). Schimmel Fund.

Fig. 126.
Jules Chéret, color lithographic cover for Charles Joliet, *Roman incohérent*
(Paris: Jules Lévy, 1887). Bartman Fund.

Fig. 127.
Théophile-Alexandre Steinlen, "Palais incohérent," photo-relief illustration for Charles Joliet, *Roman incohérent* (Paris: Jules Lévy, 1887), 41. Bartman Fund.

Figs. 128, 129, 130.
Emile Cohl, woodburytype portraits of Léon Cladel (128, left), Laurent Tailhade (129, middle), and Emile Goudeau (130, right), for L.-G. Mostrailles [Léo Trézenik and Georges Roll], *Têtes de pipes* (Paris: Léon Vanier, 1885), 169, 33, 121. Schimmel Fund.

ÉMILE GOUDEAU

two shows of 1882 and described as "des points de couleur sur un fond noir" (points of color on a black background), rely on their titles to make them complete works of art.[89] Almost seventy years before John Cage composed *4'33" of Silence*, Allais created for the 1884 Incohérent exhibition his funeral march for the deaf, a blank music score [Fig. 221]. Yet, one may only fully appreciate the *incohérence* and modernity of Allais's "composition" by seeing it published in *L'Album primo-avrilesque* of 1897 along with seven monochrome images. Titles were also used to construct complicated visual puns, such as Cohl's *Assemblée était suspendue à ses lèvres...* (The Assembly Was Hanging on His Lips) [Fig. 63] and *Abus des métaphores* (The Abuse of Metaphors) [Fig. 193]; again, a work by Cohl, *Un Général hors cadre* [Fig. 131], is a visual pun, which explicitly confirms the extension of art beyond its normal confines of the frame (*cadre*). Mesplès's humorous visual word game, *L'Honnête Femme et l'autre* [Fig. 132], expresses sexual innuendo à la Duchamp's *Grand Verre* of 1915–23 through a system of inherently nonsexual, nonorganic imagery composed solely of vertical and horizontal lines and symbols of mathematical equations of which the former are identified by the nonsexual word *raide* (upright). The joke behind the identical female portraits [see also Fig. 64], of course, is that it was not possible to distinguish between an honest (upright) woman and a prostitute (*horizontale*). Equally conceptual in nature is Aristide Boulineau's entry for the 1886 *Incohérent* catalogue: #42, *Petit Cours de géographie* [Fig. 133], in which the images have no relationship to geography but rather to the second meaning of *mer* (sea/mother), *lac* (lake/lacquer), and *cap* (cape/cape).

Another area of experimentation was typography. L. Lemercier de Neuville's premise in the first chapter of his 1891 book, *Médard Robinot* [Fig. 134], is a tongue-in-cheek rationale for designing typography to make visible for the reader the content of the text. He facetiously suggests that vocabulary had become so technical and otherwise so complicated in the nineteenth century that typographical design, the *calligramme*, is a means of clarifying or reinforcing the meaning of a text. It is with Mallarmé's elaborate "concrete poetry" in *Un Coup de dés* [Fig. 135] of 1897 (see Mary Shaw's essay in the present volume) that word and image are, in fact, made one and the same; the boundaries of literature and the visual arts are completely dissolved. From Mallarmé one jumps to the twentieth century and to the extraordinarily inventive collection by Apollinaire, *Calligrammes* [Figs. 136–139]. As early as 1880, the cover of Jouy's *L'Anti-concierge* [Fig. 140] incorporated words and images into a concentric pictorial format prefiguring the work of the *lettristes* in the 1940s and 1950s. Henri de Sta also experimented with fonts and the arrangement of typography on the title page for his book *La Chanson du colonel* [Fig. 141], as did Jarry in his 1894 *Minutes de sable mémorial* [Fig. 142].[90] None of these three works fall into the category of *calligramme*; rather, they, like Bonnard's posters for *La Revue blanche* [Fig. 143], are early examples of the extension or manipulation of words or letters as active components of visual imagery at the expense of readability. The opposite of Lemercier's goal of clarity for the *calligramme*, Jarry's and Bonnard's typographical designs deconstruct words to the point of nearly obliterating their ability to communicate.

Fig. 131.
Emile Cohl, "Un général hors cadre," photo-relief illustration for the *Catalogue de l'exposition des Arts incohérents* (Paris, 1886), 63. Schimmel Fund.

Fig. 132.
Eugène Mesplès, "L'Honnête Femme et l'autre," photo-relief illustration for the *Catalogue illustré de l'exposition des Arts incohérents* (Paris: E. Bernard et Cie, 1884), 154. Schimmel Fund.

In like manner, Faverot's illiterate poster of about 1897 for *Le Champs de Foire* [Fig. 146], a Montmartre entertainment hall, and Herter's gouache maquette [Fig. 144] for a poster of the same period subvert, with degrees of unintelligibility, the traditional communicative function of a poster in favor of *incohérent* humor.

Another system of deconstructing the function of words and text is found in 1895 in Hermann-Paul's satirical journal *Le Fond de bain* [Fig. 147], and in *Le Mur*. *Le Bâtard du connétable*, by a so-called Thomas Wack, is a serial novelette in *Le Fond de bain*. Entire passages of the story are literally left blank; chapters are omitted and sentences are incomplete because, as the author explains, the "sordid" contents were suppressed by the censors. However, according to the author, "this suppression takes nothing away from the intelligibility of the story." The absurdity of this situation is reinforced and amplified by the lavish amount of space allotted to the story within the journal and by Paul's handwritten text, in which the gaps due to "censorship" are vividly rendered. *Le Bâtard du connétable* is, in fact, a tour de force of early conceptual art. Indeed, there is really no explanation for the creation of *Le Fond de bain* other than as a form of artistic expression.[91] The same may be said about *Le Mur* and, in particular, its "Pêcheurs des perles" [Fig. 145], in which, as with Paul's *Bâtard du connétable*, visual effects deny the text to perform its normal role.

Fig. 133.
Aristide Boulineau, "Petit Cours de géographie. Cap. Lac. Mer. Baie," photo-relief illustration for the *Catalogue de l'exposition des Arts incohérents* (Paris, 1886), 111. Schimmel Fund.

Fig. 134.
L. Lemercier de Neuville, *Médard Robinot, casquettier* (Paris: E. Dentu, 1891), 32. Schimmel Fund.

Fig. 135.
Stéphane Mallarmé, *Un Coup de dés jamais n'abolira le hasard* (A throw of the dice will never abolish chance), *Cosmopolis*, no. 17 (May 1897): 424–25. Schimmel Fund.

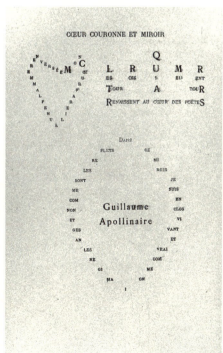

Fig. 136.
Guillaume Apollinaire, "Du coton dans les oreilles" (Cotton in the ears), *Calligrammes: Poèmes de la paix et de la guerre (1913–1916)* (Paris: *Mercure de France*, 1918), 167. Schimmel Fund.

Fig. 137.
Guillaume Apollinaire, "coeur couronne et miroir" (heart, crown, and mirror), photo-relief illustration for *Calligrammes*, 56. (See fig. 136)

Fig. 138.
Guillaume Apollinaire, "Venu de Dieuze" (On arrival from Dieuze), photo-relief illustration for *Calligrammes*, 110–11. (See fig. 136)

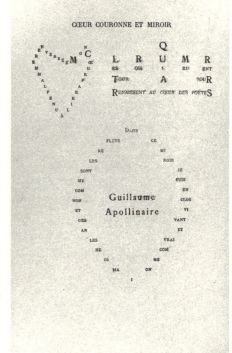

Fig. 139.
Guillaume Apollinaire, "La Cravate et la montre" (The Tie and the Watch), photo-relief illustration for *Calligrammes*, 50. (See fig. 136)

Fig. 140.
Sapeck (Eugène Bataille),
photo-relief cover for *L'Anti-
concierge*, no. 1 (1 December
1881). Schimmel Fund.

Fig. 141.
Henri de Sta, title page
for *La Chanson du colonel*
(Paris: Léon Vanier, 1882).
Schimmel Fund.

Fig. 142.
Alfred Jarry, title page for *Les
Minutes de sable mémorial*
(Paris: *Mercure de France*, 1894).
Schimmel Fund.

Fig. 143.
Pierre Bonnard, poster for *La Revue blanche*,
1894, color lithograph, 80 x 62. Gift of the Class
of 1958, Twentieth Reunion.

Fig. 144.
Albert Herter, *Exposition de l'art T . . . ,* c. 1895–1900, gouache, 62 x 48. Gift of Herbert D. and Ruth Schimmel.

Fig. 146.
Joseph Faverot, *Chan de foir,* poster for Champs de Foire, color lithograph, 95.2 x 61.6. Morse Fund

Fig. 145.
Unidentified, "Les Perles," from *Le Mur,* 1895, ink and collage. Schimmel Fund.

Fig. 147.
Hermann-René-Georges Paul, called Hermann-Paul, *Le Fond de bain*, no. 1 (25 July 1895).
Herbert Littman Purchase Fund.

81

Fig. 148.
Alfred Jarry, "Ubu Roi," woodcut illustration for *Le Livre d' art*, no. 2 (May 1896). Schimmel Fund.

Fig. 149.
Alfred Jarry, *Ubu Roi,* program for Le Théâtre des Pantins, December 1897, lithograph, 36 x 26.3. Morse Fund.

Jarry directed only two performances of *Ubu Roi* in which actors, not puppets, played the roles; these were the nights of 9 and 10 December 1896 for Lugné-Poe's Théâtre de l'Oeuvre at the Nouveau Théâtre, only a short walk from the Quat'z'Arts cabaret. The stage set and masks were designed and painted by Bonnard, Paul Sérusier, Toulouse-Lautrec, Vuillard, Paul Ranson, and Jarry; Claude Terrasse, the brother-in-law of Bonnard, composed the music; Firmin Gémier played the part of Ubu, while Louise France of the Quat'z'Arts played Mère Ubu.

The complete version of the play and Jarry's woodblock print of the fully evolved, absurd image of Ubu were first published in the April and May 1896 issues of Paul Fort's journal *Livre d'art* [Fig. 148]. Jarry's rendition of the physical appearance of Père Ubu, the obese, amoral monster-king, is a cross between Daumier's 1830s pearlike portraits of King Louis-Philippe and weirdly costumed revelers at a *bal des Incohérents*. By a curious but appropriate coincidence, Jarry's cone-head likeness of Ubu bears a close resemblance to that of future white-hooded Ku Klux Klansmen. A year and a month after the Théâtre de l'Oeuvre's production of *Ubu*, Jarry, Bonnard, Vuillard, and Terrasse collaborated on the puppet production of the fully realized *Ubu Roi* at the Théâtre des Pantins [Fig. 149], which was actually Terrasse's home at 6, rue Ballu, two blocks from the place de Clichy. The Théâtre des Pantins owed an obvious debt to the Chat Noir shadow plays:

> Rue Ballu, at the end of a courtyard, on the second floor, a miniscule theatre holding a handful of people. This is where Alfred Jarry recently revived his epic Ubu for a run of several evenings, using ingenious marionettes. The hall is small, but pleasingly decorated by Edouard Vuillard with pyrotechnics of superb colors, and by Bonnard with black and grey silhouettes drawn with great virtuosity.[92]

Louise France was the voice of Mère Ubu. Jarry designed the three lithographic covers for the music scores of *Ubu* by Terrasse [Figs. 152–154], and Bonnard made all the puppets except the one for Ubu [Fig. 150], which was fabricated by Jarry himself. For his three lithographs Jarry appropriated a system or, rather, nonsystem of drawing based on the art of children. Uncontrolled scratches and scrawls of crudely applied crayon delineate figures and text in seemingly free abandon. This infantile effect is similar to that already found in drawings by Roedel for *Le Mur* and even earlier, by Willette and Steinlen for *Le Chat noir*.

In *Le Flâneur des deux rives*, Guillaume Apollinaire notes:

> The *Grand Almanach illustré* was composed in the rue Laffitte cellar. Everyone knows that Alfred Jarry wrote the text, Bonnard illustrated it, and Claude Terrasse created the music, while the song is the work of Mr. Ambroise Vollard. Everyone knows this, and yet no one seems to have noticed that the *Grand Almanach illustré* was published without names of authors or publisher.[93]

The *Almanach du Père Ubu* [Fig. 151] is also referred to as the *Grand Almanach illustré* to distinguish it from a smaller almanac published by Jarry in 1899. Both publications were written by Jarry, illustrated by Bonnard, and published by Vollard, but as Apollinaire states above, the large 1901 version, like the earlier one, following the avant-garde preference for anonymity, gives no indication of its creators or publisher.[94]

Jarry and Bonnard knew of each other as early as 1894, when the former critiqued the latter's painting in his review of the sixth exhibition at the Galerie Barc de Boutteville.[95] In 1898 *Le Mercure de France* published the set of nine lithographic music-sheet covers for Jarry's *Répertoire des pantins*, six of which were by Bonnard [Fig.155] and three by Jarry himself, as we have seen. Bonnard's seventy-nine lithographic images for the large *Almanach du Père Ubu* are the visual counterpart to Jarry's absurd text; flouting all academic standards, Bonnard gave free rein to his imagination in the interpretation of Jarry's childlike, amoral humor and parody of French society. The spontaneous and crudely drawn images appear throughout the text as scattered vignettes; on one page they intermingle with the text they describe while elsewhere they are isolated, full-page graphic innovations [Figs. 156–159]. They are Bonnard's most far-reaching aesthetic excursions into abstraction and visual puns. As some of the most expressive examples of fin-de-siècle art of the absurd, Bonnard's lithographs for the *Almanach du Père Ubu* opened the twentieth century with an innovative, psychosexual, visual vocabulary that predicted the stylistic and contextual concerns of Pablo Picasso and Henri Matisse, as well as those of the Dadaists and Surrealists.

Jarry preferred a marionette production of *Ubu Roi* to one with live actors; it was Trombert who gave Jarry the opportunity finally to present his play with puppets to a large audience and in a nondomestic environment. Beginning on the evening of 27 November 1901 a total of sixty-four puppet performances of *Ubu Roi* took place at Les Quat'z'Arts cabaret. Entitled *Ubu sur la Butte* [Fig. 160], the play was reduced to two acts. Jarry, however, included a humorous prologue in which the only dialogue is between Trombert and Guignol. The latter is introduced to the audience as the wooden puppet, guignol, who has traveled to Paris from Lyons–the home of the French puppet theater–to perform in Jarry's play at the Quat'z'Arts for the enormous fee of 250,000 francs. The prologue serves to place the puppet show in the context of Les Quat'z'Arts and is thus similar to other Quat'z'Arts revues such as *Pour éviter la peste*, written by Gaston Sécot and the singer Yon Lug with music arranged by Charles de Sivry. *Pour éviter la peste* [Fig. 161] was a *revue fantaisiste*, performed for the first time at the Quat'z'Arts cabaret on 3 March 1897 by its regular troupe of singers and musicians. This revue is a mix of dialogue and songs filled, in the manner of stories in *Le Chat noir*, with all-encompassing Montmartre-related puns and in-jokes, as well as with comic references to sophisticated Parisians such as the ever-popular Sarah Bernhardt and to current events such as the ongoing French-Russian alliance; the revue even makes a reference to Ubu.[96]

Fig. 150.
Alfred Jarry, puppet of Ubu for Le Théatre des Pantins, reproduced in Paul Chauveau, *Alfred Jarry ou la naissance, la vie et la mort du Père Ubu* (Paris: *Mercure de France*, 1932), 111. Schimmel Fund.

Fig. 151.
Pierre Bonnard, color lithographic title page for Alfred Jarry, *Almanach illustré du Père Ubu, XXème siècle* (Paris, 1 January 1901). Schimmel Fund.

Figs. 152–155. Lithographic covers for Répertoire des Pantins, 27 x 35 each. (Paris: *Mercure de France*, 1898). Morse Fund.

Fig. 152.
Alfred Jarry, *Ouverture d'Ubu Roi.*

Fig. 153.
Alfred Jarry, *La Chanson du décervelage*
(The Debraining Song).

Fig. 154.
Alfred Jarry, *Marche des polonais.*

Fig. 155.
Pierre Bonnard, *Du pays Tourangeau.*

Figs. 156 and 157.
Pierre Bonnard, "Alphabet du Père Ubu" (156), "Ubu Colonial" (157), color lithographic illustrations for Alfred Jarry, *Almanach illustré du Père Ubu, XXème siècle* (Paris, 1 January 1901), 14–15 and 33–34. Schimmel Fund.

CES NÈGRES

ONT ROUGI

A ENTENDRE

LA CHANSON SUIVANTE

ET CETTE PAGE DE DROITE QUI EN EST PLUS PBOCHE
EST DÉJA AU ROUGE *BLANC*

— 48 —

Figs. 158 and **159** (opposite page). **Pierre Bonnard,** color lithographic illustrations for Alfred Jarry, *Almanach illustré du Père Ubu, XXème siècle* (Paris: 1 January 1901), 48 and 53. Schimmel Fund.

A heretofore unpublished letter written by a Monsieur Gauthard, the individual in charge of the actual physical constuction of the stage sets for *Ubu sur la Butte*, describes in detail aspects of the production (see Appendix Ubu). The production of *Ubu sur la Butte* at the Quat'z'Arts was the apex of Jarry's brief but influential theatrical career. Its numerous performances, at least, allowed many young artists and writers such as Picasso and Apollinaire to see a portion of the published text of Jarry's play brought to life as it was intended and, in so doing, to encounter the cabaret's conceptual journal *Le Mur*. Within a twenty-year period, from the time of the Hydropathes to the turn of the century, Goudeau's observation, that beginning in the 1870s the café had taken the place of the theater and the editorial office, was not only verified by the activities of the Chat Noir and Quat'z'Arts cabarets but had gone far beyond the functions of the more traditional establishments.[97] The relatively modest gatherings of the Hydropathe artists and writers were no longer simple opportunities for artists and writers to present their art freely but had evolved into highly sophisticated, choreographed cabaret productions, which, as Goudeau observed, had succumbed to commerce. By 1900 the cabarets of Montmartre presented visitors to the world's fair a vast variety of entertainments. Yet Montmartre's attraction for young artists and writers as a haven away from the world of the bourgeoisie was not diminished. Its legacy of innovation and freedom was still fresh and ready to be explored by the first generation of twentieth-century artists and writers [Figs. 162, 163].

Fig. 161.
Abel Truchet, lithographic cover for G. Sécot and Yon Lug, *Pour éviter la peste* (To avoid the plague) (Paris: Cabaret des Quat'z'Arts, 1897). Bartman Gift.

Fig. 162.
Pablo Picasso, "Bailarina de Can Can" 1901. Museu Picasso, Barcelona. © 1996 Succession Picasso/ Artist Rights Society (ARS), New York.

Fig. 163.
Pablo Picasso, "Picasso y Junyer llegan a Paris," 1904. Museu Picasso, Barcelona. © 1996 Succession Picasso/ Artist Rights Society (ARS), New York.

1. Félicien Champsaur, "Courrier de Paris," *Panurge*, no. 2 (8 October 1882), 2: "Qui n'a pas vu ça n'a rien vu. C'était extraordinaire. Ferdinandus a eu un succès énorme avec une peinture en relief: *le Facteur rural*. C'était vraiment de la peinture en relief, car le soulier du facteur, un vrai soulier, qui avait servi, cela se voyait, projeté en arrière avec vigueur, sortait de la toile. . . . Mlle Chabot, de l'Opéra, m'a dit avoir exposé un paysage sur la semelle de son chausson de danse. Il est si petit que je ne l'ai pas vu."

2. Jules Lévy, "L'Incohérence—son origine—son histoire—son avenir," in *Le Courrier français*, 12 March 1885, 3–4.

3. Ibid.: "Il faut réhabiliter cette gloire nationale qu'on nomme l'esprit français, c'est pourquoi les Incohérents sont venus. Et, sans jamais être sales, ils font tout leur possible pour être gais."

4. Eric Darragon, *Manet* (Paris: Fayard, 1989), 211.

5. Claretie, quoted by Darragon in *Manet*, 217.

6. Auguste Marteroy, "Histoire du Bon Bock (3)," *Le Bon Bock*, December 1905, 7–8.

7. Galipaux states that he attended the 14 June 1881 dinner; the invitation for that evening describes the program for the previous Bon Bock dinner in May, in which Galipaux performed a monologue entitled "Le Cul blanc de Ed. Grangé." Félix Galipaux, *Les Souvenirs de Galipaux* (Paris: Librairie Plon, 1937), 115–16.

8. *Album du Bon Bock* (Paris: Ludovic Baschet, 1878), preface, unpaginated: "Littérature et Beaux-Arts, Musique et Poésie, se tenant par la main, formant à nos réunions une couronne magnifique. Pas de discussions, pas de jalousies, pas d'animosités. Tous égaux, tous unis, nous nous groupons autour de cette bannière républicaine qui porte pour devise, FRATERNITÉ! Je peux donc dire, sans orgueil que si la Gaîté et l'Intelligence et la sympathie étaient bannies du reste de la terre, c'est au *Bon Bock* qu'on les retrouverait. Sur ce, très chers frères, je prie notre immortel grand maître, Rabelais qu'il vous tienne en bonne santé de corps et joyeuse humeur d'esprit."

9. Georges Fragerolle, "Le Fumisme," *L'Hydropathe*, 12 May 1880.

10. François Caradec, *Alphonse Allais* (Paris: Belfond, 1994), 213.

11. Victor Meusy and Edmond Depas, *Guide de l'étranger à Montmartre* (Paris: J. Strauss, 1900),

12. Ibid.

13. Raymond de Casteras, *Avant le Chat noir: Les Hydropathes* (Paris: Editions Albert Messein, 1945), 35–45.

14. Emile Goudeau, *Dix Ans de Bohème* (Paris: Librairie illustrée, 1888), 157–58.

15. André Gill, *Vingt Années de Paris* (Paris: C. Marpon et E. Flammarion, 1883), 6–9.

16. Charles Fontane, *André Gill, un maître de la caricature*, 2 vols. (Paris: Editions de l'Ibis, 1925), 1:123.

17. The original *Au Lapin Agile* was found in the early 1920s (Fontane, *André Gill*, 2:216) and is now in the collection of the Musée Montmartre, Paris; the original *Femme au bock* was reported in 1886 to be in the possession of the owner of the Brasserie Bon Bock (John Grand-Carteret, *Raphaël et Gambrinus ou l'art dans la brasserie* [Paris: Louis Westhausser, 1886], 161). The painting in the Zimmerli collection is most likely the 1883 copy after Gill's painting, which was located in the brasserie until a fire in 1986 damaged part of the establishment and its contents.

18. Among the members of the committee that raised the funds for the Gill monument were early Bon Bockers, Carjat and Paul Arène; Rodolphe Salis, Willette, and Charles de Sivry of the Chat Noir; and Jack Abeillé and Auguste Roedel of the Quat'z'Arts cabaret. Roedel designed the poster that promoted the monument.

19. Fragerolle, "Le Fumisme": "est à l'esprit ce que l'opérette est à l'opéra-bouffe, la charge à la caricature, le pruneau à l'eau d'Hunyadi-Janos. . . . Afin de passer pour homme d'esprit, il suffit parfois d'être un âne couvert de la peau du lion; pour être bon fumiste il est souvent indispensable d'être un lion couvert d'une peau d'âne. Dans le premier cas l'effet est direct, dans le second il est une fois, deux fois, souvent dix fois réflexe."

20. Goudeau, *Dix Ans de Bohème*, 157.

21. André Barre, *Le Symbolisme*, ser.140 (Paris, 1911; New York: Burt Franklin Bibliography and Reference, n.d.), 74–78.

22. Goudeau, *Dix Ans de Bohème*, 251–52.

23. Ibid., 261.

24. Jacques Lehardy, "Montmartre," *Le Chat noir*, 14 January 1882.

25. For his depiction of humanlike animals, Salis most certainly looked to the earlier lithographic images of J. Grandville and specifically to the cover image of the latter's 1829 album, *Les Métamorphoses du jour*, in which Grandville depicts a seated man with his head hidden behind a hanging curtain on which the "portrait" images of various animals are projected by a magic lantern so as to create a figure with the face of an animal dressed in man's clothing.

26. Jean Pascal, "Les Chansons et poésies du Chat noir," *Les Chansonniers de Montmartre* 24 (25 June 1907): 2.

27. Advertisement in *Le Chat noir*, 13 January 1883.

28. Pascal, "Les Chansons et poésies du Chat noir," 3.

29. *Le Chat noir*, 28 October 1882.

30. A'Kempis [Emile Goudeau], "Un Deuil," *Le Chat noir*, 22 April 1882.

31. Constant Chanouard [pseud.], "Les Arts incohérents," *Le Chat noir*, 8 October 1882: "Dans ce siècle éminemment progressiste où toutes les idées vieillies ont succombé sous l'inflexible marteau des novateurs puissants, en même temps que les révolutions politiques foudroyaient le monde en l'éclairant, les révolutions littéraires, parallèlement aboutissaient à des triomphes éclatants, et l'Art entrait en possession de lui-même.
 "Ce que naguère les impressionnistes avaient tenté: la vision exacte et le rendu dans l'impossible ténuité des valeurs et des taches, ce seront les incohérents qui le donneront à une foule avide de contempler cette forme essentiellement novatrice."
 "Le dimanche 1er Octobre 1882—retenez bien cette date mémorable—le *Chat Noir* dans la personne de M. Jules Lévy, organisateur délégué, ouvrait la porte d'un modeste atelier, sis rue Antoine-Dubois, 4; et grâce à la baguette magique d'une puissante idée, grâce au rayonnement qui sort des oeuvres géniales, transformait pour quelques heures cet habitacle en un temple de l'Art, en une solennelle cathédrale de l'Avenir."
 "On dira plus tard lorsque l'incohérence aura définitivement triomphé de l'envie, on dira: C'est là qu'ils sont nés."

32. On the other hand, as we will see, *L'Album primo-avrilesque* is probably the earliest "artist's book" per se and one of the first examples of conceptual art, as defined in terms of the end of the twentieth century, for it had no other purpose for its production than to be an *incohérent* work of art.

33. *Le Chat noir*, 5 May 1883.

34. Armond Fields, *Henri Rivière* (Salt Lake City: Peregrine Smith Books, 1983), 6–8.

35. Caradec, *Alphonse Allais*, 229.

36. Ibid., 230.

37. *Le Chat noir*, 10 February 1883.

38. *Le Chat noir*, 1 September 1883.

39. *Le Chat noir*, 15 September 1883.

40. *Le Chat noir*, 13 October 1883.

41. Adolphe Willette, *Feu Pierrot* (Paris: H. Floury, 1919), 132.

42. Ibid., 136.

43. Bruant's song was published in the 9 August 1884 issue of *Le Chat noir*, a little more than two months before the 1884 *Incohérent* exhibition.

44. Willette, *Feu Pierrot*, 128.

45. Edmond Drumont, *La France juive* (Paris: Librairie Blériot, 1886).

46. For an in-depth discussion of Willette's anti-Semitism and that of the fin-de-siècle in

general, see *The Dreyfus Affair: Art, Truth, and Justice*, ed. Norman Kleeblatt (Berkeley:University of California Press, 1987).

47. Caradec, *Alphonse Allais*, 229

48. Horace Valbel, *Les Chansonniers et les cabarets artistiques* (Paris: E. Dentu, 1895), 67–68.

49. Meusy and Depas, *Guide de l'étranger à Montmartre*, 7–8.

50. Only in the past fifteen years has the work of the Incohérents begun to be seriously studied and placed in context with avant-garde activities of the twentieth century. Of the following publications Catherine Charpin's 1990 seminal study is the most important in terms of documenting Incohérent exhibitions, catalogues, and participants, as well as evaluating the significance of Incohérent works of art as precursors of those of the Dadaists, Surrealists, Fluxus, etc. In the fall of 1991 a probing exhibition documenting the work of the Incohérents was held at the Grolier Club in New York. It was organized by graduate students from the Department of Art History, Rutgers University, under the supervision of the Zimmerli Art Museum, but, unfortunately, without a catalogue. The following spring, in conjunction with the Toulouse-Lautrec retrospective exhibition at the Grand Palais, Paris, the Musée d'Orsay organized a dossier exhibition and catalogue on the Incohérents. See Daniel Grojnowski, "Une Avant-garde sans avancée: Les Arts incohérents," *Actes de la recherche en sciences sociales*, Paris, November 1981, 73–86; Phillip Dennis Cate and Patricia Eckert Boyer, *The Circle of Toulouse-Lautrec*, exh. cat. (New Brunswick: Zimmerli Art Museum, Rutgers, The State University of New Jersey, 1985); Jerrold Seigel, *Bohemian Paris: Culture, Politics, and the Boundaries of Bourgeois Life, 1830–1930* (New York: Viking, 1986); Eugen Weber, *France: Fin de Siècle* (Cambridge, Mass.: Harvard University Press/Belknap, 1986); Catherine Charpin, *Les Arts incohérents (1882–1893)* (Paris: Syros Alternatives, Collection "Zigzag," 1990); Luce Abélès and Catherine Charpin, *Arts incohérents, académie du dérisoire*, Collection les Dossiers du Musée d'Orsay, 46 (Paris: Réunion des Musées nationaux, 1992).

51. Charpin lists fifty-one names in her *Petit Dictionnaire des artistes incohérents les plus connus*, 114–118, in *Les Arts incohérents (1882–1893)*.

52. Lévy, *L'Incohérence—son origine—son histoire—son avenir*. "Les incohérents n'ont aucune prétention, ils ne sont ni plus malins, ni plus spirituels que tous les gens qui s'occupent d'art d'une façon quelconque, qu'ils soient peintres, poètes, sculpteurs ou menuisiers, mais ils ont cette conviction qu'ils ne sont pas tout à fait des imbéciles."

53. Emile Goudeau, editorial in *La Revue illustrée*, 15 March 1887, as quoted in Charpin, *Les Arts incohérents (1882–1893)*, 112: "Il [l'incohérent] appartient à tous les métiers qui se rapprochent de l'art: un typographe peut être incohérent, un zingueur, jamais! L'Incohérent est donc peintre ou libraire, poète ou bureaucrate, ou sculpteur, mais ce qui le distingue c'est que, dès qu'il se livre à son incohérence, il préfère passer pour ce qu'il n'est pas: le libraire devient ténor, le peintre écrit des vers, l'architecte discute de libre-échange, le tout avec exubérance."

54. Ibid.: "A travers Paris, l'Incohérent marche comme tout le monde, il salue ses supérieurs, et serre la main de ses égaux; mais si, par hasard, il rencontre quelque part un co-incohérent, il se désarticule soudainement, se désagrège: son front, son nez, ses yeux et sa bouche forment des grimaces cabalistiques, ses bras se contournent drôlement et ses jambes s'agitent, suivant une cadence extravagante. Cela ne dure qu'une ou deux secondes. Mais ce sont les signes maçonniques, auxquels se reconnaissent les F*** en Incohérence."

55. Albert Millaud, *Physiologies parisiennes* (Paris: La Librairie illustrée, 1886), 139–40: "L'incohérent est un bon jeune homme artiste par tempérament, mais encore naïf. C'est un perdeur de temps, qui use ses qualités et son talent à trouver quelque chose de drôle qui fasse rire le public. Il y a peut-être parmi les Incohérents des Raphaël en herbe, des Guido Reni au berceau, qui, pouvant passer trois mois à créer une 'Sainte famille' ou une 'Béatrix', aiment mieux composer une pochade de brasserie ou une caricature pour un journal à 10 centimes.

"Néanmoins, l'Incohérent est un bon garçon; il est généreux et gai. Ce qu'il fait, ce n'est pas pour lui, c'est pour servir les autres, faire la charité et égayer son prochain. C'est un prodigue qui sème son or, sans regret et sans espoir de retour. Il a du coeur et de l'esprit, mais il emploie mal l'un et l'autre. J'aime l'Incohérent parce qu'il n'a pas de prétention, et qu'au contraire du wagnérien et de l'impressioniste, il ne pose pas pour régénérer l'art. Il s'amuse et veut amuser; mais il a le tort de donner trop d'importance à ses amusements, aussi puérils qu'inutiles, et dont il ne restera rien."

56. Preface to *Catalogue de l'exposition des arts incohérents* (Paris, 1884), 3. Charpin (*Les Arts incohérents [1882–1893]*) , 112, indicates that the authors of this unsigned preface were Charles Leroy and Georges Moynet: "On a dit qu'ils étaient incapables d'autre chose que de mauvaises plaisanteries; comme si parmi les incohérents ne se trouvaient pas des artistes véritables, dont les preuves ne sont plus à faire, et qui brillent au premier rang."

57. Cate and Boyer, *The Circle of Toulouse-Lautrec*, 10–11. Lautrec has often been considered a member of the Incohérents, but recently Luce Abélès has convincingly challenged that position. See Abélès, "Tolav Segreog, hongrois de Montmartre," *Actes du colloque Toulouse-Lautrec*, May 1992 (Albi: Musée Toulouse-Lautrec, in collaboration with the Musées Nationaux, 1994), 89–99. It hardly matters if Lautrec was or was not an actual participant in Incohérent exhibitions; he had the same mind-set and parallel interests as his *Incohérent* peers.

58. E. Bernard, *Exposition internationale de blanc et noir, 1885* (Paris: E. Bernard & Cie., 1885), xii–xiii. Bernard, the printer of the 1884 *Incohérent* catalogue, was the "directeur-administrateur" of *Le Dessin*.

59. *Blanc et noir*, 76.

60. Maurice Saillet, ed., with commentary and notes by Charles Grivel, *Alfred Jarry: Tout Ubu* (Paris: Le Livre de poche, 1992), 10 and 33 n. 1.

61. Henry Somm, *La Berline de l'émigré ou jamais trop tard pour bien faire*, a one-act comedy, illustrated by the author (Paris: Léon Vanier, 1892).

62. Emile Goudeau, *Les Billets bleus* (Paris: Librairie illustrée, 1886), 266–67.

63. Paul Jeanne, *Les Théâtres d'ombres à Montmartre de 1887 à 1923* (Paris: Les Editions des Presses modernes, 1937), 18.

64. Paul Eudel, *Les Ombres chinoises de mon père* (Paris: Rouveyre, 1885).

65. Henri de Sta, *La Chanson du colonel* (Paris: Léon Vanier, 1882).

66. Georges Lorin, *Paris rose*, with illustrations by Lorin and Luigi Loir (Paris: Paul Ollendorff, 1884).

67. See *Rassemblements*, ed. Octave Uzanne (Paris: Henry Floury, 1896), with thirty relief-printed black-and-white illustrations by Vallotton.

68. Paul Bilhaud, *Les Petits japonais* (Paris; Jules Lévy, n.d. [c. 1884]).

69. Jeanne, *Les Théâtres d'ombres*, 20: "Pas de décor: l'écran lumineux. Un Nègre, les mains derrière le dos, tire une corde. Il avance, disparaît,—la corde s'allonge horizontalement. Puis, un noeud dans la corde. Celle-ci se prolonge toujours, éternellement! . . . Alors,—tout à une fin, apparaît un Eléphant qui vient déposer 'une perle odoriférante,'—comme disait le Gentilhomme-Cabaretier,—d'où germe une Fleur,—puis: Rideau!"

70. The 26 June 1886 issue of the *Chat noir* announces the 195th presentation of *L'Eléphant*. This suggests that it was performed at least four hundred times a year and probably more.

71. Jacques Ferny, "Le Cabaret des Quat'z'Arts," in a special issue of *Les Chansonniers de Montmartre* (1906), unpaginated. Ferny states that Rictus's cabaret debut was on 12 December 1895, and that "l'effet fut énorme et le scandale insignifiant." An article in the 26 November 1895 issue of *L'Echo de Paris* by Laurent Tailhade implies that Rictus had performed "L'Hiver" just prior to the date of the article. See René-Louis Doyon, *Jehan Rictus* (Paris: La Connaissance,1943), 42. In his 1973 biography of Rictus, Théophile Briant misreads Ferny and incorrectly dates Rictus's debut as 12 December 1896: Briant, *Jehan Rictus* (Paris: Seghers, 1973).

72. Frantisek Deak, *Symbolist Theater: The Formation of an Avant-Garde* (Baltimore and London:

The Johns Hopkins University Press, 1993), 234.

73. Jeanne, *Les Théâtres d'ombres*, 50.

74. George Auriol, *Le Chat noir—Guide* (Paris: Le Chat Noir, [c. 1887]).

75. Jules Lemaître as quoted by Jeanne, *Les Théâtres d'ombres*, 66.

76. Cate and Boyer, *The Circle of Toulouse-Lautrec*, 19.

77. Often a supporter of young literary talent—for instance, in the first issue of *L'Hydropathe* an article by him reprinted from *XIXe Siècle* praises the activities of Goudeau's new group— Sarcey was for the last thirty-five years of the nineteenth century the most influential Parisian theater critic. As a primary symbol of the literary establishment, he was adopted by the Chat Noir group as their "uncle" and as such was the standard bearer of their sometimes cruel satire, which Sarcey accepted good-naturedly. Allais, for instance, began in 1886 signing Sarcey's name to facetious articles in *Le Chat noir*; see Caredec's chapter "Notre Oncle," 260–70, in *Alphonse Allais* for a detailed description and analysis of the pranks played on Sarcey. In true *fumiste* fashion, Gérardot's six illustrations for *L'Album de l'oncle* were copied with slight compositional changes and reproduced in color in the 12 January 1895 issue of *Le Rire*; however, this time they were signed "J. Déparquit," not "Gérardot," creating in true *fumiste* fashion ambiguity of authorship.

78. Patricia Eckert Boyer, *The Nabis and the Parisian Avant-Garde*, exh. cat. (New Brunswick: Rutgers University Press, for the Jane Voorhees Zimmerli Art Museum, 1988), 53–75.

79. Deak, *Symbolist Theater*, 142.

80. Fransique Sarcey, *Le Temps*, 22 May 1893, as quoted in Deak, *Symbolist Theater*, 167.

81. See John Richardson, *A Life of Picasso*, vol. 1, *1881–1906* (New York: Random House, 1991), 159–75.

82. Charpin, *Les Arts incohérents (1882–1893)*, 34–38.

83. Goudeau, *Dix Ans de Bohème*, 53.

84. See *The Graphic Arts and French Society, 1871–1914*, ed. Phillip Dennis Cate (New Brunswick, N.J.: Rutgers University Press and Jane Voorhees Zimmerli Art Museum, 1988).

85. Jacques Ferny, "Le Cabaret des Quat'Z-Arts," *Les Chansonniers de Montmartre*.

86. Jehan Rictus, *Les Soliloques du pauvre* (Paris, 1895). This twenty-page brochure with lithographic cover by Steinlen (Crauzat, no. 579) contains only the notorious poem "L'Hiver." It was on sale at the Quat'z'Arts cabaret until Rictus moved to the Chat Noir. The Zimmerli possesses the first and second editions of the brochure; on the latter, which is annotated and dated "Mai 1896," Rictus crossed out with pen and ink the name and address of the Quat'z'Arts cabaret and replaced it with "Chat Noir," thus indicating that at least by May 1896 he was no longer associated with Trombert's cabaret.

87. Rictus, *Les Soliloques du pauvre* (Paris: P. Sevin et E. Rey, 1903).

88. Alfred Robida, *Le Vingtième Siècle* (Paris: Georges Decaux, 1883).

89. Anonymous, in *Le Courrier français*, 7 December 1884.

90. De Sta, *La Chanson du colonel*, and Jarry, *Les Minutes de sable mémorial* (Paris: C. Renaudie, 1894).

91. See Phillip Dennis Cate, *Forums of the Absurd: Three Avant-Garde Lithographic Publications at the Turn of the Last Century*, The Tamarind Papers 16 (January 1996).

92. *L'Echo de Paris*, 1 April 1898, as quoted by Francis Bouvet, *Bonnard: The Complete Graphic Work* (New York: Rizzoli, 1981), cat. nos. 46–51, Bonnard's six music-sheet covers for the *Répertoire des pantins*.

93. For the text, which was originally published in 1918, see Guillaume Apollinaire, *Le Flâneur des deux rives* (Paris: Gallimard, 1993).

94. Antoine Terrasse, *Bonnard illustrateur* (Paris: Adam Biro, 1988), 60.

95. Alfred Jarry, "Minutes d'art," *Essai d'art libre* (February–April 1894): 40.

96. Gaston Sécot and Yon Lug, *Pour éviter la peste* (Paris: Quat'z'Arts Cabaret, 1897), 11.

97. Goudeau, *Dix Ans de Bohème*, 9–11.

Fig. 164.
Henri-Patrice Dillon, "Kakémono" (portrait of Emile Goudeau, left, and Jules Lévy, right), 1889, from the album *L'Estampe originale*, lithograph, 24.8 x 26.3. Mindy and Ramon Tublitz Purchase Fund.

Hydropathes and Company

The history of nineteenth-century French literature is packed with the Parnassian, Naturalist, Decadent, and Symbolist movements, which represent the principal currents of the second half of the century. There is little room left for the Hydropathes, who after a brief moment of fame were so thoroughly forgotten that first official historians and then enthusiasts of the movement have had to make an effort to bring their history to light.

In December 1919, in the Main Amphitheater of the Sorbonne, Georges Bourdon, historian and then Minister of Public Education, paid homage to the Hydropathes as representing "a moment of the French spirit." This homage must be understood in the context of postwar France, when Germany was viewed as the apotheosis of obscurantism. In October 1928 Jules Lévy brought the surviving Hydropathes together in the same prestigious location to celebrate the fiftieth anniversary of the founding of their group. Both commemorations were given top billing in *Le Figaro* (19 December 1919 and 17 October 1928), which rejoiced at the sight of bohemians settling down and becoming respectable writers. Paul Bourget was elected to the Académie Française in 1894; Maurice Donnay, a member of the Chat Noir group, followed in 1907. Already in 1890 the Académie Française had awarded a poetry prize to Edmond Haraucourt for his *Vikings*. Haraucourt had previously published *La Légende des sexes, poèmes hystériques par le sire de Chambley* (Brussels, 1883).

At the close of the last century the Hydropathes were immortalized in half a column, that is, one-eighth of a four-column page of the second supplement to the Larousse *Grand Dictionnaire universel du XIXe siècle* (1890). This consecration was not to be confirmed by subsequent authorities. Later reference works mention them only briefly as a literary curiosity: in Grente's *Dictionnaire des lettres françaises*, a few lines in the volume on the nineteenth century; a few words in Pouilliart's *Romantisme III*, in the Collection Littérature Française; in Demougin's *Dictionnaire . . . des littératures française et étrangères*; and in the Virmauxs' dictionary; but no mention at all in Beaumarchais's dictionary dedicated to French literature or in Didier's three-volume dictionary devoted to world literature.[1]

Fig. 165.
Georges Lorin (Cabriol), "Emile Goudeau, président des Hydropathes," hand-colored photo-relief cover illustration for *L'Hydropathe,* 22 January 1879. Schimmel Fund.

Only the *Cahiers du Collège de pataphysique* and the magazine *A rebours*, which are oriented toward eccentric and marginal groups, have attempted to rescue the Hydropathes from oblivion by turning to an audience of initiates,[2] the handful of readers who subscribe to these publications. To take an interest in this group of bohemian artists and writers is to risk becoming a collector of anecdotes, an exhumer of minor poets fallen into an oblivion where they might as well harmlessly remain. In their case we must confront fundamental questions: What was their importance in the art and literature of the last century, and what is their importance to us today?

When, at the end of his life, Théophile Gautier wrote his *Souvenirs romantiques*,[3] he made use of a device that was to serve as a model for many memoirs of the same type: a nostalgic mood illuminated by the citation of several key events and memorable figures. More than forty years had elapsed since the Romantic revolution, and Gautier's death–in 1872–was to prevent the completion of his project: "O bygone days, o vanished splendors."

His two chapters on the Petit Cénacle group of 1830 were to be recycled by future generations in the form of stories that were a blend of biography and fiction, of real events and legends made "true" by repetition. These were stories of writers and painters ("young artists"), brought together by chance and artistic calling, who spent their evenings together in somebody's furnished room or in an inn under the sign of the "Flat Broke." Among the members of the group, leaders and even masters are discerned, as well as works that eventually served as Bibles. They gradually formed a new "school," whose adherents distinguished themselves by their pallor, long hair, and eccentricities. Needless to say, they enjoyed discomfiting and mystifying the bourgeois class.

In Gautier's Petit Cénacle story, Jean Vabre ("a miracle workman") is writing a work of "transcendental cabinetmaking," entitled *Essai sur l'incommodité des commodes* (Essay on the inconvenience of the chest of drawers), which is destined to join the list of never-published "works in preparation," a list that includes Ernest Reyer's *De l'influence des queues de poisson sur les ondulations de la mer* (The influence of fish tails on ocean waves).[4] A half century later Alphonse Allais and a handful of other Hydropathes endlessly dispensed the same jokes.

The schools of the future were to signal their arrival with manifestos and disruptive scandals. The behavior of the Hydropathes, who arrived on the scene in 1878, was on the one hand similar to that of the Jeune France movement, the Bousingots, and Murger-style bohemians, while on the other hand differing in ways that had to do with the historical moment. After the defeat of France by Prussia, the collapse of the Second Empire, the Paris Commune bloodshed, and the austerity of President Mac Mahon's moral order, the Hydropathes were the first to organize open meetings that were at once republican, anticlerical, apolitical, and literary. That same year, 1878, the Latin Quarter students celebrated the one-hundredth anniversary of the death of Voltaire by rebaptizing their favorite promenade boulevard Michel, so that they would not have to say the word *Saint*. The meetings of the "young artists" of the time (most of them were between twenty and thirty years of age) are neverthe-

less still reminiscent of the Hôtel du Dragon-Bleu literary evenings imagined by Alphonse Daudet and Paul Arène in their 1866 preface to *Le Parnassiculet contemporain*, of the gathering related by Jean-des-Figues, and of the Panier Fleuri meetings described by Gabriel Vicaire and Henri Beauclair in Adoré Floupette's 1885 collection of poems entitled *Les Déliquescences*.[5]

It is to "Diego Malevue" (Emile Goudeau) that we owe a founding "chronicle" of the group, published late in 1878 in the *Revue moderne et naturaliste*. Denouncing the over-subtle phrases and convoluted sentences of Flaubert, Zola, and the Goncourt brothers, he called for "simplicity" and regretted that writers no longer took their inspiration from the unconstrained style of the best classical writers, such as Molière and La Fontaine. "What we need is a simple, lively style: the little lever that lifts the world," he wrote. The chronicle was followed by a "Song of the Pleasure-Seekers," signed by Goudeau himself, which appealed to male vigor: "Shame upon the conquered and the powerless!" Hydropathic principles spread in a decidedly down-to-earth style. Their views were short-sighted and called for a renewal that distrusted preciosity of expression. They praised good humor and good old song: Nothing there to threaten anyone!

Two anthologies, one published in 1928 by the Hydropathe Jules Lévy, the second in 1945 by Raymond de Casteras, the first historian of the group, subsequently attempted to delimit the group's territory.[6] Both works offer a disappointing picture in the sense that they bring together the productions of veteran Hydropathes, whose jokes quickly grew stale, who rendered in verse sentimental pieces that limp. (A few examples: "La lune avec lenteur s'élève, solitaire" [The moon slowly rises, solitary], Edmond Haraucourt; "La vierge est poitrinaire et va mourir bientôt" [The virgin is consumptive and is going to die soon], A. Mathivet; "Quand la fraise des bois rougit le sentier vert" [When the wild strawberries redden the green path(s)], H. Buffenoir; "Ça vous a des chagrins d'amour . . ." [They've got you, the pangs of love . . .], P. Bilhaud.) Because they lack the euphoria associated with their specific historical and group context, many of these works seem totally foolish. In any case they help us to differentiate clearly between what the Hydropathes represented during their own time in Paris and the interest that they hold for us retrospectively.

—October 1878: Emile Goudeau [Figs. 164, 165] and several friends, including Maurice Rollinat [Fig. 166] and Georges Lorin, decided to found a literary club to be known as the Hydropathes. The first meeting, held at the Café de la Rive Gauche, at the corner of rue Cujas and boulevard St.-Michel, on 11 October 1878, was successful and attracted seventy-five people according to one story, fifty according to another.

—October–December 1878: Numerous newspaper articles in France and Belgium reported favorably on club evenings. According to its articles of association, the club was composed of "dramatic artists, writers, musicians, singers, and a very large number of students." Would-be members needed only to file an application with the president and to prove that they possessed a talent, for example that of poet, musician, writer, or speaker.

—January 1879: Appearance of the first issue of the magazine *L'Hydropathe* [Fig. 165] (*Les Hydropathes* for issues 5–12).

Fig. 166.
Georges Lorin (Cabriol), "Hydropathe Maurice Rollinat," hand-colored photo-relief cover illustration for *Les Hydropathes*, 5 May 1879. Schimmel Fund.

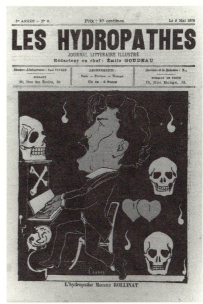

Fig. 167.
Eugène Bataille (Sapeck), "La Haute Ecole de M. Emile Zola," hand-colored photo-relief illustration for the cover of *Tout-Paris*, (formerly *Les Hydropathes*), 30 May 1880. Schimmel Fund.

Fig. 168.
Georges Lorin (Cabriol), "L'Hydropathe Charles Cros," hand-colored photo-relief illustration for *Les Hydropathes,* 20 March 1879. Schimmel Fund.

—The weekly meetings were very successful. Beginning in March 1879 they were held in the back room of a small bar on rue Jussieu, near the wine market; three months later they were moved to the Café de l'Avenir, 1, place St.-Michel, not far from the offices of the L. Vanier publishing house.

—Between January 1879 and 12 May 1880, thirty-two issues of *L'Hydropathe* were published. Each one presented a key member of the group or an artist close to the group, including Emile Goudeau, André Gill, Félicien Champsaur, Coquelin Cadet (Ernest Coquelin) [Fig. 169], Charles Cros, Sarah Bernhardt, Maurice Rollinat, Alphonse Allais, Sapeck (the nom de plume of Eugène Bataille), Emile Cohl, and others.

—*L'Hydropathe* was replaced by *Tout-Paris* [Fig. 167], with five issues published between 23 May and 26 June 1880.

—In September 1881 several Hydropathes formed the Hirsutes, which met at the Café du Commerce in the passage du Commerce. The president was Maurice Petit, later replaced in a coup d'état by Emile Goudeau. Two years later *Lutèce* published their death notice and a historical study published by one of their founders, Léo Trézenik (Léon Epinette).

—In December 1881 Rodolphe Salis founded the Chat Noir cabaret on boulevard Rochechouart. It became the meeting place for most of the former Hydropathes.

—14 January 1882: The magazine *Le Chat noir* began publication, under the editorship first of Emile Goudeau and later (starting in October 1886) of Alphonse Allais. The last issue appeared in 1895.

—1 October 1882: Jules Lévy organized the first Incohérents show at his home on rue Antoine Dubois [Fig. 1].

—August 1883: Charles Cros [Fig. 168] founded the Zutistes, which met in the bar La Maison de Bois on rue de Rennes.

—January 1884: The Jemenfoutistes began holding meetings on the rue Cujas and published a single issue (four pages) of a journal of the same name. This group soon merged with the Hirsutes.

—February 1884: After the Hirsutes group dissolved, they resurrected the Hydropathes at the Café de l'Avenir, with Emile Goudeau as president. The last meeting was held in July 1884. The Right Bank (Montmartre and the Chat Noir) won out over the Left Bank student meetings.

—15 October–15 November 1884: Second Incohérents exhibition at the Galerie Vivienne. The exhibition became more or less an annual event, and from 1885 onward included a ball. The last exhibition was held in 1893 [Fig. 112].

—1885: Buoyed by its success, the Chat Noir moved to a small building in the rue Laval (renamed rue Victor-Massé in 1887).[7]

The club made a splash as both an institution and a media event. The name commanded attention, supposedly derived from a fashionable German waltz called the *Hydropathen-valsh*. To satisfy the public's curiosity, Goudeau and his friends invented an imaginary etymology involving the *hydro-patte*, an animal with crystal legs. The explanation was doubly mystifying, since it pointed to a dubious referent

while offering no explanation of why these talented young people had adopted the word. Every member added a bit of picturesque erudition to its interpretation, claiming, for example, that "the Hydropathe doesn't drink. Its head is made of flint and its eyes are green corundum" (*La Lune rousse*, 12 January 1879).

In fact, the word *hydropathe* is so overdetermined that it deserves survival for posterity. It was motivated initially by circumstances. The members of the club were frequenters of bars and cafés; they claimed plain water made them sick, contrary to poets' traditional inspiration from the waters of the Hippocrene fountain and to Murger's *Buveurs d'eau* (1854). The Hydropathe suffered from a symptom well known to physicians: hydrophobia. Goudeau's name (homonymous with *goût d'eau*, fondness for water) and his birth in the "red" south of France predisposed him to this type of disease.

But other meanings and connotations also account for the prestige of the word. According to Littré it is a more or less medical term that is used as a joke. It was glossed as early as 1842, in *Les Aventures de Jérôme Paturot*, in which *hydropathy* is defined as "the art of curing human beings with plain water." The word is also, finally, an ironic allusion to the seemingly invincible monster whose head grows back every time it is cut off, namely the hydra of revolution, the hydra of anarchy, or, in a less parodical way, the hydra of bourgeois conformism. The plasticity and enigmatic nature of this aggregate of meanings encourage endless glosses, and it is this that ensured the promotion of the group.

In any case, the name was a lucky find that encouraged punsters, word-game players, and word enthusiasts of all kinds who dreamed of shouting or singing in unison:

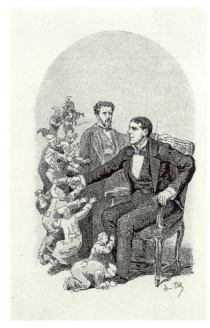

Fig. 169.
Henri Pille, self-portrait with Coquelin Cadet, photo-relief title-page illustration for Coquelin Cadet, *Le Livre des convalescents* (Paris: Tresse, 1885). Schimmel Fund.

> Enfin, voici les amis, tour à tour,
> Hydropathes,
> Sans épates,
> Sur leurs pattes,
> De retour.
> (So here are the friends, one by one, / Hydropathes, / Without swaggers, / On their paws, / Back again; Georges Lorin, *L'Hydropathe*, 10 November 1879)

> Hydropathes, chantons en choeurs,
> La noble chanson des liqueurs.
> (Hydropathes, let's sing in choir / The noble song of liqueurs; Charles Cros, *Le Chat noir*, 30 June 1883)

> J'ai pris pour ma chansonnette
> Des rimes, par-ci par-là,
> Et j'y chante la sonnette,
> La sonnette que voilà . . .
> Hydropathe
> pathe
> pathe

> Hydropathe comme nous
> elle épate
> pate
> pate
> Avec ses tintements fous.
> (For my little song I've taken / Rhymes from here and there, / And I sing
> a jingle, / This jingle that I sing . . . / Hydropathe / path / path / Hydropathe
> like us, / it swaggers / waggers / waggers / With its crazy tinklings; Mac-
> Nab, *Poèmes mobiles,* 1886)

The Hydropathes prefigured the freedoms that the Third Republic was preparing to institute. In the 1877 elections the Left was victorious, the Right defeated. The parliamentary system was finally placed on a sound footing. Mac Mahon was forced to resign in January 1879. The parliament stopped meeting at Versailles, and Paris once again became the political capital. Intensive legislative activity beginning in 1880 confirmed the democratic nature of the government. Amnesty was declared for the Communards. Freedom of assembly and freedom of the press were established, election of mayors was introduced. Schooling was made obligatory, free of charge, and nonsectarian.

The Hydropathes took their inspiration from the *cafés chantants,* which offered entertainment, and also from the variety shows, like the Folies-Bergère, which put on a series of glitzy numbers for a mixed audience. The Hydropathes organized the space and the program of the cabaret in a way that was both more convivial and more "literary," as it is still conceived today. Standing on a platform with a "slate of officers" and sometimes an instrumental performer, a chairman–master of ceremonies presented to a group of friends dining at tables in the room a series of performances declaimed, sung, or otherwise presented by amateurs or professionals. Right from the start the club developed a kind of literary, dramatic, and musical evening that was subsequently copied, particularly by the Hirsutes, and then perfected and commercialized by the Chat Noir.

Newspaper articles of the time give a precise idea of the shows that were put on. Georges Rodenbach wrote in *La Paix* for 7 December 1878:

> What I heard throughout the evening was love songs, works for piano and
> oboe and violin, remarkably well performed, alternating with recitations
> of poems and short literary pieces, almost all of them unpublished works
> performed by the authors themselves. This offers young artists an easy
> outlet and an audience that while small is nevertheless a very good critic.
> Performers were also there, including Coquelin Cadet, of the Comédie
> Française, who declaimed witty farces, such as "The Fly," and Mr. Villain,
> also of the Comédie Française, whose recital of "The Bee" was charming.

Six years later, *Lutèce* for 8–15 March 1884 listed the following Hirsutes program: Jules Lévy, in black costume, performs Grenet-Dancourt's "Les joies matrimoniales";

Laurent Tailhade, Jean Rameau, Georges Lorin, L. Trézenik, and Icres
recite their own poems;
Georges Moynet performs a monologue entitled "Le phoque";
Signac performs André Gill's "C'est la belle âge";
Emile Goudeau performs "Ce que dit le voluptueux";
Cabriol (Georges Lorin) [Fig. 170] sings his composition "Pompette," set
to a well-known melody.

Poets, monologuists, actors, singers, and musicians combined their talents, knowledge, and artistic pretensions indiscriminately at these evenings, organizing relatively inexpensive experimental performances that allowed them to perform before a knowledgeable audience that enjoyed "the flavor of the author's own live production of the expression of his thought" (Emile Goudeau).[8] The performer was put to a test that brought him into direct contact with the people for whom he was creating his work.

From a strictly chronological point of view, the Hydropathe movement was short-lived. Initially, there were two years of public meetings, beginning with the 1878 fall term and ending around the May exams. In its second phase, which lasted until July 1884, the group survived for four years, under various names (including the name Hirsutes). In its short life, however, the group sowed seeds, and its members found all sorts of homes in various locations.

They were talked about in the newspapers, in journals, and among publishing houses and were part of *la vie parisienne*. But the establishment relegated them to the background. The universities and the Académie did not pay attention to them until after they had ceased to exist, in memoriam. Writers seeking recognition mentioned them with disdain. In chapter 14 of *A rebours* Joris-Karl Huysmans referred to the writings of Charles Cros as of "a rillette grated over the workbench of just about anybody." Most simply ignored them, for example Jules Huret in his important 1891 survey of new developments in literature, published in *L'Echo de Paris*.

In the polemics of the time between the Naturalists and the Symbolists, cabaret artists had no voice and were not admitted to serious debates. Non-Parisians for the most part, they remained marginal either by choice or by exclusion, founded their own institutions, and established their own methods of recognition. During the last two decades of the century they operated under unregistered names, creating a new spirit that was both playful and profanatory, and which they propagated through numerous networks that were not noted by the historians attached to the official "schools." The configuration of end-of-the-century *fumisme* must take into account the seeds that impregnated two generations; from the jokes of André Gill's *Parodie* in the last years of the Second Empire to the Chat Noir evenings at which an avant-garde ("eighty rhymers on the Chat Noir galley"[9] [Fig. 170]) cashed in on its escapades before a well-intentioned and delighted audience.

These artists were both propagators and provokers. A few examples will show how they maintained a network of relationships.

Fig. 170.
Georges Lorin (Cabriol), "De reveurs, qui riment des vers" (Of dreamers, who rhyme verse), photo-relief illustration for Georges Lorin, *Paris rose* (Paris: Paul Ollendorff, 1884), 26. Schimmel Fund.

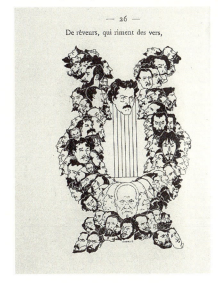

—Charles Cros founded the Zutistes, in 1883, in memory of the group that he had frequented twelve years earlier, late in 1871. Together with André Gill, Germain Nouveau, Jean Richepin, Rimbaud, Verlaine, and others, he had contributed to a parodic, obscene *Album zutique* that was not intended for publication. After participating for so long in Nina de Villard's "slightly diabolical" evenings, he performed his poem "Le Hareng saur" (The red herring) in public, with immense success. (Alphonse Allais later performed an English version of it.) This helped to cement the fashion for the modern monologue, at which Coquelin Cadet, organizer of evening performances by students and other groups, would be so successful.

—Emile Goudeau chaired both Hydropathe and Hirsute meetings. Organizer, spokesman, poet, and journalist, he collaborated with Cros on "Upside-down Stories," directed *Le Chat noir*, was the theoretician of the Incohérents (*La Revue illustrée*, 15 March 1887), and immortalized his adventures in his memoirs, *Dix Ans de Bohème*, published in 1888.

—Jules Lévy also organized evening performances at which he performed his own works and monologues by other writers. He organized the Incohérents' exhibitions and public meetings, wrote for the boulevard theater, and created a publishing house that published numerous remarkably illustrated works, including those of Félicien Champsaur and Emile Goudeau.

—Alphonse Allais acted up at Hydropathe meetings, directed *Le Chat noir*, and exhibited monochrome works, including *First Communion of Chlorotic Young Girls in Snowy Weather* (1883) at the Salon des Incohérents. Many of his friends, including Charles Cros, Sapeck, and Jules Lévy, hung out at Rodolphe Salis's cabaret and collaborated on his journal. Allais was at the heart of activities that involved various sectors of the theater, journalism, and book publishing.

In short, the Hydropathes and other *fumistes* constantly collaborated, formed partnerships, wrote prefaces for one another's books, dropped one another's names, and engaged in friendly competition. The poems in the anthologies that they published, often in very small print runs, bore dedications that provide a topography of literary and artistic life. Trézenik's 1882 *Gouailleuses* (The banterers) contained works by, among others, Goudeau, Sapeck, and Jules Jouy; Rollinat's *Névroses* of 1883 included works by Léon Bloy, Georges Lorin, André Gill, and others; and Mac-Nab's *Poèmes mobiles* (1886) [Fig. 171] had contributions by Haraucourt, Lévy, and Coquelin Cadet, among others.

Publication games went hand in hand with public meetings, poetry readings, literary and satirical newspapers, cabaret, and caricature–all kinds of "eccentric enterprises" whose fruitfulness André Breton was one of the first to realize. Without being fully aware of it, these minor artists and poets were establishing an avant-garde that did not care a whit for competing "schools."

The Hydropathes liked to transform themselves into fictional characters. The cover of their journal was decorated with sketches of people caricatured by Cabriol, who also wrote doggerel about them, including this piece about Coquelin Cadet.

Coquelinin, coquelinant
Bon Coquelin de joyeux rire
.
Bon petit cadet caquetant
Les contes que Cros sait écrire,
Et que Coquelin seul sait dire . . .

(Coquelinin, cockelining, / Good Coquelin with the happy laugh / . . . /
Good little Junior cackling / The stories that Cros knows how to write, /
And which only Coquelin knows how to recite . . . ; *L'Hydropathe*, 5
March 1879)

He ensured for twenty-six-year-old Alphonse Allais a place in Latin Quarter mythology with
this piece.

Potard potassant beaucoup
Des *combles* d'exorbitance,
Il comble son existence
D'*à peu près* faits coup sur coup.
. .
Philosophe à l'air bonasse
Ce jocrisse blond filasse
.
Met souvent sans prendre garde
Les pieds, quoiqu'on le regarde,
Dans le plat de l'infini.

(Pharmacy student cramming / The *limits* of exorbitance, / He heaps his
life / With made-to-order *more-or-lesses.* / . . . / Philosopher with simple-
minded look / This blond tow-head simpleton / . . . / Often without
watching puts his feet / Even though people are watching / Into the
mouth of infinity; *L'Hydropathe*, January 1880)

Allais published his first trap-tale in *L'Hydropathe* for 15 May 1880. Its heroes are
two club members who are participating in a contest, the victim of which is–the
reader. An identical episode occurs several years later in "A Typical Parisian Drama"
(*Le Chat noir*, 26 April 1890), at an Incohérents' ball. Allais also enjoyed featuring his
friend Sapeck in several of his stories (e.g., "Les Zèbres," in *A se tordre*), because the
shortest road to celebrity is the straight road one builds for oneself.

Félicien Champsaur depicted a Hydropathe evening in chapter 4 ("Un Grand
Mouvement littéraire") of his 1881 novel, *Dinah Samuel*. This novel also contains
several thinly disguised portraits of individual Hydropathes, including Charles Cros
("Carolus Zeph"), Alphonse Allais ("Alphonse Basil"), and Eugène Bataille ("Pasteck").
"Pasteck" revealed the stratagem of the *fumiste* who hides behind a mask of stupidity:
"I'm a dandy who hides in a donkey skin so that nobody will notice me."[10]

However, Bataille, "the Famous Sapeck," [Fig. 172] was already known on the
Left Bank more for outbursts than for discretion. Dressed in evening clothes, he
climbed into a cart and had himself pulled through the streets of the Latin Quarter;
tried to organize a women's race at Longchamps; painted his head blue to escape

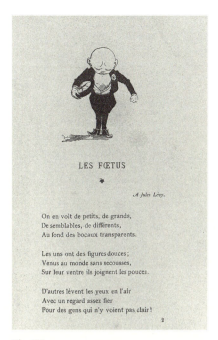

Fig. 171.
Maurice Mac-Nab, "Les Foetus," photo-
relief illustration for Maurice Mac-Nab,
Poèmes mobiles (Paris: Léon Vanier, 1889), 17.
Bartman Fund.

Fig. 172.
Georges Lorin (Cabriol), "L'Hydropathe Sapeck," hand-colored photo-relief cover illustration for *L'Hydropathe*, 15 March 1880. Schimmel Fund.

Fig. 173.
Eugène Bataille (Sapeck), "Envoyez!" (Ready!), photo-relief cover illustration for *L'Anti-concierge*, no. 4 (February–March 1882). Schimmel Fund.

from gloomy thoughts. He went out of his way to see just how far he could carry his *hénaurmités* (enormous pranks). Author, performer, caricaturist, founder of *L'Anti-concierge* [Fig. 173], organizer of parties outside Paris, a man whose concept of creative activity was very different from that of his friends, Bataille was a source of scandal. Perhaps this is why Allais, who devoted several articles to him between 1880 and 1891 in *L'Hydropathe, Le Tintamarre, Le Chat noir,* and *Gil Blas,* noted that "for him as for Homer" several cities claimed the honor of being his birthplace. Bataille created his own epic legend as a "work" completely his own, and continually fed it with his great feats. He was a precursor of twentieth-century performers whose person is their work of art.

More than solid bodies of work, the Hydropathes produced countless entertainments, stories, skits, impromptu poems, and bits and pieces that were sometimes combined into ensembles. Among them were Cros's twenty-odd monologues, a few hundred stories by Allais, and anthologies or productions bearing the mark of the group, including Jules Laforgue's *Complaintes* and the imaginary museum of Incohérent arts that are captured very clearly in exhibition catalogues.

Essentially, the Hydropathes were the initiators of a new spirit that Sapeck incarnated to perfection. Their *fumisme* was the determinant of a philosophy, an ethics, and an aesthetics, which were characterized as "fundamental skepticism" and surface *prud'homie* (smugness) by Georges Fragerolle, the first Hydropathe to try to provide a foundation for this concept (*L'Hydropathe,* 12 May 1880).

Champsaur adopted as his own the group's generally accepted division between a "wit" and a "*fumiste.*" Whereas the former made fun of idiots in terms that they were not always able to understand, "the *fumiste* accepts the ideas of the idiot" and expresses their quintessence.[11] A few years later, Goudeau paid homage to Sapeck, who had conceived of *fumisme* as "a kind of disdain for everything . . . an internal madness evidenced externally by countless buffooneries."[12] *Fumisme* experiments with a zero-degree humor that is at the opposite pole from "French gaiety."

The *fumiste* avoids discussions of ideas, he does not set up a specific target, he adopts a posture of withdrawal that makes all distinctions hazy, and he internalizes Universal Stupidity by postulating the illusory nature of values and of the Beautiful, whence his denial of the established order and of official hierarchies. From his point of view, which is that of the sage, the dandy, the observer, and the skeptic, everything has the same value, everything is one and the same thing.

In this way he undermines artistic creations, by submitting them to harsh interrogation. Long before Marcel Duchamp profaned the *Mona Lisa,* Sapeck had given her a pipe with wreaths of smoke that mocked the halos of Art and Genius [Fig. 174].[13] The ideology of laughter–laughter at any price, including the sneer and renunciation of the ideal–fertilized the group's most remarkable productions. *Fumisme* expressed, in the form of the prank, the mourning that a generation of "young men" would hand down to the various currents of "modernity."

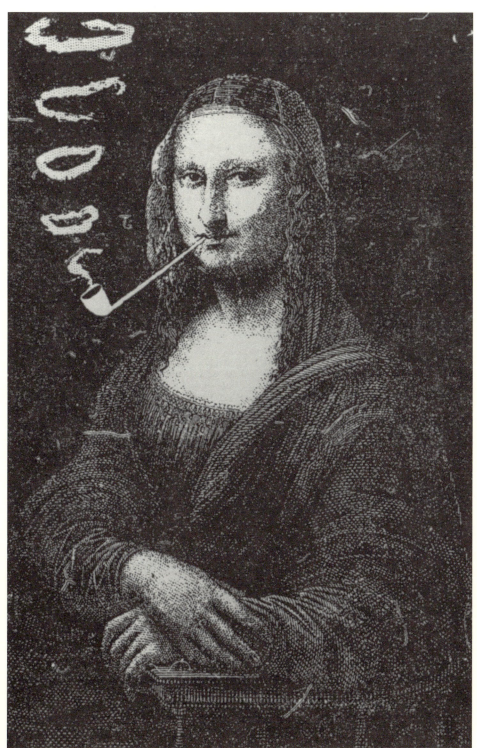

Fig. 174.
Eugène Bataille (Sapeck),
"Mona Lisa with a Pipe," photo-relief
illustration for Coquelin Cadet, *Le Rire,*
(Paris: Paul Ollendorff, 1887), 5.
Schimmel Fund.

The Hydropathes experienced what it takes to achieve a literary and artistic identity. They formed groups and organized performances, publications, and exhibitions that constituted as many parallel institutions. Following the example of the so-called independent painters, they handled their own promotion, establishing networks of friends and wearing in some cases the various hats of poet, performing artist, journalist, editor, publisher. They realized that having talent is not enough to ensure a reputation, that the artist has to do something striking to attract the attention of the press.

The writing of texts designed to be performed aloud on a stage produced remarkable results. On the one hand, they aimed for effectiveness. A fondness for brilliance, paradox, and surprise led the group to work out genuine "routines." Like the music-hall and circus performers who fascinated many of them, the Hydropathes created their monologues, poems, stories, and narratives as bravura pieces. On the other hand, they fleshed out the "person" of the performer. A spoken text is spoken by a person whose speech is characterized by a set of constant inflections. The intonations of Jules Laforgue, the emphases of Léon Bloy, and the knowing winks of Alphonse Allais provide examples of this rhetoric of orality, this literature for live interpretation. In this sense Louis-Ferdinand Céline and Raymond Queneau were the heirs of the turn-of-the-century cabaret, because they were aware of a poetics in which the text proceeds from a text writer who foregrounds himself.

In his preface to his *Poèmes ironiques* (1882), Goudeau explains to a young provincial that in Paris laughter reigns everywhere and covers various situations, including the most tragic ones, with one and the same mask. Goudeau continually laid claim to this "insane laughter" as a trademark. Several years later he published a portrait of an Incohérent who has a "headquake" (1887), then that of "the happy man" who laughs wildly "at nothing."[14] Hydropathic humor was compromised in a Belle Epoque good humor that did not disdain dirty stories and puns and wordplays in the style of the humorous *Almanach Vermot*. In their own way, Georges Courteline, Tristan Bernard, and the boulevard theater perpetuated the "gaieties" of the Chat Noir.

Yet the Hydropathes and other *fumistes* were able to take the risk of nonconforming formulations that revived comedy by making it an art form. In a climate of excess they experimented with formulas that they hurled in the face of the public, including wordplays governed by the prosody of an earlier time and floods of language that broke the dam of syntax. In his "Evocation des endormis" (Evocation of sleepers) Charles Cros recorded the literary lucubrations of a group of spiritists. Laforgue's Salomé recited a Corsican funeral chant on the Alcazar stage. Using the pretexts of *maboulisme* (madness) and *macabrisme* (the macabre), they filled the stage with fetuses, undertakers' dummies, Miss Skeleton, "dead-pan" aquarium crabs, and a clysopump, or "anus of God." (Edmond Haraucourt dedicated this "shameful sonnet," which he entitled "Philosophy," to Goudeau.)

Today, when we imagine the exhibitions staged by the Incohérents, we establish a direct connection with the turn-of-the-century spirit of subversion. In using parodies, visual plays on words, and practical jokes, they were unwittingly inventing the performance art of the future. Their participants, "people who didn't know how to draw," used subterfuges to metamorphose their productions into works of art. These included objects presented just as they were in a setting or with titles like *Bas relief* for a woman's stocking (*bas*) nailed to a wooden base, and *Niche à saints* for a corset (a play on the homonymous French words *saints* and *seins*, breasts) [Fig. 175]. *Lapin* (rabbit) became the title for the portrait of a man and a woman described by Félix Fénéon in these terms: "Out of the man's mouth there extends a rope that is attached to the neck of a live rabbit that is chewing on carrots in a cage installed in front of the painting. This allegorical way of using a rabbit [*poser un lapin*, "placing a rabbit," i.e., to stand someone up] was a great success" (exhibition, 15 October–15 November 1883).[15]

Defying seriousness, the Hydropathes engaged in universal mockery. At the same time they were engaging in an enterprise that, unbeknownst to them, represented the beginning of a policy of the clean sweep [Fig. 26]. (After all, Léon Bloy referred to himself as a demolition contractor.) Their anarchism went beyond the university or art-student pranks that had provided abundant material for literary and artistic parodies and *Salons comiques* throughout the century.

The Hydropathes' mockery crossed a threshold by introducing the fox into the chicken coop. With them, the Non-Serious became consubstantial with Art. They initiated a new view of works that until then had been considered sacred. Thanks to their blasphemy [Fig. 176] they broke through the enchanted circle, and intermingled the notions of "seriousness" and "fun" until they became blurred or inoperative. The work of art, in its most contemporaneous acceptance, nullified these distinctions. Henceforth laughter and smiling would no longer operate at cross-purposes with aesthetic emotion, achievement of "value," and adherence to inexpressible meanings. Yet *fumiste* mockery with its inherent intuition of Nothingness distilled in the Work of Art a doubt that was to taint every one of our beliefs and every one of our pleasures.

MISS ELLA

Nouvelle niche à saints.

Fig. 175.
"**Miss Ella,** nouvelle niche à saints" (New Niche for Saints/*seins* [breasts]), photo-relief illustration for the *Catalogue de l'exposition des Arts incohérents* (Paris, 1886), 125. Schimmel Fund.

Fig. 176.
Eugène Bataille (Sapeck), photo-relief illustration for Coquelin Cadet, *Le Rire* (Paris: Paul Ollendorff, 1887), 72. Schimmel Fund.

1. In alphabetical order, the dictionaries mentioned are Jean-Pierre de Beaumarchais et al., *Dictionnaire des littératures de langue française* (Paris:Bordas, 1994); Jacques Demougin, *Dictionnaire historique, thématique et technique des littératures française et étrangères, anciennes et modernes* (Paris:Larousse, 1985); Béatrice Didier, *Dictionnaire universel des littératures* (Paris: Presses Universitaires de France, 1994); Cardinal Georges Grente, *Dictionnaire des lettres françaises. Le dix-neuvième siècle* (Paris: Librairie Arthème Fayard, 1971); Pierre Larousse, *Grand Dictionnaire universel du XIXe siècle* (Paris: Administration du Grand dictionnaire universel, 1866; first supplement, 1877; second supplement, 1890); Raymond Pouilliart, *Romantisme III*, in Max Milner, *Le Romantisme* (Paris: Arthaud, 1968–73); and Alain Virmaux and Odette Virmaux, *Dictionnaire mondial des mouvements littéraires et artistiques contemporains* (Paris: Editions du Rocher,1992).

2. See *Les Cahiers du Collège de pataphysique*, nos. 17–18, 15 Ha–Ha 82 E.P. (Ere pataphysique), as well as in *A rebours*, "Le Centenaire des Hydropathes," no. 5 (1978); "Des Zutistes aux Hirsutes," nos. 22–23 (1983); and "Les Fumistes Hydropathes," nos. 34–35 (1986). In "Des Zutistes aux Hirsutes," J. P. Somoff and A. Marfée rightly emphasize the importance of the activities of groups that adopted picturesque names such as Les Vilains Bonshommes and Les Vivants, and which published group fascicules (Paul Verlaine clearly alludes to this in a letter to E. Blémont dated 22 July 1871). A famous example has come down to us: the *Album zutique*, a work of some thirty handwritten pages embellished with caricatures and obscene drawings, and signed by André Gill, Charles Cros, Paul Verlaine, Arthur Rimbaud, Germain Nouveau, Jean Richepin, and others. It contains several famous texts, including "Sonnet du trou du cul" (Asshole sonnet), "Pantoum négligé" (Neglected pantoum), and "Les Remembrances du vieillard idiot" (Memories of the elderly idiot). This album was reproduced by Slatkine in 1981. The parodies of François Coppée that embellish it gave Nina de Villard, Charles Cros, Jean Richepin, Maurice Rollinat, and Germain Nouveau the idea for a collection entitled *Dixains réalistes* (1876), published in an edition of 149 copies. It was recently reproduced in *La Doctrine de l'amour*, a volume of the works of Germain Nouveau edited by L. Forestier (Paris: Poésie Gallimard, 1981), 259–63.

3. Théophile Gautier, *Souvenirs romantiques* (1872; Paris, 1929). The Petit Cénacle memorialized by Gautier inspired a tradition of "avant-gardes" that carries on up to the twentieth century. Meeting in taverns, cafés, and cabarets, these groups were composed of writers, painters, artists, and bohemians who reviled the bourgeois class, designated by various transparent nineteenth-century epithets reminiscent of the term *Universal Man*: "Joseph Prudhomme" (Henri Monnier), "Mr. Homais" (Gustave Flaubert), and "Tribulat Bonhomet" (Auguste de Villiers de l'Isle-Adam). "It was there, in that small red house [the Petit Moulin-Rouge cabaret], worthy Joseph Prudhomme, . . . that I, the man quietly sitting next to you in the bus, drank like an unadulterated cannibal out of a skull, out of bravado, boredom, and disgust at your solemn stupidity" (Gautier, ibid., 52).

4. Ibid., 39.

5. Paul Arène, "Le Cénacle," chapter 15 of *Jean-des-Figues*, in *La Gueuse parfumée, récits provençaux* (Paris: Charpentier, 1876). Unlike Gautier, who evoked memories, Alphonse Daudet, Paul Arène, and later Gabriel Vicaire and Henri Beauclair wrote fiction. Their depictions of soirées and literary conversations are good-naturedly satirical. They mock the new poets' fondness for obscurity: "writing in a sumptuous and complicated style totally incomprehensible to the Common Man, and always inspired by enigmatic ages and regions half concealed, as if by a divine veil, by the Ideal and the Shadow: This is the true, the only criterion, our criterion, that of the Hôtel du Dragon-Bleu!" (*Le Parnassiculet contemporain*, 2d ed. [1872], 15; reprint, Plein Chant, 1993). Jean-des-Figues frequents a café whose habitués are in the grip of a generous madness that encourages them to conceive

a new Muse: "morbid . . . enjoyment," "sensations by images," and a desire to "steal from music something of . . . its harmonious uselessness" (Paul Arène, *Jean-des-Figues*, in *La Gueuse parfumée*, 94). In the Panier Fleuri café discovered by Adoré Floupette in Paris, the guests celebrate in turn macabre, mystical, and hysterical subjects (*Les Déliquescences, poèmes décadents*, 1885 [Paris: A. G. Nizet, 1984], 40). Two features distinguished the Hydropathes from these miscellaneous groups: They took little interest in questions of aesthetics, and their productions were designed to be performed in public.

6. Jules Lévy, ed., *Les Hydropathes; prose et vers de Alphonse Allais, Paul Bilhaud, Maurice Boucher et al.* (Paris: A. Delpeuch, 1928); Raymond de Casteras, *Avant le Chat noir: Les Hydropathes, 1878–1880*, preface by Maurice Donnay, 2d ed. (Paris, 1945). If the writings of the Hydropathes are often disappointing, it is because the effects of performance constituted an essential part of their interest. During their first soirées a professional actor was often retained to recite the poems, but Goudeau soon began requiring the authors to perform their texts themselves.

7. Noël Richard, *A l'aube de symbolisme*, part one (Paris: Nizet, 1961).

8. Emile Goudeau, *Dix Ans de Bohème* (Paris: Librairie illustrée, 1888).

9. Armand Masson, "Ode à Montmartre," in Daniel Grojnowski and Bernard Sarrazin, eds., *L'Esprit fumiste et les rires fin de siècle* (Paris: José Corti, 1990), 141–44.

10. Félicien Champsaur, *Dinah Samuel* (Paris, 1882), 123. "They met for the first time last winter in a room in rue Cujas, formerly rue des Grès, the famous Latin Quarter street. Initially a group of some thirty members, they soon numbered three hundred. As this was more than the room could hold, they moved their meetings to larger quarters with a stage, near the place de Jussieu, a residential neighborhood for Neapolitans who worked as art studio models. The room is quickly described: a platform in the rear, a small number of gaslights. The meetings, on Wednesdays and Saturdays from eight o'clock to midnight, were attended by four hundred young men (for not everyone came), some of them musicians, others painters or poets, all of them art lovers to the very depths of their souls. The musicians played their compositions, resonant voices sent fragments from plays, short stories, and new poems rolling out over the audience" (p. 95).

11. Ibid., 122.

12. Goudeau, *Dix Ans de Bohème*, 95.

13. Ernest-Alexandre-Honoré Coquelin [Coquelin Cadet, pseud.], *Le Rire*, with illustrations by Sapeck (Paris: P. Ollendorff, 1887), 5.

14. See Emile Goudeau, "L'Incohérence," in *La Revue illustrée*, 15 March 1887, 226–33, and his "Homme gai," in *Le Figaro*, supplément littéraire, 18 February 1888. Goudeau closely associates the celebrating of laughter with that of madness. "In certain brains, at full-moon time or even continuously, subterranean rumblings are suddenly heard in the skull, shaking the sturdiest walls erected by logic, agitating cells and overturning nucleoli, twisting nerves, and suddenly forcing the entire immobilized brain to begin a dance. A headquake, incoherence.... Incoherence, as understood by its latest followers, is a dance rather than a quaking, the lightness of mirth rather than the darkness of madness" (*La Revue illustrée*, 15 March 1887, 228). In this same article, Goudeau distinguishes the various groups that composed the Hydropathes: a right, a center, and a left. "The right was macabre, the left cheerful, the center equally divided." The members of the right became "the decadents, the deliquescents," and enjoyed the most success with the public.

15. Félix Fénéon, *Oeuvres* (Paris: Gallimard, 1948), 97–99. See Catherine Charpin, *Les Arts incohérents (1882–1893)*, preface by François Caradec (Paris: Syros Alternatives, Collection "Zigzag," 1990), and also Luce Abélès and Cathérine Charpin, *Arts incohérents, académie du dérisoire*, Collection les Dossiers du Musée d'Orsay, 46 (Paris: Réunion des Musées nationaux, 1992).

Fig. 177.
"Stéphane Mallarmé in His Study," photo-relief illustration for *Revue franco-américaine* (July 1895): 62.
Schimmel Fund.

MARY SHAW

All or Nothing?
The Literature of Montmartre

La littérature existe et, si l'on veut, seule, à l'exception de tout.
(Literature exists and, if you will, alone, in exception to all.)
–Stéphane Mallarmé

Qu'est-ce que Montmartre?–Rien! Que doit-il être? Tout.
(What is Montmartre?–Nothing! What should it be? All.)
–Rodolphe Salis

In 1894 Stéphane Mallarmé [Fig. 177], revered master of the French Symbolists and still the iconic figurehead of French literature and literary theory today, baffled English audiences at Oxford and Cambridge with this profound yet simple question: Does something such as literature exist? His answer? A resounding Yes, set forth in the radical, exclusionary terms of the above epigraph. But where, we have to wonder along with contemporaneous audiences, was the ivory-tower poet actually coming from?[1] What, concretely speaking, was implied and comprised by the "all" that, for Mallarmé, literature existed alone (and perhaps also only) as an exception to?

Mallarmé hailed from Paris, the city aptly described by Walter Benjamin as the "capital of the nineteenth century,"[2] and his mission in Oxford and Cambridge was explicitly to report on the latest activities of its literary innovators and upstarts, in short, *the* avant-garde. Thus, it may be useful to consider the relations between his celebrated claims for the "all"-embracing condition of literature, and the "all" that his compatriot Rodolphe Salis had previously promised and virtually delivered out of "nothing" in Montmartre, through the simple establishment of anartists' and writers' cabaret: "The CABARET DU CHAT NOIR . . . the only creation of its kind in the world; located right in the heart of Montmartre, the modern capital of *l'esprit*" (the mind/wit).[3]

However critical the differences, a comparison of Mallarmé's and Salis's concepts of totality is likely to be of interest. For during the reign of French Symbolism, the arcane, elitist poetic school over which Mallarmé presided, Montmartre, in large part owing to Salis, became the self-proclaimed capital of *haut gout* (good taste) and

thus the chosen place for *tout Paris*. The principal vehicle through which this status was achieved was, of course, *Le Chat noir* journal, which explicitly billed itself, in its first issue, as the "organe des intérêts de Montmartre," and which deemed Montmartre from the outset as "le berceau de l'humanité" and "le centre du monde," even as it insisted on its absolute independence from Paris and the rest of the world: "Montmartre is isolated, because it is self-sufficient. This center is absolutely autonomous. In a small city far from Montmartre and known to travelers as Paris, a local academy is said to be discussing the conditions for municipal autonomy. In Montmartre this question was resolved a long time ago" (Jacques Lehardy, "Montmartre," *Le Chat noir*, 14 January 1882).

What happens to "literature," historically and theoretically, as it passes through the collaborative, mixed, and live cultural scene of fin-de-siècle Montmartre? And what, in particular, does the canonical history of French literature, its selection of writers and works, tell us about what was happening there? Let us begin exploring these questions by briefly recontextualizing our epigraphs. If I have chosen to enter into the world of Montmartre literature through a juxtaposition of statements by Mallarmé and Salis, it is not only because both were, in different ways and to different degrees, connected with texts generated in Montmartre and equally concerned with "all," but also because these two writers occupy opposite positions in terms of their relative importance to the canon of French literature: Mallarmé's reputation having been consolidated over time to supreme status, and Salis having lost whatever recognition he had, which, given the central, yet inherently mixed role that he played in Montmartre as painter-turned-writer and cabaret founder, was, from the beginning, hardly the status of an ordinary writer at all.

To return then to our epigraphs and their respective contexts. Rodolphe Salis's campaign slogan as a candidate from Montmartre in the municipal elections of 1884 was a political-artistic statement, at the same time serious and humorous in tone [Fig. 23]. Salis's effective presentation of Montmartre as the seat of *all* artistic and political concerns stems in part from his slogan's parodical synthesis of a number of previously celebrated remarks. It diminishes and distorts, for example, a line from the Communist workers' anthem, "The International": "Nous ne sommes rien. Soyons tout" (We are nothing. Let us be all), a serious political cry to action. It echoes as well an earlier *fumiste* republican slogan attributed to Paul Vivien, the first editor in chief of the literary journal *L'Hydropathe* in 1879: "The Republic will be Hydropathe or it will not be."[4] The line also recalls the Hydropathe cabaret-songwriter Georges Fragerolle's general definition of *fumisme* published in an 1880 manifesto: ". . . *Fumisme*, borne on its two wings of basic skepticism and superficial wisdom, can finally rise to those philosophical clouds on which synthesis floats. We do not have sufficient space to formulate *fumisme* in any words other than these: *"Fumisme' was nothing, it is everything"*[5] (emphasis Fragerolle's).

However, given Montmartre's burgeoning identity as an artists', writers', and musicians' colony, Salis's slogan also functions independently from such allusions,

112

its political punch resulting more simply from the radical fusion that it not only suggests but helps politically to perform between all the arts and between art and life.

Though he is hardly remembered for it, Salis was a prolific writer. He was the author of a number of humorous tales published originally in *Le Chat noir* and later collected in two volumes entitled *Contes du Chat noir* [Fig. 178], illustrated by George Auriol, Henri Rivière, Adolphe Willette, and others (*L'Hiver* [1888] and *Le Printemps* [1891]). This series of tales is at once archaic and modern, involving early Renaissance characters (primarily corrupt saints and clerics) in intrigues of contemporary interest. Salis's narrative style recalls, particularly on the superficial level of spelling and diction, the work of the sixteenth-century novelist Rabelais. There is nothing remarkable in this. Rabelais's ribald, complex wordplay was, as has been noted and will be explored further in this volume, the predominant model for many French fin-de-siècle humorists, and the epigraph to his second novel, *Gargantua* (1534), "mieux est de ris que de larmes escrire" (It's better to write about laughter than tears), served as a motto for many *Chat noir* writers. As the interplay of modernism and archaism is a constant of the spirit of Montmartre, it is not surprising to find a thoroughly modern principle working alongside this long-standing axiom. Blazoned over the door of the second Chat Noir cabaret we find the thoroughly modern device: "Passant sois moderne" (Passerby, be modern).

The archaic-modern quality of Salis's *Contes du Chat noir* can be gleaned even from the title of the first tale, where the ubiquitous fin-de-siècle theme of infidelity is treated in a lighthearted, pseudosanctimonious way: "Où il est parlé du seul vray miracle idoine à guarir le mauldict mal de stérilité et du bon sainct Greluchon qui l'inventa" (Whiche treats of the only true myracle apte for curing the accursed ill of sterilitie, and of the goode Saint Greluchon [lounge lizard] who invented it). The humor of this tale and others also heavily depends on a second paradoxical coupling central to the spirit of Montmartre: the fusion, and often the confusion, of the sacred and the profane.

Indeed, in appraising the importance of Montmartre's marginal avant-garde communities, their general effect on the cultural life of Paris, and thus on broad developments in twentieth-century literature and other arts, it is crucial to remember the degree to which the Montmartre avant-garde consciously exploited the fact of its foundation on Paris's holy mountain. In Salis's "Prologue-Tale," where Salis plays the Devil encountering a listless and disheartened St. Nicolas ("disgusted by the modern world"), there is a general association of the *moeurs* of Montmartre and the traditions of the church. This association cannot but recall the long-privileged religious history of "la butte sacrée," described with relish by Montmartre historians ranging in perspective from the cleric Père Jonquet to the Chat Noir circle writer Georges Montorgueil, as the "mont du martyr" (St. Denis), the "sacred lightning-rod preserving Paris from the blows of divine justice," the destination for centuries of pious French pilgrims, and thus the inevitable site for the construction (completed in the late nineteenth century) of French nationalist Catholics' Sacré Coeur.[6]

Fig. 178.
George Auriol, stencil-colored photo-relief cover for Rodolphe Salis, *Contes du Chat noir–L'Hiver* (Paris: Librairie illustrée, 1889). Gift of Sara and Armond Fields.

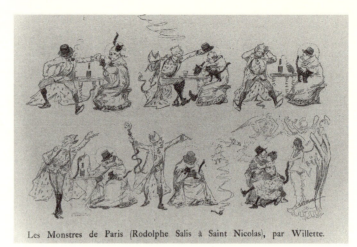

Fig. 179.
Adolphe Willette,
"Monstres de Paris
(Rodolphe Salis à St.
Nicolas)," photo-relief
illustration for *Le Chat
noir*, 1 November 1884,
detail. Schimmel Fund.

Les Monstres de Paris (Rodolphe Salis à Saint Nicolas), par Willette.

I believe that the effective promotion of Montmartre's lofty, exceptional status with respect to the rest of Paris and the world depended at least as much on this privileged religious history as it did on the leading role played by Montmartre in the Paris Commune.[7] Exaggerating this glorious history, Jacques Lehardy, for example, in *Le Chat noir*'s first self-promotional article (partially quoted above), proclaims Montmartre to be the place where Noah anchored his ark after the flood. Needless to say, however, the avant-garde's exaltation of Montmartre's inherent holiness generally served opposite, iconoclastic ends. This community subverted the religious order precisely through the paradoxical establishment of a refuge for profane, modern art, on ancient, sacred ground. As Salis's prologue-tale testifies, and Willette's illustrations whimsically portray [Fig. 179], Montorgueil's assessment of the role of profanity in Montmartre's constant religious references is generally quite correct: "Satan has nothing to complain about: His offspring is loyal."[8]

Salis–along with Alphonse Allais, George Auriol, and Félix Fénéon–was not only a widely appreciated author of *fumiste* "contes," he was also the author of numerous monologues and *saynètes*, short theatrical skits, which were published in *Le Chat noir* and performed in the cabaret. An example of his *saynète macabre* is "Le Squelette" (17 November 1883), typical of the fin-de-siècle black humor that was later celebrated by the Surrealist poet André Breton. Founding his analysis of this type of humor on thinkers ranging from the poet Rimbaud to Hegel and Freud, Breton describes it as an explosion, a superior revolt of the mind, a means by which intelligence transcends the painful limits of the human condition.[9]

Salis wrote "Le Squelette" in collaboration with Jules Jouy, a political songwriter who was also a painter of sorts and one of the first generation of fin-de-siècle *fumistes*. Author of a collection entitled *Monologues humoristiques* and of several politically engaged writings, Jouy was particularly known for the morose turn of his humor. "Night is nothing but a black cat," he writes in "Les Pensées du Chat Noir," "When it's daylight, it's because the cat isn't there" (*Le Chat noir*, 4 March 1883). This dark

114

quality was linked by some contemporaries to his eventual confinement for madness, a fate that also attended André Gill and other *fumistes*. Be that as it may, the *saynète macabre* that he signed in conjunction with Salis is exemplary of its genre, particularly in its implementation of yet a third paradoxical coupling central to the spirit of Montmartre: the synthesis of the ordinary and the extraordinary or the bizarre. Here, against the backdrop of a dark apartment, we find an *inconnu* (a passing stranger) engaged in stubborn negotiation for the occupant's skeleton.

Along with publishing, and at times performing, numerous *saynètes* and monologues, Salis also apparently served as a brilliant improvisational animator and commentator (*bonimenteur*) for the first humorous shadow plays performed at the Chat Noir, such as Caran d'Ache's *Epopée*, a panorama of Napoléon's victorious battles, and Henry Somm's *Eléphant* (1886), a short scatological piece, which was adopted as a regular opening number for the shadow theater. In his account of the rise and fall of Montmartre shadow theaters, Paul Jeanne emphasizes the superiority of Salis's wit and acerbic social satire in the early plays.[10] Certainly, though Rodolphe Salis may now be forgotten, he was considered in his own time a talented and successful writer.

On the same page of *Le Chat noir* on which "Le Squelette" is published, Léon Bloy [Fig. 180], the radical Catholic pamphleteer and author of two novels (*Le Désespéré* [1886] and *La Femme pauvre* [1897]) attacking both Naturalism and Decadence–two dominant modes of fiction growing out of the work of Emile Zola–devotes an article of high praise to Salis, the *gentilhomme cabaretier*. For Bloy, the fiercest of critics of modern bourgeois values (in his pamphlets of the 1880s and 1890s as well as in his later *Journal* and *Exegèse des lieux communs*), *Le Chat noir* represents "exclusively" the last refuge of cultural life and authenticity in Paris, in part thanks to its "énergie d'archaïsme." Bloy does not perceive as offensive the liberties that *Le Chat noir* takes on sacred ground, but on the contrary, as salutary to true religious feeling. He thus credits Salis for meriting among his contemporaries a "unique," an "exceptional" place:

> Rodolphe Salis has undertaken to be the scandalous creator of a journal that deals *exclusively* with art and without any industrial speculation of any kind whatsoever. *Le Chat noir* journal was established at the same time as the cabaret, heroically, almost without funds, like the cabaret itself. . . .
>
> I say seriously that it is very lofty, very noble, and very worthy to become enthusiastic about the person who is doing this. *Le Chat noir* is at the present time the *only* journal in which the naked and complete truth can be told about the powerful Burgraves of letters who make everything bend and before whom, trembling, that licker of stinking feet known as the French press prostrates itself.
>
> Would not that alone suffice to lift a man, already remarkable for other reasons, out of the vulgar herd of contemporary celebrity and to earn for him a completely special place, a unique place in the attention of a handful of beings who have managed to retain their human faculties in the midst of this great crowd of the castrated and the decapitated.[11] (emphasis Bloy's)

Without getting into the details of Bloy's demolition rhetoric, a rhetoric that

Fig. 180.
Uzès, "Dom Léon Bloy," photo-relief illustration for *Le Chat noir*, 16 August 1884. Schimmel Fund.

obviously allied him with the developing avant-garde, it is easy to see that *Le Chat noir* and its founder (and of course their appraisal by Bloy) were not as disinterested as Bloy's article makes them appear. Rather, the "industry" that the journal served as "Organ of Montmartre Interests" was in commercial terms simply its own. The Montmartre community of artists and writers remained, as Salis had promised, relatively autonomous or self-sufficient. All Salis's writings in particular were in one way or another inextricably bound to the influential yet small and exceptional world that he created and controlled in *Le Chat noir* journal and cabaret. Given the complete fusion of Montmartre's cabarets, personalities, and texts, it is not surprising that this world began to disintegrate almost immediately with Salis's death, taking with it much of the original spirit of Montmartre. Already nostalgic in his 1897 regular chronicle for *Le Journal*, Alphonse Allais, longtime editor in chief of *Le Chat noir*, mourns the good old days: "*Le Chat Noir* est mort. Fermé le cabaret! Evanouies les ombres chinoises! Disséminées, les poètes et les chansonniers! Aboli le journal!"[12] (*The Chat Noir* is dead. The cabaret is closed! The Shadow Theater has vanished. The poets and *chansonniers* have dispersed! The journal is abolished!)

At first glance then, the ephemeral *tout* that Salis helped to establish in Montmartre bears little relation to the absolute autonomy that Mallarmé claims for literature in his famous 1894 lecture, "Music and Literature." But Mallarmé's intense commitment to establishing the supremacy of literature in fact often led him to articulate political-artistic statements even more all-embracing than those proposed by Salis. In an 1895 article entitled "Le Livre, instrument spirituel," published in *La Revue blanche*, he writes, for example: "tout, au monde, existe pour aboutir à un livre"[13] (everything in the world exists in order to be in a book), a proposition far more outrageous than any put forward by Salis, and one that also contributed to his reputation among skeptics as a *mystificateur*, a hoaxer leading astray a flock of admiring youth.

From one perspective, Mallarmé's serious, abstract conception of literature's totality is indeed opposed to the humorous, concrete, aesthetically mixed and social "all" realized by Salis and others in the fumistic community of Montmartre. His writings do posit and play on a strict opposition between literature and the other arts, between literature and the world–in effect, between literature and "all" other things. However, it is important to note that this insistence on literature's autonomy (which, in a certain sense, helps to preserve literature for the twentieth century, firmly establishing its identity as a circumscribable field worthy of a history and theory of its own)[14] is inseparable from and dialectically related to another equally strong emphasis in Mallarmé's work, an emphasis on binding literature to its others. This contrary insistence, consistent throughout Mallarmé's journalism, on literature's inextricable relations with other arts, and with the sociopolitical world within which it comes into existence, provides an aesthetic orientation that carries twentieth-century literature far from any concept of autonomy and, indeed, in the converse direction, that of multimedia performance.

Thus, while Mallarmé preaches in "Music and Literature" and elsewhere the practice

of "pure poetry" and affirms that for the modern writer this requires a psychological retreat into an ideal literary space–an Eden of "twenty-four letters,"[15] he also concedes and demonstrates that writing in modern times also implies the author's thorough engagement with others and with "all" things. Given this paradoxical stance, we are not surprised to find France's allegedly most hermetic poet, within the cultural context of fin-de-siècle Paris, thoroughly, if somewhat equivocally, engaged.

First, as is evident from innumerable memoirs of the famous Tuesday evening gatherings of his Symbolist disciples in his home on the rue de Rome and from the incredible breadth of his correspondence, Mallarmé was throughout his lifetime deeply involved with other artists and with other forms of art. His collaborations with and unfailing support of painters such as Edouard Manet, James McNeill Whistler, Odilon Redon, and Berthe Morisot, and the seminal role he played as a theoretician of modern music, dance, and theater in critical articles in journals ranging from *La Renaissance artistique et littéraire* and *La Revue wagnérienne* to *La Revue indépendante* and *La Revue blanche* are becoming increasingly well known.[16] Second, Mallarmé's writings engaged the whole spectrum of high and low art, often bringing together the extremes of the sacred and the profane. Moreover, the scope of both his highest and lowest writings embraces the whole of France's contemporary social and political life.

The extremity of Mallarmé's range becomes obvious when we consider two of his most ambitious though never completed works: on the one hand, *Le Livre*, a lifetime project of producing for the modern French state a secular work (a book/journal and theater/rite) to take the place of the Catholic religion in an era that survives the "death" of God; and on the other, his full authorship and production (under a number of humorous pseudonyms), in the mid-1870s, of eight issues of a ladies' fashion journal, *La Dernière Mode*, which included poems, stories, and review articles on literary, theatrical, musical, and artistic events, as well as the latest news on fashion, decoration, education, society, travel, and cuisine.[17] This publication preceded by years the general proliferation of ephemeral journals in Paris in the 1880s and represented a form of journalism considerably lower, or more authentically commercial in status, than those produced by lesser-known writers such as Salis.

The fact that high and low art were, for Mallarmé, but two sides of the same coin is obvious from his inclusion of low aesthetic genres such as journalism and parades in the plans for *Le Livre*, the mysterious, metaphysical Book, which he somewhat fumistically compares, in both form and significance, to the top hat in a response to an inquiry by *Le Figaro* (19 January 1897). Finally, with a sense of daring and humor matched in his time only by exhibitors in the Arts incohérents shows (the rebus and other visual-verbal jokes of Alphonse Allais, André Gill, and other Hydropathe writers), Mallarmé literally bound modern literature to concrete things. His occasional envelope addresses in verse, at the same time meticulously collected and functionally inscribed, anticipate, as Daniel Grojnowski and Vincent Kaufmann have pointed out, mail art of the 1960s and other twentieth-century avant-garde

practices.[18] Participating like most of his contemporaries in fin-de-siècle japonisme, Mallarmé also remains the best-known French author of poetic *Eventails*–fans, which he often inscribed with verse as he also did other symbolic objects such as holiday gifts of Easter eggs and glazed chestnuts.

Thus, while Mallarmé, unlike other important writers of the period, most notably Verlaine and Jarry, is hardly remembered for his (undoubtedly rare) presence in Montmartre cabarets, or his contributions to Montmartre publications,[19] his importance as a literary point of reference and convergence for the whole of Paris's cultural life, and therefore for the avant-garde community that assembled in Montmartre, cannot be overestimated. His preeminence as the Symbolists' Master is variously reflected in statements ranging from Alphonse Allais's tongue-in-cheek complaint, "Ah . . . Monsieur Mallarmé je vous tiens pour le plus grand poète actuellement vivant, mais aussi pour le plus désastreux chef d'école qui ne soit pas encore mort"[20] (Ah . . . Mr. Mallarmé, I consider you the greatest poet now alive, but also the most disastrous school leader not yet dead), to the anarchist Félix Fénéon's contention that Mallarmé's most famous poem, *L'Après-midi d'un faune* (Afternoon of a faun; repeatedly refused by *Le Parnasse contemporain*), was the product of a monstrous coupling between Le Père Didon, a Dominican preacher, and Sapeck, an illustrious Hydropathe prankster and caricaturist.[21]

Paul Verlaine [Fig. 181], the bohemian poet par excellence, guides us, as we shall see, directly to the literature of Montmartre, since his incessant wanderings take us through the center of several generations of Paris's avant-garde, from the Left Bank Zutistes of the early 1870s to the circle of the Chat Noir. Alfred Jarry, identified over time with his principal character, Ubu, succeeds almost single-handedly in establishing and expanding the import of Montmartre's subversive spirit, with the 1896 Théâtre de l'Oeuvre performance of his play *Ubu Roi* marking, in many histories, the birth of modern drama as well as the emergence of twentieth-century avant-garde art.[22] Yet, we find in Mallarmé, who, unlike Verlaine [Fig. 182] and Jarry, was neither an intensive cabaret-goer, nor a drinker–apparently preferring to commune with others in the intimacy of his home–a critical if disjointed point of reference for much of the aesthetic experimentation that occurred in Montmartre. His work functioned for many in this community as a model or a matrix.

The risk of considering Mallarmé's texts apart from Paris's avant-garde communities is clear when we consider the importance of his contributions to major journals of the period such as *La Plume* and *La Revue blanche*. *La Revue blanche*, in particular, which brought Symbolist and anarchist writers together with Montmartre artists such as Toulouse-Lautrec, Pierre Bonnard, and other Nabis, well reflects the particular nature of Mallarmé's bonds with these communities. This journal, to which Mallarmé contributed regular articles in the mid-1890s, was founded in Belgium in 1889 by Thadée and Alfred Natanson and later directed by the anarchist writer and critic Félix Fénéon; it was said to have been originally conceived by P. Leclercq under the influence of the famous Tuesday evening gatherings in Mallarmé's living room.[23]

Fig. 181.
Henri Ibels, *Paul Verlaine at Café Voltaire,* 1890–91, oil on canvas, 27.1 x 21.7. Schimmel Fund.

It is important to remember, moreover, that the Hydropathe-Symbolist upstarts Jules Laforgue and Gustave Kahn, who in the 1880s officially "free" French verse, thus provoking the "crise de vers" or revolution that generally becomes modern French poetry, were also heavily influenced by Mallarmé. At the same time rigorously conservative and avant-garde with respect to his consideration and practice of the alexandrine, the classic, or "orthodox" twelve-syllable instrument of French verse, Mallarmé ultimately plays a double role in the development of modern poetry, producing two major opposing schools of twentieth-century poets: a relatively traditional, canonical line that begins with the intellectual-formalist Paul Valéry and the Catholic poet and playwright Paul Claudel, as well as an experimental, concrete line that begins with Jarry soon to be carried forward by Filippo Tommaso Marinetti and Guillaume Apollinaire.

From a purely textual perspective, Mallarmé's preeminence among the avant-garde writers of the period makes sense, for nowhere within the space of writing alone do we find as radical and far-reaching a subversion of literature's boundaries as in his 1897 concrete text, *Un Coup de dés* (A throw of the dice) [Fig. 184]. A *poème critique*, originally published in the international journal *Cosmopolis*, this text declares the metaphysical and aesthetic supremacy of chance and formally presents itself to the reader as a visual and musical performance score.[24] Far more complex and abstract in its exploitation of the visual impact of typography and textual space than Marinetti's 1912 *Parole in libertà* or Apollinaire's World War I *Calligrammes* [Fig. 183], *Un Coup de dés* is often cited as the first modern concrete poem. It anticipates the fundamental principles not only of Futurist, Dada, and Surrealist literature, but of twentieth-century avant-garde aesthetics in general, as is testified by the work's impact on such artists and composers as Marcel Duchamp, John Cage, and Pierre Boulez. Irreducibly combining verbal, visual, and musical forms of signification, this text in and of itself embodies the dissolution of formal differences between the arts that Montmartre's all-embracing strategy of media mixture often accomplishes and invariably implied.

Paradoxically, however, the explosion of literary boundaries that Mallarmé's most ambitious texts achieve stems, in part, from his complementary, antithetical desire also to preserve literature's autonomous, authentic effects. Although he did on several occasions collaborate with a number of painters and musicians, contributing, for example, a series of *chanson bas* (popular ditties) to accompany Jean-François Raffaëlli's drawings *Les Types de Paris* [Fig. 185] and cooperating in different ways with Manet's and Debussy's visual and musical interpretations of *L'Après-midi d'un faune*, he resisted to a certain extent the very idea of collaboration. His paradoxical stance, his all-or-nothing attitude with respect to literature's aesthetic autonomy is well exemplified in another response to a newspaper inquiry, this one regarding his opinion on *le livre illustré*: "I am in favor of–no illustration, since everything evoked by a book is supposed to happen in the mind of the reader: but if you replace photography, why not go straight to film, whose unfolding will advantageously replace, images and text, many a volume."[25] Mallarmé's awareness of and interest in

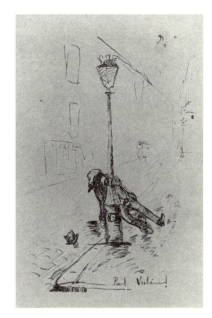

Fig. 182.
Jehan Rictus, *Paul Verlaine!* c. 1895, pen and ink, 15 x 11. Schimmel Fund.

Fig. 183.
Guillaume Apollinaire, "Il pleut" (It's raining), photo-relief illustration for *Calligrammes: Poèmes de la paix et de la guerre (1913–1916)* (Paris: *Mercure de France*, 1918), 62. Schimmel Fund.

Fig. 184. Stéphane Mallarmé, "Un Coup de dés jamais n'abolira le hasard," photo-relief, *Cosmopolis*, no. 17 (May 1897): 424–25. Schimmel Fund.

new contemporary art forms is obvious in this reference to early cinema.

His involvement with emerging forms of entertainment is also attested to by an article praising the A[...] dancer Loïe Fuller (in the 18 March 1893 *National* [...] cts struck him as at once an "indus- [...] lus, the poet was not in actuality as [...] ne sometimes seems.

[...] or, though not a successful one, for [...] d the staging or performance of un- [...] e had tried and failed to get Constant [...] ologue d'un faune," an early version [...] is. The poem was said to be inacces- [...] t lacked a clear action or intrigue as [...] n that Charles Cros's monologue "Le [...] e rage in the 1870s for the monologue [...] rgeois expectations of drama, but in a [...] y and complex way. Far from ambigu- [...] ologue takes an absurdly insignificant [...] tion and simplifies the discourse to an [...] ize the public and entertain children.

Fig. 185.
Jean-François Raffaëlli, "La Marchande d'habits" (The Clothes Seller), stencil-colored photo-relief illustration for Stéphane Mallarmé, "Types de la rue," in *Les Types de Paris*, no. 7 (1889): 30. Schimmel Fund.

[also, slang term for a policeman]

For Guy.

[...] e

[...], dry.

[...] rty, dirty,
[...] p, sharp,
A ball of string–large, large, large.

Then he climbs the ladder–tall, tall, tall,
And drives the sharp nail in–tap, tap, tap,
At the very top of the high wall–bare, bare, bare.

He drops the hammer–which falls, which falls, which falls,
Attaches the string to the nail–long, long, long,
And, at the end, the herring–dry, dry, dry.

He goes back down the ladder–tall, tall, tall,
Takes it away with the hammer–heavy, heavy, heavy,
And then he goes somewhere else–far, far, far.

And since then the herring–dry, dry, dry,
At the end of this string–long, long, long,
Sways very slowly–still, still, still.

I made up this story–simple, simple, simple,
To enrage grownups–serious, serious, serious,
And amuse children–small, small, small.

Fig. 186.
"Le Hareng saur" (The Red Herring),
as quoted in Maurice Donnay,
Dominique Bonnaud, and Vincent Hyspa,
L'Esprit montmartrois (Joinville-le-Point:
Laboratoires Carlier, 1936), 18.
Bartman Fund.

CHARLES CROS

LE HARENG SAUR

Il était un grand mur blanc - nu, nu, nu
Contre le mur une échelle - haute, haute, haute
Et, par terre, un hareng saur - sec, sec, sec.

Il vient, tenant dans ses mains - sales, sales, sales
Un marteau lourd, un grand clou - pointu, pointu, pointu
Un peloton de ficelle - gros, gros, gros.

Alors il monte à l'échelle - haute, haute, haute
Et plante le clou pointu - toc, toc, toc
Tout en haut du grand mur blanc - nu, nu, nu.

Il laisse aller le marteau - qui tombe, tombe, tombe
Attache au clou la ficelle - longue, longue, longue
Et, au bout, le hareng saur - sec, sec, sec.

Il descend de l'échelle - haute, haute, haute
L'emporte avec le marteau - lourd, lourd, lourd
Et puis, il s'en va ailleurs - loin, loin, loin.

Et depuis, le hareng saur - sec, sec, sec
Au bout de cette ficelle - longue, longue, longue
Très lentement se balance - toujours, toujours, toujours.

J'ai composé cette histoire - simple, simple, simple
Pour mettre en fureur les gens - graves, graves, graves
Et amuser les enfants - petits, petits, petits.

Le coffret de santal.
(Stock, Edit.)

When Mallarmé's *Faune* was finally accepted for staging in the early 1890s in Paul Fort's Théâtre d'Art, it was he who apparently stalled on the collaboration or ultimately refused. Though his "Guignon" and other poems were on occasion recited on fin-de-siècle stages, the theatrical version of the *Faune* and other important ambiguously theatrical works such as *Les Noces d'Hérodiade, mystère,* never came to be. Yet his poetic texts remained, with the plays of Villiers de l'Isle-Adam, the primary source of inspiration for Maurice Maeterlinck and other practioners of Symbolist theater.

122

An important measure of Mallarmé's prestige in Montmartre is found in the frequency with which parodic allusions to his work appeared in both texts and images. Although he is treated in a far less hostile and obsessive manner than was Zola, he is consistently but gently mocked in the late 1880s and 1890s as the chief representative of the Symbolist style. In poetic terms, this mocking often occurs in passing references to his aesthetic idealism. In the refrain of "La Marseillaise du Chat noir" (signed Vox Populi, published in *Le Chat noir*, 3 February 1883), for example, we find an echo of the blue that haunts the poet in his 1864 poem "L'Azur" (The azure; "En vain! l'Azur triomphe, et je l'entends qui chante / . . . / *Je suis hanté.* L'Azur! l'Azur! l'Azur! l'Azur!")[27]: (In vain! The Azure triumphs, and I hear it singing / . . . *I am haunted!* Azure! Azure! Azure! Azure!)

> Encor un coup d'aile dans l'bleu,
> V'la l'Idéal qui passe,
> Encor un coup d'aile dans l'bleu
> L'Bourgeois n'y voit que du feu.
> (Another flap of wings in the blue,
> There goes the Ideal,
> Another flap of wings in the blue
> Where the Bourgeois can't see a thing.)

Here, as is often the case, the parody in fact reflects a fundamental sympathy for the very ideal it mocks, particularly in opposition to philistine bourgeois values.

Fig. 187.
Henri Ibels, "L'Éventail du cirque" (The Circus Fan), photo-relief illustration for *Les Demi-cabots* (Paris: G. Charpentier et E. Fasquelle, 1896), 150. Schimmel Fund.

We also find full-blown Incohérent parodies of Mallarmé's texts, as occurs in André Ibels's collection *L'Eventail du cirque* [Fig. 187], where a number of the Master's best-known Symbolist poems are pulverized and then humorously mixed with each other and with other more lowbrow cultural references and texts. In the series *Clowns*, for example, the contrary nymphs of Mallarmé's *Faune* are replaced by the popular Nouveau Cirque clowns Chocolat and Footit.[28]

Finally, Mallarmé's central importance for the literature of Montmartre is established not only through his own multiple and direct connections with the writers, artists, and musicians who worked and converged there but also genealogically, as it were, insofar as he is the official and immediate successor to Paris's prince of poets, Paul Verlaine [Fig.188], and the acclaimed mentor of Alfred Jarry. That Mallarmé had a particular status among the avant-garde writers whose primary project was to promote an aesthetic at the same time supreme and without boundaries is not only natural and logical, given his own literary ambitions, but amply confirmed historically, by contemporary witnesses and accounts. In a *nécrologie* published in his 1899 *Almanach du Père Ubu illustré*, Jarry marks the 1898 death of Mallarmé as the passing of the great "Pan," which of course is supposed to mean "all," and stresses the testimony at the funeral of the poet's universal adoration and impact:

> The little church was sober and absolute, the two choristers all the more mournful for being out of tune, the windows reconciled their bareness in light as the select crowd reconciled the multiplicity of its beliefs before the *catholic* nature (since it sometimes means universal) of glory.[29] (emphasis Jarry's)

ALL THE REST IS LITERATURE

"Tout le reste est littérature." Verlaine's famous 1874 "Art poétique" (collected in *Jadis et naguère* in 1884) ends with this ironic dismissive statement after systematically recommending the subversion of all conventions previously central to the aesthetics of French poetry: the importance of symmetry and metrical balance (incarnated in the alexandrine), the values of precision and contrast, adherence to the rule of rhyme, and rhetorical marksmanship. How does the poem begin? "De la musique avant toute chose!" (Music before all else)—a reference to the necessity of poetry's infusion with another form of art.

Within the context of the history of modern French poetry, it is indeed for the fusion of a certain poetry and a certain music that Verlaine is remembered. As Joris-Karl Huysmans, the wayward Decadent disciple of Emile Zola, puts it in his documentary novel *A rebours*, Verlaine tends to be recognized more for his delicious "imperfections" than for any of the other particular accomplishments of his verse: the vague, melodious flow of poems such as the "Chanson d'automne," for example,

Fig. 188.
Frédéric-Auguste Cazals, "Paul Verlaine et Stéphane Mallarmé," invitation to the eighth banquet of *La Plume*, photo-relief illustration in *La Plume*, nos. 163–64 (1–28 February 1896), 71. Schimmel Fund.

or the whimsical nostalgic transpositions of Watteau's and other painters' *fêtes galantes*, as in the famous "Clair de lune," a poem variously put to music by Gabriel Fauré and Claude Debussy.

Beyond his discovery and promotion of Rimbaud, Verlaine was a central convening force in the first Left Bank groups of marginal poets, the Vilains Bonshommes and the Zutistes. The latter met regularly in the early 1870s at the Hôtel des Etrangers, composing together the parodical texts and drawings of the *Album zutique*. Verlaine was also the self-conscious champion of under-recognized writers in a number of critical works, such as the *Poètes maudits* (Damned poets; 1884), originally literary portraits of Tristan Corbière, Rimbaud, and Mallarmé, expanded in 1888 to include articles on the Romantic woman poet Marceline Desbordes-Valmore, Auguste de Villiers de l'Isle-Adam, and himself, "Pauvre Lélian." What is more, in the wake of Baudelaire, Verlaine presented himself both verbally and in chronic alcoholic, violent fits as a social outcast. He was thus known to his contemporaries as the marginal poet par excellence. This is how he is introduced in Huysmans's *A rebours* (Against the grain), which paints in broad strokes contemporary Parisian literary and artistic life.

The decadent hero Des Esseintes's description of the effects of emerging marginal writers gradually overtaking his devotion to his previous masters, Baudelaire, Flaubert, Goncourt, and Zola, both reveals and helps to create (or promote) the general climate within which much of fin-de-siècle literature is received:

> The domestic next brought him another series of books, which caused him more trouble. These were works to which he had grown more and more partial, works which by the very fact of their imperfection, relieved the strain after the high perfections of writers of vaster powers. Here again, in his refining way, Des Esseintes had come to look for and find in pages otherwise ill put together occasional sentences which gave him a sort of galvanic shock and set him quivering as they discharged their electricity in a medium that had seemed at first entirely a non-conductor.
>
> The very imperfections themselves pleased him, provided they did not come from base parasitism and servility, and it may well be there was a modicum of truth in his theory that the subordinate writer of the decadence, the writer still individual though incomplete, distils a balm more active, more aperitive, more acid than the author of the same period who is really truly great, really and truly perfect. In his view, it was in their ill-constructed attempts that the most acute exaltations of sensibility were to be seen, the most morbid aberrations of language pushed to its last refusal to contain, to enclose the effervescent salts of sensations and ideas.
>
> So, in spite of himself, neglecting the masters, he now addressed himself to sundry minor writers, who were only the more agreeable and dear to him by reason of the contempt in which they were held by a public incapable of understanding them.[30]

Verlaine, one of these "sundry minor writers," who in 1866 "had already made his debut with a volume of verse, the *Poèmes saturniens*" (172–73) in fact shares almost

Fig. 189.
Emile Cohl, *Maurice Rollinat,* woodbury-type portrait for L.-G. Mostrailles [Léo Trézenik and Georges Roll], *Têtes de pipes* (Paris: Léon Vanier, 1885), 24. Schimmel Fund.

equal credit with Huysmans in bringing this group of writers to the attention of the general literary public, a feat accomplished between 1885 and 1893 by the articles he contributed to *Les Hommes d'aujourd'hui,* in a critical campaign extending well beyond the original limited scope of the *Poètes maudits.* This series of literary portraits includes many now forgotten writers of Montmartre and other Parisian avant-garde communities: Jean Richepin, author of a scandalous collection of verse entitled *La Chanson des gueux* (1876) and founder with Maurice Bouchor of the Vivants, yet another marginal group; Maurice Rollinat [Fig. 189], author of *Les Névroses* (1883), whom Barbey d'Aurevilly presents in *Le Chat noir* as the natural, authentic heir of the Baudelairean diabolical spirit; and Raoul Ponchon, a Zutiste, Vivant, Hydropathe, and Chat Noirist, who wrote regular verse chronicles in *Le Courrier français,* to name only a few.

Of particular interest is the way in which Verlaine and Huysmans variously emphasize that the achievement of fin-de-siècle literariness resides precisely in its dissolution of the defining limits and constraints of literature. The subversion or abandonment of qualities that contribute to conventional literary greatness is precisely what unites Verlaine's chosen damned poets and makes them also "Absolute Poets," "Absolute by imagination, absolute in expression, absolute like the *Reys netos* of the better centuries."[31] Thus, literary subversion is not for Verlaine and other Decadents only, or even first and foremost, a matter of and for humor. Rather, it is a serious endeavor, which at the same time celebrates the decline or even end of a certain literary tradition and the emergence of a more hybrid aesthetic in which the remains of literature continue to be active.

Parody, in one form or another, then, emerges as a principal modality for fin-de-siècle literature. A genre whose effectiveness consists primarily in a text's citation and subversive relations with the elements of other texts, parody inherently undermines traditional literary boundaries even as it creates a self-enclosing community of readers. Parody is also, at the same time, intrinsically serious and humorous in its purposes and effects. As such it is perfectly consistent with the spirit of *fumisme,* which, as we saw earlier, presents humor as a counterbalancing response to a deep-seated philosophical skepticism. Parody thus becomes an essential tool for the fin-de-siècle's self-proclaimed elite, whose particular brand of humor seeks less, as Breton and others have pointed out, to oppose or to cure the evils of the world than calmly to express those ills in an ironic fashion, and thereby intellectually and emotionally to transcend them. Parody effectively achieves this by removing our attention directly from the world and focusing it instead on a superior, constructed, autonomous totality through a complex system of intertextual allusions and autoreferentiality.

POETRY

Many of Verlaine's poetic contributions to the *Le Chat noir* are parodies. An example is the *Vers à la manière de plusieurs* (Verses after several poets) series published in the 26 May 1883 issue. While the first and last poems of the series are parodies of other well-known contemporary writers, "La Princesse Bérénice" of Théodore de Banville's *Princesses* (1874) and the "Pantoum négligé" of Alphonse Daudet's *Amoureuses* (1862), the second sonnet appears to be an example of self-parody, a poem in which Verlaine mocks in advance his own importance as the leader of the *Décadent* school, which became firmly established by 1886 through Anatole Baju's journal *Le Décadent*. The poem beginning "Je suis l'Empire à la fin de la décadence" (I am the Empire at the end of the decline) starts out in a melodious, whimsical, and nostalgic, that is, typically Verlainean fashion, and then progresses toward a *fumiste* deflation, one that recalls somewhat the rhetoric of Cros's "Hareng saur."

> Ah! tout est bu, tout est mangé! Plus rien à dire!
> Seul, un poème un peu niais qu'on jette au feu,
> Seul, un esclave un peu coureur qui vous néglige,
> Seul, un ennui d'on ne sait quoi qui vous afflige!
> (Ah! Everything's drunk, everything's eaten! There's nothing else to say!
> Only, a somewhat silly poem that gets thrown into the fire,
> Only, a somewhat roving slave who neglects you,
> Only, a boredom with something unknown that distresses you; *Le Chat noir*, 26 May 1883)

The threefold repetition of "seul" corresponds to Cros's "simple, simple, simple," and the comments "Plus rien à dire!" and "un peu niais," its provocative self-denegation.

The parodical bent of this and many other *Chat noir* poems can be easily traced through the various preceding avant-garde literary groups–the Zutistes, Hydropathes, Hirsutes, Incohérents, and so forth, which were composed of various combinations of the same members.[32] In a letter to Rodolphe Salis published in the 18 August 1883 issue of *Le Chat noir*, Charles Cros, who briefly resuscitated the Zutistes in 1883, emphasizes the fundamental kinship between Montmartre's Chat Noir circle and other Left Bank avant-garde groups:

> Mon cher Salis,
> Salue les Zutistes qui t'embrassent et qui t'aiment.
> Les Zutistes seront heureux d'aller échanger des coups de langue avec le *Chat Noir* qui règne sur la rive droite de la Seine verte comme l'absinthe.
> Dans ce lointain pays de Montparnasse va donc s'établir un mouvement rhythme correspondant aux ronrons du *Chat Noir* de Montmartre.
> Tu sais depuis longtemps que Martre et Parnasse sont frères.
> Ton seul, ton absolu.
> (My dear Salis,
> Greetings from the Zutistes who hug you and love you.

The Zutistes will be happy to exchange cutting remarks with the *Chat noir* that reigns over the Right Bank of the Seine as green as absinthe.

In this far-away country of Montparnasse a rhythmic movement corresponding to the purrings of the *Chat noir* of Montmartre will thus be established.

You've known for a long time that Martre and Parnasse are brothers.

Your only, your absolute.)

We feel the importance of the avant-garde's elitism in this brief letter, not only in the exclusive terms of the closing but also in Cros's insistence that Mont-parnasse (an allusion to the mythical mountain of the Muses) and Mont-martre, two potentially rival sacred mountains of fin-de-siècle poetry, are in fact, because in spirit, essentially one.

Already in the *Album zutique*, written in the early 1870s, we find many examples of the types of poems that figure heavily in the literature of Montmartre. Although the *Album zutique* was not published or widely known until the twentieth century,[33] many of the poems were undoubtedly familiar to the avant-garde community. The texts include poems in praise of favorite cabarets such as Richepin's "Café-concert des gougnottes" (The lesbians' cabaret; a text originally attributed to Paul Bourget), monosyllabic dialogues such as Cros's obscene "Causerie" (Chat) between Tristan and Yseult, and many, many parodies. There are vulgar parodies of poems praising the beloved's body as in Verlaine and Rimbaud's "Idole. Sonnet du trou du cul" (Idol. Sonnet of the asshole); parodies of admired masters such as Baudelaire, as in Léon Valade and Paul Verlaine's "Mort des cochons" (Death of the pigs), or of despised ones such as Leconte de Lisle, as in Verlaine's injurious monosyllabic dialogue "Sur un poète moderne"; parodies of the sentimental-realist style as in the many parodical *dizains* attributed to François Coppée; insider parodies of one group member's work by another as in Germain Nouveau's parody of Verlaine's famous "Clair de lune" poem, entitled "Fêtes galantes."

Functioning as the signposts of an elite, self-defining community of writers and readers, parodic elements are often what differentiate texts in the spirit of Montmartre from other more conventional examples of literary genres. Parodical markers generally signify breaks (in one form or another) with literary traditions at the same time that they forge links for initiated readers with a network of other contemporary, subversive, avant-garde texts. In fact we find that many fin-de-siècle poems that do not immediately strike the inexperienced reader as parodical in impact are to a significant degree engaged in intertextual parodical play.

Laforgue's canonical fin-de-siècle poem "L'Hiver qui vient" (Winter's coming), written in 1886, is an example. Often anthologized, this poem is generally presented as an original example of social satire due to its critique of modern life and to its subversion of literary conventions through the use of slang and other nonpoetic expressions, and its freely structured rhythm and rhyme. One of the poet's posthu-

mously published *Derniers Vers*, this dense, complex poem does indeed represent a highly evolved stage of Laforgue's poetic style and formal experimentation. What is often overlooked, however, is that this poem, far from emerging as a work of solitary genius, exemplifies a general context of innovation. On the level of form, the revelation of free verse is preceded in many poems ranging from Rimbaud's "Enfance" (written in the early 1870s) to the Hydropathe woman poet Marie Krysinska's "Chanson d'automne" (published in *Le Chat noir*, 17 October 1882). On the levels of theme and lexical register the poem also interacts significantly with Laforgue's own previous texts and with numerous other avant-garde poems, thereby also subverting from within and from the outset its own "originality."[34]

The title of the poem echoes, for example, the beginning of a poem by Raoul Ponchon, which apparently served as the closing piece for the *Album zutique*:

> Vla l'hiver et ses guenilles:
> Un' saison qu'est emmerdant!
> J'ai sur mon blair mille aiguilles,
> Qué chouett'temps pour les ours blancs . . .
> (Here's winter and its rags
> A shitty season!
> I have a thousand needles on my schnozz
> What a great time for polar bears . . .)

These lines, which Ponchon himself took up again in 1888 in *Le Courrier français*, circulate like many others throughout fin-de-siècle poetry, appearing also, for example, in the "original" beginning of Jehan Rictus's *Soliloques du pauvre* [Fig. 190], first performed at the Quat'z'Arts cabaret in 1895:

> Merd'! V'là l'Hiver et ses dur'tés,
> V'là l' moment de n'pus s' mettre à poils:
> V'là qu' ceuss' qui tienn'nt la queue d'la poêle
> Dans l' Midi vont s'carapater![35]
> (Shit! Here's Winter and its hardships,
> The time when you can't strip down:
> The people who have the handle
> Will head for the South.)

And the preeminence of the word *Merd'* in Rictus's version cannot but make one think in turn of the "original" beginning of Jarry's play *Ubu Roi* performed on the stage of the Théâtre de l'Oeuvre about one year after Rictus's appearance at the Quat'z'Arts cabaret. As ultimate a criterion as it may seem, originality for the avant-garde is thus, in the final analysis, a play of mirrors, functioning, more precisely, or in rhetorical terms, as a *mise en abyme* (a figure of style producing an effect of repeating images). This, we shall see, is especially true in the Quat'z'Arts' construction of *Le Mur* with all its parodies.

Indeed, while a marked singularity may, paradoxically, strike us as the sole unifying feature of several of the major canonical poets of the fin-de-siècle period–for

Fig. 190.
Théophile-Alexandre Steinlen, "Espoir" (Hope), crayon, 97 x 16, reproduced in Jehan Rictus, *Les Soliloques du pauvre* (Paris: P. Sevin et E. Rey, 1903), 65. Gift of Herbert D. and Ruth Schimmel.

example, Rimbaud, Mallarmé, and Lautréamont–all "unique" in their different ways, poets such as Verlaine and Laforgue, who are perhaps equally known and equally innovative, are considered less important for defining the course of twentieth-century French poetry. This, I believe, is precisely because their work reveals them to be caught up in a turn of history that is in fact more crucial for modernity than the continuation of the canon, that is, the survival and succession of a particular line of major authors. Rather, the total immersion of the works of poets such as Verlaine, Laforgue, and Jarry within their immediate literary and artistic milieux points directly to the threatening possibility of the dissolution of the individual artist's or writer's original, autonomous "genius" into the shared aesthetics of a decentered group. For the burgeoning avant-garde, the group phenomenon both stands for and replaces the individual artist, alienated by and from bourgeois society. It thus comes to represent, as we shall see Ubu effectively do on a symbolic plane, simultaneously a pulverized unity and a contradictory, all-embracing totality.

It is not surprising then that the innovative work of several of the writers who were most prominent and aggressive in establishing these late-nineteenth-century marginal groups, which by and large have been forgotten by twentieth-century literary historians, has been effaced right along with the ephemeral communities they founded. And when this work is rediscovered, which it certainly is today, it is less because our attention is captured by the particular merits of a certain writer's work than because of the work's manifestation of a given writer's inextricable involvement with the general spirit of these avant-garde groups.

The prolific poetic writings of Emile Goudeau [Fig. 191], the founder of the Hydropathes in 1878, the first editor in chief of *Le Chat noir*, and also the driving force in convening the literary avant-garde in Montmartre, well exemplify this. This poet published numerous collections of poetry, from *Les Fleurs du bitume* (1878) to the *Poèmes ironiques* (1900), as well as a literary portrait of his life and times, *Dix Ans de Bohème* (1888), and his work and activities were heavily publicized by critics of the day from the conservative senior theater critic, Francisque Sarcey, to peers such as Paul Vivien in the first issue of *L'Hydropathe*, dated 22 January 1879. Yet he is represented as follows in a recent French dictionary of literary history: "GOUDEAU, Emile, 1849–1906–France/XIXe S.: Bohème et marginalité littéraire; Cafés et dîners littéraires."[36] Thus, for the purposes of literary history, Goudeau is absolutely (or solely and completely) identified with his aesthetic context and social milieu.

It is natural to wonder whether this kind of literary destiny–the failure to persist through one's work–is not the result of a simple lack in the literary quality of a writer's work, rather than of the social (and therefore circumstantial) conditions within which one writes. However, to posit the problem of the canon in these terms, particularly with respect to fin-de-siècle writers whose primary aim seems to assault outright the notion of literary quality, is simply to displace rather than to resolve the question of the canon's criteria. This is not to say that the forgotten writers of the fin de siècle should have been or deserve to be remembered. Indeed, none of Goudeau's

Fig. 191.
Georges Lorin (Cabriol), "Emile Goudeau, président des Hydropathes," hand-colored photo-relief cover illustration for *L'Hydropathe*, 22 January 1879. Schimmel Fund.

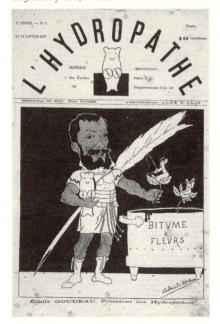

poetry strikes me as particularly worthy of "saving," as being especially compelling or original in its own right. Certainly, his first collection, *Les Fleurs du bitume* (Flowers of asphalt), appears to inaugurate a generation of ironic poetic deflations of the rebellious, radical stance of Baudelaire's 1857 *Fleurs du mal* (Flowers of evil), a series of works that includes, for example, Laforgue's abandoned 1886 collection *Les Fleurs de bonne volonté* (Flowers of goodwill). But even these poems, in my view, lack formal interest, their principal appeal residing in a kind of flattening of typically Baudelairean themes. The first lines of "Le sentier du souvenir" (The path of memory), a poem in a section entitled "Cueillette sur l'asphalte" (Flower picking on asphalt), readily show this slackening effect: "O sentier, te voilà vêtu de fleurs fanées / Dont les vagues parfums s'exhalent affaiblis"; as does the phlegmatic poem "Espoir!" in the section entitled "Une Saison de spleen" (A season of depression), which closes, "Dors, enfant, en songeant au splendide avenir. / Et j'ai soufflé la lampe amère, pour dormir"[37] (Sleep, child, dreaming of the splendid future. / And I blew out the bitter lamp to sleep). Other poems by Goudeau, such as his "Eventail" (Fan) sonnet for Henri Pille or the epic fragment "Les Polonais," capture the reader's attention through their explicit Hydropathic references and the way in which these combine with poetic themes and trends clearly associated with other writers' works. Thus, in "L'Eventail" (published in the 14 July 1883 *Chat noir*) we see a farcical, Hydropathic counterpart to Mallarmé's sublime exploitations of the poetic movements and qualities of fans, for example, "Je hais le Vent d'Ouest transocéanien, Sempiternel verseur de l'eau qui nous oxyde" (I hate the transoceanic West Wind, sempiternal pourer of the water that oxidizes us). And we find in "Les Polonais" (published in the first issue of *Le Chat noir*, 14 January 1882) a Hydropathic representation of the drunken Polish army overrunning Paris, which appears to anticipate Jarry's *Ubu Roi*, particularly given the play's original title, *Ubu Roi ou les polonais*, which appears with the play's original publication in the second and third issues of *Le Livre d'art* in 1896 [Fig. 148].

The literary destiny of the caricaturist André Gill (after whom the Montmartre cabaret Au Lapin Agile was named) [Fig. 18] is similar to that of Goudeau, although his career was cut short by bouts of madness and by his early death in 1885. In 1880 he published *La Muse à Bibi*, a collection of off-color and often paradoxically macabre light lyrical poems that was quite successful. He also produced a humorous illustrated memoir of his literary and artistic activities, *Vingt Années de Paris*, which was published with a preface by Alphonse Daudet in 1883 after Gill's definitive confinement at Charenton.

Other avant-garde poets such as Maurice Mac-Nab and Laurent Tailhade, less prominent for their roles in organizing marginal groups, tend to be remembered for their association with one or another aspect of fin-de-siècle avant-garde culture. Mac-Nab, who illustrated his own humorous 1886 collection *Poèmes mobiles*, containing poems ranging from "La Sonnette des Hydropathes" (dedicated to Goudeau), to the quasi-concrete "Ballade des accents circonflexes," to grotesque songs such as that in praise of aborted fetuses, "Les Foetus" [Fig. 192], was especially known for the hoarse

Fig. 192.
Maurice Mac-Nab, "Les Foetus," photo-relief illustration for Maurice Mac-Nab, *Poèmes mobiles* (Paris: Léon Vanier, 1889), 17. Bartman Fund.

131

Fig. 193.
Emile Cohl, "Abus des métaphores,"
photo-relief illustration for *Catalogue
illustré de l'exposition des arts incohérents*
(Paris, 1886), 74. Schimmel Fund.

Fig. 194.
Lecuit, "Le Repassage de la mer rouge" (The
Crossing/Ironing of the Red Sea/Mother),
photo-relief illustration for *Catalogue illustré de
l'exposition des arts incohérents* (Paris, 1886), 139.
Schimmel Fund.

delivery of his poems, performed at the Chat Noir and other cabarets. The politically engaged anarchist Tailhade, like several other avant-garde poets who were also his close friends (such as the multifaceted genius Charles Cros or the once-Hydropathe author of the Symbolist manifesto, Jean Moréas), wrote "serious" lyrical verse as well as parodical poems. Tailhade's 1880 *Jardin des rêves* is, for example, quite conventionally Parnassian in style, while his 1894 collection, *Vingt Ballades familières pour exaspérer le mufle,* is exemplary of the ironic social satire most typical of Montmartre poetry. These poems also participate, of course, in the kinds of parodic interplay discussed earlier. The "Ballade de la génération artificielle" presents itself, for example, as a take-off on Goethe's *Faust II,* while the "Ballade sur le propos d'immanente syphilis" develops an epigraph taken from Lautréamont's *Chants de Maldoror.*[38] Ironically, once we are familiar with it, the bitter, sarcastic refrain of this particular ballad, "Amour s'enfuit, mais Vérole demeure" (Love flees, but syphilis remains), reverberates in a twisted way through the sweet, nostalgic refrain of Apollinaire's much more famous and canonized modern love lyric "Sous le pont Mirabeau" from the 1913 collection *Alcools*: "Vienne la nuit, sonne l'heure / Les jours s'en vont, je demeure"[39] (Come the night, sound the hour / The days pass, I remain).

Finally, the ephemeral character of much of Montmartre's poetry can be directly attributed to the various ways in which it refuses categorization as literature. The earlier mentioned prolific chronical verse of Raoul Ponchon was never collected, as he did not deem it appropriate for preservation in books. Virtuoso technical feats such as *holorimes* (all-rhyming verses), impressively accomplished, for example, by the amorphous poet Franc-Nohain, were generally the matter of various "concours de mystifications mondiales et comiques" organized by Alphonse Allais and others in journals suchs as *Le Rire* and *Le Sourire.*[40] Allais was in fact himself adept at producing this kind of poetry,[41] as he was at using poetic phrases in verbo-visual works such as the famous monochromes exhibited at the Arts Incohérents and later collected in the 1897 *Album primo-avrilesque.* The essential yet often minimal poetic components of Incohérent works ranging from Georges Lorin's *Effet de lune* [Figs. 195–196] to Emile Cohl's *Abus des métaphores* [Fig.193] and Lecuit's *Repassage de la mer rouge* [Fig. 194] perhaps demonstrate best of all the extent to which avant-garde poetry of the fin de siècle seeks to accomplish "all" and thus defies our attempts to classify it along with the rest of "literature."

Figs. 195 and 196.
Georges Lorin, "Un Effet de lune" (195), and "La Comète" (196), collotype illustrations for preface to *Catalogue illustré de l'exposition des arts incohérents* (Paris: E. Bernard et Cie, 1884). Schimmel Fund.

PROSE

This being said, my current division of Montmartre literature into the three primary subgenres of poetry, prose, and theater must be taken with a grain of salt. Indeed, I am using this structural device in part just to show how arbitrary albeit necessary traditional attempts to classify this literature are condemned to be. It is not simply a matter of recognizing that prose writers such as Allais also wrote verse or that poets such as Verlaine and Laforgue also wrote remarkable works in prose.[42] Writers have always worked in the various genres. Far more important to emphasize is the extent to which the redefinition of fin-de-siècle literary genres was itself dependent on the emphasis given their interpenetration by a community of writers. Thus, the inherently hybrid prose-poem, a genre essentially introduced into the French literary tradition by Baudelaire's 1861 *Petits Poèmes en prose*, becomes during the fin de siècle the literary genre par excellence, radically affecting the development of the novel as well as of poetry for a whole generation.

Huysmans [Fig. 197], who with Maupassant was among the principal prose writers to begin the fin-de-siècle rebellion against Zola's Naturalism, describes in *A rebours* how Mallarmé's and others' Symbolist prose-poems came to have a major impact on his contemporaries' ideas regarding fictional prose. As in the passage cited above regarding the appeal of marginal writers, the aesthete hero, Des Esseintes, serves here as the critical mouthpiece for a whole generation:

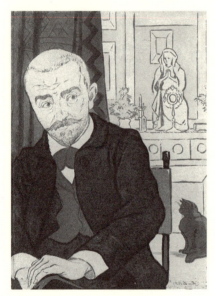

Fig. 197.
Eugène Delâtre, *Portrait of Huysmans*, 1894, color aquatint, 32.4 x 24.1.

> Of all the forms of literature that of the prose poem was Des Esseintes' chosen favorite. Handled by an alchemist of genius, it should, according to him, store up in its small compass, like an extract of meat, so to say, the essence of the novel, while suppressing its long, tedious analytical passages and superfluous descriptions. Again and again Des Esseintes had pondered the distracting problem, how to write a novel concentrated in a few sentences, but which should yet contain the cohobated juice of the hundreds of pages always taken up in describing the setting, sketching the characters, gathering toward the necessary incidental observations and minor details. . . .
>
> The novel, thus conceived, thus condensed in a page or two, would become a communion, an interchange of thought between a magic-working author and an ideal reader, a mental collaboration by consent between half a score persons of superior intellect scattered up and down the world, a delectable feat for epicures and appreciable by them only.
>
> In a word, the prose poem represented in Des Esseintes' eyes the concrete juice, the osmazone of literature, the essential oil of art. (Huysmans, *Against the Grain*, 186)

Huysmans's own practice of the novel, particularly in *A rebours*, which was for him and many others a seminal work, reflects several of the different directions in which much of the prose associated with Montmartre evolves. An important one of these involves the fusion of various forms of fiction, aesthetic criticism, and documentary

prose.[43] In countless fin-de-siècle prose works ranging from Goudeau's and Gill's already mentioned memoirs, *Dix Ans de Bohème* and *Vingt Années de Paris*, to Félicien Champsaur's *Dinah Samuel* (an 1882 roman à clef revolving around the foundation of the Hydropathe group), to Edmond de Goncourt's thinly disguised account of the famous Goncourt brothers' creative collaboration in *Les Frères Zemgano* (1879), we find these genres combined to various degrees, without much concern for separating fact from fiction. This fusion represents one dimension of the general dissolution of the boundaries between literature and journalism, an important issue to which I shall return.

A rebours also points, of course, to the development of the Symbolist and Decadent novels. In the Symbolist manifesto, Moréas insists on the necessity of a return to the psychological novel, which implies for him an "oeuvre de déformation subjective" (work of subjective distortion), a study of the psychic life of a sole character, ideally deemphasizing or even dissolving the traditional linearity of the plot. This path is pursued into the twentieth century in different ways by novelists ranging from Maurice Barrès and Paul Bourget to André Gide, and it leads to important formal innovations in the evolution of narrative structure, such as Edouard Dujardin's discovery of the "monologue intérieur," in *Les Lauriers sont coupés* (1887), which served as a model for the stream-of-consciousness writing of James Joyce.

Examples of Decadent novels steeped in flamboyant images and aesthetic emotion include Huysmans's own novels following *A rebours*, particularly the cycle of conversion novels *Là-bas* (1891), *En route* (1895), and *La Cathédrale* (1898), as well as the occultist Joséphin Péladan's massive twenty-one-volume "éthopée," *La Décadence latine*, which the Catholic novelist and critic Barbey d'Aurevilly compared at its beginnings to Balzac's *Comédie humaine*. These Decadent novels, along with other later works such as Octave Mirbeau's *Jardin des supplices* (1899) and Jean Lorrain's *Monsieur de Phocas* (1901), turn primarily around the mysteries of evil and moral perversion, as does much of Barbey d'Aurevilly's own work.

Like Mirbeau's scandalous 1900 crime chronicle, *Le Journal d'une femme de chambre*, Lorrain's *Monsieur de Phocas* presents itself in the form of a journal. It recounts the progressive degeneration of a young man (much like Des Esseintes) haunted by Astarté, the "Démon de la luxure," through numerous adventures in Parisian night life until he finally flees for the Orient in pursuit of his abominable visions, which Europe finally can no longer contain.[44] For the present context, this novel holds the particular interest of painting a picture of a declined Montmartre that is decidedly less than *gai*, where sickly dancers and prostitutes best convey as they had already earlier in the novels of Huysmans and Zola (*A rebours*, *L'Assommoir*, and *Nana*) the close association of misery, physical decline, nervous diseases, and sexual licentiousness in fin-de-siècle Paris, "le Paris de luxe et plaisir que chantent les poètes de Montmartre" (the Paris of luxury and pleasure sung of by the poets of Montmartre):

It was the hour when Paris lights up. All the filth of the city was flowing toward debauchery, and I had all this filth in my heart.

We dined at the cabaret; in the evening we made a nauseating tour of the Montmartre music clubs, the bitter pill of stupidities repeated a hundred times over and the funereal frolics of the Butte, all the slothfulness of a spree in the places where people have fun, and we ended up at the Moulin Rouge.

Poor girls consumed by anemia, wretched down-at-heels vice, misery in silk rags, and idlers aroused by dirty lusts around underthings of dubious cleanliness shaken by professionals; all the ignominies of lechery's proletariat, stirred at scheduled times to enliven the boredom of counter-jumpers and *petits bourgeois*.[45]

A preoccupation with unbridled sexuality, with feminine evils and ills, and with the confusion of the sexes is consistent throughout Montmartre's literature and journalism, and prevalent in every genre. It is equally relentless, for example, in Edmond de Haraucourt's *Légende des sexes, poèmes hystériques* (1883), several of which were published in *Le Chat noir*, and in several of the novels by the woman writer Rachilde, works such as *Monsieur Vénus* (1884) or *La Marquise de Sade* (1887). Misogyny expresses itself in a wide variety of light and humorous as well as serious and melodramatic tones, and in a wide spectrum of texts documenting fin-de-siècle images of women. Two very different examples are Lorrain's *Echo de Paris* chronicle, a series of 112 articles on contemporary women entitled *Une Femme par jour* (One woman a day) and Louis Legrand's 1892 sarcastic *Cours de danse fin de siècle* [Fig.198] (Turn-of-the-century dance course). In this last text, which presents itself, like much Montmartre literature, as a form of cultural documentary, that is, a reflection of and on various aspects of contemporary Parisian life, the "symbolism" of the cancan dancer's *grand écart* (split), which the Montmartre public could admire nightly at the Moulin Rouge, is revealed! "A fever invades her veins, drinks her blood, gnaws at her nerves, slackens her muscles. And in a final abasement, woman, overwhelmed by intoxication, exhausted by orgy, prostrates herself in the mud!"[46] Cabaret spectacle thus often presents itself and is understood as a direct reflection of the predominant "realities" and/or preconceptions of fin-de-siècle culture [Fig. 199].[47]

The development and proliferation of various types of humorous *contes* in and about fin-de-siècle cultural life is also, of course, an outgrowth of the increasing power and influence of journalism on literature. Not only were short stories, both humorous and serious, written by and large for immediate consumption in the wealth of the period's journals, but they were also obviously influenced in their style, structures, and themes by the tastes of the public to whom they were addressed. Thus, many of the "classic" tales of Maupassant, clearly a master of the serious genre, present various types of simple functionary, petit bourgeois, or peasant characters from contemporary provincial or Parisian society caught up in typical and often true contemporary situations. These stock characters and situations were familiar to his mundane readers in *Gil Blas* [Fig. 200], not because of their knowledge of long-

standing literary traditions, but rather because of their regular consumption of Maupassant's and other chroniclers' nonfictional prose on these very same situations and types. Developing consistently along the Realist and Naturalist lines set down by Flaubert and Zola, serious short stories appear to blur the boundaries between reality and fiction, by giving us the impression through the exactness of the description, the authenticity of the situations, and the apparent lack of rhetorical ornament that what we experience in reading them is a slice of life. However, as Florence Goyet has pointed out in a recent study of the genre, if we fall for this illusion it is, paradoxically, in part because the author chooses for his readers a slice of life that is removed, at least socially, from their own and keeps his readers at a distance from the characters by ensuring through paroxysm that they remain purely exemplary and therefore typical as opposed to idiosyncratic and psychologically complex.[48]

Not surprisingly, we find these fundamental principles of successful serious short stories subverted in most of the humorous tales of the period. In Villiers de l'Isle-Adam's *Contes cruels*, reasonable expectations of bourgeois readers, for example, are often cruelly reversed, thereby mocking their preconceived judgments and opinions. In "Deux Augures," this reversal directly implicates the typical journal reader's lack of literary taste. Staging an encounter between a "totally unknown" writer who claims "absolutely no talent" and a jaded journal-editor who, paradoxically, has heard such bragging pretensions and pierced through them before, the narrator closes the story with the rejected young writer storming out of the office, deeply offended by the editor's perception of literary merit in his work.[49] Unlike most of his contemporaries, Villiers was not on the whole successful at maintaining himself through journals, and "Deux Augures," understandably, figures among the *Contes cruels* that never appeared prior to the volume's 1883 publication. His dark, subversive humor and marginal status (celebrated in both Verlaine's *Poètes maudits* and Huysmans's *A rebours*) place him in the camp of *fumiste* storytellers most appreciated by the elitist avant-garde.

The mocking and reversal of bourgeois sensibility are achieved through a wide variety of means in fin-de-siècle tales, ranging from the simple exaggeration or distortion of scenes of everyday life to the complete undoing of fictional structure. Two tales by Alphonse Allais [Fig. 201] anthologized in Grojnowski and Sarrazin's *Esprit fumiste* well exemplify this variety of means. In "Le drame d'hier" (Yesterday's drama; originally published in the 23 August 1898 issue of *Le Journal*), which the anthology editors classify among the "Tableaux de moeurs," Allais, a prominent and prolific humorist who disdained "literature" in favor of journalism, simply enhances an absurd situation, which might to some degree take place on a Parisian omnibus. A rude, uneducated young woman asks a medal-sporting gentleman an impertinent but fashionable question: "Qu'est-ce que tu prends pour ton rhume?" (What are you taking for your cold?/How would you like to get creamed?). The resulting exchange of invectives escalates into a shooting at the moment when the woman hurls at him

Fig. 200.
Théophile-Alexandre Steinlen, "Le Clair de lune," photo-relief cover illustration for *Gil Blas illustré,* 30 April 1893. Schimmel Fund.

Fig. 201.
Lucien-Victor Guirand de Scévola, "Alphonse Allais," photo-relief cover illustration for *Les Quat'z'Arts,* 17 April 1898. Schimmel Fund.

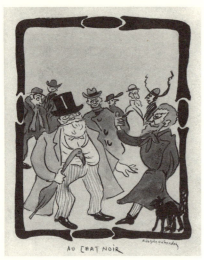

Fig. 202.
Adolphe Gérardot, "Au Chat Noir,"
1892, watercolor, 21 x 16.5, from
L'Album de l'oncle. Morse Fund.

Fig. 203.
Title page for *X . . . roman impromptu*
(Paris: Ernest Flammarion, 1895).
Schimmel Fund.

(as Allais explains it) a particularly powerful Montmartrois insult (implying probably, given the context, that the man is either a pimp or a gigolo): " 'Va, donc, hé, vieux *dos!* répliqua la jeune femme.' (Le *dos* est un poisson montmartrois qui passe à tort ou à raison pour vivre du débordement de ses compagnes)" ("Screw you, you dirty old pimp!" the young woman answered. [The pimp is a Montmartre fish that rightly or wrongly is believed to live off the debauchery of its female companions]). Naturally at this point, the entire population of the bus gets caught up in the battle, which in its final stages spills out into the streets of Paris. There is nothing inherently remarkable in this tale's plot. As with Raymond Queneau's *Exercices de style* (1947), humorous twentieth-century variations on a nonincident in a bus, in Allais's tale, everything–all the interest and humor–resides in the mocking rhetorical treatment.

In Allais's much more famous tale "Un Drame bien parisien" (originally published in the 26 April 1890 issue of *Le Chat noir*), the open-ended deformation of the plot or narrative structure, on the contrary, provides the most interest.[50] As in countless classical short stories (e.g., Maupassant's "Parure" or O'Henry's "Gift of the Magi"), in this particular tale, which involves the jealous reciprocal spying of a young couple, the narrative appears to build toward a highly dramatic ending charged with suspense–a disguised confrontation of both parties at the "bal des Incohérents, au Moulin Rouge." However, unlike the surprise endings of many short stories, which are generally logical and predictable in the sense that they can–in retrospect–be structurally or analytically deduced, the absurd surprise ending of "Un Drame bien parisien" leaves the reader totally perplexed. When the moment of truth arrives and the characters' disguises are taken off, neither party recognizes the other:

> Both of them cried out at the same time in amazement: Neither recognized the other.
> He was not Raoul.
> She was not Marguerite.

Thus, despite the narrator's affirmations to the contrary, it is impossible to know how the story concludes and whether any sense, moral or otherwise, can be concluded from it at all. Although the situations are antithetical, the absurdity of this couple's dramatic encounter anticipates the famous nonsensical recognition scene of a long-married couple in Eugène Ionesco's theater of the absurd play, *La Cantatrice chauve.*

Despite their significant stylistic differences, Allais's two *drame* tales are both clearly Parisian and involve characters who are as much "insiders" in the world of the action as are the author of the tale and the public addressed. Like many other humorists, such as the "auteurs gais," the painter-writer George Auriol (a close friend of Allais) and the actor-writer Félix Galipaux, author of a series of *Galipettes*, Allais bases many of his tales on real or concocted anecdotes involving his cohorts in the Hydropathe and Chat Noir circles. The phenomenon of the insider in many of the tales published in *Le Chat noir* is so marked that Allais is confidently able to attribute

138

their authorship to another, the respectable theater critic Francisque Sarcey, even while protesting the impudence of other Sarcey imitators in other journals and insisting on his first and exclusive rights to appropriate the identity of "notre Oncle Sarcey" [Fig. 202].

Allais's appropriation of Sarcey's identity merely extends in a consistent way a tradition of false attributions and appropriations of works among avant-garde writers going back at least to the *Album zutique*. This tradition is one of the more flagrant and humorous manifestations of the eclipse of the individual artist's identity by and for the purposes of the group. That fin-de-siècle writers consciously forsook to some degree, as the Surrealists later did, their sense of personal authorship and literary property is also clear when we consider the lengths to which they carried the principle of collaboration. *X . . . roman impromptu* [Fig. 203] by George Auriol, Tristan Bernard, George Courteline, Jules Renard, and Pierre Veber is an excellent example of this. A proto-Surrealist project originally published in *Gil Blas*, which each author was free to change from chapter to chapter in every aspect except for the main character, the work is presented as follows in the 1895 book edition's preface: "a purely mechanical serialized novel simplifying the task by division of labor. At the same time, cooperation in the work as well as in the benefits, eminently Socialist, sets an excellent example for our colleagues." The authors explicitly state that their ambition is to "revive team spirit" while at the same time providing their readers and themselves with "a perfect gaiety, the attraction of the unforeseen."[51]

So great is the range of means by which humorous fin-de-siècle prose, like poetry, escapes, oversteps, or undermines the conventional boundaries of literature, that it is impossible to enumerate them here. I will simply suggest that most of these imply in one way or another both the interpenetration of all the literary genres and, more widely, the fusion of literature with what, previous to the avant-garde, literature was not. This erasure of the inner and outer boundaries of literature occurs in at least three major senses, which in the final analysis overlap.

First, as has already been variously discussed, fin-de-siècle literary prose, whether fictional or not, consistently equates itself with journalism. A radical example of this is Félix Fénéon's minimalist headline stories, *Nouvelles en trois lignes*. It is easy to see that many of the "radically new" inventions of Futurism, Dada, and Surrealism involving the intermixture of art and mass-media forms of communication (newspapers, advertisement, telegraph, etc.) are a direct development from this particular antitradition. An obvious example, which readily deconstructs among other things the difference between poetry and prose, is Tristan Tzara's famous recipe for a Dada poem, where words may be clipped out of a newspaper, shaken up in a bag, and then rearranged in the order that they come out.

Second, as has already been considered from the visual-art perspective and will be considered further from the perspective of music, in fin-de-siècle prose, as in poetry, there is a consistent tendency to incorporate elements of other art forms as fundamental, indispensable components of verbal texts. This may, of course, occur

Fig. 204.
L. Lemercier de Neuville, *Médard Robinot, casquettier* (Paris: E. Dentu, 1891), i. Schimmel Fund.

Fig. 205.
L. Lemercier de Neuville, *Médard Robinot, casquettier* (Paris: E. Dentu, 1891), 5. Schimmel Fund.

Fig. 206.
L. Lemercier de Neuville, *Médard Robinot, casquettier* (Paris: E. Dentu, 1891), 8. Schimmel Fund.

Fig. 207.
Théophile-Alexandre Steinlen, "L'Album de cinabre," photo-relief illustration for Charles Joliet, *Roman incohérent* (Paris: Jules Lévy, 1887), 70. Bartman Fund.

Fig. 208.
Unidentified, "Merde, v'là l'i vert" (Shit, here's the winter/Green *I*), from *Le Mur*, 1895–96, crayon, 23.2 x 18. Schimmel Fund.

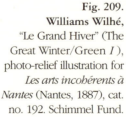

Fig. 209.
Williams Wilhé, "Le Grand Hiver" (The Great Winter/Green *I*), photo-relief illustration for *Les arts incohérents à Nantes* (Nantes, 1887), cat. no. 192. Schimmel Fund.

in a variety of more or less subtle ways, the song or visual-verbal art object being only the most explicit. George Auriol incorporates tiny drawings into the narrative to complete the meaning of his "Petit Conte semi-hiéroglyphique,"[52] and Lemercier de Neuville employs a like procedure with an added *lettriste* dimension and a general emphasis on the importance of typographical concreteness in his *roman expressif* (expressive novel), *Médard Robinot, casquettier* (Cap maker) [Figs. 204–206].[53] Charles Joliet's 1887 *Roman incohérent* [Fig. 207], illustrated by Théophile-Alexandre Steinlen and edited by Jules Lévy, presents a generically hybrid "mosaic of every color and every parish," portraying "scenes from the artist's life," which includes among other things an "Album de cinabre" containing "sixty terrible stupidities, sketches and legends."[54] Among the drawings of *Le Mur* we find an elongated portrait of Rictus that takes the form of the letter *I* [Fig. 208]; we also find a verbo-visual play on the letter *I* in Wilhé William's *Grand Hiver* [Fig. 209] in the catalogue of the *Arts incohérents* exhibition that took place in Nantes in 1887. All these texts anticipate in different ways the various concrete literature movements of the twentieth century.

Finally, and this point brings us to our last considerations, which will focus on theater, fin-de-siècle humorists' texts are fundamentally collective in spirit and often in fact and are therefore generally inextricable from both the literal and figurative theatrical displays of marginal culture in and about which they speak. From George Auriol's *Chat noir–Guide* (c. 1888), which ostensibly directs the reader through an actual "visit" to the Chat Noir cabaret, to the texts of the shadow plays or Jarry's puppet play *Ubu sur la Butte*, which present themselves as authentic performance pieces, the literature of Montmartre binds itself in one form or another to the spectacle that is life in the cabarets.

THEATER

All . . . Ubu?[55] In histories of the avant-garde ranging from Roger Shattuck's *Banquet Years in France* (1958) to Frantisek Deak's recent *Symbolist Theater: The Formation of an Avant-Garde* (1993), the dress rehearsal and performance of *Ubu Roi* on 9 and 10 December 1896 at the Théâtre de l'Oeuvre in Montmartre is considered a uniquely important event, though its significance is variously interpreted. For some, the play's "revolutionary" impact sprang primarily from its insistent, aggressive use of the word *merdre* (pschitt), hurled at the public from the curtain's rising. For others, it is less what was shouted (by either the actors or the public) at the moment of the play's opening than the global disruption of theatrical conventions that the Théâtre de l'Oeuvre's "respectable" production of Jarry's "schoolboy farce" implied.

It is of course important for scholars to investigate the multiple and complex levels of subversion that occur in the play, from the hybrid, anarchical backdrop combining elements of both indoor and outdoor decor, to the outrageous social satire and ubiquitous parodical echoing of dramatic models old and new. We find

Fig. 210.
Alfred Jarry, "Ubu Roi," woodcut illustration for *Le Livre d'art*, no. 2 (May 1896). Schimmel Fund.

141

scenes mocking Racine and Shakespeare as well as many of the latest trends in Naturalist and Symbolist drama. However, it is also true that if *Ubu Roi* [Fig. 210], alone among the works of Alfred Jarry, and even more significant, alone among the works created in Montmartre, made such a mark on theatrical and therefore literary history, this was because it delivered its subversive "message"–MERDRE–through a clear and compelling symbol from the outset, and then developed it in a very consistent Wagnerian, or perhaps I should say, organic way.

Jarry is often an extremely arcane writer, as difficult as his chosen masters Rabelais and Mallarmé. But *Ubu Roi*, a work engendered in collaboration with Jarry's high school fellows, Charles and Henri Morin is, dramatically speaking, despite its many absurdities, parodical allusions, and theatrical contradictions, a simple play. As Jarry explains in his opening presentation, the hero, Le Père Ubu–who assassinates the king of Poland and then proceeds to massacre the noblemen, bureaucrats, and peasants before fleeing to France–is modeled on a schoolboy's perception of a certain physics teacher, "Father Hébert," "who represented for him *everything* grotesque in the world."[56]

I emphasize Jarry's identification of Ubu with everything grotesque in the world because it is precisely in this expansion, this totalizing process, that I perceive the primary originality and therefore effectiveness of Jarry's rewriting and development of the character of Ubu. If *Ubu Roi* has become a modern classic, this is because its crass, round hero embodies a subversive vision that is at the same time global and unique, that is, simultaneously all-inclusive and universally identifiable with each individual spectator or reader. A monstrous symbol of unbridled selfishness and egotism, with whom Jarry identified himself as much as the bourgeois crowds, "Monsieur Ubu" is simply, he informs us, "a vile being, which is why he resembles (from down below) all of us."[57]

A grotesque caricature of everyone's lowliness, Ubu, the shittiest of kings, wields as his scepter the toilet brush, which well represents his three principal overlapping preoccupations, *physique*, *phynance*, and *merdre*, a trinity of concerns common to all humankind. Although a thorough discussion of *Ubu Roi* remains outside the scope of this essay, I would like to consider further here, if only schematically, the extent to which this particular play, its performance history, and general development within the *Ubu* cycle effectively absorb the theatrical traditions peculiar to Montmartre, as well as reflecting more generally the avant-garde literary and artistic traditions that have been discussed thus far.

First, it is important to stress the degree to which the play represents a group effort. Not only was the play written and conceived of as a collective project from the start, but its several subsequent versions and productions reflect the history of a marginal expansion that is almost archetypical of the avant-garde. Originally performed in 1888–90 under the title *Les Polonais* by the marionettes of the Théâtre des Phynances in the homes of the Morin brothers and Jarry in Rennes, the play, after Jarry's move to Paris in 1891, became increasingly well known in increasingly public

142

and formal (as opposed to private and informal) settings. In the early phases of the play's development, audiences were exclusively composed of Jarry's friends and peers–students and young avant-garde writers and artists of the sort gathering in the early 1890s in the cabarets of Montmartre and in Mallarmé's living room. Jarry was eventually able to insert *Ubu Roi* into the serious Symbolist repertoire of a highly respected Parisian theater through a combination of journal-sponsored publicity campaigns and a sequence of insider events–a tried-and-true process of establishment for avant-garde writers, which Jarry was exceptionally well able to exploit.

This self-publicizing process began soon after Jarry's move to Paris. In 1893 he won a prize for his first publication, "Le Guignol," a three-part text introducing the character of Ubu, which appeared in *L'Echo de Paris littéraire illustré*, a journal directed by Catulle Mendès, a Parnassian proponent of Wagnerian and Symbolist ideals, and Marcel Schwob, a journalist, scholar, translator, and poet. The following year, Jarry became linked with the novelist Rachilde and her husband, Alfred Vallette, the director of the journal and publishing house *Le Mercure de France*, a connection that led to a number of important publications of and about Jarry's work as well as to increasingly prestigious performances of his play–a gathering at the Mercure headquarters in 1894 and the premiere at the Théâtre de l'Oeuvre in 1896.

The range of Jarry's publications during these critical years reflects the intensity and diversity of his activities within the avant-garde. His first book, *Les Minutes de sable mémorial* (1894), a brilliant collection of grotesque and macabre Symbolist poems, was formally inspired by Mallarmé's intricate poetics of semantic polyvalence and syntactic equivocation and was hailed by the Master as an exceptional, ingenious work.[58] In 1894, with Rémy de Gourmont, he also founded *L'Ymagier*, a luxurious art journal presenting hundreds of prints, including works by Gauguin and the Douanier Rousseau as well as Jarry himself. It was undoubtedly through his brief period of involvement with *L'Ymagier* (he broke with Gourmont after co-editing only five issues) that Jarry came to know the director Lugné-Poe, as through the journal he reviewed a number of performances at the Théâtre de l'Oeuvre. In 1895 he published *César Antéchrist* [Fig. 211], a heraldic Symbolist play in which the character of Ubu is ultimately identified with the Antichrist.

Jarry's relations with Lugné-Poe and the Théâtre de l'Oeuvre were complex from the start. He served as Lugné-Poe's general secretary and publicist, before *Ubu Roi* was accepted. Then, once Lugné-Poe had committed himself to the production, Jarry harassed him with extraordinary authorial demands, attempting to take responsibility for as many aspects as possible of the direction of his play. He insisted, for example, on a puppetlike style of acting, suggested particular instruments for the (fairground-like) music to Claude Terrasse, and participated himself in the painting of the backdrop, with Edouard Vuillard, Paul Sérusier, Henri de Toulouse-Lautrec, and Paul Ranson. Although there is ample documentation to show that Jarry pushed even Lugné-Poe's directorial principles of experimentation, collaboration, and heterogeneity to an extreme, it is no coincidence that *Ubu Roi* emerged into the formal

Fig. 211.
Alfred Jarry, "Monsieur Ubu à cheval," color woodcut illustration for *César Antéchrist* (Paris: *Mercure de France*, 1895), opp. 97. Schimmel Fund.

context and official canon of modern theater through the Théâtre de l'Oeuvre, for this theater represented in and of itself a synthesis and refinement of the fin de siècle's previous avant-garde theatrical innovations: principally, those accomplished in André Antoine's Théâtre Libre and Paul Fort's Théâtre d'Art.

As Deak and others have pointed out, the clear-cut contrasts between the Symbolist and Naturalist camps that are often made in describing the relations between these avant-garde theaters are misleading. As was the case with other avant-garde groups, the repertoire and artists involved in these theaters were at the same time somewhat mixed (in terms of aesthetic orientations) and repetitive (in terms of membership) from the start. In an interview for *Le Courrier français* (15 July 1891), Antoine claimed himself to be in fact without prejudice toward Symbolism:

> if I find that there really are some interesting things of this type to be
> attempted in the theater, it is the Théâtre Libre that will attempt them.
> Just as I was the first to open my doors to Naturalist theater, so too I shall
> open them equally wide to Symbolist theater, provided that it's theater.

The primary point of contention between the two camps consisted, no doubt, in the Théâtre Libre's favoring of Naturalist material and the Théâtre d'Art's commitment to bring to life Symbolist works. Antoine's fascination with the novels of Zola and his realistic dramatizations of contemporary slices of life may indeed appear inconsistent with the Symbolists' passion for the staging of poetry and metaphysical idealism. However, it should be noted that the opposing innovative perspectives of both these types of theaters depended heavily on their common emphasis on the sensorial effects of the mise en scène and on their equally subversive mixtures of drama with previously distinct literary genres. The principal innovations of both theaters, in fact, grew out of their respective transplantations of fiction (the novel) and poetry into the space of the theater.

Before founding the Théâtre de l'Oeuvre, Lugné-Poe had been involved in both the Théâtre Libre [Figs. 212, 213] and the Théâtre d'Art [Fig. 214]. Though his aesthetic orientation was fundamentally Symbolist, he, like Antoine, was primarily concerned with introducing new kinds of plays into the French theater and with developing the art of the mise en scène. Like Antoine, he avidly searched for French playwrights of the quality of Ibsen or Maeterlinck, dramatists apparently scarce to be found. Whether or not Lugné-Poe recognized it at the time, Jarry was certainly among these. The importance of his work in this period is comparable only to that of the early plays of the prominent twentieth-century poet and playwright Paul Claudel.

Ubu Roi represents an extreme, parodical continuation of Naturalist theater by virtue of its attention to social issues, to adultery, money, and vulgar language, and by its utter physicality, the emphasis on bodily functions. Although it is unrealistic, Mère Ubu's description of the conspirator's feast–"Polish soup, chops of rastron, veal, chicken, dog pâté, turkey rumps, charlotte russe . . . *bombe*, salad, fruit, dessert, boiled meat, Jerusalem artichokes, cauliflower *à la* shit"–recalls the Naturalists' focus

Fig. 212.
Invitation for the first performances of Le Théâtre Libre, 1887.

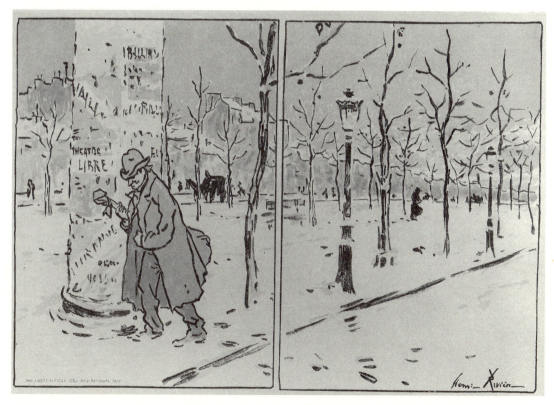

Fig. 213. Henri Rivière, *Paris en hiver,* 1889, color lithograph, 21.5 x 31.1, program for the 1889–90 season of Le Théâtre Libre.

Théâtre d'Art

THÉATRE D'ART

SOUS LE PATRONAGE

DE

STÉPHANE MALLARMÉ
PAUL VERLAINE, JEAN MORÉAS
CHARLES MORICE
HENRI DE RÉGNIER

Directeur : **Paul FORT**

REPRÉSENTATION AU BÉNÉFICE

de

Paul VERLAINE et Paul GAUGUIN

PAUL VERLAINE

Dessin de David Estoppey, gravé par Maurice BAUD

A Paul Verlaine.

Banal comme l'amour, la mort et la beau té,
Marbre pur envolé de bannières de soie,
Au geste du Poète un temple se déploie
Où s'exhale en amen toute l'humanité.

Banal comme l'amour, la mort et la beauté,
En cris d'ivresse, en fleurs de feu tonne et flamboie
Sous des nuages d'or fauve un jardin de joie
Où s'exhale en désir toute l'humanité.

Graves processions et vagues théories,
Des bosquets radieux aux voûtes assombries
Va, priant et riant, toute l'humanité :

Et vers le ciel penché sur cet éternel drame,
Banal comme l'amour, la mort et la beauté,
Monte l'accord d'un Psaume et d'un Epithalame.

Charles MORICE.

Cinq Poëmes de Paul Verlaine

LA CHANSON DE GASPARD HAÜSER

Je suis venu, calme orphelin,
Riche de mes seuls yeux tranquilles,
Vers les hommes des grandes villes :
Ils ne m'ont pas trouvé malin.

A vingt ans un trouble nouveau
Sous le nom d' « amoureuses flammes »
M'a fait trouver belles les femmes :
Elles ne m'ont pas trouvé beau.

Quoique sans patrie et sans roi
Et très brave, ne l'étant guère,
J'ai voulu mourir à la guerre ;
La mort n'a pas voulu de moi.

Suis-je né trop tôt ou trop tard ?
Qu'est-ce que je fais dans ce monde ?
O vous tous, ma peine est profonde !
Priez pour le pauvre Gaspard.

PRIÈRE

Voici mon front qui n'a pu que rougir,
Pour l'escabeau de vos pieds adorables
Voici mon front qui n'a pu que rougir.

Voici mes mains qui n'ont pas travaillé,
Pour les charbons ardents et l'encens rare
Voici mes mains qui n'ont pas travaillé.

Fig. 214. Photo-relief title page for *Théâtre d'Art* (21 May 1891).

146

on graphic and gory details, and also Antoine's insistence that these be faithfully transmitted by the objects presented on the stage, as with the famous example of the bloody piece of meat.

The play also allies itself explicitly with the Symbolist tradition in a number of ways. Beyond its clear development of a theatrical symbol (*merdre*) and an abstract character type (Le Père Ubu), it combines a number of Symbolist principles of presentation. In a lecture delivered to the public just before the curtain, Jarry insisted that the ultimate significance of the play was to be determined by each spectator, remaining thus multiple, open-ended: "you will be free to see in Mr. Ubu the many allusions that you want to see, or a mere puppet."[59] A nonrealist depersonalization of the characters is also effectively achieved in the play through an emphasis on puppetlike gestures and masks. The time and place of the action are established as abstract from the outset through the multiple contradictions in the backdrop and then developed through a play of references between the backdrop and various heraldic elements in the general staging and decor. This staging, which Deak describes in detail,[60] takes the Symbolist principles of (Baudelairean) correspondences and Wagnerian synthesis to parodical extremes, principles that had been applied seriously (if sometimes extravagantly) in numerous previous productions of the Théâtre d'Art, the Théâtre de l'Oeuvre, and also in Joséphin Péladan's occultist Théâtre de la Rose-Croix.

Jarry also clearly wished to implement in *Ubu Roi* several of the Symbolist principles expressed in Gustave Kahn's 1889 manifesto, "Un Théâtre de l'avenir: Profession de foi d'un moderniste"[61] (A theater of the future: A modernist's profession of faith). The reduction of crowds to a single representative character is one example. Moreover, in attacking the fundamental tenets of both traditional dramas and contemporary realist representations, Jarry's own best-known theatrical manifesto, "De l'inutilité du théâtre au théâtre" (On the uselessness of theater in the theater), simply extends in several respects a previous Symbolist work, "De l'inutilité absolue de la mise en scène exacte"(On the absolute uselessness of exact staging), a manifesto by Pierre Quillard, the author of the "classic" Symbolist drama, *La Fille aux mains coupées*.

Ironically, the Symbolists' subversion of theatrical conventions ultimately had the effect of leading modern theater back in the direction of classicism, though in a somewhat convoluted way. Through contradiction, incoherence, and implausibility, rather than through the opposed contrary principles ensured by the implementation of the classical unities, the dramatic symbolism of *Ubu Roi* finally leaves us, for example, with an impression of abstraction and universality, an achievement for which Mallarmé especially compliments Jarry. Although ostensibly situated in Poland, the action of *Ubu Roi* in fact comes across, as Jarry insists it should, as eternal, and particular to "Nulle part" (Nowhere).

Identifying himself with a number of other Symbolist writers, Jarry conceives of *Ubu Roi*'s ideal public as the intellectual, artistic elite. He also claims, however, that the vulgar hordes, the hostile bourgeoisie, have also proved capable of understanding his play all too well. They react negatively, he states, because they recognize their

L'Incohérent.

Fig. 215.
Caran d'Ache, "L'Incohérent," photo-
relief illustration for Albert Millaud,
Physiologies parisiennes (Paris: Librairie
illustrée, 1886), 141. Bartman Fund.

own image in Ubu, see and hear themselves in his gross behavior and stupid remarks.

It is by his mastery of an elitist world of parody and social satire, through his paradoxical formation of a hall of mirrors that mocks the grotesque bourgeoisie, that Jarry rejoins the *fumiste* spirit of Montmartre and departs, for the most part, from the particular traditions of the Symbolist theater per se. Although Symbolist theorists such as Kahn recommended lowbrow forms of theater such as character comedy, clownish pantomime, and circus comedy, the principal plays representing this tradition, Villiers de l'Isle-Adam's *Axël*, for example, or Maeterlinck's *Pélléas et Mélisande*, are extremely lofty and serious. The dark scatological humor of Jarry finds its precedents instead in the subversive artistic performances of the Incohérents, as illustrated, for example, in Caran d'Ache's portrait of Jules Lévy holding a chamber pot and brush [Fig. 215],[62] and in the marginal, nonofficial theatrical traditions of literary performances presented in fin-de-siècle cabarets: principally, in the tradition of the monologue, loosely defined as a short, humorous literary text (whether a scene, poem, or story) written for oral presentation and in avant-garde puppet and shadow theaters, such as the ones developed in the Chat Noir cabaret by Henri Rivière and Henry Somm.

The fin-de-siècle monologue subverts most of the conventions that define theater, particularly in its status as a literary genre. It may consist of a text virtually indistinguishable from a poem, a tale, or a brief dialogue, and may contain, despite its name, one or several characters, though it is generally conceived to be presented by one actor with a minimal amount of theatrical trappings. Several examples of the genre have already been discussed (e.g., Salis and Jouy's "Squelette," Cros's "Hareng saur," and Mac-Nab's "Foetus").

In *Le Monologue moderne*, the prominent Comédie Française actor Coquelin Cadet describes Charles Cros as the "mother" of this tradition and himself as its midwife, or "sage-femme."[63] This is because Cros gave birth to this particular form of whimsical, off-color humor in a number of classic texts such as "Le Hareng saur," "L'Obsession," and "Le Bilboquet," which Coquelin Cadet "delivered" in an original, deadpan yet affected performance style, an unrealistic style not wholly dissimilar to that employed by Jarry himself in conversation, by Lugné-Poe, and by Firmin Gémier, the prominent actor who played Le Père Ubu.

Coquelin Cadet describes the monologue as combining a paradoxical mixture of aesthetic orientations, a complex of contradictions that anticipates in several respects the incoherence of the mundane yet farcical humor associated with Jarry:

> The monologue is one of the most original expressions of modern humor; an extraordinarily Parisian stew, in which *fumiste* French farce and catch phrases are combined with violence of American concept, in which the improbable and the unforeseen gambol peacefully on a serious idea, in which reality and the impossible fuse in a cold fantasy.[64]

In an all-or-nothing formula by now familiar to us, Coquelin Cadet puts the

emphasis on fantasy as the monologue's indispensable ingredient: "Le monologue moderne sera donc fantaisiste ou il ne sera pas."[65] Indeed, however sad or macabre the incident recounted in a monologue, its dark humor remains, paradoxically, rather lightweight, less oppressive in color and tone than the aggressive humor of Jarry. Because of this it is easy to overlook the degree to which this cabaret genre influences Jarry as a comic-yet-serious dramatic form turning on the exposition of a single character, which in Ubu's case, as Rémy de Gourmont puts it, is that of "un personnage d'un sinistre largement comique."[66]

The puppet and shadow theaters of Montmartre are more obviously related to the development of Ubu for a number of reasons. Most obvious is that the first and last dramatic avatars of the Ubu cycle are puppet plays. The earliest version of *Ubu Roi* was, as has been mentioned, performed by the "marionnettes du Théâtre des Phynances" in 1888, and the fifth and last play of the Ubu cycle, *Ubu sur la Butte*, was performed in 1901 by the "marionnettes du Théâtre des Gueules de Bois" (puppets of the Theater of Hangovers/Wooden Heads) at the Quat'z'Arts cabaret in Montmartre. As with Maeterlinck and other Symbolists, Jarry's preference for puppets over actors stems from the poet's ability to control them absolutely and thus translate directly through them the exactness of his vision and his thoughts:

> We don't know why, but we have always been bored at what is called
> the Theater. Maybe we were aware that the actor, no matter how inspired,
> betrays—and the greater the inspiration the greater the betrayal—more than
> the poet's thought? Only puppets of which we are master, sovereign, and
> Creator, because we feel it is absolutely necessary to build them ourselves,
> translate passively and rudimentarily—which is the schema of precision—
> our thoughts.[67]

If puppet theater provided Jarry with the original and ultimate context for Ubu's revelation, the Chat Noir's shadow theater provided him with an important precedent in its fusion of popular comic theatrical forms with the serious, highbrow aesthetics of Symbolism. The Chat Noir's shadow theater repertoire ranges from very short humorous pieces, such as Henry Somm's already mentioned scatological one-act *L'Eléphant* (1887), whose literal denouement consists in the shadow of an elephant relieving itself of an "odoriferous pearl," to Maurice Donnay's very long and involved play *Ailleurs* (1891), in which a weary poet named Terminus leaps to his death in the Seine and is then led back to hope through a series of ancient and modern scenes by the philosopher Voltaire. Dedicated to Paul Verlaine, with sets by Henri Rivière and music by Charles de Sivry, this play typically combines Symbolist tastes, preoccupations, and theories with numerous parodies and satirical commentaries on contemporary Parisian life.

We also find a mixture of humor and seriousness, mystical symbolism and farcical decadence, in Rivière's 1887 *Tentation de Saint Antoine*, a *féerie à grand spectacle* [Pl. VIIIa] in two acts and forty tableaux. This parody is based on a work by Gustave

Figs. 216–218
Henri Rivière, stencil-colored
photo-relief illlustrations for the
shadow-theater album *La
Tentation de Saint Antoine* (Paris:
E. Plon, Nourrit et Cie, 1888).
Bartman Fund.

Fig. 217. "La Bourse," 22.

Fig. 216.
"Les Dieux scandinaves–Odin et les
Walkyries," 69.

Flaubert which was itself originally inspired by a form of popular theater–puppet
shows presenting the trials of Saint Anthony, which Flaubert saw as a child at the St.-
Romain fair.[68] Here, interlaced with quotations of Flaubert's prose, we find cita-
tions of contemporary opera and ballet–passages from Richard Wagner's 1870 "Ride
of the Valkyrie" [Fig. 216] and from two of Léo Delibes's ballets, *Sylvia* (1876) and *Le
Roi s'amuse* (1882)–as well as original compositions by Albert Tinchant and Georges
Fragerolle. We also find satirical allusions to various prosaic modern temptations,
such as the bourgeois sin of "Avarice" [Fig. 217] manifested at the stock exchange.
The simultaneity in this piece of ancient [Fig. 218] and modern references and the
mixture of the sacred and the profane is typical, we recall, of the general spirit of
Montmartre. This blend, as well as the radical opening of the literary work embrac-
ing the immediate and a mixture of other arts, also characterizes the efforts of Jarry,
not only in *César Antéchrist* and in the Ubu plays (which contain songs and even
audience interaction in *Ubu sur la Butte*), but also in the ostensibly nondramatic
fourth element of the Ubu cycle, the 1899 and 1901 *Almanachs du Père Ubu* illus-
trated by Pierre Bonnard.

In certain respects the most radical and avant-garde of Jarry's productions, the
Almanachs combine without hierarchical or any other order of distinction numerous
short satirical scenes–such as the "Confession d'un enfant du siècle" a monologue-
type confrontation between Le Père Ubu and "Sa conscience," a Père Ubu "Alpha-
bet," saints' day calendars, weather predictions, and universal *reportage*: the *nécrologie*
for Mallarmé, a list of who's who in Parisian arts and letters, a *fumiste* report on the
latest inventions, and a colonialist Ubu.

Fig. 218. "Les Dieux égyptiens," 77.

Jarry's description of the nature and function of the 1899 *Almanach* provides a fitting conclusion for this discussion of "all" Ubu, and more specifically of Ubu's capacity to symbolize the marginalized/totalizing spirit of Montmartre literature. In an exhortation to his reader, Jarry/Ubu unequivocally states that his *Almanach* replaces all other journalism, providing an attractive and economical alternative for all kinds of apocalyptic news-hungry readers, anxious about the nearing end of the century, and thus, perhaps, the end of the world:

> Great princesses and princes, townspeople, villagers, military soldiers, all you loyal subscribers to and purchasers of this Almanac of our astrology and our beloved subjects male and female, you will not have to read newspapers this winter. O what a saving of money. The one-penny journal every morning adds up to four francs, ten, eleven, or twelve francs every three months. Not to mention people who buy three-penny newspapers; because the more they charge you for falsehoods, the more they're stealing from you. And since we not only reveal the past to you, but predict the future, we're offering you three months as a real gift, and the Almanac doesn't cost you anything. You're worried, poor people, readers of daily disaster rags, hungry for news: maybe tomorrow will be the end of the world. You go to bed trembling with fear. For the bathroom those paper dials that have only the minute hand. Our *trimestrial* almanac (the English call it a *quarterly*) is an installment paid in advance in the round, solid, comfortable, like our Gidouille [a neologism for Ubu's enormous round belly], terrestrial building.[69]

In emphasizing the global incorporation of bourgeois values in the "terrestrial"

home of Ubu's belly [Fig. 219], Jarry, like the majority of his compatriots in the spirit of Montmartre, significantly undercuts our ability to separate the marginal avant-garde from the conservative mainstream, or the bohemians from the bourgeoisie.[70] This is only natural, for Jarry/Ubu's supposedly "marginal" and "elitist" aesthetic ambition is explicitly absolute and universal, like that of Mallarmé and Salis.

> We, Père Ubu, open to you our knowledge of all (read all the) things past, truer than any newspaper, because: either we tell you what you have read everywhere else, in which case the universal testimony will assure you of our veracity: or you will not find confirmation of what we say anywhere: our work will then stand in its absolute truth, without argument.[71]

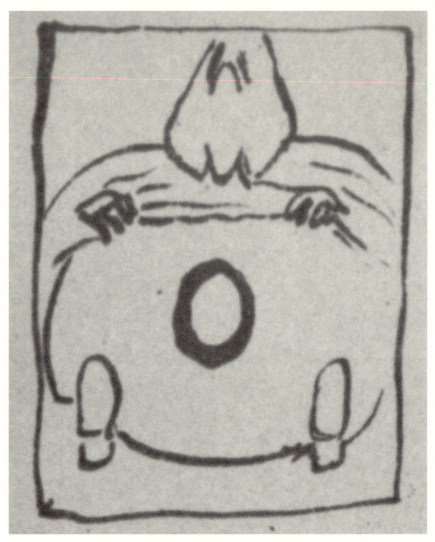

Fig. 219. Pierre Bonnard, "Alphabet du Père Ubu," detail. (See fig. 156)

1. Mallarmé's Oxford and Cambridge audiences–elite, no doubt, and conservative–apparently did not have a clue. Although the lecture, "Music and Literature," was translated for them into English, it remained absolutely incomprehensible owing to Mallarmé's deliberately convoluted, arcane prose. Playing upon the "mystery" that surrounded his texts and oral performances within the context of the lecture itself, Mallarmé did not hesitate to refer to himself as a *mystagogue* and to suggest that circuslike farce would be the appropriate mode for public appearances among his peers. He thus subtly aligns himself with the *fumiste* wing of the avant-garde as well as with the more seriously engaged Symbolists and anarchists. Stéphane Mallarmé, *Oeuvres complètes* (Paris: Gallimard, 1945), 635–57.

2. Walter Benjamin, *Reflections* (New York: Schocken Books, 1986), 146.

3. *Le Chat noir*, 26 May 1883. Advertisements such as these, emphasizing at the same time the cabaret's exclusivity and its universal appeal, appear throughout the journal. Here is another example: "LE CHAT NOIR is the most extraordinary cabaret in the world. You rub shoulders with the most famous men of Paris, meeting there with foreigners from all corners of the world" (*Le Chat noir*, 18 March 1882).

4. This line is attributed to Vivien by Félicien Champsaur, cited by François Caradec, *Alphonse Allais* (Paris: Belfond, 1994), 105.

5. A variant of the line attributed to Vivien–"Les arts seront fumistes ou ne seront pas" (The arts will be fumiste or they will not be)–also serves as an epigraph (jokingly attributed to Zola) for Fragerolle's article "Le Fumisme," *L'Hydropathe*, 12 May 1880.

6. See, for example, Père Jonquet, *Montmartre autrefois et aujourd'hui* (Paris: Dumoulin et Cie, 1890), and Georges Montorgueil, *La Vie à Montmartre* (Paris: G. Boudet and Ch. Tallandier, 1897).

7. In an unpublished thesis, Michael A. Cavaliere analyzes the dialogue "Il faut lutter" (We must fight) by Emile Goudeau (under the pseudonym of A'Kempis) published in the 8 April 1882 issue of *Le Chat noir*, an excellent example of Montmartre's self-proclaimed superiority on the basis of its subversive political history: "Quoi! peuple, ces volailles de la basse-cour parisienne commanderaient aux aigles des Buttes! Non, non, non. Il faut lutter. Pour l'art et le libre ciel bleu. Debout!" (What! Comrades, these Paris barnyard chickens want to command the eagles of the Buttes! No, no, no. We must fight. For art and an open blue sky. On your feet!; Cavaliere, "L'Aliénation et la fin: Limites de la modernité" [Henry Rutgers Undergraduate Honors Thesis, Rutgers University, 1994], 41).

8. Montorgueil, *La Vie à Montmartre*, 5.

9. André Breton, *Anthologie de l'humour noir* (Paris: Livre de Poche, 1966). Fin-de-siècle writers that Breton includes in his anthology along with Arthur Rimbaud are Auguste de Villiers de l'Isle-Adam, Charles Cros, Isidore Ducasse, Joris-Karl Huysmans, Tristan Corbière, Germain Nouveau, Alphonse Allais, André Gide, and Alfred Jarry.

10. Paul Jeanne, *Les Théâtres d'ombres à Montmartre de 1887 à 1923* (Paris: Les Editions des Presses Modernes, 1937).

11. "Rodolphe Salis a entrepris d'être le scandaleux créateur d'un journal *exclusivement* occupé d'art et en dehors de toute spéculation industrielle d'un genre quelconque. Le journal *Le Chat noir* a été fondé en même temps que le cabaret, héroïquement, presque sans ressources, comme le cabaret lui-même. . . .

"Je dis sérieusement que cela est très fier, très noble, et très digne qu'on se passionne pour celui qui le fait. Le *Chat noir* est actuellement le *seul* journal ou la vérité crue et complète puisse être dite sur les puissants Burgraves de lettres qui font tout fléchir et devant qui se prosterne avec tremblement cette lécheuse de pieds fétides qui s'appelle la Presse française.

"Cela seul ne suffirait-il pas pour tirer un homme, déjà remarquable à d'autres titres, du banal troupeau de la célébrité contemporaine et pour lui mériter une place tout à fait à part, une place unique dans l'attention des quelques êtres qui ont pu conserver leurs facultés d'hommes en plein milieu de ce grand peuple d'eunuques et de décapités." (Léon Bloy, *Le Chat noir*, 24 November 1883)

12. Reprinted in Alphonse Allais, *Autour du Chat noir* (Paris: Georges Vernard, 1955), 7.

13. Mallarmé, *Oeuvres complètes*, 378.

14. Mallarmé's insistence on literature's autonomy is what makes him so important to the development of literary theory, particularly for the Structuralist and Poststructuralist schools predominant in French criticism since the early 1960s.

15. Mallarmé, *Oeuvres complètes*, 646.

16. See, for example, Penny Florence, *Mallarmé, Manet, and Redon: Visual and Aural Signs and the Generation of Meaning* (Cambridge: Cambridge University Press, 1986), and my own study *Performance in the Texts of Mallarmé: The Passage from Art to Ritual* (University Park: Pennsylvania State University Press, 1993).

17. Two important critical works on these diverse projects are Bertrand Marchal, *La Religion de Mallarmé* (Paris: Corti, 1988), and Jean-Pierre Lecercle, *Mallarmé et la mode* (Paris: Séguier, 1989.)

18. See Daniel Grojnowski, "De Mallarmé à l'art postal," in *Poétique* (November 1994): 427–34, and Vincent Kaufmann, *Le Livre et ses adresses* (Paris: Méridiens Klincksieck, 1986).

19. Prose poems of Mallarmé appearing in *Le Chat noir* include "L'Orgue de barbarie" (1885), "Plainte d'automne," "Frisson d'hiver," "Le Phénomène futur," and "Le Démon de l'analogie" (all 1886).

20. Alphonse Allais, *Le Journal*, 21 October 1896, cited in Caradec, *Alphonse Allais*, 451.

21. Daniel Grojnowski and Bernard Sarrazin, *L'Esprit fumiste et les rires fin de siècle* (Paris: José Corti, 1990), 20.

22. See, for example, Denis Hollier, *A New History of French Literature* (Cambridge, Mass.: Harvard University Press, 1989), and RoseLee Goldberg, *Performance Art: From Futurism to the Present* (London: Thames and Hudson, 1988).

23. A. B. Jackson, *La Revue blanche, 1889–1903* (Paris: M. J. Minard, 1960), 13.

24. The principal difference between the original May 1897 *Cosmopolis* edition and the more familiar and definitive edition published in 1914 by Edmond Bonniot is that the material of each original *Cosmopolis* page is in the final edition spread, not recto-verso, but over one double page.

25. "Je suis pour–aucune illustration, tout ce qu'évoque un livre devant se passer dans l'esprit du lecteur: mais si vous remplacez la photographie, que n'allez-vous droit au cinématographe, dont le déroulement remplacera, images et texte, maint volume, avantageusement" (Mallarmé, *Oeuvres complètes*, 878).

26. Charles Cros, in Charles Cros, Tristan Corbière, *Oeuvres complètes* (Paris: Gallimard, 1970), 138.

27. Mallarmé, *Oeuvres complètes*, 37.

28. André Ibels in *Les Demi-cabots: Le Café-concert, le cirque, les forains* (Paris: G. Charpentier et E. Fasquelle, 1896). For a fuller discussion of this parody and of Mallarmé's relation to fin-de-siècle parody in general see my article "Mallarmé at the Circus: Incoherent Parody," in *Dalhousie French Studies* 24 (1993): 71–85.

29. "La petite église fut sobre et absolue, les deux chantres plus douloureux d'être faux, les vitraux concilièrent leur pauvreté dans de la lumière comme la foule choisie la pluralité de ses croyances dans l'agenouillement ensemble devant le *catholique* (puisque ce veut dire quelquefois universel) de la gloire"(Alfred Jarry, *Tout Ubu* [Paris: Livre de Poche, 1985], 384–85).

30. Joris-Karl Huysmans, *Against the Grain* (New York: Dover, 1969), 172–73.

31. Paul Verlaine, *Oeuvres en prose complètes* (Paris: Gallimard, 1972), 637.

32. In "Nous sont des autres," an unpublished paper presented at the Northeast Modern Language Association convention (Pittsburgh, April 1994), Madhuri Mukherjee gives a full analysis of this phenomenon, centering her discussion on its implications for the alleged singularity of the work of Rimbaud.

33. A facsimile of the original manuscript was first published in 1961 and then reissued in 1981 with notes and commentary by Pascal Pia: *Album zutique* (Geneva and Paris: Slatkine, 1981).

34. For a thorough presentation of Laforgue's work and a full discussion of the particular nature of its originality, see Daniel Grojnowski, *Jules Laforgue et l'"Originalité"* (Neuchâtel: La Baconnière, 1988).

35. Jehan Rictus, *Les Soliloques du pauvre* (Paris: P. Sevin et E. Rey, 1903), 9.

36. *Dictionnaire universel des littératures*, ed. Béatrice Didier (Paris: Presses Universitaires de France, 1994).

37. Emile Goudeau, *Les Fleurs du bitume* (Paris: Lemerre, 1878), 20–21, 121–24.

38. Laurent Tailhade, *Vingt Ballades familières pour exaspérer le mufle* (Paris: Bibliothèque Artistique et Littéraire, 1894), 68–69, 73–75.

39. Guillaume Apollinaire, *Oeuvres poétiques* (Paris: Gallimard, 1965), 45.

40. See Caradec, *Alphonse Allais*, 448–56. This kind of exaggerated play on the formal conventions of poetry is a constant of *fumisme*. It is already in full force, for example, in the monosyllabic sonnets and dialogues of the *Album zutique* and is also presented humorously as a poetics in Charles Cros's 1874 piece *L'Eglise des totalistes* published in the *Revue du monde nouveau* (cited in Grojnowski and Sarrazin, *L'Esprit fumiste*, 291–94).

41. See, for example, the samples and comments he provides in *Gil Blas* (28 May 1892):
 Alphonse Allais de l'âme erre et se f...out à l'eau.
 Ah! l'fond salé de la mer! Hé! Ce fou! Hallo!

 Le public est prié d'apporter sa bienveillante attention à ce curieux exercice.
 Ainsi que dans le cochon où tout est bon, depuis la queue jusqu'à la tête, dans mes vers, tout est rime, depuis la première syllabe jusqu'à la dernière.
 Allons-y.

 Par ses charmes, appas, ris, et du Pacha beauté
 Parsé charma Paris et dupa chat botté.
 (Alphonse Allais of the soul rambles and throws himself into the water.
 Ah! the salty bottom of the sea! Hey! crazy guy! Yoo-hoo!

 The public is asked kindly to attend to this strange exercise.
 As in the pig in which everything is good, from head to tail, in my verses everything is rhyme, from the first syllable to the last.
 Let's go.)

42. Laforgue's most striking parodies, *Moralités légendaires* (1887), are rewritings of Shakespeare, Wagner, and others in the form of poetic tales. And Verlaine's Montmartre prose includes, along with much of the earlier mentioned literary criticism, many interesting pieces ranging from the odd "pantomime-ballet" *Gaspard Hauser* (published in three subsequent issues of *Le Chat noir* in 1883) to the numerous autobiographical chronicles from *Mes Hôpitaux* and *Mes Prisons* published in *Le Chat noir* in 1890.

43. Huysmans was himself an accomplished, widely respected art critic, as Baudelaire had been before him, treating many of the major artists of his time in works such as *L'Art*

moderne (1883) and *Certains* (1889).

44. Jean Lorrain, *Monsieur de Phocas* (Paris: Ollendorf, 1901), 12.

45. "C'était l'heure où Paris s'allume. Toute la boue de la ville coulait vers la débauche, et j'avais toute cette boue dans le coeur.

"Nous dinâmes au cabaret; le soir ce fut une écoeurante tournée dans les boîtes à musique de Montmartre, la pilule amère des idioties cent fois ressassées et des funèbres gaietés de la Butte, toute la veulerie d'une vadrouille dans les endroits où l'on s'amuse, et nous finîmes au Moulin-Rouge.

"De pauvres filles rongées d'anémie, du vice besoigneux et triste, de la misère en haillons de soie et des badauds excités de sales convoitises autour de dessous douteux remués par des professionelles; toutes les hontes d'un prolétariat de luxure secouées, à heures fixes pour émoustiller l'ennui de calicots et de petit bourgeois"(ibid., 249–51).

46. Louis Legrand, *Cours de danse fin de siècle* (Paris: E. Dentu, 1892), 37.

47. For a general work on images of the sexes and sexuality during the period see Elaine Showalter, *Sexual Anarchy: Gender and Culture at the Fin de Siècle* (New York: Viking, 1990). Two works that discuss from different perspectives the relations of fin-de-siècle literature, spectacle, and society are Rae Beth Gordon, "Le Caf'conc' et l'hystérie," in *Romantisme* 64 (1989): 51–67, and Robert Storey, *Pierrots on the Stage of Desire: Nineteenth-Century French Literary Artists and the Comic Pantomime* (Princeton, N.J.: Princeton University Press, 1985).

48. See Florence Goyet's thorough presentation of this point in *La Nouvelle, 1870–1925* (Paris: Presses Universitaires de France, 1993).

49. Villiers de l'Isle-Adam, "Deux Augures," in *Contes cruels* (Paris: Garnier-Flammarion, 1980), 63–77.

50. The structuralist critic Umberto Eco analyzes this tale in *Lector in fabula: La cooperazione interpretiva nei testi narrativi* (Milan: Bompiani, 1979).

51. George Auriol, Tristan Bernard, George Courteline, Jules Renard, and Pierre Veber, *X . . . roman impromptu* (Paris: Flammarion, 1895).

52. George Auriol, "Petit Conte semi-hiéroglyphique," in Grojnowski and Sarrazin, *L'Esprit fumiste*, 265–67.

53. Lemercier de Neuville, *Médard Robinot, casquettier* (Paris: E. Dentu, 1891).

54. Charles Joliet, *Roman incohérent* (Paris: Jules Lévy, 1887).

55. *Tout Ubu* is the title given to the Livre de Poche edition of the complete Ubu cycle. Yet in the preface, Charles Grivel disclaims any pretensions to capturing "all Ubu" on the grounds that "Ubu n'est pas un personnage littéraire, Ubu déborde l'expression écrite qu'on lui connaît" (Jarry, *Tout Ubu*, 1–2).

56. Jarry, ibid., 19.

57. Jarry, ibid., 23.

58. In a congratulatory letter to Jarry, Mallarmé writes: "Comme vous accomplissez d'abord la première chose qu'il y a et avant tout à faire en venant, mon cher poëte: de reculer à l'infini la possibilité des vieux terrains littéraires, pour mettre le pied sur quelque chose de vierge ou de bien à vous, sauf à se laisser disperser le reste–cela en le livre exceptionnel que je ferme, les *Minutes de sable mémorial*: où ce qui, chez d'autres, resterait au niveau du falot, par vous atteint, richement, l'Insolite" (How well you accomplish first of all the first thing and the thing above all to do upon arriving, dear poet: To push back infinitely far the possibility of old literary terrains, in order to set foot on something virgin or completely yours, save letting the rest disperse–this in the exceptional book that I am closing, *Minutes de sable mémorial*: where that which in other people would remain merely quaint, is achieved by you, richly, the Unusual; Stéphane Mallarmé, *Correspondance* [Paris: Gallimard, 1982], 7:95.

59. Jarry, *Tout Ubu*, 19.

60. Frantisek Deak, *Symbolist Theater: The Formation of an Avant-Garde* (Baltimore and London: The Johns Hopkins University Press, 1993), 229–33.

61. Gustave Kahn, in *La Revue d'art dramatique*, September 1889, 335–53.

62. This portrait appears in Albert Millaud's 1887 *Physiologies parisiennes*.

63. Coquelin Cadet, *Le Monologue moderne* (Paris: Ollendorf, 1881), 11.

64. Ibid., 12.

65. Ibid., 28.

66. Rémy de Gourmont, in *Le Mercure de France*, October 1894.

67. "Nous ne savons pas pourquoi, nous nous sommes toujours ennuyés à ce qu'on appelle le Théâtre. Serait-ce que nous avions conscience que l'acteur, si génial soit-il, trahit–et d'autant plus qu'il est génial–davantage la pensée du poète? Les marionnettes seules dont on est maître, souverain et Créateur, car il nous paraît indispensable de les avoir fabriquées soi-même, traduisent, passivement et rudimentairement, ce qui est le schéma de l'exactitude, nos pensées" (Jarry, *Tout Ubu*, 495–96).

68. Gustave Flaubert, *La Tentation de Saint Antoine* (Paris: Garnier Frères, 1954), vi.

69. "Grandes princesses et princes, citadins, villageois, soldats militaires, vous tous fidèles abonnés et acheteurs de cet Almanach de notre astrologie et nos bien aimés sujets et sujettes, vous n'aurez point à lire de journaux cet hiver. O quelle économie d'argent. Le journal d'un sou chaque matin, cela fait bien près de quatre francs, dix, onze ou douze sous tous les trois mois. Je ne parle pas de ceux qui achètent des journaux à trois sous; car plus on vous fait payer cher des faussetés, plus on vous vole. Et comme non seulement nous vous révélons le passé, mais prédisons l'avenir, nous vous offrons donc trois mois en pur don, et l'Almanach ne vous coûte rien. Vous êtes anxieux, pauvres gens, liseurs de feuilles à chute quotidienne, laissés sur votre faim de nouvelles: peut-être demain la fin du monde. Vous vous couchez tremblants de peur. Au cabinet ces cadrans de papier qui n'ont que l'aiguille des minutes. Notre almanach *trimestriel* (*quarterly* disent les Anglais) est un terme payé d'avance dans le rond, solide, confortable, à l'image de notre Gidouille [a neologism for Ubu's enormous round belly], immeuble terrestre" (Jarry, *Tout Ubu*, 348).

70. On the relations of bohemia to bourgeois life in Paris in general see Jerrold Seigel, *Bohemian Paris: Culture, Politics, and the Boundaries of Bourgeois Life, 1830–1930* (New York: Viking, 1986).

71. "Nous, Père Ubu, vous ouvrons notre savoir de tous (lire toutes) les choses passées, plus vraies que de n'importe quel journal, parce que: ou nous vous dirons ce que vous avez lu partout ailleurs, le témoignage universel vous assurera ainsi de notre véracité: ou vous ne trouverez nulle part la confirmation de nos dires: notre parole s'élévera donc en sa vérité absolue, sans discussions" (Jarry, *Tout Ubu*, 349).

157

Fig. 220.
Jules Grün, color lithographic proof for cover of *La Chanson à Montmartre* (Paris: *L'Echo de Paris*, 1900). Bartman Fund.

Fig. 221. **Alphonse Allais,** "Marche funèbre," *Album primo-avrilesque* (Paris: Paul Ollendorff, 1897), 25. Schimmel Fund.

158

Music on Montmartre

In 1900 Erik Satie contributed a short essay, "Les Musiciens de Montmartre," to a guidebook designed to lure tourists from the grounds of the Exposition Universelle to the Butte [Pl. IXa].[1] Satie, the accompanist of the cabaret chansonnier Vincent Hyspa, was then better known for his seven identical velvet-corduroy suits, his makeshift religious sect, and his journalistic battles with the music critic Henry Gauthier-Villars (alias Willy) than for any "serious" musical compositions. Not surprisingly, his essay is more *fumisterie* than factual survey. After a pseudo-apology for his concision—"One may reproach my brevity; so what?" Satie devotes two facetious sentences to pseudohistorical context: "Two or three hundred years ago, very few present-day musicians of the Butte were alive, and their names were unknown to the wider (or even to the narrower) public. But all this has changed, especially–so it would seem–in the last ten years." Having led his reader by the nose into the subject, he devotes the better part of his essay to weaseling out of it. The parting shot is an aphorism worthy of Alphonse Allais [Fig. 221]: "If music does not please the deaf, even if they are mute, that is no reason to disregard it."[2]

All too often, however, it has been disregarded. The perennial difficulty of describing a medium that relies on nonverbal signification, together with the proverbial French preference for the conceptual clarity of the word over the supposed vagueness (even meaninglessness) of purely musical resource, have often conspired against serious consideration of music in the Montmartre cabarets.[3] Nonetheless, cabaret chansonniers *sang* their verse, shadow plays had musical accompaniment, and the parodic slant of Montmartre humor often depended on allusions to familiar tunes, both lofty and lowbrow. While the present essay cannot pretend to be a thorough account, it will attempt something more than Satie's *fumiste* commemoration–namely, to describe characteristic examples of *chanson montmartroise* and of the role that music played in cabaret theaters.

Fig. 222.
Henri de Toulouse-Lautrec, *Carnot malade!* (Sick Carnot!), 1893, stencil-colored lithographic music-sheet cover, 27.6 x 17.6.

159

Fig. 223.
Théophile-Alexandre Steinlen, "Fin de siècle," color photo-relief illustration for *Gil Blas illustré,* 24 February 1895. Bartman Fund.

CABARET CHANSON

Several general distinctions are relevant to a discussion of cabaret song–first, that between a *chansonnier* [Fig. 223] and a *chanteur.* The chansonnier sang poetry he (sometimes she) had written, even though another might have composed (or arranged) the music. The chanteur sang poetry created by someone else. The chansonnier was typically not a trained singer and might even be a rather bad one. Vocal shortcomings, however, were either overlooked or regarded sympathetically, as part of the idiosyncratic savor essential to the performance. The chanteur, on the other hand, typically had the better voice but was less highly regarded by his comrades, unless he happened, like Paul Delmet or Marcel Legay [Fig. 224], to have composed the melodies he sang. As in the meetings of the Hydropathes, so too in the cabaret, the performing poet and composer generally enjoyed a higher artistic cachet than the interpreter of words and music written by others.

A second distinction is that between chansons with newly composed melodies and parodies, or retextings, of melodies originally written for other lyrics. Sentimental chansons were by and large set to newly composed melodies, since they required a somewhat higher degree of musical persuasiveness to complete the sense of the (often rather trite) poetry. Parody, a practice based on centuries-old tradition (e.g., sixteenth-century noëls, the *mazarinades* of the Fronde, and eighteenth-century *comédies en vaudevilles*), was more common in satirical or political chansons, where the main emphasis lay on the text. The listener, already familiar with the tune (or *timbre*), could focus all the more attentively on the words. Parody also opened up rich possibilities of purely melodic reference and subtle interplays between the original text evoked by the tune and the new text provided by the chansonnier. In some cases, the parody invited line-by-line intertextual comparison in the listener's imagination.

A third distinction concerns the privilege, enjoyed by the Montmartre cabarets but not by the café-concert or by cabarets on the Left Bank, of relatively tolerant censorship. Whereas the café-concert was subject to close supervision,[4] the prefecture of police found that, when it tried to crack down on the Chat Noir, the cabaret was "supported energetically by numerous persons of note in politics, letters, and the arts." Even the president of the council had telephoned (on 20 December 1888) to enjoin benevolence toward Monsieur Salis. And yet, the laxity permitted vis-à-vis "a special artists' milieu like that of Montmartre" would (so the police judged) have been all too dangerous if extended to cabarets in the Latin Quarter, which were frequented primarily by university students. Hence, *l'esprit montmartrois* could develop its satirical, irreverent voice without serious interference from the police, until, on 6 April 1897, the prefect Lépine, bowing to pressure from directors of cafés-concerts, established regulations for censoring chansons at the cabarets.[5]

In terms of musical style, cabaret chansons represented a wide gamut. For his famous *chansons réalistes,* Aristide Bruant devised bone-simple recitation formulas (reminiscent of ecclesiastical psalm-tones) that typically move by step within a narrow

melodic range and in short-breathed phrases involving a high degree of repetition. His tunes are deliberately unobtrusive vehicles for their texts; melodic adornment would have been out of keeping with the street folk he aimed to portray. On the other end of the spectrum, Marcel Legay frequently wrote ambitious *mélodies* (that is, art songs) with multiple contrasting sections, even passages of recitative.[6] The stylistic range of the parodies was, if anything, even more varied, for any tune known to the audience was fair game for retexting: arias from operas by Gounod and Bizet, *mélodies* by Massenet, saucy rondos from the *opéras bouffes* of Offenbach and from current operettas, popular songs from the café-concert and music hall, military songs, folk songs, children's songs, and so on. For all its variety, the music was not cosmopolitan. Unlike the cafés-concerts and music halls, which readily welcomed musical imports (and after 1900, the syncopated rhythms of American cakewalk and ragtime songs), the cabarets championed *la bonne chanson française*: folk song and its latter-day imitations. The cabaret composers Georges Fragerolle, Léopold Dauphin, and Charles de Sivry devoted considerable energy to the arrangement of folk songs from the provinces; singers like Suzanne Dariel, Théodore Botrel, and Georges Chepfer specialized in their performance; and the Quat'z'Arts cabaret organized a series of

Fig. 224.
Théophile-Alexandre Steinlen,
"Les Cloches" (The Bells), photo-relief illustration for *Gil Blas illustré*, 29 December 1895. Schimmel Fund.

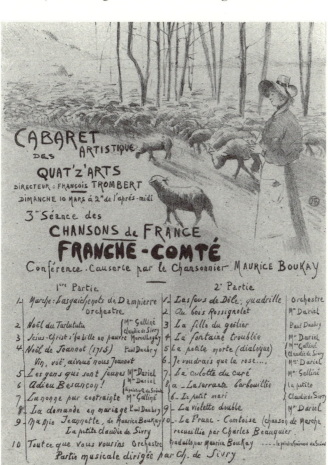

Fig. 225.
Abel Truchet, *Chansons de France, Franche-Comté,* n.d., color lithograph, 32.8 x 24.6. Morse Fund.

Fig. 226.
L. Brunner, portrait of Vincent Hyspa,
from *Le Mur,* 1904, crayon, 19.5 x 12.5.
Schimmel Fund.

Fig. 227.
J. Depaquit, stencil-colored photo-relief
cover illustration for Jacques Ferny,
Chansons immobiles (Paris: E. Fromont,
1896). Schimmel Fund.

causeries-concerts devoted to regional folk song [Fig. 225].[7]

Musical style per se had relatively little to do with the definition of genre within the chanson; this depended rather on the content of the lyrics and the mannerisms (even the physical appearance) peculiar to certain stellar performers. In his autobiographical novel *Qu'il était beau mon village*, Lucien Boyer has François Trombert, owner of the Cabaret des Quat'z'Arts, survey the specialties supposedly available to the beginning chansonnier. The descriptions have virtually nothing to do with musical style.

> "Well, well, if you want to succeed, pick a genre . . . : the realist genre, with boots and red scarf, is all over; Bruant remains inimitable. For the *socialo* genre, you need a filthy mug, and that's not your style. For the open-air chanson, you have to be bald in front and long-haired in the back, like Legay. For the Breton genre, we've got Botrel. For the satirical genre, you've got to be mean, and you look like you still love your mommy. For the romance, there's Delmet, and for the *genre idiot*, I've already got more than enough."[8]

By implication, there were as many genres as performers, for each genre required the cultivation of a distinct persona–preferably one that had not already been defined by an established star. Imitations of Bruant, Legay, Botrel, and Delmet did better in the café-concert than in the cabaret. Vincent Hyspa [Fig. 226] and Jacques Ferny [Fig. 227], with their frostily casual delivery, dominated the "satirical genre." The *socialo* (i.e., socialist) genre, with its obligatory doses of slang, profanity, and indignation, had to be practiced by the hard-up likes of Jehan Rictus, Paul Paillette, and Gaston Couté to be credible. The *genre idiot*, while it here served to vent the frustrations of Trombert's office, referred to the frenetic farcical style practiced by the café-concert performer Dranem and his many imitators. While such performer-defined genres were not without connotations of musical style, the habit of parody blurred any boundaries that might have been drawn on that basis alone. The present discussion will follow Trombert's example and let the lyrics define the categories (however makeshift), starting with chanson [Fig. 228] in which music played the most obvious expressive role.

THE SENTIMENTAL CHANSON

Chief among the sentimental songsters was Paul Delmet, whom Jean Lorrain called the "compositeur ému et printanier d'adorables chansons."[9] A music engraver and chorister at St.-Vincent-de-Paul, he debuted at the second Chat Noir in 1886, singing the *romances* of Jules Massenet and Georges Fragerolle.[10] His supple, finely nuanced baritone seemed a breeze of wholesome nostalgia and *tendresse* in this temple of *fumisme* and irony. He soon began to compose–that is, to write tunes, while depending for the harmonization on musicians better trained than he.[11] His

162

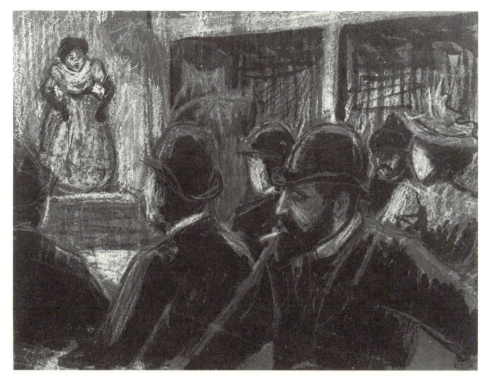

Fig. 228.
Maurice Gueroult, *Jeanne Block at a Cabaret*, c. 1900, pastel, 40 x 52. Gift of the University College New Brunswick Alumni Association.

lyricists were regulars at the Chat Noir (e.g., the poet and house pianist Albert Tinchant, Armand Silvestre, Maurice Boukay, Maurice Vaucaire), whose more or less elevated love poetry usually kept Delmet's chansons from sinking to the saccharine facility of café-concert *romances*.[12] Fetching and unaffected in their musical diction, they prompted Claude Debussy (no stranger to the Chat Noir) to remark that "we have only one musician who is truly French, and that's Paul Delmet [Fig. 229]; he alone has set down the melancholy of the *faubourgs*, and that sentimentality that laughs and weeps upon the reddened sword of the fortifications."[13]

The typical Delmet tune ambles at a leisurely pace, usually in compound meter, over a fairly wide melodic range. The harmony is technically simple but ingratiating, tinged with melancholy without wallowing in it. A characteristic example is "Tout simplement" [Figs. 230a–b] Maurice Boukay's poem works with the commonplace metaphor of the lover's heart as a flower–gathered by the beloved, worn as a corsage, growing toward her lips, and there expiring.[14] The key of this sixteen-measure strain is A-flat major, but the medial cadence falls on F minor (on the lines "Vous avez pris mon coeur morose, / En passant devant ma maison"). The gently undulating melody sets the text syllabically, with simply grasped rhythmic patterns that recur in every four-measure phrase and thus provide coherence to its variations and contrasts.[15] The principal rhythmic contrast is reserved for the words of the title, which recur at the end of every stanza in longer note values.

Fig. 229.
Adolphe Willette, lithographic portrait of Paul Delmet, for Paül Delmet, *Nouvelles Chansons* (Paris: Henri Tellier, c. 1895).

Figs. 230a–b.
Maurice Boukay, "Tout simplement," *Les Chansonniers de Montmartre,* 5 April 1906. Bartman Fund.

Figs. 230c–d.
Paul Delmet, "Le Vieux Mendiant," *Les Chansonniers de Montmartre,* 25 March 1906. Bartman Fund.

Fig. 231.
George Auriol, photo-relief cover illustration for Gabriel Montoya, *Chansons naïves* (Paris: Paul Ollendorff, 1895). Gift of Sara and Armond Fields.

"Le Vieux Mendiant" [Figs. 230c–d], one of Delmet's successes at the Chat Noir,[16] sets Henri Bernard's poem of the resigned old beggar who has squandered his wealth on "Margot la brune" and now is left only with the song of his woes, which he pours out "au clair de lune." More vigorous rhythmically than "Tout simplement," the song nonetheless shares many features with it: largely syllabic declamation, and a major key darkened momentarily by a patch of (rather awkwardly handled) minor harmony just after the medial cadence (at the text "Ah! mes écus, qu'en as-tu fait . . . Margot la brune?"). Foursquare phraseology and the regular phrasing is altered only by an inserted measure in which, *ad libitum* and unaccompanied, the voice trips upward, in short rhythmic values, through an octave and a fourth–to depict, in each stanza, the rapid disappearance of the singer's worldly wealth.[17]

The Chat Noir's other acclaimed *romancier* was Gabriel Montoya [Fig. 231], the physician from Perpignan who abandoned his medical career for the cabaret. Endowed with a "voix chaude, captivante et prenante," Montoya was a rhymer rather than a composer;[18] his tunes were provided by Gaston Maquis, Marie Kryzinska, Sivry, and Legay (among others). Unlike the texts favored by Delmet, Montoya's typically have a bawdy or sarcastic bite. "Les Jolies Poupées" is sardonically dedicated to two celebrated courtesans of the café-concert, Liane de Pougy and Otéro, whose chief talent (according to Montoya) is spending money and weakening men's knees. "Le Professeur de musique," a *chanson de diction* with music by Jules Rotys, plays on a topos at least as old as Rossini's *Barber of Seville*: the music lesson as pretext for amorous play, which in this case advances so far that the pupil achieves, within the course of an hour, "plus de six fois l'accord parfait."[19] On the more serious side, "Le Vieux Modèle" (music by Kryzinska) paints a sympathetic portrait of an artist's model suffering personal and professional rejection. A standard lover's plaint is the relatively straightforward "Serment trahi," simply and syllabically set by Legay in a manner akin to Delmet's style. The most striking feature of the song is its brief refrain, in which the mode changes from major to minor for the swain's bitter lament: "Tra-la-la, how mad I was to believe [her words]!"

Of all styles of cabaret chanson, the *romance* was the least provocative and the most widely appreciated. Delmet's chanson albums and sheet music (illustrated by the likes of Adolphe Willette and Théophile-Alexandre Steinlen) sold briskly, and *divettes* of the café-concert eagerly took his songs into their repertoires. By the same token, the sentimentality of Delmet's chansons made them an easy target for parodies, the sheer number of which attests to the popularity of their models.

PARODY AND SATIRE

In early 1895 the young Breton poet Théodore Botrel attended the inaugural performance at the Chien Noir, the first *cabaret montmartrois* to open in Paris proper.[20] The highlight of the evening for Botrel was the combination of Delmet and Vincent Hyspa. Delmet closed his set with "Le Vieux Mendiant" (described above).

> What an admirable voice and what diction! We could have listened to him the whole night without tiring, so effortlessly did he seem to sing; he sang as one breathes.
> Then, Vincent Hyspa took the stage . . . and it was delirium. He customarily began his *tour de chant* with a parody of the last song interpreted by Delmet. . . . By holding in his hand a minuscule piece of paper [usually a cigarette paper], Hyspa already parodied his colleague, who always leafed through thick scores to give himself airs. Then he announced, with a lugubrious voice, "Le Vieux Mendigot."[21]

Fig. 232.
A. Rouveyre, "Le Noyau qui ne passe pas," for Vincent Hyspa, *Chansons d' humour* (Paris: Enoch & Cie, 1903), 167. Bartman Fund

Botrel compares Delmet's lyrics with Hyspa's distortion line for line and describes how Hyspa even imitated his colleague's crooning style by shifting into head voice, his deadpan face belied only by a twinkle in his eye.

Hyspa had begun parodying Delmet's *romances* in 1892 at the Chat Noir, so successfully that other cabarets often tried to hire the two performers together.[22] Characteristic of Hyspa's mordant style is his transformation of Delmet's "Femme qui passe" (poem by Henri Maigrot) into "Le Noyau qui ne passe pas" [Fig. 232].[23] The nostalgic evocation of a woman passing by becomes a quest for an accidentally swallowed prune pit. In Maigrot's four stanzas, a man propositions an unknown woman in flowery language and with a string of dichotomous rhetorical questions ("Es-tu le vice ou la vertu?" and "Es-tu l'ange, es-tu le démon?"). By the third stanza, the chance meeting has become an affair. The two enjoy a day of love, but the man, not trusting the woman entirely, withholds his heart. In the last stanza, he looks back wistfully–"J'étais jeune, elle était jolie"–and decides that he will love her endlessly and without restraint. The circumstance that the woman is no longer there to reciprocate does not deter the man from a high-flown peroration, "Le ciel est bleu, L'amour est roi!"

Hyspa's parody, three stanzas long, selects specific lines from Maigrot's lyric for distortion, in complete disregard of their original order and context. Hyspa must have designed it to follow directly Delmet's own rendition of the model, for he seizes first on Maigrot's last stanza:

> J'étais jeune et plein d'esperance.
> Un soir, en mangeant des pruneaux,
> Je laissai passer un noyau
> Et depuis, je suis dans les transes!
> Petit noyau, noyau pointu,
> Petit noyau, où t'en vas-tu?

167

The nostalgic *romance* is instantly deflated: "I was young and full of hope. One evening, while eating prunes, I let a pit go down." Hyspa's fourth line lances the ecstatic "Et depuis . . . je l'aime toujours," while his closing line goes back to Maigrot's first stanza, "Femme inconnue, où t'en vas-tu?" Punning viciously, Hyspa ends his second stanza with an allusion to Maigrot's high-flown rhetorical questions: instead of "es-tu passé, es-tu l'avenir?" (are you the past, are you the future?) he sings "noyau têtu, Es-tu passé, passeras-tu?" (stubborn pit, have you passed, will you pass through?). In Hyspa's last stanza, one would expect some distortion of Maigrot's "l'amour est roi," but instead he broadens the scope of his parodic attack with three ironic references to the *chansons revanchardes* that became wildly popular in the cafés-concerts and in the streets after the humiliating defeat of 1871:

> Je l'attend à brève échéance
> Et je fêterai son retour.
> Qu'il soit d'Agen, qu'il soit de Tours
> C'est un noyau qui vient de France!
> Petits enfants, chantez plus bas;
> Sentinelles, ne tirez pas!
> (I await it within short order, and I shall celebrate its return. Be it from Agen or from Tours, it is a prune pit that comes from France. Little children, sing more softly; "sentinels," hold your fire!)

The third last line plays on the refrain of "L'Oiseau qui vient de France,"[24] while the next quotes "Le Maître d'école alsacien."[25] "Sentinelles, ne tirez pas" (also from "L'Oiseau qui vient de France") annihilates Delmet's *romance* and all *romances* of patriotic sentiment, since *sentinelles*, in the present context of gastric distress, takes on its vulgar subsidiary meaning (turds) instead of its usual one.

Cabaret chansonniers frequently directed their parody at "highbrow" repertoire. Hyspa appropriated the famous toreador song from Bizet's *Carmen* for "La Triste Fin du taureau Romito aux courses de deuil," which recounts a bullfight from the beast's point of view.[26] Henri Fursy took aim at Xavier Leroux's *Astarté*, a four-act grand opera premiered at the Académie Nationale on 15 February 1901, with a parodic potpourri of airs from Méhul's *Joseph*, Meyerbeer's *Huguenots*, Halévy's *Juive*, Meyerbeer's *Africaine*, and (finally) Gounod's *Faust*.[27] In such an unusual case, the satiric end justified the operatic means. Those means, in turn, depended on the often-decried calcification of repertoire at the Opéra, which helped to assure the audience's acquaintance with any air lifted from its stock of continually repeated standards. Pierre Trimouillat [Fig. 233], whose reputation was made as much in song-and-supper societies like the Caveau as at the Chat Noir, showed a penchant for the *mélodies* of Jules Massenet, whom one scholar of French art song has characterized as "the idol of the cultivated bourgeois of his time."[28] Like Delmet's sweetish airs, Massenet's songs "in suede gloves" lent themselves to parodic deflation.[29] A telling example is "Les Enfants," which sets to appropriately syrupy harmonies a sugar-coated poem by Georges Boyer about the innocence of childhood. Boyer's

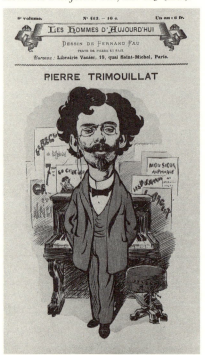

Fig. 233.
Fernand Fau, "Pierre Trimouillat," stencil-colored photo-relief cover for *Les Hommes d'aujourd'hui*, no. 413 (n.d.).

first strophe is here reproduced with the matching verse from Trimouillat's "Gouvernants."[30]

> [Boyer]
> On ne devrait faire aux enfants
> Nulle peine, même légère.
> Ils sont si doux, ces innocents
> Suspendus au sein de leur mère!
> Dieu mit dans leurs yeux caressants
> Comme un rayon de sa lumière.
> Quand ils vont à pas chancelants,
> Le lys s'incline jusqu'à terre,
> Et les voyant passer si blancs,
> Le tourtereau se croit leur frère!
> (One should not administer any punishment to children, even a mild
> one. These innocents are so gentle, hanging at their mother's breast. God
> placed in their caressing eyes something like a ray of his own light. When
> they go toddling along, the lily bows to the earth, and, seeing them pass
> by, white as they are, the turtle dove thinks himself their brother.)

> [Trimouillat]
> Il ne faut faire aux gouvernants
> Qu'une opposition légère.
> Ils sont si doux, si peu gênants,
> Pour la Majorité, leur mère,
> Qui, les croyant entreprenants,
> Leur donne un pouvoir éphémère.
> Devant eux et tous leurs parents,
> Chacun s'incline jusqu'à terre,
> Et les voyant soudain si grands,
> Le Président leur traite en frère.
> (One must offer the powers that be only mild opposition. They are so
> gentle, so little troubling to their mother the Majority, which, believing
> them enterprising, grants them an ephemeral power. Before them and all
> their relatives, everyone bows to the earth, and, seeing them suddenly so
> great, the president treats them as a brother.)

With evident relish Trimouillat expands on the wholly ironic point that politicians are not to be despised as scoundrels but indulgently tolerated, like so many well-meaning if inept children. The parody gains considerably in comic impact from Trimouillat's close adherence to the rhyme scheme and vocabulary of Boyer's poem, with which it invites continual comparison. Vincent Hyspa proceeded rather more brutally with the same verses. He took over Boyer's first strophe nearly intact, changing only the first poetic line to "On ne doit faire aux éléphants." This single satiric twist renders ludicrous the remainder of the strophe (in ll. 7–8, the lilies now bend under the weight of tottering pachyderms) and brings Boyer's idyllic and idealized portrait crashing to earth.[31] The *envoi* of each poem deserves quotation:

[Boyer]
Aussi, soyez leur indulgents,
Pour eux, jamais de front sévère,
Les chérubins ont bien le temps
De connaître notre misère.

[Trimouillat]
Aussi, soyez leur indulgents,
Pour eux, pas de discours sévère.
Les malheureux n'ont pas le temps
De connaître leur ministère.

[Hyspa]
Aussi, soyez leur indulgents,
Pour eux, jamais de front sévère,
Car ils ne mettraient pas de gants
Pour nous mieux botter le derrière.[32]

Each parodist begins by quoting Boyer exactly. Trimouillat then gently bends the model in the direction of his point about the ignorance of ministers, while Hyspa thrusts the model aside for a blunter conclusion.

The café-concert [Fig. 234] produced a ready supply of chansonnettes that cabaret parodists turned to satiric account. They did so all the more avidly because the *caf'conç* as an institution was disdained in cabaret circles. Rodolphe Salis, whenever his audience was not sufficiently responsive to his witticisms, would tell them, "You'll find the Concert Européen in the rue Biot!" hinting that their tastes would be better

170

served by the supposedly mindless entertainment to be found there.[33] Jacques Ferny went so far as to write a chanson for a café-concert chanteuse, Camille Stéphani, that mocked the shortcomings of such chansons generally (including the obligatory *couplet patriotique*). Yet the request had come from Mlle Stéphani, and Ferny had been at a loss how to fulfil it. As he admitted to the poet Hugues Delorme, "Une chanson de café-concert, ça n'est pas mon rayon!" (A café-concert song isn't really my thing). Delorme advised him, "Très simple: change ta manière, c'est-à-dire écris quelque insanité soigneusement dépourvue d'esprit; et tu t'excuseras en disant dans le refrain: c'est une chanson de café-concert" (It's easy: change your manner; I mean to say, write some mindless nonsense for which you apologize in the refrain by saying that it's a café-concert song).[34] Accordingly, halfway into the first stanza, Ferny had his singer address the public as follows:

> Vous vous dit's, j'en suis sûr, d'avance,
> Mesdam's, messieurs de la société,
> Qu'à la façon dont ell' commence
> Ma chanson manque de nouveauté . . .
> C'est un' chanson d'café-concert;
> Qu'est-c' que vous voulez que j'vous dise?
> Celui qui l'a faite a vraiment souffert . . .[35]
> (You are surely saying to yourselves already, ladies and gentlemen of high society, that, to judge from the manner in which it has begun, my chanson lacks originality . . . Well, it's a chanson for the café-concert; what else can I say? The one who wrote it really suffered in doing so . . .)

Fig. 235.
Alfred Le Petit, "Jules Jouy," photo-relief illustration for Horace Valbel, *Les Chansonniers et les cabarets* (Paris : E. Dentu, 1895), 143.

For the last three lines, Ferny underscores his satiric point by shifting into an appropriately simpleminded melodic style, with short, repetitive triadic figures that evoke the manner of a café-concert *scie* (saw).[36] Such musical and textual swipes, however, should not distract one from observing that chansonniers of the cabaret and even the Hydropathes had frequently reverted to the jingling redundancy of the *caf'conç scie*[37] as if courting popularity while mocking it. Their audience had, in any case, long been accustomed to such musical frivolity by Offenbach's *opéras bouffes*. From the patter song à l'Offenbach to the patter of Charles Cros's "Hareng saur" is but a short step, stylistically as well as chronologically.

One of the most notorious of café-concert chansonnettes was "En rev'nant de la revue," introduced by Paulus in July 1886 at the Alcazar d'Eté. The sprightly march song had an innocent enough subject: a family enjoying the military exercises at Longchamp on Bastille Day. What made the song notorious was Paulus's decision, for his Bastille Day performance, to substitute two new lines acknowledging the dashing figure cut in those exercises by General (and currently war minister) Georges Boulanger.

> Ma tendre épouse bat des mains
> Quand défilent les Saint-Cyriens.
> Ma bell' mèr' pouss' des cris

> En r'luquant les Spahis,
> Moi, j'faisais qu'admirer
> Not' brav' général Boulanger.[38]
>
> (My gentle wife claps her hands when the cadets of Saint-Cyr [the French military academy] pass by. My mother-in-law cries out as she ogles the Spahis [North African soldiers]. Myself, I did nothing but admire our brave General Boulanger.)

Paulus's hit became inseparable from the military strongman who seemed to promise simple solutions to every national ill, especially to wounded French pride smarting at the Prussian occupation of Alsace and Lorraine. Jules Jouy [Fig. 235], no friend of Boulangism, accordingly chose this tune for a sarcastic account of the general's surreptitious return to Paris from the provincial post to which a nervous government had assigned him–quite at odds with the expectations of "les courtisans de la Boulange" for a glorious epiphany (*Cri du peuple*, 16 November 1887).

> Il s'est fait, pour ce jeu d'cach'-cache,
> Couper la barbe et la moustache;
> C' qui lui donnait, à lui si beau,
> La mine d'un vulgair' cabot
> .
> Il est r'venu;
> Et personn' ne l'a vu;
> Il est rentré par u-
> n' porte de derrière.
>
> (For this game of hide-and-seek, he had his beard and mustache shaved off, which gave the ever so handsome fellow the air of a common corporal. . . . He has returned, and no one even saw him; He slipped in through the back door.)

Unlike the parodies by Hyspa and Trimouillat discussed above, Jouy's hardly refers to the text of the original song.[39] It is the melodic association alone that makes his point. A dozen years later, Henri Fursy adopted the same tune and the same technique for "M. Loubet au Grand Prix," but Fursy's political sentiment is diametrically opposed to Jouy's. On 4 June 1899, one day after the Cour de Cassation had decreed revision of the verdict against Dreyfus, President Loubet had attended a grand steeplechase at Auteuil; royalists and other anti-Dreyfusards were out in force, and one young baron actually attacked the president with his cane, crushing his top hat.[40] The subject of Fursy's chanson was the counterdemonstration staged the next week by Dreyfusards at Longchamp, where Loubet was to attend the Grand Prix. Fursy, who prided himself on his aristocratic clientele, notes the absence of *les grands Cercles* at a race that would otherwise have been a major event for high society ("Rien que les Cercl's républicains"), then comments snobbishly on the unwashed workers who did go to Longchamp to express support of Loubet, implying that their support had been purchased with a "hail of *sous*":

Il n'y avait là qu'des Anarchistes:
Les seuls, les vrais bons électeurs!
 Ils échangaient entre eux
 Un tas d'lazzis joyeux;
Ils échangaient mêm' quelques poux,
Quelques punais's et quelques coups.
 Puis un silenc' se f'sait,
 Un signal s'élevait,
 Un' grêle de sous tombait,
Et tout l'mond' criait: «Viv' Loubet!»
(There were only anarchists, the only constituents, the truly good ones!
They exchanged a heap of jeers, some fleas, some bedbugs, and several
blows. Then, silence, and upon signal, a hail of sous fell to earth, and
everyone shouted, "Long live Loubet!")

The choice of "En rev'nant" for parody would seem to have been motivated by two
factors: the location of both events (the Bastille Day military review and the Grand
Prix) at Longchamp, and the implied contrast between "Not' brav' général Boulanger"
and the mild-mannered Loubet, who in Fursy's chanson arrives with egg yolk from
a previous demonstration still plastered to the back of his coat, and who fears, at the
end of each strophe, that someone will emerge from the crowd to "M'casser la
gueule." Fursy would turn again to "En rev'nant" (again at Loubet's expense) for "Le
Czar en France," which comments sarcastically on the second visit of Nicholas II to
Paris (18–22 September 1901).[41] The choice of tune is prompted in this case by the
military review that Nicholas witnesses and by the fact of his *return* to France after a
hiatus of several years:

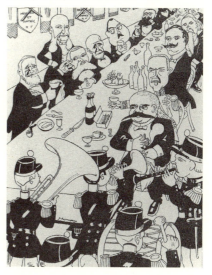

 Depuis qu'Loubet est roi de France,
 Notre ami le Czar Nicholas
 Avait brillé par son absence,
 A nos fêtes, à nos galas.
 (Since Loubet is king of France, our friend Czar Nicholas has been con-
 spicuous by his absence at our holidays and gala events.)

"En rev'nant" is only the framing song in a potpourri drawing on ten different
chansons. Fursy changes his *timbre* for each episode of the visit (e.g., the "Berceuse
bleue" for Loubet's approach over the waters to Nicholas's yacht, "Joséphine elle est
malade" for a boatload of seasick senators), and saves the pithiest musical allusion,
to the military tune "As-tu vu la casquett' au père Bugeaud," for the French chief of
protocol:

 Et les p'tits troupiers
 Se mir'nt à crier:
 «As-tu vu la casquette russe à Crozier?»
 (And the little campaigners began to shout, "Have you seen the Russian
 helmet on Crozier?")

The more widely known the tune, the more often it was used for parody. The children's song "Compère Guilleri," "Au clair de la lune," "Cadet Rousselle," "Mon Père était pot," "Le Bureau de placement," Offenbach's "Ronde du brésilien," and the old Bonapartist rouser "T'en souviens-tu" are among the *timbres* that recur time and again in the published anthologies, often without attribution or with no further designation than *air connu*. Often the *air connu* itself would be distorted.[42] Ferny, for example, transforms "T'en souviens-tu" into a waltz for his jibe at that self-appointed guardian of public morality, Senator Bérenger (known on Montmartre as Père la Pudeur). The parody bears no relation to the original lyrics of the tune; the only connection is the homonymic likeness of Ferny's subject with the supposed composer of the tune, Pierre-Jean de Béranger, the famous chansonnier of the Caveau Moderne.[43] But the musical transformation itself, from martial tune to dainty parlor waltz, makes its own comment about Père la Pudeur. Just as pointed is Ferny's distortion *en valse* of Frédéric Bérat's once-popular romance "Ma Normandie" (which Ferny, as a Norman, would have known quite well) to describe the minister who constantly travels to the provinces to inaugurate public monuments, for the sole purpose of pocketing hefty per diems.[44]

One obvious butt of parody was "La Marseillaise," which, as the musical emblem of republican patriotism, had been retexted countless times during the nineteenth century.[45] Even untexted, "La Marseillaise" could have a satiric impact through purely melodic quotation, as may be shown by the first cabaret chanson that Erik Satie composed for Vincent Hyspa, "Un Dîner à l'Elysée" [Fig. 236]. In May 1899 Loubet invited various artistic boards to banquets at Elysée Palace in connection with the annual Salon. To judge from the incongruities in the text, Hyspa smelled a rat in the mingling of painting and politics. Satie's tune has incongruities of its own; it is an off-kilter march in which no phrase matches any other. After each course in the banquet, Hyspa brings on a regimental band to play the national anthem. While the print gives only Satie's melody for the couplets, one learns from Satie's manuscript that Hyspa spoke the refrain ("Ça sentait bon") while Satie introduced a snippet of "La Marseillaise" into the accompaniment:[46]

> Le Président, d'une façon fort civile,
> Avait invité nos grands peintres français[47]
> A venir goûter de sa cuisine à l'huile.
> On raconte que ce fut vraiment parfait.
> Après la soupe, radis et caviar
> Pour faire plaisir au Czar, . . .
> Ça sentait bon—et le moment fut suprême—
> Et la musique du soixante-quatorzième
> De ligne jouait
> (Ne vous déplaise),
> La Marseillaise,
> Hymne vraiment français

(Ou française).

(The President, as civil as could be, had invited our great French painters
to come taste of his cuisine in oils. They say it really was just perfect.
After the soup, the radishes, and the caviar [just to please the czar] . . .
{Refrain} The taste was fine, the moment supreme, and the band of the
seventy-fourth regiment was playing [like it or not] the "Marseillaise," a
truly French hymn [or is it her?].)

Hyspa's witticisms are difficult to render in English translation without further
explanation. For example, "cuisine à l'huile" stands in place of "peinture à l'huile"
but also connotes "his greasy fare," for Loubet hailed from the south of France,
where cooking oil is used generously. The humor of the last two lines derives from
the uncertainty whether the adjective *French* should agree in gender with *hymne* in its
secular (masculine) sense or its religious (feminine) sense. In subsequent strophes,
the president's wife attempts refined conversation with the minister of fine arts
but can utter little more than the refrain of a café-concert *scie* ("En voulez-vous, du
z-homard?"); Loubet has to send his son to the corner bistro when the wine unex-
pectedly runs out; and (worst of all, from the standpoint of Montmartre bohemians)
the artists depart bowing and scraping in servile fashion, "tout en borborygmant."
As in many of Hyspa's chansons, what should be a grand affair is only pretentious
and brings out the essential meanness of everyone concerned.

Jacques Ferny figuratively pulverized the national anthem for "La Statue (Discours
d'inauguration d'un ministre)."[48] Returning to the theme of the vapid political speech,
Ferny has his anonymous minister inaugurate the statue of a provincial nonentity of
whose name and accomplishments he has not even bothered to inform himself.
Ferny's melody, a patter song in 6/8 time, alternates with successive fragments of "La
Marseillaise." A burlesqued version of the anthem's first four measures introduces
the first strophe, the refrain of which ("C'était, messieurs, un vieux républicain")
leads to the next two measures of the anthem, and so forth through six strophes.
Each reference to the "old republican" brings a wry musical tribute in the form of a
snippet torn from its melodic context.

The Left Bank chansonnier Georges Millandy observed that the true Montmartre
chansonnier was ever ready to laugh at himself, and he cites Hyspa's "Chansonniers"
as a case in point.[49] For his deflation of cabaret songsters, Hyspa chose a salacious
chansonnette légère by Gustave Goublier, the orchestra conductor at the Moulin Rouge,
titled "Musique de chambre." The title refers to the (bed)chamber "music" made by
an amorous couple. The beginning of the second stanza gives an idea of the (rather
heavy-handed) imagery involved: "We're always in unison, we don't need any pre-
lude, we attack our loveliest piece straight off, without having to warm up." Hyspa's
parody presupposes acquaintance with this frivolous text while referring to it only
indirectly (see line 6 of the stanza below):

Les chansonniers, bien que divers,
Ont tous une égale manie:

175

Fig. 237.
"Vincent Hyspa," photo-relief illustration
for *Paris qui chante* (7 October 1906).
Collection of Steven Moore Whiting.

Après qu'ils vous ont mis en vers
Toute les proses de la vie,
Ils collent tout ça sur des airs,
Sur de honteuses mélodies . . .
Ça n'est pas leur moindre travers,
Faut encor qu'ils les psalmodient!
(Chansonniers, while a diverse lot, all have the same mania: after they have
rendered into verse all the prose of our life, they paste the stuff onto
tunes, onto shameful melodies . . . And that's not their least fault; they feel
called upon to chant them as well!)

The ironic self-observation extends to the chansonniers' penchant for far-fetched
wordplays. The third stanza is full of expressions that involve puns on animal
names, then derides chansonniers for making the "jeu de mots ahurissant" ("Dieu,
que c'est *bête* et stupide!"). The fourth stanza attacks those malcontents, the political
chansonniers, of which Hyspa himself was a sterling example:

Un qui n'est pas souvent content,
C'est le chansonnier politique,
Sous n'import' quel gouvernement
Il se fout de la République.
(One who's almost never happy is the political chansonnier; no matter
what the government, he doesn't give a damn for the Republic.)

In the final strophe, the bohemian cop-out, that of claiming that one's poetic wares
are too good for a public that would surely reject them, comes up for sarcastic
comment (as it also did in the merciless "Les Bohèmes" of Hyspa's fellow law-student
Léon Xanrof[50]). The autoreferential aspect of cabaret literature has received due com-
ment elsewhere in this volume; in this case, it seems to have been a question of
keeping one's satirical self honest.

If Hyspa [Fig. 237] parodied a café-concert chanson about "music making" for a
derisive song about song making, Henri Fursy [Fig. 238] had a different motivation
for his potpourri "La Mort des chansonniers." By 1900 journalists were observing
ever more frequently that the chansonniers of Montmartre were losing their creative
impetus. On 22 October Jean Rameau (formerly a poet at the Chat Noir) observed
that Parisians were beginning to ridicule those who ridiculed for a living: "they have
had enough of biting songs, served up hands-in-pockets, enough of *redingotes* down
to the feet, powdered with dandruff, and of other graces by virtue of which Montmartre
has conquered the universe."[51] Fursy introduced, in early November, a composite
parody in which he imitated each chansonnier in his troupe: Mévisto aîné, Gabriel
Montoya, Dominique Bonnaud, Paul Delmet, Hyspa, and Jean Goudezki.[52] He
changes *timbre* for each imitation and, in at least two cases, selects tunes that the
chansonnier in question had introduced at the Boîte à Fursy the preceding season:
"Etoile d'amour" for Delmet and "Ça fait toujours plaisir" for Hyspa.[53] With obvious

Fig. 238.
"La Boîte à Fursy," photo-relief illustration for Victor Meusy and Edmond Depas, *Guide de l'étranger à Montmartre* (Paris: J. Strauss, 1900), 43. Schimmel Fund.

Fig. 239.
Henri Rivière, "La Ventouse" (The Sucker), from *L'Album du Chat noir,* 1886, collotype, 27 x 21. Morse Fund.

irony, Fursy echoes the complaints registered in the press. Concerning Mévisto aîné, for example, he notes

> D'abord, et c'est l'un de mes gros reproches,
> Il n'met pas toujours ses mains dans ses poches:
> Et chacun sait bien qu'un vrai chansonnier
> Ne doit, au public, montrer que ses pieds.
> (First—and this is one of my greatest reproaches—he doesn't always stick his
> hands in his pockets; and everyone knows that a real chansonnier ought
> not to show anything above his feet in public. [The conventional standard
> for ladies' dress lengths is here applied to the chansonnier's frock coat.])

Jean Goudezki, famous for his *sonnet holorime* to Alphonse Allais, is castigated by Fursy for his "poèmes peu concrets, / Qui ne riment pas à grand'chose!" (Not very concrete poems, / Which do not rhyme with much!). As for Delmet, "C'est les Poires d'amour [the Pears of love instead of the star of love—"l'étoile d'amour"], Qu'il chante avec tristesse." Concerning Hyspa, the usual complaint was that he kept the same chansons too long in his repertoire; a good *chanson d'actualité*, Hyspa claimed, should "last" at least seven years.[54] Fursy, who set great store by productivity, thus commented rather pointedly in Hyspa's case:

> Quant à Hyspa, qui porte
> Un séduisant complet,
>
> V'là dix ans qu'il apporte
> Toujours le même couplet
> .
> C'est un bonheur suprême
> De souvent l'applaudir,
> Mais si c'n'était pas l'même
> Ça f'rait bien plus d'plaisir!
> (As for Hyspa, who wears a seductive suit, . . . He's been singing the same
> verse for ten years now.... It is supreme happiness to applaud it often, but
> if it weren't always the same one, it would please us all the more!)

Fursy reserves his final stanza to mock his own performance mannerisms, thus bringing the autoreferential parody full circle. Mutual parody had been an important component of the "insider" verse copied into the *Album zutique* (e.g., by Arthur Rimbaud) and published in *Le Chat noir* (e.g., Verlaine's "Vers à la manière de plusieurs," which included a parody of himself). Fursy's composite parody, however, is trimmed for public consumption, to answer charges that cabaret performance was, so to speak, a victim of its own financial success. Increasing professionalization entailed the risk of increased exploitation of the same routines. However, the antidote proposed by Fursy and other cabaret owners—*toujours du nouveau*—went against the spirit of the semiprivate gatherings that had been the glory of the first Chat Noir, where each poet and chansonnier offered his work (without remuneration) for the delectation

Fig. 240.
Jean Veber, *Yvette Guilbert,* c. 1895,
watercolor, 25.8 x 23.4. Gift of Carleton
A. Holstrom.

Fig. 241.
Gerlier, photo-relief cover illustration for
Jules Jouy, *La Muse à bébé* (Paris: Librairie
Marpon & Flammarion, 1892).
Schimmel Fund.

of his colleagues. Now subject to public market forces of supply and demand, and to the pressures of staking their livelihoods on the continuation of a Chat Noir "tradition," chansonniers were expected to furnish novelties in a steady stream for a public of wealthy Parisians and tourists eager for fashionable titillation.

The use of musical parody virtually enforces ephemerality. While it originally increased chances of comprehension through reference to musical texts whose familiarity was taken for granted, it also foreclosed comprehension by generations unfamiliar with the tunes and their original texts. Latter-day observers who painstakingly reconstruct the manifold allusions and explain their import have little chance of re-creating the unforced smile or even belly laugh that the allusions would have had for listeners steeped in their models. Fursy's *Astarté* must fall flat, not only because of the obscurity of its subject (i.e., Leroux's opera), but because its parodic frame of reference–the once-favorite airs of Méhul and Meyerbeer–can no longer be assumed; just as John Gay's *Beggar's Opera* cannot be appreciated without some familiarity of the broadside ballads of the 1720s and Tom Lehrer's allusions to Jerome Kern are lost on all but a few devotees of the Broadway musical. Ultimately, the most durable of the satiric cabaret songs have proven to be those that ridiculed bourgeois mores rather than political events of the day, and those for which the chansonnier provided his own melody rather than appropriating another. Both circumstances apply to Léon Xanrof's famous chanson "Le Fiacre," which made it possible for this and others of Xanrof's songs to be grafted into the café-concert repertoire through the championship of Yvette Guilbert [Fig. 240].

MACABRE CHANSONS

Of the chanson styles cultivated at the Chat Noir, perhaps the most peculiar (and least transportable to other venues) was the macabre style associated with three chansonniers who had been heard first among the Hydropathes: Jules Jouy, Maurice Rollinat [Fig. 239], and Maurice Mac-Nab. All three wrote poems with "dark" subject matter, unrelieved by any humor except of the blackest sort. Jouy, certainly the most prolific of the *chansonniers d'actualité* and the one most radically left-wing in his political sentiments,[55] occasionally took on subjects that make the grimmest of Bruant's *chansons réalistes* pale by comparison. Typical of Jouy in this vein is "Le Petit Martyr," a horrible tale of child abuse that ends with the child's death, to be sung to the tune of "La Complainte de St.-Nicholas." The first strophe imitates the standard "gather round and ye shall hear" gambit of the *complainte*:

> Enfants, écoutez le récit
> Que je m'en vais vous faire ici:
> A Paris, dans une maison
> Aussi triste qu'une prison.

Il était un petit martyr
Qu'on ne voyait jamais sortir.
(Children, heed the story that I now shall tell you: In Paris, in a house sad
as a prison, there once was a little martyr whom one never saw go out.)

This is the unlikely first chanson in Jouy's collection *La Muse à bébé: Chansons pour les enfants dédiées aux grandes personnes* [Fig. 241],[56] a placement surely meant to sharpen its impact on *grandes personnes*. Unfortunately, the frequency with which one encounters stories of *enfants martyrs* in the agony columns of Parisian dailies around 1900 justifies the means by which Jouy expressed his outrage. Jouy devoted similarly bitter verses to "La Veuve" (the guillotine) as grisly "lover":

Appelant le mâle attendu,
La veuve à lui s'offre, coquette
.
Dans un accouplement hideux,
L'homme crache son dernier râle,
Car ses amants, claquant du bec,
Tués dès la première épreuve,
Ne couchent qu'une fois avec
La veuve.[57]
(Calling her awaited mate, the "widow" offers herself coquettishly. . . . In
a hideous coupling, the man spits out his death rattle, for her lovers—their
teeth a-chatter, killed in the first round—sleep only once with the "widow.")

In the view of Jean Rameau, it was Jouy who had launched the vogue of morbid subjects haunted by the spirit of Baudelaire.[58] That honor, however, more rightly falls to Maurice Rollinat, one of the founding members of the Hydropathes, who catapulted to celebrity in the fall of 1882 when his performance at a soirée chez Sarah Bernhardt was lavishly praised on the front page of *Le Figaro*. Michel Herbert summarizes contemporary accounts of Rollinat's uniquely gripping manner of performance:

> An incomparable reciter of poetry, Rollinat transfigured himself and became sublime when, seated in three-quarter profile at the piano, he brushed the keyboard with his inspired fingers and sang that bizarre, jerky, captivating music—music composed by instinct, in a single cast, without care for the laws of harmony, music that, most often, his extraordinary voice ranging over five octaves was alone capable of rendering. He added to the strangeness of his compositions with howls, groans, and gutteral cries that are impossible to transcribe on a musical staff but supremely evocative.[59]

Rollinat, indeed, transcribed none of his music; he improvised and sang at the piano and left it to more learned hands to put the results on paper as best they could. As Mary Ellen Poole aptly observes, he "clung to ignorance as proof of his sincerity."[60] While literary Paris eagerly awaited the publication of *Les Névroses* (June 1883), it was probably Rollinat who contributed most to bringing fashionable curiosity-seekers to

Fig. 242.
Ferdinand Bac, photo-relief cover illustration for Maurice Mac-Nab, *Chansons du Chat Noir* (Paris: Au Ménestrel, Henri Heugel & Cie). Bartman Fund.

Fig. 243.
Stop (Louis Morel-Ritz), *Le Pendu*, c. 1890, lithographic music-sheet cover, 35 x 26.8.

181

the bohemian soirées at the first Chat Noir. Yet Rollinat was also among the first to abandon the cabaret, in August 1883, two years before the move to the town house in the rue Laval that disillusioned so many of the original Chat Noir circle. Indeed, he fled Paris and his sudden notoriety altogether, returning only for such occasions as Yvette Guilbert's performances of his Baudelaire settings at the Bodinière in January 1901.[61]

Maurice Mac-Nab [Figs. 242, 243], unlike Rollinat, occasionally lightened his macabre offerings with doses of pure folly. In "Vae soli," for example, he sang the lonesome plight of the tapeworm (in French, *ver solitaire*); the verses begin with exaggerated sweetness ("Qu'il est doux d'être deux"), and only the final line deflates the idyllic mood:

> Il faut bien l'avouer, dans la nature entière,
> L'être le plus à plaindre est . . . le ver solitaire.
> (One must admit that, in all of nature, the most pitiable being is . . . the
> "lonely worm.")

Another song, set to a gentle waltz strain, muses on the fate of miscarried fetuses, bobbing in their beakers of alcohol like so many Cartesian divers:

> Et vous seuls, vous savez, peut-être,
> Si c'est le suprême bien-être,
> Que d'être mort avant de naître![62]
> (And you alone, you know perhaps whether it is supreme happiness to die
> before being born!)

While dark humor established his reputation among the Hydropathes, Mac-Nab later shifted toward political satire that reflected convictions similar to those of Jouy. For "Le Général: Souvenir du populo," he adopted the *timbre* "Parlez-nous de lui, grand'mère" to make fun of the uncritical hero-worship that Boulanger inspired (taking a swipe at Paulus along the way).[63] For "Le Grand Métingue du Métropolitain," Mac-Nab stepped into the shoes of the worker who, early on pay day, empties several bottles before betaking himself to a demonstration of support for fellow proletarians on strike. With liberal amounts of argot in Bruant's manner, he describes how the worker attacks a police spy and is taken into custody, "fourré au violon pour rien."[64] The *morale* adopts an inflammatory tone, but the clumsy diction and rhyme invite the listener to take it with something of less than complete seriousness:

> Peuple français, la Bastille est détruite,
> Et y a z'encor des cachots pour tes fils!
> Souviens-toi des géants de quarant'-huite,
> Qu'étaient plus grands qu'ceuss' d'au jour d'aujourd'hui.
> (People of France, the Bastille is destroyed, but there's are still dungeons
> enough left for thy sons! Remember the giants of '48, who were bigger
> than thoze of two-day.)

Herbert calls Mac-Nab "le chef de file de tous les chansonniers actuels,"[65] but his

Fig. 244.
George Auriol, stencil-colored photo-relief cover for the Théâtre du Chat Noir program, 1891, 32 x 23 (each page).

tenure at the Chat Noir was short-lived. Tuberculosis forced him in 1888 to seek a warmer clime, and Salis asked the newcomer Vincent Hyspa to step in for his ailing comrade (who died on Christmas Day 1889 at the age of thirty-three). Salis astutely judged the comic effect of Mac-Nab's repertoire delivered with Hyspa's heavy southern accent, and added to the joke by introducing Hyspa as "le bon belge." While Hyspa soon found it irksome not to sing his own material, there is no question that he learned from the experience. When in 1892 Hyspa finally debuted at the cabaret "dans ses oeuvres," he offered a poetic tribute to the inspiration of Mac-Nab with his own account of "Le Ver solitaire" that, like its model, delivered its comic punch only at the end.

From a purely musical standpoint, the work of Jouy, Rollinat, and Mac-Nab is virtually irretrievable. Published transcriptions can give only a pale impression of Rollinat's demonic performances. Horace Valbel echoed the sentiments of many contemporaries when he wrote that "his works have been published by Hartmann, but no one will ever be able to interpret them before those who knew [Rollinat], because no one could recapture, even remotely, the strangeness of the impression he made."[66] Jouy, no matter what the *timbre* assigned to his chansons, delivered them all with the same piano accompaniment: alternating C-major and G-major chords hammered out in the highest register of the instrument. "The chords fell as best they could, usually in the wrong key [à faux] and always at the wrong time."[67] Mac-Nab, according to an oft-repeated account,

> possessed the harshest, most out-of-tune voice one could possibly imagine; he sounded like a seal with a head cold. But that worried him little. He sang in spite of all, unconcerned by the despairing gestures of Albert Tinchant, his regular accompanist. He had only three gestures, just as he

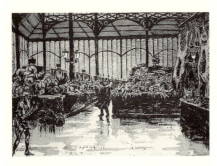

Fig. 245.
Henri Rivière, "La Gourmandise. I. Les Halles," stencil-colored photo-relief illustration for *La Tentation de Saint Antoine* (Paris: E. Plon, Nourrit et Cie, 1888), 13.

Fig. 246.
Henri Rivière, "La Gourmandise. III. Le Vin–Cortège de Silène et de Bacchus," stencil-colored photo-relief illustration for *La Tentation de Saint Antoine* (Paris: E. Plon, Nourrit et Cie, 1888), 17.

had only three notes in his voice; but what gestures and what notes! The effect was irresistible, though without a trace of self-derision. Every time he opened his mouth to recite his verse, he seemed to pronounce a funeral oration.[68]

The funereal delivery of outrageous or merely funny chansons left its mark on a generation of *pince-sans-rire* humorists (Hyspa and Ferny most prominent among them) who delivered everything with deadpan understatement. By placing diction and delivery at odds with expressive contents, such chansonniers anticipated an aesthetic standpoint common to any number of later (otherwise quite diverse) manifestations of artistic modernity, from Erik Satie's "furniture music" to the theatrical alienation of Brecht and Weill to Ionesco's theater of the absurd.

SHADOW THEATER

With the establishment of the shadow theater in the second Chat Noir, the chansonniers and poets were pressed willy-nilly into the function of hors d'oeuvre and intermission entertainment. Yet music also had an important function in the most ambitious of the shadow plays. Nearly from the start, one may note two diverging tendencies. For some shadow plays, the musical accompaniment (like the narration itself) was largely improvised. For others, a complete musical score was newly composed. The former approach was characteristic of Albert Tinchant and Charles de Sivry; the latter, of Georges Fragerolle.

La Tentation de Saint Antoine, first performed on 28 December 1887, shows the two approaches in combination. An ambitious production comprising forty tableaux, *Tentation* marked Henri Rivière's debut as author of a scenario and his first use of projections in color rather than black-and-white. According to a printed program, Fragerolle played at least some of the music on a harmonium (other accounts imply Tinchant playing the piano), while Alphonse Allais, as *chef de batterie*, supervised the sound effects created by four percussionists (among them Jouy and Mac-Nab). Salis, as *bonimenteur*, narrated the action more or less ex tempore. Tinchant coordinated the whole as *chef d'orchestre*,[69] and given Salis's tendency to launch into oratorical flights on the spur of the moment, his task cannot have been easy.

Just as the billing of the play as a *féerie à grand spectacle* alluded to the lavish *revues à grand spectacle* that were the specialty of the Folies-Bergère, so too the incidental music followed the *musique nouvelle et arrangée* formula common in music-hall revues. The deluxe edition of the play shows which music accompanied which scenes.[70] In the fifth tableau, for example, the Devil has transported the saint to Les Halles [Fig. 245] and tempts him with wine; Tinchant provides a simple march to accompany the shadowy cortege of those mythological tipplers Silenus and Bacchus [Fig. 246]. But when the Devil offers the temptation of wealth, a golden calf appears in front of the Bourse and Tinchant duly quotes the famous "Ronde du veau d'or" from act 1 of Gounod's *Faust*.[71] When the Devil offers Anthony either the political power of

General Boulanger or that of President Sadi Carnot, another musical quotation, of "En rev'nant de la revue," slyly suggests the preferable choice. At the end of act 1, Anthony contemplates the heavens to the strains of Schumann's "Träumerei." In act 2, the erotic dance of the queen of Sheba is accompanied by two quotations from ballet scores by Léo Délibes (*Sylvia* and *Le Roi s'amuse*). Norse gods process to the music of Wagner's "Ride of the Valkyries" [Fig. 216], and Greek muses to a tune from Offenbach's *Orphée aux enfers*. After Anthony has successfully resisted all temptations of the flesh and of the intellect, angels descend from heaven in a splendid apotheosis, while children's voices intone a "Venite adoremus" from the wings. Ascribed in the edition of *Tentation* to Haydn, this music is actually the Christmas hymn "Adeste, fideles." Finally, Anthony rises heavenward [Pl. VIIIa] to the appropriate music from the last scene of Gounod's *Faust*. Interspersed among the quotations are original contributions by Tinchant, all of them short and quite simple musically but well suited to the various tableaux. The most extended original music is Georges Fragerolle's march to accompany the "Cortège et défilé de la reine de Saba," which dwarfs the musical snippets by Tinchant and was probably not a part of the original production.[72] Otherwise, the fragmentary score suggests intermittent rather than continuous music, which not only provided atmospheric accompaniment but also counterpointed the shadows and narration with allusions to readily identifiable pieces.

Tinchant's successor as house pianist at the Chat Noir was Charles de Sivry [Fig. 247], a versatile composer of light music and a facile improviser who extemporized accompaniments to the shadow plays of Maurice Donnay and others. The published edition of Donnay's *'revue symbolique' Ailleurs* (first performed 11 November 1891) includes no music, and Sivry probably wrote none of it down.[73] Rather, one finds descriptions of what Donnay asked Sivry to do. During the first tableau, for example, "The invisible orchestra plays vague, colorless music." In the change of scene that precedes the fifth tableau, "The orchestra plays something like a funeral march by Chopinhauer"; the pun matches the description of a sad young poet who, through too extensive reading of Schopenhauer, has so exacerbated his critical faculties that he has extinguished his creative ones.[74] Donnay has Sivry quote several well-known melodies, from the ballet of the sylphes in Berlioz's *Damnation de Faust* to "l'air de la Périchole" by Offenbach and the revolutionary song "La Carmagnole" (for a tableau depicting "Le Socialisme").[75] The fourth tableau ends with a spoof on contemporary advertising, underscored with an outrageous musical pun:

> Maladies secrètes / Grâce à la liqueur de Maria Petrowna, doctoresse / Plus de virus!!! (Sur cette patriotique assonance, l'orchestre joue complaisamment l'hymne russe. Dans la coulisse, des voix exaspérées crient: «Assez! Assez!» L'orchestre, intimidé, se tait.)[76]
> (Creeping illnesses? Thanks to Dr. Maria Petrovna's syrup, no more vi-Russias!!! [After this patriotic assonance, the piano obligingly plays the Russian anthem. In the wings, exasperated voices call out, "Enough! Enough!" The piano, cowed, stops playing.])

Fig. 247.
Vincent Hyspa, portrait of Charles de Sivry as an eyeball, from *Le Mur*, n.d., pen, ink, and crayon, 31 x 23. Schimmel Fund.

Fig. 248.
Henri Rivière, "L'Etoile," color lithographic illustration for *La Marche à l'étoile* (Paris: Enoch & Cie, 1902), 13.

Fig. 249.
Henri Rivière, color lithographic poster
for *Clairs de lune*, 1896, 29 x 78.

Two scenes after this melodic allusion, provoked by the homonymic equivalence of *virus* and *vie russe*, equal time is given to the French anthem ("L'orchestre joue terriblement la Marseillaise") as the protagonists walk through a landscape strewn with statues of Republican politicians.[77] For the by then obligatory apotheosis, the off-stage harmonium intones "Venite adoremus," an allusion to the comparable scene in *Tentation*. During the tableau devoted to "Le Militarisme," in which the narrator decries "the obstreperous patriotism carefully maintained in the masses by café-concert chansons," Sivry likely "noodled" on tunes from the *revanchard* repertoire. In *Ailleurs* and in Donnay's next shadow play, *Phryné*, the narration was set down beforehand and recited in performance by Donnay, who stood next to the piano so that (the extremely myopic) Sivry could coordinate his musical effects with Donnay's delivery.[78]

In such shadow plays, the musical accompaniment often seems a direct extension of the chansonniers' practice of parodying well-known tunes. While some tunes are retexted for the occasion, in other cases musical allusion alone makes the humorous point. Perhaps inevitably, more ambitious musicians provided newly composed scores that eschew parodic allusion, starting with Georges Fragerolle's *Marche à l'étoile* (first performed 6 January 1890) [Pl. IVc]. The play was novel in two respects. The subject was serious and seriously treated; and the narrative poem (written by Fragerolle) was sung throughout. Music, as a consequence, was no longer a mere accompaniment to stage action and spoken narrative; it presented the action.

As published, Fragerolle's *Marche* comprises ten numbers of stylistically conservative music that might be described as second- or third-rate Gounod.[79] The numbers are fairly brief, ranging in length from nine to thirty-three measures, and most lead harmonically into the next, implying continuous performance. The performing forces were, for a shadow play, unusually elaborate. Besides Fragerolle himself, there were two other *récitants* (one of them Paul Delmet). These were probably accompa-

186

nied with a harmonium (apparently played by Erik Satie), but two numbers also called for obbligato instruments: an oboe ("Les Bergers") and a cello ("Les Lépreux"). The musical high point, according to the testimony of Maurice Donnay, was the four-part canon for children's choir to accompany the adoration of the Christ Child.[80]

Fragerolle's *Marche* was, in effect, a chamber oratorio. It set the standard for subsequent shadow plays in which everything, music and narration, was spelled out and nothing was left to improvisation. These *ombres lyriques* included *Héro et Léandre* (first performed 24 November 1893, with music by Lucien and Paul Hillemacher) and three further plays by Fragerolle: *L'Enfant prodigue* (3 December 1894), *Le Sphinx* (21 January 1896), and *Clairs de lune* (14 December 1896) [Fig. 249], not to mention plays produced in other venues after the demise of the Chat Noir.[81] However, the artistic high point of *ombres lyriques*, far surpassing Fragerolle in musical sophistication, was *Sainte Geneviève de Paris*, first performed in January 1893 with music (and libretto) by Claudius Blanc and Léopold Dauphin. This work managed to attract not only the notice but also the support of the Parisian musical establishment. It was praised in the august weekly *Le Ménestrel*, and the critic Arthur Pougin devoted a study to it in *L'Encyclopédie (La Revue encyclopédique)*.[82] The music publisher Heugel issued the piano-vocal score (unfortunately without reproducing Rivière's tableaux) that comprises no fewer than 109 pages of continuous music. Dauphin, who like Charles de Sivry [Fig. 250] had written operettas during the 1870s,[83] here produced a score of nearly operatic scope involving extended (and fairly complex) choral writing, a challenging part for the *récitant*, even leitmotifs à la Wagner. Among the most effective passages are the song of Geneviève (second tableau), almost neoclassical in its dignified simplicity; the counterpoint of the harvesters' rustic evensong with the heroine's Pater Noster (third tableau), with a brief musical foreshadowing of the impending invasion by the Huns; and the scene in Nanterre cathedral (sixth tableau), in which an officiant intones the "Asperges me," the choir joins in with unmeasured, harmonized plainchant, and the organ peals out Geneviève's leitmotif (*fff tutta forza*) as the sainted heroine makes her vow of chastity before the bishops Rémy, Loup, and Germain d'Auxerre.[84] For the performance, the wings of the shadow theater were crowded with fourteen singers (including four boys from the chorus of the Opéra), an organist, a pianist, and a violinist.[85]

Because *ombres lyriques* did not depend on the incomparable *boniments* of Salis, they were more readily transferred to other venues, such as François Trombert's short-lived Hostellerie du Lyon d'Or, which temporarily lured Fragerolle away from the Chat Noir, and fashionable theaters like the Bodinière.[86] Meanwhile, the *musique nouvelle et arrangée* formula of the more improvisatory shadow plays was applied to the cabaret revue, an innovation first offered at Trombert's Cabaret des Quat'z'Arts in April 1894. Long a staple in Parisian theaters, cafés-concerts, and music halls, the revue took a different turn in the cabarets. They involved fairly informal, often spur-of-the-moment collaboration among the chansonniers and poets of the house troupe, who also made up the cast. Their raison d'être was to satirize current affairs and

Fig. 250.
Unidentified, portrait of Charles de Sivry, from *Le Mur*, n.d., crayon and oil pigment, 22.5 x 14.5. Schimmel Fund.

Fig. 251.
Georges Rochegrosse, color lithographic poster for *Louise,* 1900, 78.2 x 58. Gift of Mr. and Mrs. Herbert Littman.

fashions, not to showcase the ingenuity of the costumer, set designer, and choreographer and the pulchritude of the chorus line. By contrast with the *revues à grand spectacle*, the cabaret revue was a bare-bones production. "Pas de perruques, pas de costumes, pas de décors," one reads at the beginning of *Au clair de l'urne*, a one-act revue written by Lucien Boyer and Numa Blès for the Quat'z'Arts.[87] Each scene in this revue involves one or two chansons, all of them satirical parodies set to *timbres* presumably familiar at the time; to judge from their melodic style, the tunes would seem to stem from currently popular operettas. Other *cabarets artistiques* quickly took up the new genre. Without going to the expense of mounting shadow plays, they could still compete with the Chat Noir by offering stage shows that drew on the parodic talents of their resident chansonniers.

THE WIDER IMPACT

With *Sainte Geneviève de Paris* the Chat Noir's *ombres lyriques* had made a credible claim to be regarded as part of "serious" Parisian musical life. What of the more general impact of cabaret music on the city's serious composers? While detailed consideration of this question is impossible here, three prominent cases may be briefly discussed. Claude Debussy was an occasional guest at the Chat Noir and at the nearby Auberge du Clou, where his lifelong friendship with Erik Satie began. It was probably in the latter cabaret that Debussy also met Vincent Hyspa, whose ironic retelling of the Sleeping Beauty legend, "La Belle au bois dormant," he set to music in the summer of 1890. In Hyspa's poem, the beauty wears a ring on her finger, to betoken the coming wedding with the knight who is to revive her. But the knight proves less than chivalrous; he steals the ring and leaves La Belle to slumber on. True to the parodist's habit of ironical allusion to familiar material, Debussy wove quotations of the children's song "Nous n'irons plus au bois" into the piano accompaniment, as if to suggest–in answer to that song's question, "La belle que voilà / La lairons-nous danser?"–that there would be nothing to celebrate in the wood. While this song arguably helped to nudge Debussy away from Wagnerism toward more independent creative paths, the cabaret life was but a youthful phase in his career, as it was in the lives of many others. Once broad recognition came, he moved on to other venues.

Montmartre made a more lasting impression on Gustave Charpentier, who moved there while a (by all accounts unruly) student at the Conservatoire and never left, except for his tenure at the Villa Medici as winner of the 1887 Prix de Rome in composition. Charpentier is perhaps best known for his opera *Louise* [Fig. 251], which was set on the Butte and exploited many an opportunity for local color–from the cries of street vendors at dawn to the ceremonial crowning of a muse of Montmartre in a raucous street festival. Finished in 1896 and a resounding success at the Opéra-Comique in February 1900, the opera concerns a midinette who emancipates herself

from a stultifying upbringing by running off with a cabaret poet–a symbolic union of proletarian with intellectual that, as some believed, would set the course of future social progress.[88] For the second Vachalcade parade (June 1897), Charpentier elaborated the street festival scene from *Louise* (act 3, scene 3) into an independent cantata, *Le Couronnement de la muse*, in which Adolphe Willette, costumed as his alter ego Pierrot, mimed the sufferings of humanity at large and bohemian artists in particular–sufferings to be alleviated only through dedication to Montmartre's muse.[89] For the cantata, Charpentier set the locale even more conclusively than he had in *Louise* by adding solemn quotations of Bruant's "Ballade du Chat Noir." Charpentier conducted the gala premiere of *Le Couronnement* at the Nouveau Théâtre; the planned open-air performance in the place Pigalle had to be cancelled. Equally noteworthy were Charpentier's philanthropic initiatives, the Oeuvre and the Conservatoire Populaire de Mimi Pinson, which (respectively) offered free theater tickets and music lessons to working-class women such as his operatic heroine represented. Marcel Legay, a chansonnier with a thick streak of idealistic socialism, taught classes in popular song at Charpentier's Conservatoire.[90] By the Great War, Charpentier's

Fig. 252.
Adolphe Willette,
A Martyr to Pleasure, 1900,
watercolor, 29.6 x 22.5.
Morse Fund.

devotion to his social oeuvre had all but eclipsed his activities as a composer.

The composer whose music bore the most distinctive impression of the Montmartre cabarets was perhaps Erik Satie. Satie entered the Chat Noir the evening of the premiere of *La Tentation de Saint Antoine*, and he quickly became a fixture there. He backed up Albert Tinchant and Charles de Sivry as second pianist, while the house weekly advertised his oddly titled piano compositions (the *Gymnopédies* and the *Ogives*). Like Charpentier, Satie lived on the Butte and wandered freely among its many nightspots. He wrote the music for a shadow play by Vincent Hyspa at the Auberge du Clou, consorted with Marcellin Desboutin at the Nouvelle Athènes, and accompanied Hyspa at the Tréteau de Tabarin, the Boîte à Fursy, and the Quat'z'Arts. Over the course of a decade, Satie composed nearly a dozen cabaret songs for Hyspa, which furnished his only reliable venue for a public hearing until 1911, when Maurice Ravel brought him out of bohemian obscurity and into the limelight of Parisian concert life. Thereafter, Satie transferred the techniques of parodic quotation and distortion learned in the cabaret to whimsical but disconcerting piano suites, to songs by turn medieval and madcap, and eventually to avant-garde ballets like *Parade* (1917), *Mercure* (1924), and *Relâche* (1924)—leaving it to enraged critics and engaged supporters to argue whether his music was *fumisterie* or motivated by serious artistic intentions or both at once. By that time, the avant-garde had left the Butte for Montparnasse, but Jean Cocteau, despite his distaste for Satie's bohemianism, could declare in 1920 that French musical life had been "sauvé par Montmartre!"[91] Whatever the extent of Cocteau's polemical exaggeration, Satie's impact on later composers from Darius Milhaud to John Cage suggests that *l'esprit de Montmartre* has survived in some of the most challenging music of our century, notwithstanding Willette's bittersweet image of the martyred Muse, crucified by musical symbols of the very art she has inspired [Fig. 252].

1. Victor Meusy and Edmond Depas, *Guide de l'étranger à Montmartre* (Paris: J. Strauss, 1900), 31–32, in a chapter of representative humor titled "La Fantaisie montmartroise." The article is more readily available in Erik Satie, *Ecrits*, ed. Ornella Volta, 3d ed. (Paris: Champ Libre, 1990), 47.

2. Jokes about the musical aptitudes of the deaf and of deaf-mutes were common in the cabaret milieu. The best known, perhaps, is Allais's musical contribution to the third of Jules Lévy's expositions of Incohérent art (1884): a score with the pompous title "Les Grandes Douleurs sont muettes: Marche funèbre incohérente," which comprised 24 blank measures marked *Lento rigolando* (cf. John Cage's *4'33"*). Publishing this "work" in his *Album primo-avrilesque* (1897), Allais retitled it "Marche funèbre composée pour les funerailles d'un grand homme sourd." An occasional rubric in the monthly paper issued by the Lune Rousse cabaret was "Impressions musicales d'un sourd-myope." It is perhaps not coincidental that Charles Cros had devoted considerable study to the education of deaf-mutes. See Cros, *Inédits et documents*, ed. Pierre E. Richard (Villelongue [Aude]: Atelier du Gué, 1992), chap. 1, for his scientific papers on the subject.

3. One recent monograph is the laudable exception to this rule: Mary Ellen Poole, "Chansonnier and Chanson in Parisian *Cabarets artistiques*, 1881–1914" (Ph.D. diss., University

of Illinois, 1994). While providing a balanced survey of popular musical entertainment in all Parisian venues, Poole focuses most closely on the music of Marcel Legay.

4. For a detailed account of procedures and penalties, see Concetta Condemi, *Les Cafés-Concerts: Histoire d'un divertissement* (Paris: Quai Voltaire, 1992), 28–48.

5. Quotations from Elisabeth Pillet, "Cafés-concerts et cabarets," *Romantisme* 75, no. 1 (1992): 45. Writing in 1897, Edmond Deschaumes recalled that one habitué of the first Chat Noir was "Lépine, le préfet de police actuel"! (Deschaumes, "Le Cabaret du Chat Noir," *Revue encyclopédique* [16 January 1897]: 43).

6. A striking example is Legay's setting of "Le Cochon" by Charles Monselet, published in his lavish album *Toute la gamme: Quinze Compositions illustrées et lettres autographes* (Paris: Brandus & Cie, 1886). In this case, Legay's expenditure of musical artifice matches Monselet's mock-serious paean to the pig.

7. Such lecture-recitals were more common in fashionable theaters like the Bodinière and the Marigny, where in 1907 Yvette Guilbert regaled audiences with *chansons de la vieille France* performed in period costume. The argot poetry of Bruant and Jehan Rictus, and the dialect songs of Gaston Couté inter alia, were special manifestations of the widespread interest in music of "the people." The lecture-recitals at the Quat'z'Arts–described in Jacques Ferny, "Le Cabaret des Quat'z'Arts," *Les Chansonniers de Montmartre*, no. 10 (25 October 1906): [7]–were so successful as Thursday "5 o'clocks" that François Trombert went on tour with them during the summer of 1897. According to Horace Valbel, these *conférences* surveyed the whole of France, region by region (Valbel, *Les Chansonniers et les cabarets artistiques* [Paris: E. Dentu, 1895], 234).

8. Boyer, *Qu'il était beau mon village* (Paris: Baudinière, 1934), 42. Boyer may actually have had such a conversation with Trombert just before his debut at the Quat'z'Arts, in 1896.

9. Quoted in Philippe Jullien, *Jean Lorrain, ou le satiricon 1900* (Paris: Fayard, 1974), 50.

10. Michel Herbert, *La Chanson à Montmartre* (Paris: La Table Ronde, 1967), 213. (Despite the title, Herbert excludes discussion of music; the book is rich in anecdotal history.) See also the biographical essay by Jean-Pascal in the issue of *Les Chansonniers de Montmartre* (no. 2, 25 March 1906) devoted to Delmet.

11. Hugues Delorme, writing thirty years after Delmet's death, referred to "the flock of envious ones" who maintained that Charles de Sivry and Charles Levadé actually composed Delmet's chansons. Sivry, Delorme recalled, merely shrugged off such gossip, while Levadé attested that his assistance was limited to providing accompaniments for "a certain number of his melodies. . . . Delmet was a good musician who wrote without orthographic error" (Delorme, "La Chanson sentimentale: Paul Delmet–Gabriel Montoya," in Maurice Donnay, Dominique Bonnaud, and Vincent Hyspa, *L'Esprit montmartrois: Interviews et souvenirs*, 2d ser. [Paris: Léon Ullmann, 1938], 79–80). According to Horace Valbel, Delmet's musicianship enabled him to read by sight, "avec toutes les nuances voulues," an entire program of unpublished chansons in a charity concert at Lariboisière (Valbel, *Les Chansonniers*, 203).

12. One gains some notion of the prejudice among cabaret denizens against the *romance* from Delorme: "Would you like instantaneously to transform an authentic poet into a flat versifier? A man of merry wit into a sinister cretin? . . . Have him write a *romance*. . . . One would search in vain through most sentimental chansons for a sincere sentiment. . . . Nearly everywhere, only *déjà vu* and *déjà lu*; mass-produced clichés; the monotonous recurrence of the same rhymes (*caresse* and *maîtresse*, *ivresse* and *tendresse*, *lèvres* and *fièvres*, *rose* and *éclose*)." It is therefore all the more to Delmet's credit that he rehabilitated the *romance* genre (Delorme, "La Chanson sentimentale," 75–77).

13. In a letter of 9 March 1897 to the poet and novelist Pierre Louÿs (Claude Debussy,

Correspondance, 1884–1918, ed. François Lesure [Paris: Hermann, 1993], 127). Debussy, unable to stomach the operatic realism of *Messidor* by Emile Zola and Alfred Bruneau, herewith mocks the latter's pretension to have written music that was modern and truly French.

14. Boukay has recourse to one of the hackneyed rhymes decried by Hugues Delorme (see n. 12): "Parmi les Désirs et les Fièvres, / Sans savoir pourquoi ni comment, / Elle a fleuri jusqu'à vos lèvres, / Tout simplement!"

15. The melody may be diagrammed $A^4 A'^4 B^4 C^4$; the superscript numerals represent the number of measures in each phrase.

16. *Le Chat noir* of 26 March 1892 reports that Delmet had introduced the song the preceding week.

17. The melody may be diagrammed $A^4 A^4 B^4 C^5$. The inserted measure (here counted with the last phrase) sets phrases referring, respectively, to the crowns "fondus dans tes doigts," the manor "vendue au notaire," the wealth "mangé, dévoré," and finally the pitiable state of the narrator, "un vieux mendiant." It leads, in each stanza, to the resignedly ironic refrain, "C'est parfait, / Et chantons au clair de la lune."

18. Valbel, *Les Chansonniers*, 113.

19. At the beginning of act 2 in Rossini's comic opera, Count Almaviva appears in Bartolo's house disguised as a music master in order to give Rosina a "singing lesson." Xanrof's "Exercices de piano" (*Chansons ironiques* [Paris: Ernest Flammarion, n.d.], 124–32) is another seduction scene during a piano lesson. Montoya's wordplay is between the common meaning of achieving "perfect concord more than six times" and the musical sense of cadencing together on the tonic triad.

20. Six chansonniers–Victor Meusy, Armand Masson, Jacques Ferny, Jules Jouy, Paul Delmet, and Vincent Hyspa–had defected the preceding year from the Chat Noir, because Salis had called off the summer tour in which they expected to participate. They founded their cabaret in the mezzanine of the Nouveau-Cirque, naming it for the supposed natural enemy of the black cat.

21. See Théodore Botrel, *Les Mémoires d'un barde breton* (Paris: P. Lethielleux, 1933), 179. Photographs of Delmet in performance confirm Botrel's account reference to the "thick scores"; see *Paris qui chante* 2, no. 60 (13 March 1904): 5.

22. Announcements of Hyspa's parody, originally called "Le Pauvre Bougre," are found in *Le Chat noir* of 26 March and 3 April 1892. As chansonnier Léon de Bercy later recalled, "It was no small pleasure to hear, immediately after the baritone balladeer [Delmet], the parodist [Hyspa], who managed his deep voice with such kindly suppleness that the melody was not bruised in the least" (de Bercy, "Le Chansonnier Vincent Hyspa, "*La Bonne Chanson* 6 [1913]: 226).

23. Delmet's chanson was published in *Chansons des femmes*, no. 4. The parody is in Vincent Hyspa, *Chansons d'humour* (Paris: Enoch, 1903), 267–72.

24. Music by Frédéric Boissière, words by Soubise. "Les coeurs palpitaient d'espérance, / Et l'enfant disait aux soldats: / 'Sentinelles, ne tirez pas: / C'est un oiseau qui vient de France!'" (All hearts trembled with hope, and the child said to the soldiers, "Sentinels, fire not; it is a bird that comes from France!") Reproduced in Pierre Barbier and France Vernillat, *Histoire de France par les chansons*, 8 vols. (Paris: NRF/Gallimard, 1956–61), 8:43–45.

25. Text by Villemer and Delormel, music by L. Benza. In the refrain the Alsatian schoolmaster tells the children to lower their voices, for a German patrol is passing by, and speaking French is no longer permitted. Reproduced ibid., 31–33.

26. Hyspa, *Chansons d'humour*, 345–50.

27. Henri Fursy, *Chansons de la Boîte* (*Chansons rosses, 3e série*) (Paris: Paul Ollendorff, 1902), 63–65. Fursy takes offense at the subject matter of the opera, which he finds "*lesbien* au possible," and remarks along the way that, if such fare had been offered at the Folies-Bergère music hall, the censor would have forbidden the performance. In substantial agreement with Fursy's assessment is the account of the music critic Arthur Pougin, who

wrote in the 1905 supplement to the *Dictionnaire des opéras* that "the play is no less immodest than the goddess. . . . In truth, the Opéra had gone a little too far this time." Sale of the unexpurgated libretto was forbidden. (See Félix Clément and Pierre Larousse, *Dictionnaire des opéras*, rev. Arthur Pougin, 2 vols. [Paris, 1905; reprint, New York: Da Capo, 1969], 2:1186).

28. Frits Noske, *French Song from Berlioz to Duparc: The Origin and Development of the "Mélodie,"* trans. Rita Benton, 2d rev. ed. (New York: Dover Publications, 1970), 210.

29. The phrase is Reynaldo Hahn's, quoted ibid.

30. Trimouillat, *Oeuvres: Ballades, chansons, fantaisies, monologues, parodies, poèmes divers* (Paris: Stock, 1931), 186. The parody bears no date but is immediately followed by a "Toste à la chanson" dated 2 April 1900. Cf. the date of Hyspa's parody "Les Eléphants," to be discussed presently.

31. Hyspa, *Chansons d'humour*, 217–25. In publicity notices in the Parisian daily *Le Gaulois*, "Les Eléphants" is mentioned as a new song on 19 and 21 March 1900, when Hyspa was performing at the Boîte à Fursy. His pianist on this occasion was probably Erik Satie, who transposed Massenet's accompaniment down to a key Hyspa could manage. Ironically, this accompaniment draft (which does not include the vocal line) was mistaken for an original composition by Satie and even published as such under an invented title, "Petite Musique de clown triste." For details, see Steven Moore Whiting, "Musical Parody and 'Two Oeuvres posthumes' of Erik Satie," *Revue de musicologie* (forthcoming).

32. Boyer: And so be lenient toward them–no stern faces. The cherubim will have time enough to learn of our misery. Trimouillat: And so be lenient toward them–no stern speeches. These unfortunates do not have the time to learn anything about their ministerial posts. Hyspa: And so be lenient toward them–no stern faces; for they would not have the least compunction about booting our rear ends.

33. *La Lune rousse*, 15 June 1905. Ten years earlier, an advertisement for the shadow theater at the Chat Noir began with a damning comparison to the café-concert: "Are you as tired and distressed as I am by refrains at the café-concert, where idiocy vies with triviality, where flailing arms and splits take the place of wit and originality . . . ? Come spend an evening . . . at the Chat Noir Theater, and I promise that you will leave with an impression more salutary than that left by three hours spent in one of those establishments where you have to swallow, along with a smokey atmosphere, nineteen insipid numbers for every tolerable one" (*Le Chat noir*, 22 December 1894). The atmosphere in any cabaret was bound to be as smoke-filled as that in a café-concert, and one may suspect that commercial considerations played a large part in the chorus of scorn. The variety theaters competed with the cabarets not only for audiences but also for performers, whom they could lure with much higher fees than Salis was willing to offer.

34. Delorme recounts the story in Donnay, Bonnaud, and Hyspa, *L'Esprit montmartrois*, 127.

35. Quoted from Jacques Ferny, *Chansons de la roulotte* (Paris: E. Fromont, 1900), 66–68. The *couplet patriotique*, marked "Vibrer," ironically predicts a glorious future for an infant *fils naturel*: "Peut-être un jour à la frontière, / Pour la France!—héroïque destin!— / Sonnera son heure dernière!! / (Danser) Mais heureus'ment ça n'est pas certain!" (Perhaps one day, at the border–O heroic destiny!–his last hour will strike for France!! [Dance] But fortunately that's not a sure thing!)

36. The *scie* is defined in Littré's *Dictionnaire de la langue française* (1863 ed.) as "a refrain of a premeditated monotony, to be repeated all the more often if it seems to irritate." It featured jingling lyrics of little sense delivered rapid-fire. A characteristic example is "L'Amant d'Amanda," introduced by the *chanteur gommeux* Libert in 1878, which derived its comic effect from the title's long string of assonances.

37. For examples, see Daniel Grojnowski, "Laforgue fumiste: L'Esprit de cabaret," *Romantisme* 19, no. 64 (1989): 7–8.

38. Quoted from Paulus [Jean-Paul Habans, pseud.], *Trente Ans de café-concert* (Paris: Société d'Editions et de Publications, n.d.), 10–11.

39. Jules Jouy, *Chansons de l'année 1887* (Paris: Bourbier et Lamoureux, 1888), 319–20. The beginning of the refrain ("IL est r'venu") does refer to the title "En rev'nant de la revue."

40. While the incident aroused wide sympathy for the beleaguered president, the chansonniers of Montmartre seized gleefully on its satiric possibilities. A publicity notice for the Tréteau de Tabarin (*Le Gaulois*, 6 June 1899) notes that "Fursy had, with his customary rapidity of improvisation, introduced a malicious allusion to the events at Auteuil into one of his chansons, and one can imagine how the public made merry over this item hot off the press" (*cette actualité servie brûlante*).

41. Fursy, *Chansons de la Boîte*, 223–33. The event also inspired Hyspa's *Deuxième Visite impériale*, for which he recycled the music of his own "Visite impériale" of 1896, and "Le Carnet d'ami (Impressions du czar)," which parodied Delormel's "Ça vous fait tout d'même quelque chose" (*Chansons d'humour*, 145–57). The latter chanson, scheduled for performance at Georges Oble's Petit Théâtre on 14 October 1901, led to the temporary closing of that cabaret because it had not cleared the censor. Reported in the entertainment column of *Le Figaro*, 17 October 1901.

42. Hyspa's *Chansons d'humour* identifies one appropriated tune as an "old air collected and deranged by V. Hyspa" ("Félix [Faure] à Lens," 61).

43. Ferny, *Chansons de la roulotte*, 90–93. The chanson was also included in a special issue of Adolphe Willette's occasional journal *La Vache enragée* (May–June 1897), devoted to the second Vachalcade.

44. "Les Inaugurations," in Jacques Ferny, *Chansons immobiles* (Paris: E. Fromont, 1896), 28–32.

45. For examples, see the pertinent volumes of Barbier and Vernillat, *Histoire de France par les chansons.*

46. For a fuller discussion of the chanson and its manuscript sources, see the present author's "Erik Satie and Vincent Hyspa: Notes on a Collaboration," *Music & Letters* 77 (1996): 64–91. This and other differences between the bare melodies printed in Hyspa's *Chansons d'humour* and the manuscript scores from which Hyspa and Satie performed suggest how sketchy an impression the published chanson collections generally give of actual cabaret performance. Because Satie felt compelled to write down what other cabaret accompanists probably improvised, and because Satie is so well known as a "serious" composer that his autographs have been deposited in research libraries, we have more complete musical evidence regarding Hyspa around 1900 than for nearly any other chansonnier.

47. Satie skews the declamation of the word by giving the metric accent to the first syllable, which only underscores Hyspa's ironic point.

48. Ferny, *Chansons immobiles*, 72–76.

49. Millandy, *Au service de la chanson: Souvenirs d'un chansonnier aphone* (Paris: Editions Littéraires de France, 1939), 65.

50. "Les Bohèmes," a poem not intended for music, is printed in [Léon] Xanrof, *Chansons à rire* (Paris: E. Flammarion, n.d.), 65–68.

51. Jean Rameau, "Montjoie! Montmartre!" on the front page of *Le Gaulois,* 22 October 1900. Rameau's characterization exactly matches accounts of Hyspa's dress and manner of delivery. Fursy's parody is mentioned in the same daily paper on 3 November.

52. "La Mort des chansonniers" stands at the head of Fursy's *Chansons de la Boîte*, 3–10.

53. Delmet had introduced "Etoile d'amour" on 11 April 1900 (*Le Gaulois*, 12 April 1900). "Ça fait toujours plaisir" was a number from Louis Varney's operetta *La Femme de Narcisse* (first given at the Théâtre de la Renaissance on 14 April 1891), which Hyspa had parodied (also in April 1900) for "Les Joies de l'exposition," a comment on how unlivable the capital had become owing to the influx of tourists.

54. Jean Bastia, "Un Grand Chansonnier: Vincent Hyspa," *Paris-Soir*, 17 October 1938 (an obituary notice). Fursy tossed off his chansons much more quickly, admittedly at the cost of stylistic infelicities: "my songs are satires written on the spur of the moment, and precisely in this crude state I present them to the public. If I worked them over they would lose much of their freshness" (as related to F. Berkeley Smith in *How Paris Amuses Itself* [New York: Funk and Wagnalls, 1903], 204).

55. He was also the most versatile. Earlier in his career, Jouy wrote many a chansonnette for the café-concert, which he then freely parodied in the political songs that he contributed on a daily basis to the left-wing daily *Le Cri du peuple*. It was a source of considerable frustration to Jouy that his café-concert chansonnette "C'est ta poire" was appropriated by the Boulangist faction as a rallying cry. See Bertrand Millanvoye, *Anthologie des poètes de Montmartre: Notes biographiques et bibliographiques*, 6th ed. (Paris: Paul Ollendorff, 1909), 215.

56. (Paris: Flammarion, [1892]), 2–7.

57. Quoted from Millanvoye, *Anthologie*, 218. See also Jouy's "Incinération: Conseils utiles" (ibid., 219–21), offered to those wanting to dispose of their murder victims.

58. Rameau, in *Le Gaulois*, 22 October 1900. Concerning the author of *Les Fleurs du mal*, Rameau writes, "We shall never know all the ill this second-rate poet has wreaked upon French brains."

59. Herbert, *La Chanson à Montmartre*, 99. For eyewitness accounts, see Alexandre Zévaès, *Maurice Rollinat: Son Oeuvre* (Paris: Editions de la Nouvelle Revue Critique, 1933), 30–33.

60. On this matter, see Poole, "Chanson and Chansonnier," 112, and the contemporary sources cited therein. In a letter of 4 August 1898 (quoted in Zévaès, *Rollinat*, 76), Rollinat invites the cabaret pianist Albert Chantrier to assume the duties of musical secretary: "In the event, the musician's role is thus limited to following, as slowly as he wishes, the melodies and the chords my fingers play at the piano, and to notating them exactly as I play them, with all their faults, defects, solecisms, and transgressions against the rules of harmony properly speaking." Chantrier spent a month at Rollinat's country home carrying out this arduous task.

61. Guilbert's series of six recitals was announced in *Le Figaro*, 8 January 1901, as forthcoming in three days, with the enticement that Rollinat himself would attend the first recital. The complex motivations for Rollinat's sudden departure from Paris are analyzed in Régis Miannay, *Maurice Rollinat: Poète et musicien du fantastique* (Orvault: [L'auteur], 1981), 411–29.

62. Quoted from the posthumous collection of Maurice Mac-Nab, *Nouvelles Chansons du Chat Noir* (Paris: Heugel, 1892), 55–66. Unfortunately, it is not clear what relation the musical settings in this collection bear to the melodies used by Mac-Nab; the title page credits "musique nouvelle ou harmonisée" to Camille Baron.

63. [Maurice] Mac-Nab, *Poèmes incongrus: Suite aux "Poèmes mobiles" contenant ses nouveaux monologues et dernières chansons* (Paris: Léon Vanier, 1891), 56–59.

64. Reprinted in Barbier and Vernillat, *Histoire de France par les chansons*, 8:114–16, unfortunately with Camille Baron's melody, so it is impossible to know which tune Mac-Nab actually used.

65. Herbert, *La Chanson à Montmartre*, 109.

66. Valbel, *Les Chansonniers*, 87.

67. As recalled by Dominique Bonnaud, "La Fin du Chat Noir, ou Les Derniers Mohicans

de la Butte," *Les Annales*, no. 2179 (29 March 1925): 331. Edmond Deschaumes adds two more picturesque details: "an eternal five-cent cigar in the corner of his mouth, his derby hat slouched down over his eyes" (Deschaumes, "Le Cabaret du 'Chat Noir,'" 43).

68. Drawn from *Les Hommes d'aujourd'hui* for the preface to Mac-Nab, *Chansons du Chat Noir*, and paraphrased in Millanvoye, *Anthologie*, 239.

69. The program is held by the Archives de la Fondation Erik Satie (Paris). An account of the stage action and some of the music is to be found in Jules Lemaître's review, dated 9 January 1888, reprinted in *Impressions de théâtre*, 2:331–43.

70. *La Tentation de Saint Antoine: Féerie à grand spectacle en 2 actes et 40 tableaux* par Henri Rivière, . . . Musique nouvelle et arrangée par Albert Tinchant et Georges Fragerolle (Paris: E. Plon, Nourrit et Cie, n.d.). Publication was announced in *Le Chat noir*, 7 July 1888. Fragerolle is not identified as co-composer either in the original program or in Lemaître's review; apparently his music was added after the early performances.

71. The audience members would have, as it were, automatically imagined Mephisto's text: "Le veau d'or est toujours debout! / On encence Sa puissance / D'un bout du monde à l'autre bout!" (The Golden Calf still stands! One burns incense to His power from one end of the world to the other!) Graced as the Chat Noir was by Willette's stained-glass window on the subject, poets and chansonniers at the cabaret returned again and again to the image of the golden calf, often by distorting the text of Gounod's ronde. In Maurice Donnay's *Ailleurs*, to be discussed presently, the seventeenth tableau depicts the Bourse in ruins, and an impoverished banker remarks, "Mais le veau d'or dort, / Il n'est pas mort, / On peut le réveiller encor" (But the golden calf is only sleeping, he is not dead, and we can yet wake him). Vincent Hyspa's mock-scholarly lecture on "Le Veau" (*Les Quat'z'Arts*, 28 November 1897) includes another pun on the same text: "ai-je besoin d'affirmer, messieurs, que le Veau dort, et toujours debout" (need I add, good sirs, that the calf always sleeps standing up).

72. *La Tentation*, 42–61.

73. Maurice Donnay, *Ailleurs: Revue représentée au Chat Noir*, 3d ed. (Paris: Paul Ollendorff, 1908). The play is reprinted in id., *Autour du Chat Noir* (Paris: Bernard Grasset, 1926), 135–92, to which subsequent citations will refer. References to *l'orchestre* should be understood to mean the piano, not an actual orchestra.

74. Ibid., 149–50.

75. Ibid., 143, 174, and 187.

76. Ibid., 148.

77. Ibid., 154–55. Donnay even puns in his orchestral indications, which were not part of the narration. The fifteenth tableau, a Black Mass, is to be accompanied by a "musique étrange . . . Fifres, timbales. L'orchestre déchaîné sort de ses gongs"–a direction for the off-stage percussionists to *sortir de leurs gonds* and let loose.

78. In Donnay's words: "Standing next to the piano, in front of the little door that led to the wings, I recited verse or prose, while Charles de Sivry, according to his inspiration of the moment, accompanied my text, prose or verse, with music that created the atmosphere" (Donnay, *Mes Débuts à Paris* [Paris: Arthème Fayard, 1937], 210). *Phryné* (reprinted in *Autour du Chat Noir*, 103–34), has virtually no specific instructions concerning music; Donnay must have left Sivry even greater leeway in this show than in *Ailleurs*.

79. *La Marche à l'étoile*, mystère en 10 tableaux, poème et musique de Georges Fragerolle, dessins de Henri Rivière (Paris: Enoch Frères & Costallat, n.d.). An "édition nouvelle avec les planches modifiées" and with headings lettered by George Auriol was issued by 1902. The music is identical, as is the list of performers given on p. 5. The list names Charles de Sivry as *chef d'orchestre*; Fragerolle, Delmet, and Oct. Spoll as the récitants; L. Thomas as cello soloist; L. Déo as oboe soloist; and Jean de Sivry as *cymbalier*. A contem-

porary program for the Théâtre du Chat Noir omits all of these names except that of Charles de Sivry and names (among others) Fragerolle and Erik Satie as organists. This list of performers is reproduced in Ornella Volta, "Dossier Erik Satie: L'Os à moëlle," *Revue internationale de musique française* 8, no. 23 (June 1987): 68.

80. "And at the appearance of the tableau that represented the manger, radiant with light, where the Christ Child lay, and around which Magi and fishermen and children were singing . . . , one could feel the spectators ready to cry 'Noël! Noël!' just as they had shouted, during performances of *L'Epopée*, Long live the Emperor!" (Donnay, *Mes Débuts*, 208–9).

81. Dates of first performances are provided in Paul Jeanne, *Le Théâtre d'ombres à Montmartre de 1887 à 1923* (Paris: Les Presses Modernes, 1937), 62–64. One may also note Georges d'Esparbès's *Roland*, billed as an "oratorio en 3 tableaux" and praised by Donnay as "un véritable opéra" (*Mes Débuts*, 208); unfortunately, none of Sivry's music seems to survive.

82. *Le Ménestrel* (19 February 1893): 63. Pougin's study includes ten reproductions of Rivière's tableaux and a facsimile of a page from the composers' autograph score (*L'Encyclopédie* 3, no. 53 [15 February 1893]: 156–66).

83. Including *Les Deux Loups-garous* to a libretto by Paul Arène (1873) and *Un Mariage en Chine* (premiered on 27 December 1874 at the Bouffes Parisiens).

84. Théâtre du Chat Noir, *Sainte Geneviève de Paris*: Mystère en quatre parties et douze tableaux, musique de Cl[audius] Blanc & L[éopold] Dauphin, partition chant et piano . . . (Paris: Heugel et Cie, 1893), 18–19, 20–25, 54–58.

85. As reported in Herbert, *La Chanson à Montmartre*, 164.

86. The Hostellerie opened in the winter of 1891–92 and survived three months. Trombert preferred to present *ombres lyriques* because he lacked Salis's spontaneous eloquence. The following summer, Trombert organized a company, the Théâtre des Ombres Lyriques, that toured France several weeks before Salis's first tour with the Chat Noir troupe. After the demise of the Chat Noir, Fragerolle wrote his "épopée de la Mission Marchand," *La Marche au soleil*, to a patriotic poem by Léon Durocher, premiered at the Bodinière on 17 December 1899. During the Exposition Universelle of 1900, a shadow theater was set up in the rue de Paris.

87. *Au clair de l'urne* was published in the weekly *Paris qui chante* 2, no. 60 (13 March 1904): 6–7. The melodies of the chansons are printed as well, with an identification of the original titles but not of the composers. This source is all the more valuable because these ephemeral productions rarely made it into print.

88. For a useful biography of Charpentier, see Robert Orledge's article in *The New Grove Dictionary of Music and Musicians*, ed. Stanley Sadie (London: Macmillan, 1980). For a recent interpretation of the opera as a political document, see Jane F. Fulcher, "Charpentier's Operatic 'Roman Musical' as Read in the Wake of the Dreyfus Affair," *19th-Century Music* 16 (1992): 161–80. Debussy roundly condemned the opera; see his letter of February 1893 to Prince André Poniatowski in *Correspondance*, 72.

89. Gustave Charpentier, *Le Couronnement de la muse: Apothéose musicale* (Paris: Propriété de l'auteur, imprimé chez M. Delanchy, 1898). A detailed description of the festivity is to be found in *La Vache enragée: Numéro spécial du comité de la Vachalcade* (May–June 1897), a rare copy of which is held by the Jane Voorhees Zimmerli Art Museum.

90. I am indebted to Mary Ellen Poole for sending me her excellent paper, "Gustave Charpentier, Mimi Pinson, and French Popular Song as Social Propoganda," read at the meeting of the American Musicological Society, Minneapolis, 30 October 1994.

91. Jean Cocteau, "Fragments d'une conférence sur Erik Satie" (1920), reprinted in *La Revue musicale*, nos. 386–87 (1985): 35.

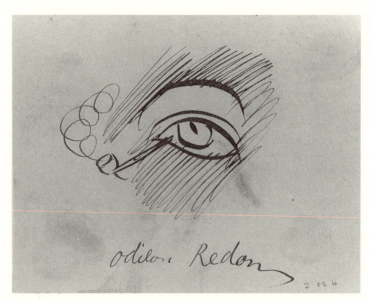

Fig. 253.
Auguste Roedel, "Odilon Redon," from *Le Mur*, 1894, pen and ink,
9 x 10. Schimmel Fund.

Fig. 254. Adolphe Willette, photo-relief cover illustration for *Les 4 z'Arts* (6 November 1897). Schimmel Fund.

198

OLGA ANNA DULL

From Rabelais to the Avant-Garde: Wordplays and Parody in the Wall-Journal *Le Mur*

"First of all," said Gargantua, "there must never be walls built around it, for all other abbeys are proudly walled." "Yes indeed," said the monk, "and not without cause; where wall [*mur*] is, front and rear, there is abundant murmur [*mur-mur*], envy, and mutual conspiracy."–Rabelais, *Gargantua*

When Gargantua, the friendly giant character created by the sixteenth-century humanist writer, monk, and doctor François Rabelais, was about to build his antimonastery Thélème (Greek for "will"), he decided to get rid of walls. Frère Jean, the brave monk whom Gargantua honored with the abbey, had to agree that there should be no walls surrounding a utopian community united by the liberating slogan, "Do what you will." These represented the dark ages, repressive power, and confinement nurturing suspicious and potentially harmful gossip, as the pun *mur-mur* humorously suggests. By contrast, Rabelais's wall-less utopia with its caustic but healthy laughter and conviviality–the so-called Gallic spirit that had previously appealed to the French revolutionaries–was deemed by virtually all the avant-garde groups of Montmartre as the best remedy against the boredom, moral decay, and perversion that impregnated the fin-de-siècle world. It seems, paradoxically, that a radical, imaginative, and jocular father-figure was needed for the self-proclaimed autonomous Montmartre community. Such a need was expressed in any case by all of its avant-garde groups and manifested in its numerous quotations and illustrations of Rabelais's texts[1] and also in the naming of one of Montmartre's cabarets, the Abbaye de Thélème [Fig. 255].

The famous Butte sought to separate itself ideologically from the rest of Paris in order leisurely to cultivate and sacralize its antiestablishment aesthetics, using the slogan of Thélème, "Do what you will," as its own founding device. However, it never actually achieved a utopian freedom from the ideologies and artistic forms it claimed to reject. Rather, for all its claims to radicalism, the Montmartre version of Rabelais's ideal abbey turned out to be an anti-utopia, as we shall see in reference to *Le Mur* [Fig. 253], a happening-like pseudojournal produced on a wall of the

Fig. 255.
After L. Tanzi, "Gargantua sur les tours de Notre-Dame," photo-relief cover illustration for *Le Courrier français*, 23 May 1886.

199

Quat'z'Arts cabaret. Whereas Rabelais ultimately banished walls together with the "murmurs" they stirred, the artists of *Le Mur*, as well as Montmartre in general, never transcended their own walls and "murmurs," as one of the frustrated anonymous "clients" of the Quat'z'Arts cabaret explicitly argued, echoing Rabelais's pun: "Je profite de la publicité du *Mur* pour y étaler mes murmures" (I take advantage of *Le Mur*'s publicity to display my murmurs; *Le Mur*, n.d.).

What are the forms of expression, as well as the ideological, literary, and artistic messages of the "murmurs" that were routinely exhibited on the wall of the Quat'z'Arts? To answer these questions, I shall analyze those devices, namely puns, rebuses, and parody, which, although extensively cultivated by Rabelais himself outside his utopian abbey, were nearly the exclusive tools through which "murmurs" came to life on the cabaret's wall.

PUNS, REBUS, AND PARODY IN RABELAIS

There were few periods in history, except perhaps our own, during which the idea of imitation was more dramatically explored, creatively or subversively, than the end of the nineteenth century. Imitation, whether of contemporary or past, political or aesthetic models, was believed a means of providing new sources for reshaping the self-image of a country recovering from the hardship and humiliation of such disasters as the Franco-Prussian War.[2] Thus, similarly to previous or contemporary nineteenth-century groups, the community of Montmartre turned with interest to the past. The Romantics and later the Symbolists were profoundly inspired by the Gothic spirituality of the Middle Ages, an interest that resulted in the creation of new journals and a whole new discipline, the "archeology of the Middle Ages."[3] The Decadents deemed the Roman decadence their favorite epoch. But for the seemingly anarchic, antiacademic community of Montmartre, the most esteemed refuge was the early-sixteenth-century Renaissance. A period of great cultural and technological innovations, the Renaissance was revered primarily for the rediscovery, translation, and combined imitation of the ideologically diverse texts that form the basis of Western culture: the Greco-Latin classics and the Christian scriptures, in their original Hebrew and Greek forms. Aimed at revitalizing the present by imitating these eclectic sources, the Renaissance was a period marked by value clashes: classical versus vernacular, official versus popular, oral versus written, sacred versus profane, scientific versus literary. Also, the Renaissance provided the example of such significant technological inventions as the printing press. This cultural revolution was only to be equaled by the introduction, in the nineteenth century, of photomechanical printing processes.[4]

It was primarily the heterogeneous, spontaneous, and subversive allure of Rabelais's epic work, along with the poetry of his late medieval predecessor François Villon, the master of argot, that appealed to the artists of Montmartre. Author of five books of

which the best known are *Gargantua* (1534) and *Pantagruel* (1532),[5] François Rabelais (1494–1553) reemerged on the literary scene only in the nineteenth century, thanks to the enthusiasm of Romantic authors, historians, and artists such as Victor Hugo, Chateaubriand, Jules Michelet, and Gustave Doré, respectively. Although Alfred Jarry and later the Dadaists also expressed great admiration for Rabelais's fantasy world and verbal dynamics, the academic rehabilitation of the humanist did not occur until Mikhail Bakhtin's landmark reappraisal of the sense and impact of his work. For the Russian critic, Rabelais's texts best exemplified the carnivalesque style, describing in grotesque, obscene, oral language the world turned upside down.[6]

During the reign of classical norms, from the seventeenth to the beginning of the nineteenth century, Rabelais's *esprit gaulois* was persistently decried for its provocatively obscene, popular, and boldly scatological character. The labeling of Rabelais as the ultimate champion of oddity was due primarily to the disappearance of the mixed social and cultural milieus that were dominant in the Renaissance, and implicitly to "the separation of the high and the low culture, of elite and folk that took hold after Henry IV's death (1610), [and] the consolidation of a restrictive decorum."[7] The most hostile rejection of Rabelais's fantasy world was formulated by the French moralist La Bruyère, who in his *Caractères* (1690) qualified Rabelais's language a "monstrous assemblage of fine, witty moralism and foul corruption."[8] The evocative contradiction in terms–"monstrous assemblage"–points to the indiscriminate mixture of wildly ranging languages and styles. La Bruyère could not but interpret this diversity as a serious attempt to destabilize good literary manners, rather than as a constituting creative force in itself. What makes Rabelais's language "monstrous"?

In *Jokes and Their Relation to the Unconscious*, Freud gives an intuitive analysis of the psychological mechanism underlying the comic, humor, and wit. These are, he explains, pleasurable situations insofar as they result from an "economy of psychical expenditure."[9] Specifically, Freud selects the German Heinrich Heine's commonplace pun *familionär*, as a revealing example of how, through such an economy, semantically unrelated terms, in this case *familiär* and *Millionär*, randomly "condense" into a brand new, "monstrously assembled" word, as La Bruyère would have argued. According to Freud, puns, like dreams, are spontaneous, innovative manifestations of the human spirit, susceptible thus to amuse by provoking surprise and laughter. As such, they have been favorite linguistic devices of comic authors, from Rabelais to his self-proclaimed descendants, whether the Montmartre bohemians or the twentieth-century Dadaists and Surrealists.

In Rabelais, word games represent, first of all, "weapons against intimidation" by religious, military, or political institutions. But they also serve to uncover repressed sexual instincts and, correlatively, buttress the humanist's misogynistic viewpoints,[10] which are amply shared by the confraternities of Montmartre. This kind of wordplay is usually, although not exclusively, attributed to Panurge, the proto-Ubu and "satanic manipulator of language."[11] For instance, in a famous parody of a scene

of seduction, the cunning rogue addresses a lady with the ambiguous phrase, "A Beaumont le Vicomte" (A creek rises for a handsome punt); in so doing, he actually turns the words inside out so that the phrase obscenely sounds, "A beau con le vit monte" (A prick rises for a handsome cunt"; *Pantagruel*, 21:205).

It should be emphasized, however, that in playing with words, Rabelais, although satirical of religious and social conventions, never goes so far as to undermine the communicative power of language, the way the writers of *Le Mur* do, as will later be shown. Rather, he playfully unmasks and ridicules the mania for puns and their indiscriminate application in the "dark ages."[12] The ultimate proof of Rabelais's mildly critical and selective attitude toward word games is found in his rejection of the rebus:

> In . . . darkness are engulfed those court show-offs and name-changers who, wanting their mottoes to signify *espoir* [hope; then pronounced "espwere"], have depicted a sphere [spher], birds' feathers [pennes] for pains [*poines*; then pronounced "pwenes"], *ancholie* for melancholy [melancholie], the two-horned moon for "to live in growth" [*vivre en croissant*, meaning "to live in growing" or "in a crescent"], a broken bench for bankruptcy . . . , which are homonyms so stale, so uncouth and barbaric, that someone should attach a foxtail to the collar of, and make a cow turd mask for each and every one who would henceforth try to use them in France, since the restoration of good letters. (*Gargantua*, 25–26)

As a more complicated subgenre of the pun, the rebus had been wildly illustrated by the Rhétoriqueurs, courtly poets of the late Middle Ages. Rabelais explicitly refers to these poets in the above-quoted passage, but they were evoked even more frequently by the Montmartre avant-garde [Fig. 256] than by Rabelais himself. A "monstrous assemblage" in the sense that it associates, besides incongruous words, unrelated means of expression, the rebus combines various images and texts in the most surprising and amusing way. In the late Middle Ages, when there was great interest in the interplay between writing and painting, the rebus proved an imaginative way to convey moral teachings.[13] Rabelais's rejection of the rebus, on the other hand, was consonant with the humanist ideal of language as an accurate and straightforward rendering of things, rather than as the representation of a fortuitous clash between the visual and the verbal in which chance, as opposed to logic and morality, played the major role. When the rebus became popular later among avant-garde groups, however, it was used primarily as a satirical device targeting everything from symbols of power and women to the academic world. The *Vénus de mille-eaux* (Venus of a thousand waters) [Fig. 257], a fin-de-siècle replica of the famous statue by the Incohérent Van Drin, is a good example of the kind of visual wordplay that the Montmartre avant-garde groups practiced. The pun *mille-eaux* (which sounds the same as "Milo") is inspired by the spring water labels that cover the body of the goddess for extra discretion. The *Portrait by Van Dyck* [Fig. 258] is hardly a portrait, but a *porc trait*, that is, a pig being milked by the famous Flemish portrait painter. Thus, it is hardly

Fig. 256.
Henri Pille, "Rabelais," photo-relief cover illustration for *Le Courrier français*, 4 April 1886 (special Incohérent issue).

surprising that, puzzled and contemptuous, contemporary critics explicitly compared the Incohérents, and all those who were tempted to play with words, to the Rhétoriqueurs: "You are like those miserable *équivoqueurs* (punsters), like those flat name transposers, of whom Rabelais once spoke," storms an indignant journalist.[14]

If puns and rebuses are bound to bring together unfit words and images, one could argue that parody "monstrously assembles" texts produced in geographically and temporally remote areas and periods. As "the imitative reference of one literary text to another, often with an implied critique of the object text,"[15] parody, as we have already seen, was a favorite form of literary expression not only for Rabelais, whose mock epic and mock praises are among the most creative examples of the genre, but for the Montmartre community in general. Since it deals with imitation of texts by texts, parody, like puns and rebuses, always involves a certain "reading" competence, and thus addresses an initiated community. André Gill, the well-known artist and founder of the journal *Parodie*, could thus pertinently call it "the mother of laughter" (preface, 19 June 1869).

A favorite literary expression during cultural periods obsessed with imitation and subversion, such as the nineteenth century, parody was manifested in both "official" and underground arenas. As shown before (in Mary Shaw's essay), parodies by canonical authors–Victor Hugo, Théophile Gautier, Théodore de Banville–were further rewritten and subverted so that at the end of the century, a whole new wave of parody popped up either in alternative journals, such as *Les Hydropathes*, *Le Décadent*, and *Le Chat noir*, or in individual volumes, such as *Le Parnassiculet contemporain*, *Dixains réalistes*, and the *Album zutique*.[16] In the 1890s, and especially in *Le Mur*, parody, together with verbal and visual word games, became so extensive as to target not only figures and symbols of the establishment, outside of the Montmartre utopia, but also the constituencies of the avant-garde community itself. Given the absence of an external, critical point of view, this self-referentiality implied that the Quat'z'Arts turned into a more and more enclosed community within its own "murmurs." Implicitly, as we shall see, traditional aesthetic categories, such as the distinction between original and reproduction, author and work, character, performer, and audience, were also put into question, as the collaborative spirit turned to uniformity and self-derision.

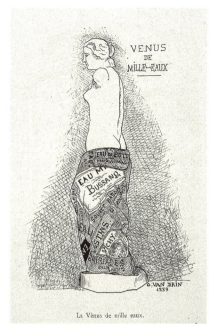

Fig. 257.
G. Van Drin, "La Vénus de mille-eaux," photo-relief illustration for *Catalogue illustré de l'exposition des arts incohérents* (Paris, 1889), 56. Schimmel Fund.

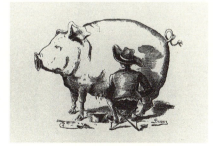

Fig. 258.
Boquillon Bridet, "Porc trait par Van Dyck," photo-relief illustration for *Catalogue illustré de l'exposition des arts incohérents* (Paris: E. Bernard et Cie, 1884), 119. Schimmel Fund.

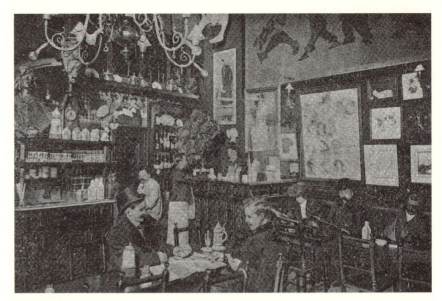

Fig. 259.
Unidentified, "Café at the Quat'z'Arts Cabaret," photograph reproduced in *Les Chansonniers de Montmartre*, special issue, of *Les Quat'z'Arts*, 10 October 1906.

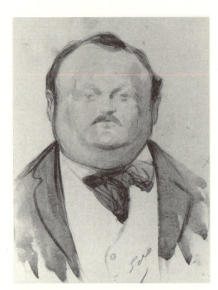

Fig. 260.
Lucien-Victor Guirand de Scévola, "François Trombert," from *Le Mur,* 1895, watercolor and graphite, 21 x 15. Schimmel Fund.

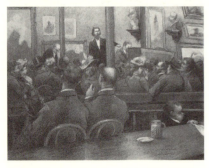

Fig. 261.
Charles Maurin, *Les Quatre'z'Arts*, c. 1895, pastel, 38.2 x 59.3. Ex-Schimmel Collection.

THE QUAT'Z'ARTS CABARET

> La France est le pays des lettres et des arts / Le nombre de ceux-ci s'élève jusqu'à 'quartre': / Aussi le nomme-t-on le pays des 4-z-Arts / Antique cabaret célèbre dans Montmartre.
> (France is the country of literature and the arts / Which are four in number: / So it's called the country of the four arts / Ancient cabaret famous in Montmartre.)
> –Jarry, *Ubu sur la Butte*

It was at the Quat'z'Arts, one of the last sparkles of the Montmartre *cabaret artistique*, that Rabelaisian fraternity, jocular satire, and also the implicit melting of the boundaries between traditional aesthetic categories were most extensively cultivated. Echoing the self-promoting commonplace rhetoric of all Montmartre circles, Jacques Ferny, known from his days at the Chat Noir as "a new Mac-Nab,"[17] proudly insisted on the "uniqueness" of the Quat'z'Arts as the new center of the cabaret world: "doyen des cabarets, lumière de la Butte, palais-royal de la chanson et porte-fanion de la gaîté montmartroise"[18] (doyen of cabarets, light of the Butte, royal palace of the *chanson*, and flag-ship of Montmartrian gaiety.) Founded in 1893 by François Trombert [Fig. 260], and located at 62, boulevard de Clichy, the Quat'z'Arts inscribed itself in the tradition of the Chat Noir with which it coexisted for two years. Like the Chat Noir, the Quat'z'Arts provided an "alternative space" [Fig. 261], where both permanent and temporary exhibitions of works by artists who by the

1890s had made themselves a good reputation were held: Abel Truchet [Fig. 262], Jules Grun, Charles Léandre, Guirand de Scévola, Adolphe Willette, Georges Redon, Emile Cohl, or Henri de Toulouse-Lautrec, to name the best known. The Quat'z'Arts shared the Chat Noir's taste for an eclectic interior design inspired by the past and for its choice of artists and repertoire. It also explicitly promoted the cult of Rabelais's Gallic spirit. Designed by Henri Pille, the *locale*, one of the three rooms of the cabaret, was decorated, like the interior of the Chat Noir, in a pseudo-Gothic, pseudo-Renaissance spirit. The second room, the *salle de café* [Fig. 259], was embellished with wood panels and bronze objects and statuettes, among which a group of Rabelaisian figures stood out as particularly attractive. The interdisciplinary mixture of the arts and the fraternal spirit between the artists and the audience, which formed the hallmark of the *cabaret artistique* and which were reminiscent of Rabelais's convivial utopia, were most evident, however, in the tendency to expand collaborative performance beyond the genres launched at the Chat Noir: "On y voit Truchet, Yon Lug-ue / Bobèche, Ichac, Clovis Hugues / Sécot, Roedel et Numa Blès, Legay, Teulet, Baltha / Cartier, Munch, Denis et Chaise / Et la caissière sur sa chaise" (There you meet Truchet, Yon Lug-ue / Bobèche, Ichac, Clovis Hugues / Sécot, Roedel, and Numa Blès, Legay, Teulet, Baltha / Cartier, Munich, Denis, and Chaise / And the cashier on her chair [*chaise*]; *Le Mur*, 1? September 1895).

Named fumistically after the four disciplines of the Ecole des Beaux-Arts–architecture, painting, printmaking, and sculpture–the Quat'z'Arts served as a gathering place not only for a large number of artists but also for composers, musicians, performers, poets, illustrators, and even such emissaries of established disciplines as the theater critics Francisque Sarcey and Catulle Mendès. Among the artists, first, we should mention those who were discovered by the director Trombert and launched at the Quat'z'Arts, such as the poet and singer Yon Lug [Fig. 263] (Constant Jacquet), whom Trombert discovered in Lyon and who spent almost ten years at the Quat'z'Arts (1893–1904); the singer Gaston Sécot (Jules Costé), one of the founders of the cabaret and a talented Rabelaisian satirist called by his comrades "a good archer of the Gallic dream"; and the poet and singer Jehan Rictus (Gabriel Randon), author and performer of the *Soliloques du pauvre*. Moreover, at the Quat'z'Arts performed those artists who became well known here but started their careers elsewhere: Numa Blès, the satirical singer, who acted as artistic administrator of the Quat'z'Arts, but later became director of the cabaret La Lune Rousse; Charles de Sivry, the composer and piano player who performed at the Chat Noir; Xavier Privas, the "prince of cabaret singers," who, to the surprise of all, was received in the Légion d'honneur; and finally, those who had been well known from the Chat Noir and other *cabarets artistiques* but appeared at the Quat'z'Arts as well: Mévisto, Edmond Teulet, Vincent Hyspa, Marcel Legay, Gabriel Montoya, Hugues Delorme, George Brandimbourg, Louise France, Charles Quinel (who only published in different revues), and Emile Goudeau, founder of the Hydropathes and editor in chief of the *Quat'z'Arts* journal, among other things.

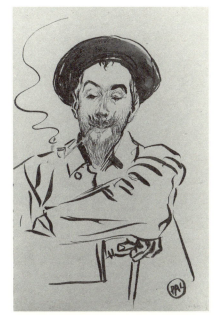

Fig. 262.
PAL (Jean de Paléologue), portrait of Abel Truchet, from *Le Mur,* c. 1895, india ink, 25 x 15.5. Schimmel Fund.

Fig. 263.
Unidentified, "Montmartre, le Cabaret des Quat'z'Arts" (Yon Lug peeks through the curtain while Marcel Legay performs, accompanied by Gaston Sécot at the piano), from *Le Mur*, photo-relief illustration for *Le Journal*, 25 September 1894. Schimmel Fund.

Fig. 264.
Auguste Roedel, "Le Crucifié des Quat'z'Arts," from *Le Mur,* 1896, crayon, 31 x 21. Schimmel Fund.

The name of the cabaret came directly from the notorious Bal des Quat'z'Arts, a fancy parade resembling a Roman Saturnalia, organized by the students of the Ecole des Beaux-Arts and the Atelier des Maîtres. The 1893 ball turned out to be so provocative that it attracted not only the indignant eyes of the official representatives of the bourgeois moral order of the Third Republic but also those of Trombert, who found it ideal as the model after which to name his new center for collaboration between the arts.[19] What is the aesthetic significance of the emphasis on ephemeral spectacle, which complemented the collaborative spirit of the Quat'z'Arts?

In a manifesto published in the first issue of the weekly literary-artistic journal *Les Quat'z'Arts* (6 November 1897) [Fig. 254], Emile Goudeau vehemently opposed the idea of a school as the avant-garde's own Catch 22:

> Vous les monstres, ces lions, ces lionceaux, échappés aux bonnes de l'Institut, et suivant les quatre Muses qui traversent l'eau vers l'Apollon du Mont-Sacré, ils allaient, ces nouveaux-venus, et ils crurent un temps, que l'Aventin deviendrait une Acropole.... Et ils s'étonnèrent quand des aruspices mal renseignés par les entrailles des poulets sacrés, et ignorant la science du vol des oiseaux sauvages, décrétèrent qu'il existait une Ecole de Montmarte. Oh! Ecole! toujours école! Programmes, exemptions, pensums, prix, retenus, médailles, pain sec! Ecole! Ils imaginèrent l'Ecole ironique de Montmartre, puis l'Ecole rosse, puis l'Ecole sensuelle, Nib de Nib! Il n'y a pas d'Ecole de Montmartre.
>
> (You monsters, those lions, those cubs, who escaped from the Institute maids, and following the four Muses who had crossed the water toward the Apollo of the Sacred Mountain, and they kept moving, these newcomers, and for a time they believed that the Aventin would become an Acropolis.... And they were astonished when haruspices poorly informed by the entrails of sacred fowl, and unfamiliar with the science of the flight of wild birds, decreed that there was a Montmartre School. Ah, School! always school! Schedules, exemptions, punishments, prizes, detentions, medals, dry bread! School! They conceived the Ironic Montmartre School, then the Nasty School, then the Sensual School. Nothing of the sort! There is no School of Montmartre.)

Significantly, in a suggestive sketch exhibited on *Le Mur*, Jehan Rictus, the self-proclaimed apologist of the poor, but also a *fumiste* mystic who in his monologue *Le Revenant* identified himself with Christ,[20] is also depicted as being sacrificed to the four arts [Fig. 264]. The implied message of the drawing is similar to Goudeau's protest: the threat that the Quat'z'Arts could turn into just another censoring institution.[21]

To further promote free expression and inventiveness, the artists of the Quat'z'Arts seemed to have opted even more than their comrades at the Chat Noir for those literary and artistic forms that were based not only on collaboration but on improvisation and performance. This view is consistent with RoseLee Goldberg's argument about the fundamental nature of performance art, which "has been considered

as a way of bringing to life many formal and conceptual ideas on which the making of art is based," as well as her contention that "live gestures have constantly been used as a weapon against the conventions of established art."[22] New, happening-like events were introduced at the Quat'z'Arts, in addition to the typically Chat Noir–esque shadow and puppet plays and to active participation by some of its members in the whimsical Vachalcades (cowalcades;1896 and 1897), parades named after Goudeau's novel, and the journal *La Vache enragée* (1885). These new events included such original genres as the revue, and "the walking songs," in which the traditional boundaries between performer and audience were spontaneously brought down [Fig. 266]. Ephemeral to the point of being forgotten the day after their production, the revues were, as in earlier cabaret performances, dialogues and songs performed

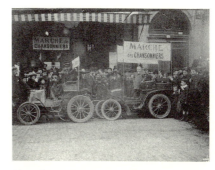

Fig. 265.
Unidentified, "Marche des chansonniers," from *Le Mur,* c. 1900, photograph, 8.8 x 12.2. Schimmel Fund.

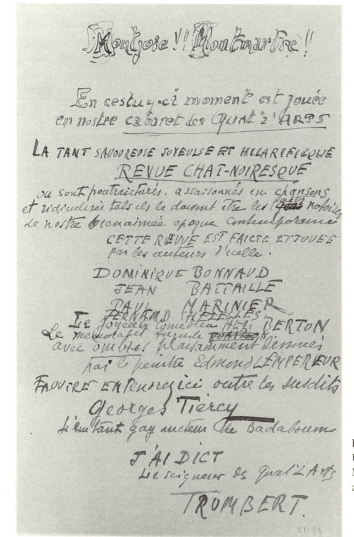

Fig. 266.
Unidentified, "Montjoie!! Montmartre!!" from *Le Mur,* 1894, pen and ink, 21.5 x 13. Schimmel Fund.

207

by individual artists in a casual setting. No decor was required, but participation of the audience was strongly encouraged. "La chanson en marchant," on the other hand, referred to a funny contest during which the *cabaretistes* were asked to compose songs on the theme of a walk which they also performed to the Châtelet and back to the cabaret [Fig. 265]. But the most significant example of the Quat'z'Arts's innovative spirit, collaboration, satire, and improvisation was the wall-journal *Le Mur*.[23] Here, under the auspices of Rabelais, literature, the arts, music, journalism, and performance were combined in an original, although not entirely unprecedented, way. Paradoxically, it was through this inherently ephemeral project that the artists of the cabaret left their most dramatic and enduring mark on literary and art history.

LE MUR: HISTORICAL OVERVIEW

In the last decades of the nineteenth century, following the abolishment of press censorship in 1881 and the easy availability of newly invented photomechanical printing processes, political, literary, artistic, and satirical journals considerably multiplied.[24] Simultaneously, news agencies, such as the Agence Havas, frequently referred to parodically in *Le Mur*, were created.[25] Fin-de-siècle journals appeared to be eclectically if not "monstrously assembled," from the point of view of both content and reception. On the one hand, they promoted elaborate literary and artistic forms together with ephemeral but factual news reports intended for immediate mass consumption; on the other hand, they integrated the resulting artworks into a wider circuit of consumption, one that included a heterogeneous public outside the intimate space of the cabarets themselves. By virtue of their varied content, form, and reception, journals thus contributed to the phenomenon that Walter Benjamin pertinently called the disappearance of "the aura of the work of art in the age of mechanical reproduction." They represented one of the most important means by which traditional aesthetic categories–imitation, original versus reproduction, authorship, and reception–were put into question.[26]

As an antijournal and an alternative or underground version of the official publication of the Quat'z'Arts cabaret, the wall-journal *Le Mur* was inaugurated in September 1894. Unlike other antiacademic publications, which turned out to be short-lived,[27] *Le Mur* continued to "happen" for a period of approximately ten years, if with interruptions of months each year. Somewhere between a bulletin board, graffiti writing, and a show, *Le Mur* functioned as a collaborative "happening" with satirical glances at politics and the literary and art worlds, rather than a real publication intended for mass consumption.[28] The activity clearly reflected the "desire . . . to undermine this pervasive means of communication [photomechanical reproduction] creating works about which very little can be conveyed through reproduction."[29] The contributions would never have been collected in a publication, intentionally perhaps, were it not for the weekly literary and satirical journal *Le Grillon* and its editor,

208

Le « Cabaret des Quat' z'-Arts » inaugure à nouveau *Le Mur*, journal-paroi.

Semainiers : Numa Blès, Charles Quinel, Gaston Sécot, Edmond Teulet, Yon Lug, Hugues Delormes, René Dubreuil, etc.

SOMMAIRES :

N° 1, par Numa Blès :

Epigraphe, Gryllus. *Ses Etrennes,* Ch. Quinel. *Chronique,* Numa Blès. *La Tisane* Yon Lug. *Illustrations,* Mensch, Rœdel. *Mots de la faim,* Numa Blès. *Mépris,* Léon, marchand de fleurs *Bulletin Commercial,* Ichak. *Poésie,* Broustaille.

N° 2, par Edmond Teulet :

Yon Lug, portrait-charge, Grün J. *Poème en toc,* N. Blès. *Sur un squelette japonais,* Gaston Richard. *L'Herbier,* « à Madame Baretta », François Coppée. *Fromage de Roquefort,* Rémy Broustaille. *Dessins-Charges,* Rœdel, G. Bonnamour. *Nouve le à la main,* G. Brandinbourg. *Plus qu'une nuit,* Yon Lug. *Mots de la fin,* Ch. Quinel. *Les Mal-nommés,* Hugues Delormes, etc.

N° 3, par Ch. Quinel :

Chroniques du Jeudi, le Semainier. *Les Aisselles* (poésie), Hugues Delorme. *Jean et Jeanne* (drame en prose), Laurent Geay. *Souvenir* (poésie), Yon Lug. *Le Quatrain de l'A-peu-près-Midi,* Mensch. *Impromptu* (poésie), Ed. Teulet. *Paysages* (poésie), René Dubreuil. *Actualité rimée,* Numa Blès. Extraits :

Les Pêcheurs de Perles, la Chanson des Qnat' z-Arts, par les Chansonniers des Quat' z'-Arts. *Le Sonnet des Jouissances,* Charles Quinel. Dessins hors texte : *Projet de statue équestre pour M. Ichak,* Roedel. *Un petit Ichak,* Rœdel.

Fig. 267.
Extract from *Le Grillon*, 20 September 1895, as it appeared in *Le Mur*, 26 September 1895. Schimmel Fund.

Edmond Teulet. A poet and a *muriste* himself, Teulet had reconstituted lists of works exhibited on *Le Mur*, according to the selection of its so-called *semainier*, the weekly editor [Fig. 267]. Specifically, issues 1 through 9 from 1895 were compiled by Numa Blès, Edmond Teulet, Yon Lug, Gaston Sécot, Hugues Delorme, Charles Quinel, and René Dubreuil.

There are, however, other, more general contemporary references to *Le Mur* in two articles published in *Le Courrier français* by a certain J. d'A. Even though the first (9 June 1895) mistakenly refers to *Le Mur* as a wall-journal of the *cabaret artistique* Les Assassins (also known as Au Lapin Agile), it gives a thoughtful account of the kind of unusual activity this underground journal represented: "Ce journal aura cette

originalité précieuse qu'il ne sera pas mis en vente et qu'il faudra se déranger pour l'aller voir-le voir et non le lire" (The invaluably original thing about this journal will be the fact that it will not be on sale and that people will have to go there to see it—see it, not read it). In the second article, published on 21 July 1895, the author admits the inaccuracy and recontextualizes *Le Mur* as the wall-journal of the Quat'z'Arts, but he erroneously adds that by mid-1895 it had literally stopped "being."

Similar to a modern collage, *Le Mur* consisted of, among other things, a patchwork of formally skillful *mur-murs*, that is, parodies, puns, and rebuses echoing political, literary-artistic, and everyday events: poems, short stories, serial novels, *fables express* (short fables with a final pun), biographical sketches known as *images d'Epinal*, music sheets, caricatures of the writers of *Le Mur* themselves and of many others. It also included comic strips, newspaper clippings with inscriptions and satiric comments, fake news reports, advertisements, and correspondence [Figs. 269–277]. All the contributions were handwritten on regular paper, music sheets, stationery, or bills, and randomly pinned or glued to a bare wall in the Quat'z'Arts, as pointed out in a sonnet dedicated to Trombert: "Suspendus, attachés, cloués vaille que vaille / Regarde ces lambeaux pantelants sur des croix / Que des hommes ont mis le long de la muraille / Afin que tu t'écries un jour: 'J'ai vu! Je crois!'" (Suspended, attached, nailed no matter how / Look at those rags gasping on crosses / That people have placed along the wall / So that one day you may cry out, "I have seen! I believe!"; Grun? "Le Long du *Mur*," n.d.). It seems that this spontaneous, graffiti-like satirical *murmur* occurred in the first year four times a week (in fact, as many times as the four arts), and then from 13–14 September 1895, due to "popular demand," every day, as an integral part of the cabaret routine activity: "Hyspa caricature De Sivry et rime des spirituels à peu près puis, collant au *Mur* le numéro du jour du Roman Collectif, Delorme se baisse" (Hyspa caricatures De Sivry and more or less rhymes spiritual songs. Then, gluing the issue of the day of the Collective Novel to *Le Mur*, Delorme bows; Emile Lutz, "Cabaret des Quat'z'Arts," n.d.).

The most frequent target of the wall was, of course, the common enemy of all Montmartre, the eternally mocked and despised bourgeois: "Bourgeois, tandis que tu reposes, / L'esprit fermé, les yeux ouverts, / A la syntaxe, de travers, / On fait dire d'étranges choses" (Bourgeois, while you're resting, / Your mind closed, your eyes open, / They're making syntax, all askew, / say strange things–"Un mur derrière lequel se passe quelque chose"; a wall behind which something is going on, parody of a verse by Victor Hugo, signed "an audacious anonymous").

The writers of *Le Mur* undermined not only the content and form of contemporary journals but also the whole apparatus involved in the publishing business, mocking such diverse aspects as censorship, editing, advertising, and marketing. In addition to its satirical and jocular spirit, *Le Mur* was thus programmatically spontaneous, childlike, improvised, and eclectic, as pointed out by Emile Lutz, one of the *muristes*: "Le rédacteur en chef du *Mur* change tous les jours. Son devoir est de collectionner autographes, fusains, aquarelles des amis et passants et de les épingler

Fig. 268.
Auguste Roedel, "Je dis Monmerte!" (I say Montmartre/Shid; self-portrait), from *Le Mur*, c. 1897, crayon, 26 x 21. *Le Mur*. Schimmel Fund.

Selections from *Le Mur*:

The Herbert D. and Ruth Schimmel Acquisition Fund permitted the Zimmerli Art Museum to acquire in 1991 three scrapbooks that contained the more than 1,500 items comprising *Le Mur*. Two of the scrapbooks were organized chronologically with many pages dated and were intact from the period. The third scrapbook is of a more recent vintage and held its miscellaneous contents in no apparent order. The entire collection of *Le Mur* has subsequently been separated from its original housing and conserved.

Fig. 269.
Jules Grün, "J'ai beau chercher, Rien! . . ." (Look as I may, Nothing. Not an idea, damn . . ."; self-portrait), from *Le Mur*, c. 1895, crayon and india ink, 35 x 27.

211

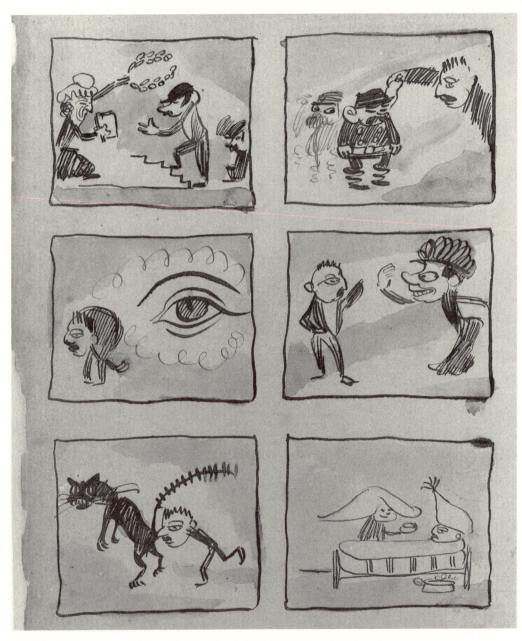

Fig. 270.
Auguste Roedel, "Sécot, sa vie et son oeuvre, image d'Epinal," from *Le Mur*, 1894, watercolor and ink, 22.5 x 18.

212

Fig. 271.
Auguste Roedel, "Yon Lug montoja rdin des oliviers," from *Le Mur,* 1894, pen and ink, 13.5 x 12.

Fig. 272.
Unidentified, "Antique, moderne" (portraits of Xavier Privas and Jehan Rictus), from *Le Mur,* 1896, crayon, 23 x 18.

213

Fig. 273.
Auguste Roedel, four from
the series *Le Nègre plus
culture* (including a parody
on the work of Henri Ibels),
from *Le Mur*, 1894, india
ink, each 21 x 13.5.

Fig. 274.
Numa Blès, "Addition, soustraction, multiplication," from *Le Mur,* c. 1895, pen and ink, 21 x 13. *Le Mur.*

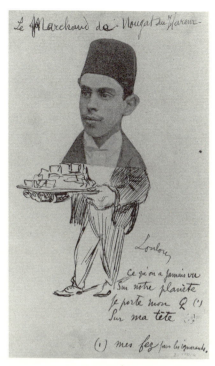

Fig. 275.
Unidentified, "Le Marchand de nougat du harem," from *Le Mur,* 1895, pen and ink with collage of photomechanical illustration, 21 x 13.

Fig. 276.
Auguste Roedel, "Ville Lacustre" (Lakeside Town), from *Le Mur,* c. 1895, pen and ink, 13 x 21.

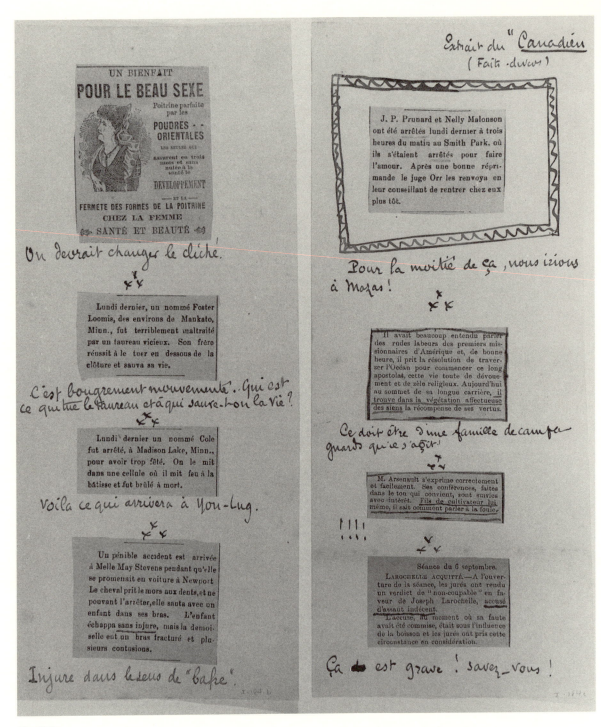

Fig. 277.
Unidentified, two examples of "Les Pêcheurs des perles," from *Le Mur*, 1895, pen, ink, and collage, each 28 x 12.5.

au tableau" (There's a new editor in chief of *Le Mur* every day. His duty is to collect autographs, charcoal sketches, and watercolors from friends and passersby and to pin them to the board; "Cabaret des Quat'z'Arts"). With few exceptions, the self-proclaimed "journalists" coincided with the above-mentioned artists of the Quat'z'Arts, although they appropriated the most exotic identities. Their humorous insistence on the collaborative spirit, however, is also indicative of the admitted randomness of their artistic endeavors: "Des poètes chantent leurs proses / Des prosateurs clament leurs vers" ("Un Mur derrière lequel se passe quelque chose," n.d.). In a parody of the "Echos" section of the journal, we find that the poet "Yon Lug vient de produire une nouvelle intitulée 'Chanson'. C'est ce qu'il appelle une chanson nouvelle" (Yon-Lug has just produced a novella entitled "Chanson". It's what he calls a novel song). Similarly, Vincent Hyspa, the well-known pianist, could also produce poems, such as the fumistically entitled "Sonnet pianissimo" (n.d.). Moreover, the skillful poster artist Auguste Roedel [Fig. 268], who was dubbed by his comrade Hugues Delorme, the "Petrarch of lithography" (9 November 1895), was whimsically remembered by Charles Quinel as a "born lithographer who died as a poet" because "verses" or "worms" (the French pun *vers* makes no distinction between these two terms) did not want him: "Il a trop tôt quitté la pierre / Et les vers n'en ont pas voulu" (He gave up the stone too quickly / And the verses [worms] did not want him; n.d.). The audience of these artists, the *muristes* jokingly insisted, in any case never went beyond the close circle of the Quat'z'Arts. Obviously, no penalty was levied against those who missed their subscription renewal deadline, as subscriptions cost nothing (signed, "l'ad-mi-nis-tra-tion"). All these characteristics, reminiscent of the free interaction of Rabelais's jocose community in the Abbaye de Thélème, indicate that *Le Mur* went even further than the Quat'z'Arts generally with regard to the blurring of the boundaries between artists, journalists, and audience.

Like all avant-garde groups of Montmartre, the writers of *Le Mur* did not miss any opportunity to proclaim themselves the new redeeming force of French literature, which, from their point of view, had been consistently in a state of prolonged agony:

> Pour attirer sur le Journal "Le Mur" l'admiration de tous—nous—cerveau de l'Esprit Parisien, comme dit si bien la Rédaction, nous avons décidé de ne point choisir un but trop haut pour être atteint. Nous n'aspirerons donc, par la publication de notre journal quatre fois quotidien par semaine, qu'à *complètement régénérer la Littérature française, sans plus*! Et, comme simple est le but, complète sera la réalisation. (Numa Blès, *Chronique de Blès*, 8 September 1895; emphasis mine)
>
> (To earn everyone's admiration for the journal *Le Mur*—we—the brains of Paris Wit, as the Editorial Staff so aptly puts it, we decided not to choose a goal too high to be achieved. So in publishing our journal four times a week, *we shall merely aim to regenerate French literature completely, nothing more*! And simple being the goal, complete will be the accomplishment.)

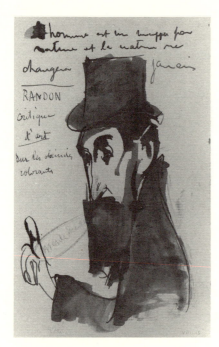

Fig. 278.
Lucien-Victor Guirand de Scévola,
portrait of Jehan Rictus, from *Le Mur*,
1895–96, india ink, 21 x 13.5.

In the spirit of the Abbaye de Thélème, *Le Mur* promoted Rabelais's slogan, "Do what you will," to the point of literally allowing anything to happen, as formulated in the pseudomanifesto pinned to the wall on 24 September 1894: "On pourra le long de ce mur / Tout crayonner et tout écrire . . . / Des romans listes, mots pour rire . . . / Mais il est défendu . . . C'est dur!!!" (signed, "un maçon") (Along this wall people will be able / To draw and write anything . . . / Serial novels, words for laughter . . . / But it's forbidden . . . it's hard!!! [signed, "a mason"]). For the close community of *Le Mur*, however, the act of writing and the writer himself were not only free but also as common as the signature "a mason" suggests. In fact, only the initiated reader was able to identify "a mason" as the poet Armand Masson, known for his publishing habits under various unacknowledged pseudonyms.[30] The emphasis of the manifesto, however, was on the fact that an ordinary wall had replaced the traditional artistic frame. As an alternative frame, *Le Mur* tolerated any comparison, from the obscene to the scatological, material alluded to perhaps in the phrase "C'est dur!" (It's hard). In the "Ballade du vieux mur" (Ballad of the old wall), Numa Blès uses the plaintive tone of the medieval ballad to compare the old wall to an equally old male sexual organ: "Tu te mets au lit, tu t'installes / Et tu te livres, coup sur coup, / A des choses pyramidales! / Le vieux mur est toujours debout" (You get into bed, you settle in / And you engage, blow by blow / In colossal things! / The old-aged wall is still standing; one also finds such a reference in the pun "le mur"/"le mûr," "the wall"/"the aged"; 1 February 1904). But most significant, the descriptions of the wall directly evoke Jehan Rictus's opening poem of the *Soliloques du pauvre*, "L'Hiver," performed in mid-November 1894. As mentioned earlier by Phillip Dennis Cate and Mary Shaw, Rictus, who had appropriated the colorful half-humorous, half-serious argot of the late medieval bohemian poet François Villon, explicitly expressed his indignation at and contempt for high art and society in general, by publicly uttering the outrageous word *merde*, a cry that came at least one year before Alfred Jarry scandalized the public with a Freudian *merdre* at the Théâtre de l'Oeuvre. A true manifestation of the *esprit gaulois* turned against petrified conventions, the word *merde* represented, for Rictus [Fig. 278] as well as for Jarry, the common denominator of all bourgeois society and the kind of art that it promoted:

> Mais, les Bourgeois objecteront sans doute, qu'ils protègent les arts, puisqu'ils couvent, engraissent ces multitudes de faux artistes, ces rapins blagueurs et orduriers qui encombrent des halls d'obscénités colorantes [*merde*] et dont la masse gagnant de l'or autant que des agents de change, égale, si elle ne le dépasse pas, la marée toujours croissante des prostituées et des voleurs." (Gabriel Randon, *Le Mur*, n.d.)
>
> (But the Bourgeois will undoubtedly object that they protect the arts since they incubate and fatten the crowds of phony artists, those cynical and scurrilous daubers who clutter halls with coloring obscenities ["shit"], making money just like foreign-exchange agents, and the number of whom equals, if it does not exceed, the rising tide of prostitutes and thieves.)

218

It is significant that the twentieth-century avant-garde movements would share similar beliefs, as stated for instance by Filippo Tommaso Marinetti, the founder of Futurism, in his *Variety Theater Manifesto*: Futurism is about "the destruction of the Solemn, the Sacred, the Serious and the Sublime in Art with a capital A."[31] Ironically, however, for the *muriste*, *merde* was not merely the only thing worth saving, but also the only word worth praising: "un mot qu'il ne faut pas que l'humanité perde" (a word that humanity must not lose; Alfred Poussin, "Un Mot qui réconforte" [A comforting word] n.d.).

THE WORLD AS NEWS AND TEXT

What is the ideological profile of a confraternity engaged in producing a fake journal whose constitution is complicitous satire, obscenity, and the absurd? We shall see that *Le Mur*, like manifestations of other Montmartre circles, was hardly innovative in its treatment of politics, race, and gender, although it often oscillated between conservatism and radicalism. On the contrary, the views the *muristes* expressed basically coincided with those of the petite bourgeoisie, the rising class of the Third Republic, whose members were characterized as "frondeurs mais non révolutionnaires"[32] (rebels but not revolutionaries).

At the fin de siècle, the cult of patriotism and nationalism gradually turned to widespread support of colonial imperialism. As anticolonialism did not consolidate into a left-wing political agenda before 1914, however, definitions of colonialism wavered: some perceived it as a "civilizing mission," others as an "economic interest." Moreover, during the years *Le Mur* happened, the idea of colonialism was inseparable from a growing chauvinism, which opposed France to powerful, long-time rivals, such as Britain.[33]

Le Mur satirically monitored all major political incidents of the period; these events were humorously staged as major happenings at the Quat'z'Arts with the *muristes* as the main characters. For instance, one can find allusions to the Franco-Russian Alliance (1897), in which Félix Faure, elected president of the Third Republic in 1895, played a conciliatory role [Fig. 279]. But in the late 1890s, the hottest conflict of interests between the Western powers involved the island of Madagascar.[34]

Christianized by Protestant missionaries, the island opened its doors to trade with the Western world under queens Ranavalona II (r. 1868–83) and Ranavalona III (r. 1883–95), but the contacts were pro-Anglo-Saxon rather than pro-French. Beginning in 1883, France claimed an old right over the island inherited from the time of Richelieu (1643)–Madagascar had been declared a protectorate but Queen Ranavalona III refused to recognize it as such–and in 1895 French troops occupied the capital, Tananarive. The expedition of General Duchesne in 1895, which took place under Faure's presidency, resulted in the fall of Ranavalona III and the direct colonization of the island in 1896.[35]

Fig. 279.
Unidentified, "Faure tification," from *Le Mur*, n.d., pen and ink, 21 x 13.

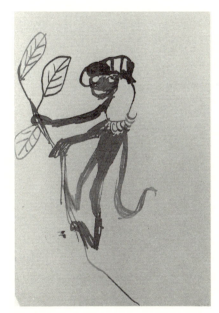

Fig. 280.
Auguste Roedel, from the series *Le Nègre plus culture*, from *Le Mur*, 1894, pen and ink, 21 x 13.

219

Fig. 281.
Auguste Roedel, "Reine à vau-l'eau," from
Le Mur, 1895, pen and ink, 13 x 17.5.

Although the French intervention was generally presented in laudatory terms between 1896 and 1905, due to the abolishment of the repressive monarchy of Ranavalona by General Gallieni,[36] the very notion of colonialist intervention constituted a favorite target for satirical journals. Among the publications clearly denouncing or mocking the assault inflicted by the Western world on the African population, and the nascent racism [Fig. 280] the intervention fostered, *L'Assiette au beurre* and Jarry's *Almanach du Père Ubu* occupy a prominent place.[37]

Although it was generally consonant with the petit-bourgeois nationalistic ideology that dominated Montmartre, *Le Mur* provided an ideologically ambivalent view of colonialism: both the abuses of the French and the false submissiveness and collaborative politics of the native population with the British were admonished. This ambivalence was expressed in Rabelaisian puns and parodies, which "monstrously assembled" the exotic world of Madagascar and Montmartre, with the writers of *Le Mur* playing the major role.

The *Lettre de Madagascar* (*Le Mur*, n.d.) is a fictitious, epistolary account of the experience on the island of the *muriste* And(h)ré Joyeux, who under the identity of a French soldier in Madagascar, addresses his friend Alphonse Allais.[38] The underlying incongruity of the letter's word games is a humorous criticism of the French intervention. Systematically highlighted as elements of intrusion in the narrative, puns are deliberately used to support the view that the French presence in Madagascar was both alien and intrusive. The writer proceeds by enumerating the natural resources of the island, while denouncing the false reports of the "Hovas," the leading native caste of Madagascar and enemy of the French. *Hovas* is a pun on the name of the recently created news agency Havas, whose handling of information about the colonialist intervention is thus implicitly discredited. The riches extolled include exotic trees, such as gum and, curiously, oak trees, referred to as "Du chesne." The pun on the name of the leader of the French expedition, General Duchesne, humorously indicates that the presence of the oak tree in the tropical climate is as unnatural as that of the French in Madagascar. Moreover, the agricultural products enumerated include not only rice, coffee, and sugar cane, but also "vanille aux enchères," a product made from a pun on a card game, "manilles aux enchères," a favorite pastime not only in Madagascar but also at the Quat'z'Arts. When Joyeux invites Allais to "installer son comptoir" (literally, to settle one's account), he alludes to the brilliant financial opportunity future expeditions would mean for fortune hunters. But the writer does not limit himself to criticizing the French: the hostile Queen Ranavalona is also on his list. The queen has got "black ideas," says one of her subjects, because she wants "to kill . . . time" when she decides to read a rebus by the Montmartre cartoonist Jules Depaquit.[39] Unable to "cut," that is, to overcome her difficulties, she turns "white with rage," meaning that she is ready to collaborate with the invaders, indubitably the English. The rebus "Reine à vau-l'eau" [Fig. 281], a pun on the name Ranavalona, shows the queen carried away by the stream ("à vau l'eau" means just that), while, in fact, she is being exiled by the French. In conclusion,

the writer ironically praises the "air de campagne," alluding to his satisfaction with the colonial "campaign," which feels like the fresh air of the French countryside.[40]

Improvised to the point of the absurd, the *Great Serial Novel*, which also focuses on Madagascar, gives the *muristes* the opportunity to elaborate not only on the notion of colonialism but on paraliterary concepts later explored in the twentieth-century novel, such as authorship, originality, and the role of the reader. The ironically entitled "high antique" serial novel *Les Quatre Fils Pharamond* is a parody of the twelfth-century Christian epic *Les Quatre Fils Aymon*, which was translated in the nineteenth century into modern French and innovatively illustrated by Eugène Grasset in an 1883 edition published by Launette. Since the time of Aristotle, the epic represented, together with tragedy, the most noble of genres celebrating the birth of a nation. Parodic, as it often may be, the frequency of the epic in the fin de siècle–see for instance Caran d'Ache's *Epopée*, a shadow play performed at the Chat Noir– denotes the need the French felt to consolidate their emerging national consciousness.[41]

Taking their cue from the paradigmatic confrontation of Christian and Saracen forces, the *muristes* viewed the confrontation between the French and the native population of Madagascar in similar terms. Yet in *Les Quatre Fils de Pharamond*, the traditional polarization of good and bad has been blurred. This is a nightmarishly absurd travel novel, which relies on Rabelaisian puns and parody mixed with Alphonse Allais–type black humor. It is significant that, unlike the normal epic, which, as the founding text of a nation, intrinsically conveys the idea of continuity, "the great novel" is a serial, a fragmentary compilation of events elaborated daily through the collaborative but random efforts of its authors, the *muristes humouristes*. As was mentioned in Mary Shaw's essay, a similar collective serial novel had been produced by George Auriol, Tristan Bernard, Georges Courteline, Jules Renard, and Pierre Veber, under the title *Roman impromptu*. But the writers of this particular epic claim affinity, instead, with Raoul Ponchon, the *fumiste* known for his whimsical chronicles published in *Le Courrier français*. The participating *muristes*-journalists were not only the authors of the epic; they were also the characters. Their names vary with each

Fig. 282.
Unidentified, "Le Boulet qui fit des 4 fils Pharamond . . . ," excerpt from "Les 4 Fils Pharamond," from *Le Mur,* 1895, pen and ink, 16 x 21.5.

contribution, so that on certain days "the seven authors of the four sons of Pharamond" turn out to be in fact only six. Among the members of the Pharamond family we find the owner of the Quat'z'Arts, Trombert himself, the noble "Trombert," or as the *muriste* further insists in Jarryesque neoscientific fashion, "Tromolithophile Bert" ("merde–Le Ciel est si rouge que mon absinthe n'est plus verte?") (Shit–the Sky is so red that my absinthe is no longer green?). Ironically, the readers are designated as the caretakers of the journalists-authors-characters, so that the epic is indeed a family business.

The absurd, macabre tone of *Les 4 Fils de Pharamond* is set in the prologue, in which René Dubreuil subverts the tradition of the epic lineage by informing the reader that in fact "Pharamond has never had his own children, but that they are mute." On 14 July 412 Clovis, one of Pharamond's sons, whom one can identify as the artist Clovis Hugues, also known as a contributor to *Les Quat'z'Arts*, is climbing the Butte, bypassing the house of George Brandimbourg, another writer of *Le Mur*. King Pharamond, called *le roi vénérien*, to form a pun on the expression *roi vénéré* (he is "venereal" here, instead of "venerated"), is in a state of epic agony and consequently expresses his last wish, which is to address his four sons. These are whimsically named *à l'antique*: Théodoric-le-Chauve, Jules-le-Douillard, Clovis, Clodion-le-Chevelu. Later, these names will be corrected, then changed to Clodomir, Ludovic, and Mérovée. The king's final intention is to inform them about their compromised lineage: "Enfin, vous voilà tous réunis, mes enfants, je puis claquer. . . . Vous n'êtes pas mes enfants! C'est une affreuse blague. . . . Vous êtes tous bâtards!" (At last you're all here together, my children, I can die. . . . You're not my children! It's a horrible lie. . . . You're all bastards!). The traumatic news leaves the sons instantly speechless.

After the prologue, the chapters are arbitrarily picked up by the participating *muriste*-journalist on call, so that the narrative voices randomly intermingle, stop, and continue. After having studied at the Special School for the Deaf, the four sons decide to respond to their patriotic duty and leave for Madagascar. But, to their deep surprise, as they raise their hands to the sky in a symbolic gesture seeking benediction, a bullet swiftly cuts through their bodies, leaving them "culs-de-jatte" (legless cripples) [Fig. 282]. From this point on, the narration moves back and forth between Montmartre and Madagascar, as the sons of Pharamond pursue both their absurd military expedition on the island (which they conquer miraculously) and their macabre love affairs.

Queen Ranavalona is informed by the British authorities that the French have sent three "valorous princes," Jules, Clodomir, and yet another character named Clayton (Clovis decided not to join), who, although mutilated by one of the serial's authors, are determined to chase her away (chap. 9). The conquest of the island and its capital, Tananarive, by General Duchesne is a good opportunity for the writer to criticize the selfishness of the military intervention: "Tananarive qu'à moi" actually reads, "Tu n'arrives qu'à moi!" that is, "You belong only to me." Second, monstrosity also affects love. One of Clodomir's amorous conquests, Pamela, is a monster with

Fig. 283.
Auguste Roedel, "Oh! Oh! dit Clovis à Jules . . . ," excerpt from "Les 4 Fils Pharamond," 1895, pen and ink, 23 x 21.

"6 arms, 6 legs, one head, and one single sex born at the Bifurcation." She is, in fact, a counterpart of Huysmans's Miss Urania in the canonic decadent novel *A rebours*. Instead of a love affair, however, the reader of the serial novel witnesses a scene of a transsexual experiment cast in black humor, as Pharamond's sons ruthlessly cut off the woman's limbs and attach them to their own mutilated bodies. As a result, they become shockingly "feminine," whereas Pamela's mutilated body looks, fumistically, just like the French franc (contribution by Yon Lug).

Thus, the solemn and the trivial, the past and the present, the real and the fictional, the macabre and the domestic–oppositions already seen in Rabelais and further explored by the Dadaists and the Surrealists[42]–are intermingled in the epic in a shockingly absurd, monstrous way. The universal thematic frame of traditional epic–conquest, love, fraternity–is fused with detailed descriptions of place, time, and milieu characteristic of the Realist, Naturalist, and Decadent novel, which, however, will be systematically subverted. As the parodic title suggests, the time and space of the early Christian and fin-de-siècle encounter with the other world are conflated in mock-heroic terms, echoing Jarry's juxtaposition of Poland and France in *Ubu Roi*. The time of the action is the revolutionary Bastille Day absurdly transplanted into the past: we are in April, but it is in fact 14 July of the year 412.[43] The temporal clash is doubled by a series of absurd geographical juxtapositions: the place is concomitantly Lutèce (or the ancient Paris) and, more specifically, the "Butte" Montmartre and Madagascar; and, as in the Surrealist novel, symbols of modernity are condensed with those of primitive times and cultures–the Eiffel Tower, for instance, with the desert of Madagascar. Moreover, modern technology complements the epic paraphernalia, as the mythical warhorse Bayard is being followed, in Jarryesque fashion, by a bicycle [Fig. 283]. Recent or contemporary events, such as the bloody Commune, are also incorporated and recycled in the colonialist trip, as the barricades of the Commune are transformed into carriages for the handicapped. As we move from the Middle Ages to present-day politics, from Montmartre to Madagascar, the reader is abruptly reminded by direct intrusions from the narrator that he or she "has lost the thread of the story": "Le lecteur a peut-être perdu le fil de notre intéressante histoire. Cela tient à toutes les stupidités qu'accumulent à ce Mur les six rédacteurs-feuilletonistes" (The reader may have lost the thread of our interesting story. That's a result of all the stupidities gathered at this Wall by the six editors–serial novelists; contribution by René Dubreuil).

In its random mixing of the fantastic, the macabre, and the familiar space of the cabaret, in its breaking of lines between author, character, narrator, and reader, *Les Quatre Fils de Pharamond* is a good example of a "monstrous assemblage." The monstrosity of the text is a sarcastic reference not only to colonialist intervention but also to the manipulation of the news by the press.

On 31 October 1894 the Havas News Agency reported that Alfred Dreyfus, the Jewish officer accused of spying for the Germans, had been arrested. As it turned out, Dreyfus would be rehabilitated, declared innocent, but only in 1906, not before

Fig. 284.
Auguste Roedel, "V'la comme Ychaç," from *Le Mur,* 1895–96, pen and ink, 22 x 14.5.

Fig. 285.
Lucien-Victor Guirand de Scévola, "Dreyfus–ce coffret contient ce qui nous divisait" (Dreyfus–This chest contains what divided us), from *Le Mur,* 1898, pen and ink, 21 x 13.

Fig. 286.
Auguste Roedel, "Ecce Chamo," from *Le Mur,* 1895–96, pen and ink, 22 x 14.

Fig. 287.
Auguste Roedel, "Geai home et truie," from *Le Mur,* 1895–96, pen and ink, 12 x 13.5.

having been put on trial and condemned to life imprisonment on Devil's Island, a penal colony of French Guiana. It was the Dreyfus Affair on the heels of the political-financial Panama Scandal involving a Jewish banker (1892) that launched the first wave of organized anti-Semitism in modern France. The subsequent polarization of French society into pro- and anti-Dreyfusards was due to the manipulation of public opinion by the press, although this polarity would eventually be rendered even greater and more complex by political left- or right-wing orientation. Indeed, anti-Semitic elements were not rare among leftist groups, such as the socialists, the anarchists, or the syndicalists (*L'Assiette au beurre*, 173), nor among the popular press– *La Libre Parole, Psst!*, including *Les Quat'z'Arts* itself.[44] Moreover, well-known Montmartre artists, such as Adolphe Willette, Jean-Louis Forain, and Caran d'Ache, were overtly anti-Dreyfusard, whereas others, such as Théophile-Alexandre Steinlen, Félix Vallotton, and Henri Ibels were pro-Dreyfusard.

The artists and the writers of *Le Mur* evidently shared the anti-Semitic views of their comrades at the Quat'z'Arts, but their attacks were frequently directed against a certain Ichac (Isaac) [Fig. 284], a pseudonym created by one of the *muristes*, whose identity, however, remains unclear. This was consistent with the overall principle of the wall-journal *Le Mur*, according to which the Quat'z'Arts community acted as the scene of all major political and cultural events. *Le Mur* contains direct references to specific circumstances of the Dreyfus Affair, such as the exile to Devil's Island [Fig. 285]. Also, as if in anticipation of the heavily anti-Semitic issue of the journal "*Ecce homo*, numéro anti-chrétien" (*Behold the Man,* Anti-Christian issue; 29 December 1906), which went so far as to accuse the first Christians for their Semitic origin,[45] *Le Mur* displayed an *Ecce Chamo* [Fig. 286], a drawing forming a pun on the biblical Ecce homo and the Jewish name "Samuel." In another example [Fig. 287], the point of the rebus *géometrie*, combining *geai* (jay), a *home* (house), and the profile of a Jew, is a slanderous *truie* (pig). In general, however, the artists do not push their malice any further than humorously to typify Jews' laziness or avarice. For example, when Ichac leisurely hunts (a pun on *I chaç*, that is, "I chasse," "Ichac hunts") [Fig. 284], with his gun pointed at an *oeil-de-perdrix*, his target is hardly a partridge but the corn on his own toe.

In a fictitious financial news report, Ichac wonders whether there is any similarity between a woman in search of social status and the fluctuating national debt. The answer is yes, since both are driven by the "furious desire" to be "consolidated," suggests Ichac (8 October 1894). As the malicious comparison shows, in the world of *Le Mur*, as in general at the fin de siècle, women were treated as part of the circuit of consumption.

Traditionally, there was a strong prejudice against women writers and artists in the Montmartre confraternities. Membership was guaranteed only to those women who were well recognized as artists, such as Sarah Bernhardt [Fig. 288], whose glorious acting career seemed ground enough for acceptance in the group of the Hydropathes.[46] In the article "Cabaret des Quat'z'Arts," Jacques Ferny justifies this

Fig. 288.
Georges Lorin (Cabriol), "L'Hydropathe Sarah Bernhardt," hand-colored photo-relief illustration for *Les Hydropathes*, 5 April 1879. Schimmel Fund.

Fig. 289.
Unidentified, portrait of Louise France (rear view), from *Le Mur,* n.d., pen and ink, 21 x 13.5.

Fig. 290.
Auguste Roedel, "En France Madame France est chouette ouett ouett ouett" (In France, Madame France is cute, hoot, hoot, hoot), from *Le Mur,* 1894, pen and ink, 21.5 x 13.5.

Fig. 291.
Unidentified, "Pour le journal 'Le Mur'" (portrait of Louise France), from *Le Mur,* 1897, pen and ink, 21 x 13.

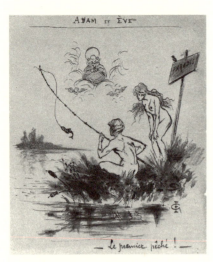

Fig. 292.
Edmond Gros, "Adam et Eve–le premier pêché!" from *Le Mur,* n.d., pen and ink, 25 x 21.5.

lack of the female sex in the cabaret world by the nature of the shows: as the performers coincided with the authors, the best women could do was to sing couplets. The Quat'z'Arts and *Le Mur*, however, seemed to have made significant concessions to women writers. Such was the case of the Hydropathe Marie Krysinska[47] and of the actress Louise France who became well known as Mère Ubu in the first performance of Jarry's *Ubu Roi*. A poet, she was the author of *Berceuse verte* [Fig. 294], a black-humored parody of Gabriel Montoya's *Berceuse bleue*, one of the few works exhibited on the wall that was published, first as a music sheet (October 1896), and later in a journal and in a volume. Louise France also acted as full-time secretary of *Le Mur*. Since mockery was, paradoxically, the guarantee for acceptance in the confraternity, Louise France must have been exceptionally well recognized, for she was often caricatured by established artists such as Guirand de Scévola and Roedel [Figs. 284–291].

But in general, as we have previously seen, in the late 1800s, women were treated in a crudely misogynistic way. They were classified, regardless of their social position, under the generalizing clichés of "goddess and slut," as one group of objects of consumption.[48] Thus, for the *muriste* Numa Blès, *fleur de lys*, the traditional symbol of virginity, had given way to *fleur de lit*, a pun conflating virginity and prostitution ("Ballade sur ceux qui n'ont pas de maîtresse" [Ballad about those who have no mistress; *Le Mur*, n.d.]). The disappearance, after 1870, of the demarcation between the aristocrat, the bourgeoise, or the working-class woman resulted in a "monstrous" object that *Le Mur* frequently described in its own equally monstrous parodies, which were often reminiscent of Rabelais's mock praises. These parodies of traditional forms of love poetry, such as the Renaissance sonnet, the blazon, or the medieval ballad, were also directed, in genuine *fumiste* spirit, against such major, yet contrary, literary trends as Symbolism and Mysticism, on the one hand, and Positivism and Naturalism, on the other.

Yon Lug, a notorious iconoclast, was the author of numerous parodies of Symbolist and Mystic poetry. In these works, the reversal of the sacred and the profane, which was generally fundamental to Montmartre, reached the most blatantly pornographic extremes. In the poem "Marie-Madeleine" (a fragment of the later published volume, *Bible d'amour*[49]), Yon Lug subverts the biblical commonplace of Mary Magdalene's redemption from a sinful life, presenting this not as an exhortative moral device but as a sarcastic praise of carnal love: "O femme! péchez / Du soir à l'aurore, / Ce n'est pas assez / Oui! péchez encore!" (O Woman! sin / From eve to dawn, / That's not enough / Yes! sin some more!). The term *péché* (sin) itself has turned into a funny pun, as shown in the rebus "Adam et Eve" [Fig. 292]. As the expression *le premier pêché* ("pêché"/"péché") indicates, in Montmartre, the first sin was nothing more than a banal fishing trip.[50]

The sonnet "Jouissances" was both exhibited on the wall and published in October 1895 by Lemerre, the publisher of Verlaine and other well-known poets, as one of the twelve poems of the cycle *Eternelle Histoire*. In his poem, Charles Quinel plays on the traditions of the sixteenth-century poetic form of the blazon (a poem praising

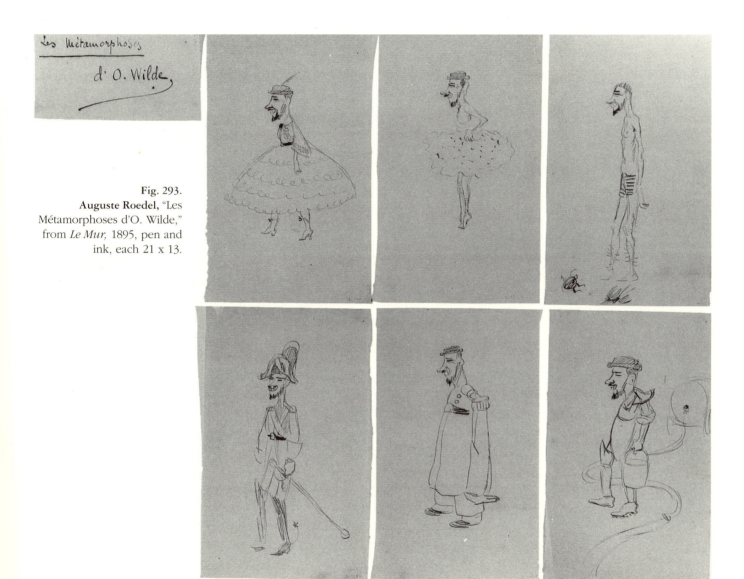

Fig. 293.
Auguste Roedel, "Les Métamorphoses d'O. Wilde," from *Le Mur,* 1895, pen and ink, each 21 x 13.

229

isolated parts of the female body), to elaborate on his own sexual fantasies.[51] Although the praise is initially conventional, including references to beautiful hair, brilliant eyes, white lips, white arms, beautiful breasts, and ivory hands, in the last stanza, the discourse falls into obscenity as the poet abruptly turns to describing sexual intercourse in vulgar slang.

In his "Sonnet vieux jeu" (Old-fashioned sonnet), Léo Epinette, known as Léo Trézeni[c]k, one of the founders of the Hirsutes (1882), subverts both Symbolism and Positivism, in a truly *fumiste* "monstrous assemblage" of love and medical rhetoric. Here, the Baudelairean "spleen" turns into "cancerous boredom" that can only be cured by a "prestigious Muse doctor," whose lips are positivistically compared to a *cataplasm*, and whose eyes are characterized as a *cautère* (cautery).

At the fin de siècle, the theme of the "castrating woman" incarnated by Salomé became a central issue in Decadent discourse, as, for example, in Huysmans's *A rebours* or in Oscar Wilde's *Salomé* (performed in 1893 in Paris with Sarah Bernhardt in the title role). References to women's unsatiable desire thus permeated the parodies of *Le Mur*. For instance, René Dubreuil, in his *Vingt Vers*, complains: "Au doux frisson de tes chairs roses / Je suis insensible, j'ai peur" (To the smooth shiver of your pink flesh / I'm insensitive, I'm afraid; *Le Mur*, 12 October 1894?).[52]

Closely related to female monstrosity are the notions of travestism and metamorphosis. Roedel's sketches entitled *Les Métamorphoses d'O. Wilde* [Fig. 293] are humorous depictions of the multiple identities the artist appropriated in both his life and work: an officer, a ballerina, a worker, and a prisoner. As an eccentric, prolific English writer of Irish origin, but also a homosexual and an artist interested in the reversal of art and life,[53] Oscar Wilde provided the *muristes* with an ideal model of travesty. Following the translation of his play *Salomé* into English, Wilde was attacked by the press for his homosexual behavior. Bankrupt and abandoned, in 1898 he was condemned to two years of forced labor and to prison. Set free, he returned to France, where he spent the last years of his life. Although he found refuge among bohemians such as Verlaine and Rictus (to whom he dedicated a ballad), Wilde was hardly exempt from vulgar comments on his homosexuality. In *Le Mur*, for example, Roedel maliciously notices that "when Oscar Wilde is riding his bicycle, his friends call him *pédaléraste*." The Rabelaisian pun humorously combines *pédaliste* and *pédérastre*. As we shall see, the recurrent theme of disguise and metamorphosis in *Le Mur* is inseparable from the general, fin-de-siècle obsession with originality and artistic autonomy.

THE SELF

One night, during a performance of Gabriel Montoya's *Berceuse bleue*, an enthusiastic guest proudly exclaimed that he was able to identify the song as a skillful parody of Louise France's *Berceuse verte* [Fig. 294]. But, as it turns out, Montoya's "blue," not France's "green," represented the so-called original version of the lullaby.[54] The anecdote indicates not only the popularity of France's poem but also the perception within the Montmartre community that the relationship between original works and parodies, pastiches or fakes, could be freely reversed and blurred.

The *muristes*' obsession with imitation, subversion, and, implicitly, plagiarism, whether of past or contemporary works, logically implied the questioning and ultimate denial of their own artistic identity. As mentioned before, literary idols among the Symbolists, Decadents, or Parnassians were favorite subjects of the adventurous *muristes*, although their subversive attitude oscillated between mock praise and sarcasm. Thus, whereas all-time idols, such as Baudelaire and Verlaine, provided the artists with inexhaustible sources for benevolent pastiches, of which Baudelaire's *Pipe* or Verlaine's *Au clair de la lune* (In the moonlight) are noteworthy—see Yon Lug's version *Au clair de la lampe* (In the lamplight), which was later published—other "masters," the Parnassian Leconte de Lisle, for example, deserved no more than malice. As in many *fumiste* poems, Leconte de Lisle was criticized by the *muristes* for the artificiality of his style. In a satiric imitation of the Parnassian's well-known *Poèmes antiques*, their declared intention was to "railler un poème en toc" (to poke fun at a fake poem). The expression *en toc*, which means "a fake, an imitation," is a double pun on *en tic* and *antiques*, meaning that Leconte de Lisle's poems were considered nothing but fakes (*Le Mur*, n.d.). Naturalism and especially its master, Zola, were also frequently ridiculed, as in the "latest news," in which the *muriste* informs the reader that the new title of Zola's novel *L'Attaque du moulin* (The attack of the mill) will be *Tic-tac du moulin*, since the book is about *tactics* (n.d.).

But the *muristes* also used puns to conceal their personal identities under the most ludicrous nicknames, anagrams, and pseudonyms. And their ubiquitous name games signal that they maintained a skeptical attitude toward traditional concepts of authorship, which distinguish between original works and imitations. For instance, when Louise France, the secretary of *Le Mur*, mockingly instructed her colleagues to "sign" their works, she actually asked them not to reveal their names, but just add an irrelevant "It's me!" (9 October 1894). One must wonder whose the appropriated identities are.

In a parody of a cabaret monologue written for Coquelin Cadet, the famous actor and writer known as the best interpreter of Charles Cros's monologues, Hugues Delorme playfully substitutes *Poquelin* for *Coquelin*: "Déjà le nom de Molière / Avec le mien s'accommodait / D'une façon particulière / Je suis un Poquelin Cadet" (The very name of Molière / Went well with mine / In a special way / I'm a Poquelin Cadet; *Le Mur*, n.d.). Delorme implies that Coquelin Cadet should be placed in the

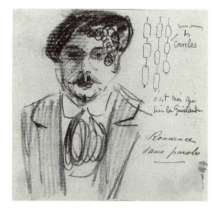

Fig. 295.
Lucien-Victor Guirand de Scévola, "Romance sans paroles," from *Le Mur*, 1894, crayon, 13 x 13.

Fig. 296.
Lucien-Victor Guirand de Scévola, "Guirlande de sert-Zola," from *Le Mur*, c. 1898, pen and ink, 11 x 13.

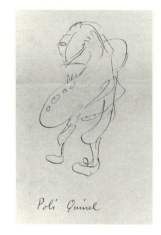

Fig. 297.
Unidentified, "Poli Quinel," from *Le Mur*, 1895, pen and ink, 19 x 13.

231

great lineage of Jean-Baptiste Poquelin, the classical playwright known as Molière. Elsewhere, L. Munch's name is inscribed in Shakespeare's *Much Ado about Nothing*, which reads *Munch Ado about Nothing*, whereas the traveling Yon Lug becomes Yon Gul, a pun on Swift's *Gulliver*: "Il s'appelle Yon Lug / A Paris en été / et il s'appelle Yon Gul / l'hiver quand il va en Swift" (He's called Yon-Lug / In Paris in the summer / and he's called Yon Gul / in the winter when he goes to Swift [an approximate pun on "Suisse"–Switzerland]; *Le Mur,* n.d.).

Not only illustrious figures of the past but also contemporary literary models were subject to "monstrous assemblages" by puns and rebuses. In one example [Fig. 295], the word *guirlande* (garland), the title of a collection of poems by Verlaine, is replaced with the drawing of a sausage, a ploy that alludes to the *guirlande de Cervelas* (a sausage) and to Lucien-Victor Guirand de Scévola, the well-known artist. Then, in a rebus, the same name Guirand de Scévola is changed into a "Guirland de sert-Zola" [Fig. 296], a drawing showing Scévola as a waiter serving Zola with a big pig's head instead of dessert.

Along with these references to literary figures, the works of well-known contemporary artists are also turned into fakes. Indeed, the *muriste*s go so far as not only to blur but literally to appropriate various artists' identities.[55] Manet's *Polichinelle* for instance, which was censored because of its obvious resemblance to President Mac Mahon and which was subsequently parodied in the *Album zutique*, becomes a pretext for a caricature and a self-derisive pun on the name of the *muriste* poet Charles Quinel, "Poli Quinel" [Fig. 297]. And among the numerous caricatures, imitations, and copies, viewers of *Le Mur* can also find fakes signed abusively "Valotton," "Hermann-Paul," "Ibels," "Redon," and "Paul Gauguin." For example, "La Demoiselle de Province" [Fig. 301] is a pastiche of Hermann-Paul's "Dame de province" [Fig. 302]; "La Mort dans l'âme par Mévisto" [Fig. 303] is a fake Ibels [Fig. 304]; equally false appropriations are Ibels's itinerant circus performer figure, Redon's smoking eye (October 1894) [Fig. 253], and Paul Gauguin's "Ouis c'est moué et toué" [Fig. 305]. In the latter, the name *Caucuin*, a pun on *Gauguin* and *coquin* (mischievous), combined with the title of the pastiche, is a parodic reference to Gauguin's recent (1895) trip to Tahiti.

Names, works, and identities were generally exchangeable and combinable within Montmartre's *muriste* community. For example, the biblical theme of Christ's ascent to the Mount of Olives, "Christ monta au jardin des Oliviers" (Christ climbed up to the Garden of Olives), is fumistically or, rather, muristically rewritten in the rebus "Yon Lug monto jardin des oliviers" [Fig. 271]. This is a pun on the combined names of Yon Lug and Gabriel Montoya, the author of the *Berceuse bleue*.[56] Elsewhere, by the technique of condensation, the name of the author actually fuses with his own work: the "Ballade Yon Loufiques" conflates Yon Lug with his "Rimes loufoques" (Whimsical Rhymes; *Le Mur,* n.d). Similarly, the tall and slim Jehan Rictus, who launched his poem "L'Hiver" with the notorious *merde*, is represented in the equally slim shape of the letter *I* [Fig. 298]. In the rebus, the famous line "Merd'! V'là l'Hiver

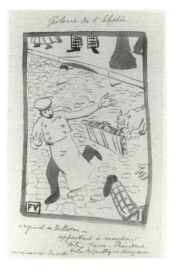

Fig. 299.
Auguste Roedel,
"Galerie de l'Elysée"
(parody on the work of
Félix Vallotton), from *Le
Mur,* 1895, india ink,
28 x 18.

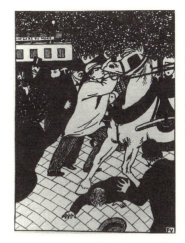

Fig. 300.
Félix Vallotton, "Le Cheval
emporté" (The Runaway
Horse), relief illustration for
Les Rassemblements (Paris:
Bibliophiles indépendants,
Henri Floury, 1896).

Fig. 301.
Auguste Roedel, "La
Demoiselle de
province" (parody
on the work of
Hermann-Paul),
from *Le Mur,* 1894,
india ink, 21 x 14.

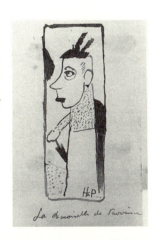

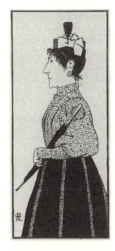

Fig. 302.
Hermann-René-Georges Paul,
called Hermann-Paul, "La Dame
de province," 1894, india ink, 41.5
x 24.5, reproduced in *Le
Courrier français,* 30 September
1894. Marian and Allan Maitlin
Purchase Fund.

Fig. 303.
Auguste Roedel,
"La Mort dans
l'âme par Mévisto"
(Death in the Soul
by Mévisto)
(parody on the
work of Henri
Ibels), from *Le Mur,*
1894, india ink,
18.5 x 14.

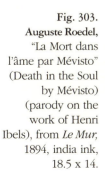

Fig. 304.
Henri Ibels, Mévisto performing
Mimi, 1894, stencil-colored
lithograph, 35 x 27. Schimmel
Fund 2.

233

Fig. 305.
Auguste Roedel, "Oui c'est Moué et Toué, Cauquin" (Yes it's me and you Roguin [a pun on rogue/Gauguin]) (parody on the work of Paul Gauguin), from *Le Mur*, 1894, india ink, 21 x 13.

234

Unidentified, extraits du journal *Le Canadien*, from "Les Pêcheurs de perles," from *Le Mur*, 1895, pen, ink, and collage.

Fig. 307.
Unidentified, "Le Pendu des Epinettes" (page 3), from *Le Mur*, c. 1904, pen and ink, 21.5 x 13.5.

Fig. 308.
Unidentified, "Petites Affiches," from *Le Mur*, 1894, pen and ink, 19 x 14.

et ses dur'tés" (Shit! Here's Winter and its hardships), reads as a minimalist "Merde, v'la l'I vert" (Shit, here's the green *I*).

As a "monstrous" condensation of images and words, the rebus reflects the *muristes*' overall interest in the relationship between different forms of communication, a phenomenon that had such canonical predecessors as Mallarmé's *Coup de dés* [Fig. 184] and was further developed by the Dadaists, in Conceptual art, and other experimentation with multimedia.[57]

Using an original interplay between text and image, and also between handwriting and typography, the *muristes* combined newspaper clippings, collagelike, with their own corrections, deletions, and marginal notes that functioned as critical or gratuitously humorous glosses [Fig. 277]. This particular enterprise was called "Les Pêcheurs de perles" (pearl fishers) and lasted for the entire period of production of *Le Mur*. The collage activity was ritualistically performed along with other portions of the show at the Quat'z'Arts: "Des extraits des journaux du jour lui sont apportés par les 'Pêcheurs de perles', qui ont découvert dans quelque roman palpitant la phrase bienvenue" (Clippings from the day's newspapers are brought to him [the editor in chief] by the "Pearl Fishers," who discovered the right phrase in some thrilling novel; Emile Lutz, "Cabaret des Quat'z'Arts"). As a prefiguration of the Dadaist poem or of "word processing," in "pearl fishing" the task of the editor on call consisted of actually highlighting, erasing, and making marginal notes on commonplaces, and on grammatical or ideological errors committed by other journals. The journal *Le Canadien* [Fig. 306], a publication of the French community in Canada, was a special satirical target for such treatment. But the overall function of the "pearl-fishing" display seemed to be to question the traditional separation between finished and unfinished works and their concomitant hierarchy.

Fig. 309.
Unidentified, "La Grande Ménagerie de Montmartre," from *Le Mur*, c. 1896, pen and ink, 13.5 x 21.

On *Le Mur*, language itself became a pictorial representation of the things it described. Recalling the complicated visual poems of the early-sixteenth-century Rhétoriqueurs whom the Incohérents, among others, had rediscovered,[58] and also prefiguring Apollinaire's *Calligrammes* [Figs. 136–138], the artists of *Le Mur* often experimented creatively with the physical, visual aspect of language. The collective serial novel *Le Pendu des Epinettes* [Fig. 307], for example (the word *Epinette* refers directly to the real name of Léo Trézeni[c]k), was inspired by a banal event in the journal, "monstrously" juxtaposed with themes from the late medieval chronicle *La Vie de St.-Louis* (The Life of St. Louis) by Joinville.[59] As the narration moves back and forth between a daily news report and the legendary past of St. Louis recast in the *fumiste* verses of Aristide Bruant, the reader is abruptly informed that a corpse had been hanging from the king's favorite oak tree in the woods of Epinettes. Black humor is made visual as the text concretely shows the balancing of the corpse "ho-ri-zon-ta-le-ment." The dislocated words violently disrupt the habitual linear logic of the narration, as well as regular syntax, and become "free," like the "parole in liberta" presented by the Futurist Marinetti.[60] Similarly, in the fake *petites affiches* (small ads) [Fig. 308], the first syllables of the first words are set "free." Obviously, the role of the highlighted vulgar term *con* in *confection* (ready-made clothes), in the last ad, *commerce facile* (easy negotiation), is to ridicule the advertisement section of the newspaper.

Le Mur aimed at turning upside down social, political, religious, literary, and artistic conventions, and ultimately the strategy of subversion itself. But it also clearly aimed to elevate the status of ordinary and trivial things to the status of cult objects. From this perspective again, *Le Mur* prefigures twentieth-century avant-garde art, the aesthetic promotion, for example, of kitsch. Like the promoters of kitsch, the *muristes* idolized the common as aesthetic, not so much, however, for its own value as indirectly to condemn a society that depreciates artistic values in general.[61]

Fig. 310.
Unidentified, "Les 4 z'Arts,"
from *Le Mur*, 1894,
pen and ink, 13 x 21.

237

What happens to the artist and to art in the "age of mechanical reproduction," as defined by Walter Benjamin? Again, the *muristes* responded to this quandary in a collaborative, carnivalesque, spontaneous, self-referential, and self-derisive way. Having exhausted past and contemporary models, they turned to the animal world. In the rebus "La Grande Ménagerie de Montmartre" [Fig. 309], "dissected," that is, directed by Trombert, names seem to convey the fate of the artist, as Yon Lug is depicted as a lion (Lion Lug), Sécot as a group of piglets ("Sécot"/"ces cochons"), and Horace Valbel as a voracious crow ("Le Corbeau vorace"). The lion, Yon Lug's animal alter ego, is a double reference to Lyon, the poet's hometown, and to his participation in the Cirque Molier prior to his entry to the Quat'z'Arts as an artist: "C'est le lion d'Yon-Lug et le Yon Lug de Lyon" (It's the lion of Yon-Lug and the Yon-Lug of Lyon; Charles Quinel, *Le Mur*, n.d.). But perhaps the cleverest of all these rebuses is that called "Les 4 z'Arts" [Fig. 310], in which the names of the four arts (printmaking, architecture, painting, and sculpture) are dislocated and brought together under the common denominator *hure* (which is a pig's head but also a hunting trophy): *grav-hure, architect-hure, peint-hure, sculpt-hure* (*Le Mur*, September 1895). Here, the artist reaffirms the fraternity and implicit uniformity of the four arts and also literally idolizes the profane, as the sole appropriate mode for all creative effort is to depict a pig's head as a trophy.

Though Montmartre artists in general, and those of *Le Mur* in particular, proudly declared themselves the descendants of Rabelais's spirit of fraternity and caustic *gauloiserie*, the identification never, in fact, went further than a superficial literary game. For whereas Rabelais reaffirmed the values of humanism and evangelism, in which satire, parody, and puns served playfully to banish all things that compromised such values, the artists of *Le Mur*, lacking a particular critical point of view, made these devices into techniques of general subversion aimed at the world in general, the text, and the self. If Rabelais's text appears as a "monstrous assemblage," its eclecticism is exploratory, the *gauloiserie* correctively creative, rather than indiscriminately destructive. The realms of low and high never replace each other but coexist in a cornucopian complementarity.[62] In the case of *Le Mur*, and of the late Montmartre avant-garde in general, the very lack of a clear artistic standpoint in applying such devices was consistent with the overall questioning of such traditional aesthetic oppositions as subjects and objects of imitation, original works versus reproductions, and with the challenging of long-standing concepts of authorship and artistic autonomy. The primary innovation of the *muristes* consisted in examining the process of coming into being of the work, rather than in perfecting the final product itself, in exploring the interaction between text and image, and in cultivating the aesthetic interest of the ordinary. When the artist, the editor, the spectator, the reader, and the critic, are all the same, wall-writing may become nothing but an anonymous, narcissistic, and thus self-destructive *mur-mur*. This self-effacing process effectively opens the way, however, for the twentieth-century avant-garde.

1. "The French gaiety and spirit have been sullied with this bumptious race divided in many categories: the sticky or the thin dandies; the prostitutes or the 'quart-de-mondaines'; the pornographics, the naturalists or the realists. We have to rehabilitate the national glory called the French spirit," declared Jules Lévy in "L'Incohérence—son origine—son histoire—son avenir," in *Le Courrier français*, 12 March 1885, 3–4.

2. Sanford Elwitt, *The Making of the Third Republic* (Baton Rouge: Louisiana State University Press, 1975), 14–52, 215–29.

3. Anthony Burton, "Nineteenth-Century Periodicals," in *The Art Press*, ed. Trevor Fawcett and Clive Phillpot (London: The Art Book Company, 1976), 3–10.

4. Henry J. Chaytor, *From Script to Print* (New York: October House, 1967), 115–37; Elizabeth Eisenstein, *The Printing Press as an Agent of Change: Communications and Cultural Transformations in Early Modern Europe*, 2 vols. (Cambridge: Cambridge University Press, 1980); Phillip Dennis Cate, *Printing in France, 1850–1900: The Artist and New Technologies*, in *Gazette of the Grolier Club*, nos. 28–29 (June–December 1978): 57–73 (pub. 1982).

5. Rabelais's other books are the *Tiers Livre* (1546), the *Quart Livre* (1546 and 1552), and *L'Isle sonnante* (1552), which is probably only partly his own. For an edition of his works in English translation, see *The Complete Works of François Rabelais*, trans. Donald M. Frame, ed. Raymond C. La Charité (Berkeley: University of California Press, 1991).

6. Mikhail Bakhtin, *Rabelais and His World* (Moscow, 1965; Cambridge, Mass., 1968).

7. Samuel Kinser, *Rabelais's Carnival: Text, Context, Metatext* (Berkeley: University of California Press, 1990), 155–61.

8. La Bruyère's negative perception of Rabelais's verbal fantasy was transformed by the Romantic historian Jules Michelet into a positive view: "*Gargantua*! Quel livre! le sphinx ou la chimère, un monstre à cent langues, un chaos harmonique, une farce de portée infinie, une ivresse lucide à merveille, une folie profondément sage" (*Gargantua*! What a book! The sphinx or the chimera, a monster with a hundred tongues, a harmonic chaos, a farce of infinite reach, a wondrously lucid drunkenness, a profoundly wise folly; Lazar Sainéan, *L'Influence et la réputation de Rabelais* [Paris: Gamber, 1930], 194).

9. Sigmund Freud, *Jokes and Their Relation to the Unconscious*, trans. James Strachey (New York: Norton, 1960), 18–19, 147–48, 159–80. See also *The Philosophy of Laughter and Humor*, ed. John Morreall (Albany: State University of New York Press, 1987), 111–16.

10. Guy Demerson, "Les Calembours de Rabelais," in *Le Comique verbal en France au XVIe siècle* (Warsaw: Editions de l'Université de Varsovie, 1981), 73–93.

11. François Rigolot, "Rabelais, Misogyny, and Christian Charity: Biblical Intertextuality and the Renaissance Crisis of Exemplarity," *Papers of the Modern Language Association* 109 (March 1994): 225–37.

12. Demerson, "Les Calembours de Rabelais," 93.

13. Jean-Claude Margolin, "Les Rébus au XVIe siècle: Histoire et structure," *Revue des sciences humaines* 3 (1980): 47–59.

14. *Le Gaulois*, 1884, quoted in Catherine Charpin, *Les Arts incohérents (1882–1893)* (Paris: Syros Alternatives, Collection "Zigzag," 1990), 64.

15. Joseph A. Dane, *Parody: Critical Concepts versus Literary Practices* (Norman: University of Oklahoma Press, 1988), 4–5.

16. Daniel Grojnowski and Bernard Sarrazin, *L'Esprit fumiste et les rires fin de siècle* (Paris: José Corti, 1990), 27.

17. Horace Valbel, *Les Chansonniers et les cabarets artistiques* (Paris: E. Dentu, 1889), 173–75.

18. Jacques Ferny, "Le Cabaret des Quat'z'Arts," in *Les Chansonniers de Montmartre*, special issue, unpaginated, 1906.

19. Phillip Dennis Cate, "Paris Seen through Artists' Eyes," in *The Graphic Arts and French Society, 1871–1914*, ed. Phillip Dennis Cate (New Brunswick, N.J.: Rutgers University Press, 1988), 3–53.

20. Théophile Briant, *Jehan Rictus* (Paris: Seghers, 1973), 69–80.

21. Rictus's plain language and attacks on such preeminent literary figures as Victor Hugo did actually provoke the anger and protest of Catulle Mendès, the theater critic, who was present at the performance of the *Soliloques du pauvre* (Ferny, "Le Cabaret des Quat'z'Arts").

22. *Performance Art: From Futurism to the Present* (London: Thames and Hudson, 1988), 7.

23. A similar spirit of fraternity and spontaneity was previously promoted in the *Livre d'or* of the Bon Bock, published in 1878 as the *Album du Bon Bock* (see Cate's essay).

24. *The Art Press*, 1.

25. Yves Guillauma, *La Presse en France* (Paris: Editions de la Découverte, 1988), 13.

26. "The Work of Art in the Age of Mechanical Reproduction," in *Illuminations*, ed. Hannah Arendt (New York: Schocken Books, 1969), 217–51.

27. Among the short-lived artistic journals with limited circulation founded by well-known artists and writers such as Hermann-Paul, Marc Mouclier, and Alfred Jarry respectively, were *Le Fond de bain* (1895–98), the *Omnibus de Corinthe* (1896–98), and *Almanach du Père Ubu* (1899, 1901). See Phillip Dennis Cate, "Forums of the Absurd: Three Avant-Garde Lithographic Publications at the Turn of the Last Century," *The Tamarind Papers* 16 (January 1996).

28. Although these works were not intended for publication, selected pieces, such as Yon Lug's *Bible d'amour* and Louise France's *Berceuse verte*, were nonetheless published in regular Montmartre journals.

29. *The Art Press*, 2.

30. Valbel, *Les Chansonniers et les cabarets artistiques*, 189.

31. *Variety Theater Manifesto*, in Goldberg, *Performance Art*, 17.

32. Serge Dillaz, *La Chanson sous la IIIe République* (Paris: Tallandier, 1991), 63.

33. Ibid., 41–42.

34. Grojnowski and Sarrazin, *L'Esprit fumiste*, 444.

35. George A. Shaw, *Madagascar and France* (New York: American Trade Society, n.d.), 117–288; Harold D. Nelson and Margarita Dobert, et al. *Area Handbook for the Malagasy Republic* (Washington, D.C., 1973), 9–18.

36. Elisabeth Dixmier and Michel Dixmier, *L'Assiette au beurre* (Paris: F. Maspero, 1974), 206–9.

37. Alfred Jarry, "Ubu colonial," in *Tout Ubu* (Paris: Le Livre de Poche, 1962), 421–39.

38. Allais's monochrome artworks included in the *Album primo-avrilesque* were, in fact, largely inspired by colonialist exoticism.

39. Jules Depaquit was known for his caricatures of Senator Béranger published in the satirical journal *Le Rire*.

40. Roedel's sketches illustrating the "black spirit" of Tananarive are exotic curiosities in the minimalist style similar to Bonnard's illustrations of the *Almanach du Père Ubu*.

41. Originally, *Les Quatre Fils Aymon* belonged to a cycle of *chanson de geste* retracing the revolt of the French knights against central power. It is implicit that the choice of the *Les Quatre Fils de Pharamond* by the writers of *Le Mur* is a veiled political statement about the handling of power by the leaders of the Third Republic.

42. See André Breton, *Manifestoes of Surrealism*, trans. Richard Seaver and Helen R. Lane (Ann Arbor: University of Michigan Press, 1969), 1–47.

43. Allais illustrated the same conflation of time in his *Petit Marquis*, using the absurd date "the 33rd of July 712, shortly before the Restoration" (Grojnowski and Sarrazin, *L'Esprit fumiste*, 172–75).

240

44. *The Dreyfus Affair: Art, Truth, Justice*, ed. Norman L. Kleeblatt (Berkeley: University of California Press, 1987), 50–95; Michael R. Marrus, "Popular Anti-Semitism," 50–61, and Phillip Dennis Cate, "The Paris Cry: Graphic Artists and the Dreyfus Affair," 62–95, in *The Dreyfus Affair*.

45. Dixmier and Dixmier, *L'Assiette au beurre*, 175.

46. Emile Goudeau, *Dix Ans de Bohème* (Paris: Librairie illustrée, 1888), 172.

47. Marie Krysinska who gave, as we have seen, her own version of Verlaine's "Chanson d'automne" participated in *Le Mur* as a serialist. She was responsible for selected chapters of the macabre story "Pietro le Bandit."

48. Ann Ilan-Alter, "Paris as Mecca of Pleasure: Women in Fin-de-Siècle France," in *The Graphic Arts and French Society*, 55–82.

49. Valbel, *Les Chansonniers et les cabarets artistiques*, 250.

50. See also Yon Lug's version of Alphonse Allais's *fumiste* story, "Amours, délices et orgues," also parodied by Vincent Hyspa, in "Amour, délices et orges" (*Le Mur*).

51. See also Albert Merat's sonnet "Idole," inspired by the "blasons du corps feminin" of the sixteenth-century poet Clément Marot, and François Coppée's *Intimités*.

52. See also the *fumiste* story "La Grande Anglaise" (*conte cruel*) and Jules Bois's *Douleur d'aimer*.

53. *The Annotated Oscar Wilde*, ed. H. Montgomery Hyde (London: Orbis, 1992) 7–26; Jerrold Seigel, *Bohemian Paris: Culture, Politics, and the Boundaries of Bourgeois Life, 1830–1930* (New York: Viking, 1986), 389.

54. Léon de Bercy, *Montmartre et ses chansons* (Paris: H. Daragon, 1902), 100.

55. We have previously seen in Mary Shaw's essay that Alphonse Allais also proceeded in similar fashion when he appropriated the name of the theater critic Francisque Sarcey.

56. Similar anagrams can be seen in the collaborative "Contes sens dessus-dessous," signed "Carlemyl," a combination of the names of Charles Cros and Emile Goudeau (Grojnowski and Sarrazin, *L'Esprit fumiste*, 249–54).

57. Mary Lewis Shaw, *Performance in the Texts of Mallarmé: The Passage from Art to Ritual* (University Park: Pennsylvania State University Press, 1993), 171–83. Other contemporary examples of this experimentation are the "Sonnet pointu" by Edmond Haraucourt from *La Légende des sexes*, and Alphonse Daudet's "Pan-tho-mètre" in *Le Parnassiculet contemporain* (ibid., 49–50).

58. As was shown in Mary Shaw's essay, similar attempts were made by other *fumistes*, such as Alphonse Allais in *Un Drame bien parisien*, or George Auriol in *Petit Conte semi-hiérogliphique* (ibid., 255, 265).

59. Ibid., 27.

60. Goldberg, *Performance Art*, 11–30.

61. Lionel Duisit, *Satire, parodie, calembour* (Saratoga, Calif.: Amma Libri), 81–82.

62. La Charité, introduction to *The Complete Works of François Rabelais*, xli.

Appendix *Ubu*

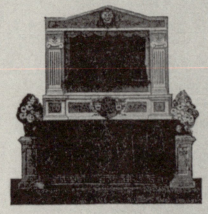
Vendredi, 4 Mars.

Monsieur Méry-Picard.

Voici les tuyaux sur Ubu!

Ubu a été joué, comme vous le savez, aux Bouffes du Nord par le théâtre de l'Œuvre. Puis, repris au théâtre! de la rue Ballu, avec des marionnettes, genre Liégeois. Jarry avait comme co-directeur, le compositeur Terrasse. Les premières représentations eurent lieu avec un éclairage spécial, des pots à chandelles, avec un porte-mouchettes chargé d'enlever les charbons de mèche. Quelles odeurs!. Jarry y tenait beaucoup à cette odeur, car étant partisan du plus lourd que l'air et estimant sa densité trop faible, il laissait accumuler du haut en bas de son chétif individu, des couches successives destinées à le rendre un homme de poids. Donc, les représentations de la rue Ballu ne durèrent que quelques jours, mais on eut plusieurs fois

le grand plaisir d'entendre le maître terrasse composer
des fantaisies admirables sur Ubu. Malheureusement, les
quelques pages que j'avais pu réunir, ont disparu.

Quelque temps après, Ubu fut repris en 4 3 actes.
Comme au théâtre de la rue Ballu, il fallut sacrifier
une grande partie de la mise en scène originale de l'ouvrage pour
faire un à peu près. M. Gauthard fut chargé de la mise à la Scène.
à Ubu vu en guignol ! Jarry voulait 2 décors, mais je
lui fis comprendre que le Merdre! d'Ubu avait bien
pâli depuis son succès des Bouffes, et que ça ne suffisait
plus ; le Pâlotin ayant besoin du croc à Phynance, souffla
la chandelle verte en criant : " Cornegidouille ! s'enfonça dans la trappe.
Alors Ubu y eut quatre décors : le 1er le logis d'Ubu. le 2e au milieu
le palais où se fait l'assassinat du roi et les apparitions
à Bougrelas. ainsi que le réunion des notables. le champ de bataille, où manœuvraient
les Russes et les Polonais, équipés par 6 et défilant
en soldats de cirque. les équipes de 6 soldats se rangeaient
de front, de flanc, et faisaient demi-tour. Ubu apparaissait
à cheval, un cheval de bois qui ruait. Il y avait le
combat de l'ours. pendant que Ubu, prisonnier dans
le moulin, regardait par la fenêtre en récitant Pater Noster.
Le moulin avait des ailes qui tournaient pendant la durée
du tableau. Pour le 3e et dernier, le vaisseau était représenté
par un bateau à voile, dans lequel étaient Ubu, la mère
Ubu et des officiers polonais : le tableau était terminé par
un chœur nautique bien connu « Vers les rives de France,
voguons en chantant avec les répliques « Voui ! ». et
rideau . Il y eut 64 représentations, au grand scandale
des chansonniers de la Butte.

Voilà, cher Monsieur Meir-Picard, tout ce que je
peux vous donner en fait de tuyaux.
Pour la Revue trimestrielle Boucherait-tout, vous savez qu'il n'y
eut que 23 numéros ; ils sont rares au complet.
Les paradis ne forment qu'une partie ; si vous désirez lire les
autres, je les tiens à votre disposition.
Très-cordialement, votre obligé
Gauthier

1993.1046

Friday, 4 March [1904] *

Mr. Méry-Picard,

Here's the inside story on *Ubu*!

As you know, *Ubu* was staged at the Bouffes du Nord** by the Théâtre de l'Oeuvre, then performed again at the Théâtre ! de la rue Ballu with Liegeois-type puppets. Jarry's co-director was the composer Terrasse. The first performances were staged with special lighting, namely, *candle pots*, with a snuff holder for removing soot from the wicks. What odors! Jarry insisted on this odor, because being a partisan of the heavier-than-air and finding his density too weak, he allowed to accumulate from top to bottom of his puny person a series of layers designed to make him a person of consequence. So, the rue Ballu performances ran for only a few days, but on several occasions we had the great pleasure of hearing Mr. Terrasse compose admirable fantasias on *Ubu*. Unfortunately the few pages that I was able to gather have disappeared.

Some time later, *Ubu* was played at the 4'z'Arts.*** As at the Théâtre de la rue Ballu, a large part of the play's staging had to be sacrificed so as to create an approximation (a large part of the original staging had to be sacrificed). I was (Mr. Gauthard was) put in charge of staging the Puppet version of *Ubu*! Jarry wanted two sets, but I got him to understand that Ubu's Merdre! had indeed paled since its success at the Bouffes, and that this would no longer be enough: The Palottin, being in need of a Phynance hook, blew out the green candle while shouting *Cornegidouille*! and dove into the Nobles' hatch. And so *Ubu* had four sets: The 1st: *Ubu's lodging*; the 2d: *the palace*, scene of the king's assassination and the apparitions to Bougrelas as well as the massacre of the leading citizens; 3: *The battlefield*, where the Russians and the Poles, maneuvering in groups of six, paraded like circus soldiers. These six-soldier teams formed a line by the flank and executed about-turns. Ubu would appear on horseback, a wooden horse that bucked. There was the battle with the bear, while Ubu, imprisoned in the mill, watched from the window and recited the Our Father. The mill had vanes that turned throughout the scene. For the *4th and last set*, the vessel was represented by a sailboat with Ubu, Mère Ubu, and some Polish officers on board; the scene ended with a well-known nautical chorus, "Vers les rives de France, voguons en chantant . . ." (Let's row toward the shores of France, singing as we go . . .), with refrains of "Voui!" (Yeah!), and curtain. There were 64 performances, much to the indignation of the chansonniers of the Butte.

And these are all the tips I can give you, Mr. Méry-Picard.

As for the Revue Britannique *Touche-à-tout*, you know that only 23 issues appeared; complete sets are rare. Parodies form only a small part of them. If you want to read the others, I have them for you.

Very cordially, your servant,

[Signature]
Gauthard

*Although Gauthard did not specify the year, the fact that 4 March was a Friday enables us to confirm that the letter was written in 1904.

** Gauthard is incorrect. *Ubu* was first staged at the Nouveau Théâtre, not at the Bouffes du Nord.

***(In left margin): At Trombert's, F. Chézelles played Ubu, Dicksoun(?) played the chansonnier. The hatch scene–well-known figures = Lépine, Brisson, Deschanel; the rout scene = groups of dolls.

244

Appendix of Biographies and Index

The following are brief biographies of some of the artists, authors, poets, singers, etc., mentioned in the preceding essays. Better-known personalities, easily found in standard reference works on art, literature, and music, are not annotated. Numbers following entries refer to pages on which the names can be found; bold numbers refer to pages with illustrations.

Selected Bibliography

Abélès, Luce, and Catherine Charpin. *Arts incohérents, académie du dérisoire*. Collection les Dossiers du Musée d'Orsay, 46. Paris: Réunion des Musées nationaux, 1992.

Caradec, François. *Alphonse Allais*. Paris: Belfond, 1994.

Cate, Phillip Dennis, ed. *The Graphic Arts and French Society, 1871–1914*. New Brunswick, N.J.: Rutgers University Press and Jane Voorhees Zimmerli Art Museum, 1988.

Charpin, Catherine. *Les Arts incohérents (1882–1893)*. Paris: Editions Syros Alternatives, Collection "Zigzag," 1990.

Deak, Frantisek. *Symbolist Theater: The Formation of an Avant-Garde*. Baltimore and London: The Johns Hopkins University Press, 1993.

Fields, Armond. *Le Chat Noir*. Santa Barbara, Calif.: Santa Barbara Museum of Art, 1993.

Goldberg, Roselee. *Performance Art: From Futurism to the Present*. London: Thames and Hudson, 1988.

Grojnowski, Daniel, and Bernard Sarrazin. *L'Esprit fumiste et les rires fin de siècle*. Paris: José Corti, 1990.

Seigel, Jerrold. *Bohemian Paris: Culture, Politics, and the Boundaries of Bourgeois Life, 1830–1930*. New York: Viking, 1986.

Storey, Robert. *Pierrots on the Stage of Desire: Nineteenth-Century French Literary Artists and the Comic Pantomime*. Princeton, N.J.: Princeton University Press, 1985.

Henri Gray, *Chat Noir*, c. 1895, watercolor and graphite, 31.5 x 23.5.

Museum Staff

ADMINISTRATIVE

Phillip Dennis Cate, Director
Ruth Berson, Associate Director
Jeffrey Wechsler, Assistant Director
 for Curatorial Affairs
Donna DeBlasis, CFRE, Director
 of Development
Marguerite M. Santos, Business Manager
Judy Santiago, Principal Secretary
Hilary Brown, Development Associate
Ulla-Britt Faiella, Receptionist
Nina Danielson, Receptionist

CURATORIAL

Trudy V. Hansen, Director, Morse
 Research Center and Curator of Prints
 and Drawings
Katherine Tako-Girard, Curator of
 Education and Publicity Coordinator
Pamela Phillips, Education and Public
 Relations Coordinator
Alla Rosenfeld, Curator
 for Russian and Soviet Nonconformist Art
Marianne Ficarra, Assistant Curator
 for Soviet Nonconformist Art
 and Public Relations Officer for Soviet
 Nonconformist Art
Caroline Goeser, Assistant Curator
Patricia Cudd, Curatorial Assistant
Gail Aaron, Curatorial Assistant
Madhuri Mukherjee, Cataloguer of Rare
 Book Collection
Roberto Delgado, Preparator
Elaine Beca, Graphics Coordinator
John Campbell, Computer Graphics Specialist

REGISTRARIAL

Barbara Trelstad, Registrar
Leslie Kriff, Assistant Registrar

PUBLICATIONS

Anne Schneider, Publications Coordinator

EXHIBIT INSTALLATION/SECURITY

Edward Schwab, Director of Musuem
 Installation/Physical Plant
John Nasto, Workshop Manager
Eleuterio Peralta, Senior Guard
Daniel Trush, Installation Preparator
Ron Varlow, Weekend Security

FRIENDS OF THE ZIMMERLI

Marilyn Hayden, Coordinator
Lynn Biderman, Museum Store Manager
Elliot Bartner, President
Inge Helling, Z Café Assistant